Medieval and Renaissance Illuminated Manuscripts in Australian Collections

Published with the assistance of grants from:

Dame Elisabeth Murdoch, D.B.E.

The Ian Potter Foundation

The Helen M. Schutt Trust

The Estate of the late H. P. Williams

Percy Baxter Charitable Trust

H. and L. Hecht Trust

The Committee of Research and Graduate Studies,
University of Melbourne

MEDIEVAL AND RENAISSANCE
Illuminated Manuscripts
IN AUSTRALIAN COLLECTIONS

Margaret M. Manion and Vera F. Vines

with a foreword by K. V. Sinclair

302 illustrations, 48 in colour

Thames and Hudson
Melbourne · London · New York

PUBLISHER'S NOTE

An explanation of the system of measurements used in the
Catalogue will be found in the Glossary on pp 20–21. As a guide
to the degree to which the original has been enlarged or
reduced the overall dimensions are also given in the captions
for complete pages, double pages and 'cuttings'
from manuscripts in the Australian collections and
wherever possible for comparative material
so reproduced.

Phototypeset by Tradespools Limited, Frome, Somerset
Printed and bound in Great Britain by
Balding and Mansell Wisbech

Contents

Foreword *by* K. V. Sinclair 7

Introduction 9

The Collectors 14

Guide to Liturgical and Devotional Books 18

Glossary of some Descriptive Terms 20

Byzantine Manuscripts 23

Italian Manuscripts 27

English Manuscripts 98

Netherlandish Manuscripts 132

German Manuscripts 152

French and Franco–Flemish Manuscripts 169

Spanish Manuscripts 229

Acknowledgments 230

Bibliography 232

Index 235

Illustrations

Byzantine

Plate 1 29

Figs. 1–7 41–42

Italian

Plates 2–24 30–36, 61–68, 77–84

Figs. 8–87 43–56, 113–118

English

Plates 25–29 101–105

Figs. 88–111 119–124

Netherlandish

Plates 30–34 106–108, 141, 142

Figs. 112–146 125–128, 153–157

German

Figs. 147–150 158

French and
Franco-Flemish

Plates 35–48 143–148, 189–196

Figs. 151–252 159–168, 209–224

Spanish

Figs. 253–254 224

Foreword

The publication of this volume is welcome on several counts. Australians themselves desire to know much more about the range and splendour of their nation's medieval miniatures. Brief visits to art gallery show-cases and library shelves have led them to the brink of anticipation. The rest of the world, however, has for long been in a state of disbelief about the presence of illuminated manuscripts in a nation that is only two hundred years old, and one, for that matter, that is situated far from the European culture that produced book illumination and developed it into a distinctive art form with its own spiritual, allegorical and hermeneutic appeal.

As such, manuscript illumination has its own special place in the history of painting, and therefore needs to be accessible to scholars and the public so that informed comment can be made and discussion sustained at all times. Yet, paradoxically, such works have often had to be confined to library safes and bank vaults in order to protect their fragile surfaces and delicate luminosity. Some miniatures even have become sequestrated from the public at large because governments have declared them national treasures; one can view them normally only on State occasions.

Faced with such stringent preservation measures on the one hand, and, on the other, the truism that medieval illuminated manuscripts have to be seen to be believed – and appreciated – modern man has been obliged to find a compromise: let the originals remain in vaults and let their place in the light of day be taken by very clear colour or black-and-white reproductions prepared with extra fine lenses and controlled lighting.

The authors of this volume are therefore to be congratulated for discerning the public need for instruction and enlightenment about such art treasures, and for meeting it with thoroughness, sensitivity of purpose, and perception of values and concerns. The forty-eight colour plates and two hundred and fifty-four black-and-white figures will more than satisfy the keen enquiries and fastidious tastes of the art connoisseur, the art historian, the art student, and the interested public. The volume constitutes a ready and authoritative guide to the location of the original hand paintings on vellum or parchment, to the quality of the artwork, the range of styles and the approximate dates of completion. The authors pay careful attention to detail, discuss new evidence for provenances, workshop productions and identities of select painters. A lay person who is uncertain how to interpret the wealth of specialized information supplied will feel reassured and be greatly assisted by the glossary of descriptive terms. He also has the opportunity to learn something about the leading bibliophiles whose undemonstrative acts of bringing illuminated medieval manuscripts to the Antipodes have contributed immeasurably to the enhancement of Australia's artistic heritage.

As the authors explain so lucidly in their Introduction, the paintings are grouped, for purposes of historical accuracy and immediacy of reference, into broad geographical regions, such as Byzantine, Italian, French and so on. Within these divisions the sequence

of visual evidence is arranged chronologically. The time span overall is late eleventh to the middle of the sixteenth century.

This resplendent collection of photographs and plates has been painstakingly and expertly assembled over several years by Professor Margaret Manion, with the assistance of Dr Vera Vines. Both have travelled extensively in the United Kingdom, Europe and the United States in search of other works by the same artists or from the same ateliers as are represented in Australian collections. The comparative material enhances the total reference impact of the volume on the user and reader.

Thames and Hudson, distinguished British publishers of art works, are to be commended for undertaking the production and publication of this volume. They too realize that it is the first comprehensive survey of medieval manuscript illumination in Australia and, as such, it will retain its value and appeal to the expert and the general public for generations to come.

K. V. Sinclair

Introduction

Books on any subject should bear the germ of fresh ideas and inspiration, capable of generating new dreams and visions to be explored in a variety of circumstances, until they too become part of a richer human experience which may give rise to renewed literary and artistic endeavour. In one sense this particular book could not have a more prosaic subject, concerned as it is, to a very large extent, with as precise a recording and analysis as possible of the physical elements – the material dimensions, rulings, illustrations etc. – of a group of books themselves. Yet, paradoxically, it is precisely through such objective scrutiny that each of these crafted manuscripts, now hundreds of years old, yields up unique secrets, stimulating mind and imagination to make contact with the vitality of the past.

Each of the books or fragments of books selected for inclusion here is 'illuminated', a term used in a broad sense for the decorated and illustrated manuscripts produced prior to the printed book, or whose execution slightly overlaps the appearance of that phenomenon. For the writers and users of these works, the written word was elucidated by its decorative or illustrative context, and it is precisely these elements which are the object of this study. The relationship between text and decoration or illustration is crucial to such a study, however, and our research builds directly on the pioneering achievement of Professor K. V. Sinclair. In his *Descriptive Catalogue of Medieval and Renaissance Western Manuscripts*, published in 1969, Sinclair identified two hundred and sixty-four manuscripts or fragments thereof known to have been in Australia at some time and he meticulously recorded the codicological and textual elements of those which were still in Australian public and private collections. Sinclair alluded only in general terms, however, to the wealth of artistic material encompassed by these manuscripts. The present study seeks to supplement his work in this respect, focusing attention on those books which may be called illuminated and adding certain hitherto uncatalogued items to his list.

Vera Vines discusses in an essay on the Collectors, below, how these books came to Australia and some of the varied interests and motivations behind such acquisitions. For the historian, and even more particularly the art historian, there is always cause to marvel at how, from seemingly chance and haphazard decisions, certain clear patterns of survival emerge. Given its remoteness from Europe and its relative youth, Australia possesses a remarkable range of illuminated manuscripts, several of which are distinguished by their high quality of artistic execution, while they all contribute to the varied history of the hand-written and decorated book.

One of the country's oldest and finest books is the Byzantine Gospels, No. 1, probably executed in Constantinople about AD 1100 (Plate 1, figs. 1–7). Bereft of its evangelist portraits, it nevertheless retains much of its pristine splendour and is an important example of book illumination from the Comnenian period. The decoration of the *Life of St Wilfrid*, No. 47, produced about fifty years later for an English monastery, is confined to a simple introductory initial in bright red, blue and green (fig. 105). Yet it too provides

precious testimony to the taste and demands of specific patrons. To match the sumptuousness of the Byzantine Gospels one must turn to the French courts of the early fifteenth century and to works such as the great tome of Bersuire's French translation of Livy, No. 72 (Plate 38, figs. 183–194), which seems to have been commissioned for a Burgundian prince. It too gleams with gold and abounds in rich and ornate patterns; but its illustration is penetrated by the secular interests of the French and Burgundian nobility, and is as far removed in this sense from the liturgical function of the Greek lectionary as is its Gothic style from Middle Byzantine art. To the sumptuous, glittering class belong, too, some of the manuscripts from the final period of book illumination – the splendid *Historia Augusta* of 1479, No. 31 (Plate 22, figs. 68–74), executed for Lorenzo de' Medici, or the so-called Strozzi–Acciaiuoli Hours, *c.* 1495, No. 33 (Plate 23, figs. 76–80), where the ancient practice of staining sections of vellum red, blue or purple is adapted to the canons of taste of Renaissance art.

As well as such immediately eye-catching examples, a host of works takes us into the highways and byways of medieval and Renaissance illumination. Sometimes it has been possible, with the generous assistance of widely dispersed colleagues, to contribute to the reconstruction of the *œuvre* of a particular artist or atelier, as is the case with the Aspremont Offices, No. 70 (Plate 36, figs. 163–174), the Hours for the Use of York, No. 56 (Plate 31, figs. 120–127), and the Manning Hours, No. 81 (Plate 44, figs. 229–234). It has been exciting, too, to engage in the hunt which led to the identification of a section of a small but rare fourteenth-century English breviary, No. 43, with its other half, now Ms. Laud. Misc. 3A, in the Bodleian Library, Oxford (Plate 26, figs. 88–93); and to witness, as part of the renewed momentum in the study of Italian illumination, a thirteenth-century Franciscan missal, No. 4 (Plate 4, figs. 12–23), assume a vital role in the story of Umbrian book illustration.

A survey of the Australian material indicates a substantial representation of Italian and French illumination from the twelfth to the sixteenth century, with a smaller but noteworthy group of English and Netherlandish books spanning the same period. Except for the Byzantine Gospels, absent are works from the great traditions of Late Antique, Byzantine, Celtic, Carolingian and Ottonian illumination; while late medieval and Renaissance German and Spanish work is only marginally represented. Given the vagaries of history, however, and the treasures which still change hands in the sale rooms each year, the scope of the Australian collection, by no means a static entity, may one day encompass some of these areas also.

We have included, for comparison, photographs from other collections side by side with the Australian entry, especially when the manuscript has been related to others executed by the same master or atelier. Since these books have remained for so long virtually inaccessible to the art historian, it has been our objective to produce as detailed a photographic record as possible, extending this even to items where the line between historical and visual interest is very thin indeed.

To devise a satisfactory cataloguing system appropriate for each item proved a challenging task. Confronted with manuscripts, both intact and fragmentary, from a

variety of different periods and countries, one is forced to the conclusion that the individuality of the hand-written and decorated work defies in the last analysis uniform categorization. The style of entry which we have developed is based in the first place on Sinclair's previous work so that our emphasis on the decoration may complement his earlier research.

Thus, the presentation of the physical and codicological elements, necessary also for our purpose, follows largely that of Sinclair. These have all been re-examined, however, and we have chosen to list the collation in the now more generally accepted form, that is with the number of the quire being followed by the number of folios and not vice versa. Scripts, too, are here characterized in the more general English descriptive manner instead of using the Latin terminology favoured by the Belgian school of palaeography. Wherever appropriate, the title of a text or author is given in its accepted anglicized form.

Rulings generally follow the recent system developed by L. Gilissen. This formula, explained in the Glossary, allows, in theory, for the reconstruction by the reader of the layout of the whole page of a particular manuscript. In some instances it has helped to confirm the common identity of now independently bound and dispersed portions of a single manuscript. (See, for example, Nos. 43 and 70.) However, it has not always proved either relevant or possible to apply this formula. In Renaissance humanist manuscripts, where the vellum was often ruled in mass sheets in dry-point before being distributed to individual workshops, a simpler description is used. Again, certain items, because of either their antiquity, their damaged state, or local peculiarities, vary significantly from page to page even as to the numbers of columns of text, and their rulings are irreducible to such a formula. In these cases a more descriptive method has been employed.

We have recognized that binding is an area of specialized study in itself. It is often treated in considerable detail by Sinclair, and we have provided only a summary description and approximate date, except where it is in fact contemporary with the manuscript or is indicative of ownership.

The heading 'Ownership' in our entries records only the marks, coats-of-arms, inscriptions etc. which may indicate original and subsequent owners. The precise codes of booksellers are omitted, although attached catalogue extracts are noted, and the general commentary always states, if it is known, through whom a particular book was sold. Where coats-of-arms, mottoes etc. form part of the original decoration they are referred to in this section, but described under the heading 'Decoration'.

The description of textual contents is summary, in view of Sinclair's work, except where manuscripts have not been catalogued, and for liturgical or devotional books where details of the text such as entries in calendars, litanies, particular prayers etc. are directly relevant to the tracing of a particular school of illumination or the location and interests of the original owner.

The section on decoration is more detailed. In keeping with recent research methods, we have described as thoroughly as possible all decorative elements, ranging from calligraphic or flourished initials, line fillers or line-endings, to larger decorated and historiated initials, borders and miniatures, thereby endeavouring to indicate the particular hierarchical

patterns established within various decorative systems, and more especially their relevance to the text in question. For this reason we have given a special emphasis to the relationship between text and illumination under the heading 'Programme of Decoration and/or Illustration'. This deals with the major decorative programme, listing in detail the series of historiated initials or miniatures etc., and their particular relationship to the text. In certain cases, for instance in thirteenth- and fourteenth-century Italian commentaries or liturgical books, large decorated initials are often as important as miniatures to note in this regard. The charting of such programmes allows certain patterns of artistic production to emerge, and highlights the often intricate but integral and sometimes extremely functional relationship between text and illumination. Conclusions which already flow from such analyses are presented in the relevant commentaries.

The business of describing and recording decorative elements is perhaps one of the most critical tasks which confronts the art historian dealing with the illuminated book. It is sometimes argued that detailed description is unnecessary, repetitive and uninspiring, and that ample photography is more desirable. Granted the dangers involved in literary description, we believe it nevertheless important, at this stage of research into the schools and methods of book illumination, to combine both photographic and literary description. All the items discussed and reproduced here, whether in Australian collections or referred to for comparative purposes, have been closely studied at first hand – in most cases by both authors. It is only as one pores over the individual details, registers their colours, the nuances of patterns and figurative style etc. that the distinctive qualities of each work, together with the links and patterns which they form with other manuscripts, begin to emerge. We have therefore endeavoured to give a precise description of decorative elements relating this as much as possible to relevant reproductions. Attempts continue in this field to establish a common quasi-technical vocabulary in the interests of brevity and lucidity. Words and terms used in this manner are listed in the glossary (p.20). Perforce they are mingled with more general descriptive phrases, especially when a particular period or individual characteristic warrants more detail or different treatment.

In the commentaries which conclude all the major entries, we have drawn together the threads of our research to date. In some cases we have been able to attribute manuscripts quite precisely to a particular artist or atelier and to date them exactly. For other works many questions still remain open. It has been our particular concern to register the relative degrees of precise knowledge and probable conjecture in this area.

In organizing the material according to countries or regions, certain manuscripts presented particular problems, since geographical boundaries do not reflect accurately the culture in which they were produced. We have classified under 'Netherlandish' a group of manuscripts from centres in the south-west Netherlands such as Bruges and Ghent, including also in this category No. 58, probably from St Omer, which lies within the French border, because the style of this manuscript is closely related to influences radiating out from Bruges and Ghent. The term 'northern Netherlands' encompasses a small group of Dutch manuscripts. Under 'French and Franco-Flemish' is listed No. 69, a product of late thirteenth-century Liège, since it incorporates pronounced French Gothic influences

and seems to fit best in the company of No. 70, the Aspremont psalter-offices from Verdun, which in its turn reveals a distinctive blend of French, English and Flemish strains.

Appended to each of the major sections is a group of shorter entries, which either contain minimal decoration or are too fragmentary to warrant further treatment. Each is accompanied by a photographic reproduction. References to Sinclair's catalogue, wherever applicable, are provided.

For the major public institutions in Australia we are confident that our listings and reproductions are comprehensive up to 1982. There is less certainty, in this regard, concerning manuscripts in semi-public collections such as college and school libraries, seminaries etc., and even less about those in private hands. Only very few items under the latter heading are included, and it is clear that some privately owned manuscripts mentioned by Sinclair are no longer in Australia.

Books are for reading, yes, but also for imaginative and visual enjoyment. Text, decoration and figurative scenes interact in countless different ways in the manuscripts discussed here. Rarely indeed does a visual image simply repeat the literal meaning of the text. It is hoped that, as well as apprising scholars of book illumination of the contents of Australian collections, this book in its turn may be enjoyed, and stimulate both the mind and the eye of those that read and use it.

MARGARET M. MANION

The Collectors

Professor Sinclair has paid tribute to the institutions and benefactors whose wisdom and generosity have been responsible for the presence of medieval manuscripts in Australia. That some of these manuscripts are illuminated brings added enjoyment and interest to scholars and to the wider public, and the question is often asked 'How did these fine books come to Australia and who were the collectors?'[1]

In this country we can claim no single great benefactor. We have no counterpart to the American Henry Walters whose library containing some eight hundred medieval manuscripts reflects the discriminating taste of a collector devoted to the art of illumination.[2] The collection described here is by contrast widely distributed. Three leaves and two manuscripts are privately owned. Another fragment was donated to a school. Four manuscripts belong to ecclesiastical institutions. Several treasures have been bought for libraries through the financial assistance of 'Friends' or private donors.

The public libraries of Australia early recognized that illuminated manuscripts should be represented in their holdings and have made purchases as funds permitted. The State Library of Victoria was the first in the field when it acquired a fifteenth-century Carthusian monastic book in 1902 (No. 60). It has since gained several volumes, the most outstanding of which is the *Historia Augusta* (No. 31), once the property of Lorenzo de' Medici. Manuscripts have been bought also by the libraries of South Australia and New South Wales, and New South Wales received the Richardson bequest. The National Library of Australia in 1964 acquired six illuminated manuscripts as part of a library formerly the property of the Cliffords of Chudleigh.

The greatest treasures, which are housed in Melbourne in the State Library and the National Gallery of Victoria, have been gathered as a result of enlightened interpretation of the terms of the Felton Bequest. Alfred Felton's will authorized the purchase of 'works and art objects ... (with an artistic and educational value ... calculated to raise or improve public taste)'. Under the wise guidance of successive advisers the Trustees have purchased ten manuscripts and a book of fragments since 1920.[3]

Four Australian collectors bequeathed their libraries to public institutions and in other ways made outstanding contributions to the nation's cultural heritage. To two of these men medieval manuscripts were peripheral to their main spheres of interest, and having no records to guide us, we can only guess at their reasons for possessing such treasures. Nevertheless each collector brought different tastes to bear, and their purchases contribute to the wide spectrum of the Australian collection.

Sir Charles Nicholson, Bart., was born in England in 1808. After completing an M.D. in Edinburgh in 1833 he emigrated to New South Wales to practise medicine. However, in 1836, when he inherited the property of his uncle, a wealthy settler, he began to devote himself to pastoral pursuits, to politics and to the promotion of education and culture. Nicholson's tastes and background were those of an eighteenth-century gentleman and he

saw it as his duty to contribute to the culture of the young colony where life could be, as he said, 'prosaic and very intolerable'. Thus he helped to found Sydney University, becoming its first vice-chancellor from 1854 to 1861 and was instrumental in gaining a Royal Charter which gave the institution equal status with English universities. He was knighted in 1852.[4]

Sir Charles returned to Britain to live in 1862 and for the next forty years devoted himself to archaeology, the arts and letters. He was created a baronet in 1869. Other honours included degrees from Oxford, Cambridge and Edinburgh. During these later years he continued to promote the interests of the colony of New South Wales, and he remained actively involved in the affairs of the University of Sydney, to which he donated crates of antiquities (now housed in the Nicholson Museum) and books from his own library. He died in 1903.

In 1924 the family made a further generous benefaction with the Nicholson Gift of Sir Charles's remaining personal papers, paintings, books and a large group of manuscripts, some of which are discussed in this catalogue. These include several fine Italian humanist books. The Bolognese Decretals of Boniface VIII (No. 17) was presented by the Nicholson family in 1937. All these manuscripts attest to the breadth of Sir Charles's interests and to his discriminating taste as a collector.

David Scott Mitchell (1836–1907), Australia's greatest bibliophile, came from a similar cultural background. His father was an army surgeon in Sydney whose artistic and literary tastes led him to patronize artists such as Conrad Martens and to foster the Australian Subscription Library, the precursor of the public library of New South Wales. At the age of sixteen Mitchell became one of the first seven undergraduates to attend the new Sydney University, taking his B.A. and then his M.A. by 1859. He was admitted to the Bar although he never practised.[5]

After his father's death in 1869 Mitchell forsook Sydney society, becoming a recluse and devoting his energies to the study of Elizabethan drama and eighteenth- and nineteenth-century writers. *Ex-libris* and the craft of the book interested him also. But his main pursuit was the acquisition of Australiana with the avowed aim of making a complete collection. This collection remains his most enduring monument.

In 1898 Mitchell expressed the intention of giving his books to the Public Library. On his death in 1907 his entire collection passed, with a large endowment, to the Library Trustees. The Mitchell Library was opened in 1910.

It is clear that, unlike Nicholson, Mitchell made no sustained attempt to collect medieval and Renaissance books. His personal library contained only three illuminated manuscripts. These possibly attracted him more as fine examples of the hand-crafted book than as medieval works of art. Subsequently three further manuscripts were bought for the Mitchell Library, with money from his endowment, at the sale of J. T. Hackett's art collection in 1918.

Sir William Dixson, the grandson of a Scottish migrant who had established the family fortune from tobacco, was born in Sydney in 1870. He was educated in Bathurst and then in Edinburgh where he qualified as an engineer. On his return to Sydney in 1896 he soon became involved in business interests. A man of blunt and forthright character, a genial and

charming host, well travelled, he was knighted in 1939 in recognition of his public benefactions.

While still young, Dixson had begun to devote himself to collecting. His collections reflect an individual and scholarly taste, especially in navigation and geography; hence his many rare charts and documents, and early accounts of exploration in the Pacific area, which he studied and in many instances translated into English. Australian pictures of historical and topographical value also became his special province.

Dixson delighted in what he called good books, claiming that his was 'a picked library'. Only the best copies satisfied him, and many of these are in splendid original bindings. Among his fine illuminated manuscripts the late French Book of Hours (No. 88) could have made a direct appeal to him as a historian of Australian affairs. The book once belonged to the Rev. John Francis of Canterbury, whose daughter Sarah is said to have brought it to Australia when she arrived with her husband, the pioneering churchman William Broughton, in 1829.

In 1929 Dixson gave his major pictures to the Public Library of New South Wales and subsequently he made further generous gifts. At his death in 1952 the remainder of his varied collection, including his personal library, came to the Trustees to be held together as the Dixson Library. It is housed in the Dixson wing of the State Library (formerly the Public Library) which encompasses the gallery built in 1929 to accommodate his pictures.

Today James Thompson Hackett (1858–1924) is less well remembered than Nicholson, Mitchell or Dixson, and his career as a collector is yet to receive adequate attention. He was born and educated in Victoria, and after taking a degree in arts he moved to Adelaide where he later qualified in law, and practised for many years. He periodically visited other parts of the world where he made varied and valuable purchases. Towards the end of his life he disposed of much of his collection at auction in Sydney in 1918 and at Sotheby's in London in 1923.[6]

His collection included paintings, china, glass, oriental carpets, many rare books and incunabula, and a few illuminated manuscripts, three of which, as we have said, were purchased by the Mitchell Trustees. The fourth came to the State Library of Victoria in 1926, having been passed in at Sotheby's. Hackett evidently selected his manuscripts for their aesthetic qualities. Correspondence kept with his Arras Book of Hours (No. 75) points to his additional interest in provenance and antiquarian value. It is mentioned that the volume retains signs of coins sewn between the sheets of folios 210–211, and that it supposedly belonged to the regicide Joseph Fouché (1759–1820), while there is another letter about the unusual carved ivory covers, which still await a further study.

The most recent of Australia's public benefactors in this field, Colonel the Honourable Richard Armstrong Crouch, was a man remarkable for his life of service to the Australian community. He was born in Ballarat in 1868, the son of English immigrants to the goldfields. He studied law at Melbourne University, where his interest in politics was aroused. In 1901 Crouch became the youngest member of the House of Representatives in the first Commonwealth Parliament, retaining his seat until 1910. He subsequently joined

the army and was wounded at Gallipoli. In 1929 he was re-elected to the Federal Parliament for one more term.

Crouch was an active historian, a writer, and a notable benefactor to his native city, whose art gallery he endowed with money for two memorial art prizes. During his visits to Europe he collected thirteen medieval manuscripts which he donated to the Ballarat Fine Art Gallery in 1944. These are wide-ranging in origin and they testify to the collector's broad tastes for old books and unusual objects. Several of these manuscripts are illuminated. One of them dates from the second half of the twelfth century (No. 47), while another – of great rarity – is a fifteenth-century English portable calendar with astrological diagrams (No. 44).[7]

Doubtless the pattern of future collecting in this field in Australia will continue to be influenced by the multi-faceted attraction of the ancient book. It is perhaps significant, in this context, that the Australian National Gallery, which opened in October 1982, numbers among its works of art one Renaissance illuminated leaf (No. 34) – a modest but tangible expression of the abiding attraction of the art of the illuminated book.

VERA F. VINES

Notes

(References other than those given in full are to the Bibliography, p.232)

1 Sinclair (1969), Introduction, p.x.
2 L. Randall, Manuscripts in the Walters Art Gallery, Baltimore, *Manuscripts*, Vol. 32, No. 4, 1980, pp.298–301.
3 (Felton 1938).
4 D. S. Macmillan: 'An Australian Aristocrat. The Personality and Career of Sir Charles Nicholson' in *Australian Quarterly*, Vol. XXVIII, 1956, pp.40–47, and, by the same author, 'The Australians in London 1857–1880' in *Royal Australian Historical Society*, Vols. XLIV–XLV, 1958–1959, pp.155–181. (I thank Ms Pamela Green for her kind assistance.)
5 On David Scott Mitchell and Sir William Dixson, see *Australian Dictionary of Biography* entries 'David Scott Mitchell', 'William Dixson' and 'William Broughton'; S. Mourot, 'Two Great Collectors' in *The Great South Land*, Melbourne, 1979, pp.3–7 (I thank Miss S. Mourot for her kind assistance); A, W. Jose, 'David Scott Mitchell' in *The Lone Hand*, 2 September 1907, pp.465–470; B. Stevens, 'The Mitchell Library' in *The Lone Hand*, 1 October 1907, pp.581–585; A. H. Spencer, *Hill of Content: Books, Art, Music, People*, Sydney, 1959; Tyrrell (1952); and G. D. Richardson, 'The Dixson Library and Galleries' in *The Australian Library Journal*, Vols. IV–V, pp.5–12.
6 See Bibliography under Hackett's name, also J. J. Pascoe (ed.): *The History of Adelaide and Vicinity*, Adelaide, 1901, p.482; and Sotheby (1923), pp.72–106.
7 K. V. Sinclair: 'R. A. Crouch (1868–1949), Politician, Soldier, Man of Letters, Bibliophile and Public Benefactor' in *Biblionews and Australian Notes and Queries*, Vol. III, No. 3, 1969, pp.5–14, and Vol. IV, No. 1, 1970, pp.20–27; Sinclair (1968).

Guide to Liturgical and Devotional Books

Choirbook: a general term for a fragment of a book used for the chanting of the Divine Office or
 the Mass when it is not possible to identify the manuscript more precisely.

Gradual: a manuscript containing chants for the proper of the Mass: introits, graduals, tracts,
 alleluia, offertory and communion verses, and sequences for special feasts. It may also
 include chants for the ordinary of the Mass: kyrie, gloria, sanctus and agnus dei and
 for the introductory 'asperges' rite.

Antiphonal (or a manuscript containing chants for the canonical hours of the Divine Office: first
Antiphonary): vespers or the vigil of great feasts, matins, lauds, prime, tierce, sext, none, vespers
 and compline.

Both graduals and antiphonals were frequently produced in a series of separate volumes which reflect the
complex organization of the Church's calendar year and liturgy, e.g.:

temporal or proper containing feasts for the liturgical seasons, Advent, Christmas, Lent, Easter,
of the time: Pentecost and post-Pentecost.

sanctoral or proper containing feasts of the saints throughout the year beginning with the feast of St
of the saints: Andrew on 30 November.

common of the containing a series of standard liturgies used for a martyr, confessor, virgin etc. and
saints: votive liturgies for particular occasions such as for the dedication or anniversary of the
 dedication of a church.

Various combinations of the above divisions occur in the manuscripts.

Missal: a compendium of all the texts used for the celebration of Mass, prefaced by a liturgical
 calendar.

Breviary: a compendium of all the texts used for the recitation of the Divine Office, prefaced by
 a liturgical calendar. Sometimes breviaries are divided into separate volumes,
 according to the same pattern as antiphonals or according to the seasons of the year.

Pontifical: a manuscript containing the order of ceremonies and blessings for use by a bishop.

Benedictional: a collection of blessings for use by a bishop.

Psalter: the book of the psalms, often accompanied by a selection of biblical canticles and
 prefaced by a liturgical calendar. In conventual or liturgical psalters the psalms are
 arranged in order for recitation in the Divine Office and are accompanied by the
 appropriate antiphons, versicles and responses etc.

Psalter-Offices: a combination of the psalter with a selection of full offices for particular feasts taken
 from the Breviary.

Psalter-Hours: a combination of the psalter with a selection usually of short offices and prayers. It is
 popular in the thirteenth and early fourteenth centuries prior to the development of
 the Book of Hours as a separate manual.

Book of Hours:

a devotional book, popular with the laity from the late thirteenth century onwards. It contains a selection of short offices, prayers and devotions, and is prefaced by a liturgical calendar. The Little Office of the Virgin Mary is often included, and from this element comes the name 'Book of Hours' or 'Hours of the Virgin'.

Vigils of the Dead:

The Office for the Dead, which is regularly included in breviaries and Books of Hours etc., but sometimes also forms an independent manual.

Prayer-book:

a devotional book, written either in Latin or the vernacular. Although it may contain some 'Offices' or 'Hours' it is distinguished from the Book of Hours by the predominant number of local prayers and devotions, often in the vernacular.

Glossary of some Descriptive Terms

INITIALS

Flourished: initials ornamented with pen-work whose flourishes sometimes extend into the margins.

Decorated: a broad term referring to painted initials as distinct from calligraphic flourished initials.

Dentelle: a type of decorated initial in English, French and Netherlandish manuscripts of the fourteenth and fifteenth centuries. These initials are usually gold on red and/or blue grounds which are patterned with white tracery or filigree designs.

Foliate: a type of decorated initial in English, French and Netherlandish manuscripts of the fourteenth and fifteenth centuries. The body of the initial is usually in pink or blue with white tracery or filigree work. The initials are set on a gold ground with infills of ivy-leaf sprays.

Historiated: initials containing figures or scenes.

Miniature: a term used for a painted scene or illustration.

BORDERS

Bar or Bar-baguette: borders which occur in English, French and Netherlandish Gothic manuscripts from the thirteenth century onwards. They are characterized by varying types of framing bars or staffs from which develop ivy-leaf extensions and cusped elaborations. In the later fourteenth and the fifteenth centuries, the baguette is often an elaborate panel which may be decorated with a wide range of motifs. It usually frames the miniature on three sides, and from it develops the border proper.

Panel: this term usually refers to borders which extend along one vertical side of the page.

Bracket-left or bracket-right: vertical panel borders on the left or right side of the page with partial horizontal extensions along the upper and lower margins. This term is confined to fifteenth-century French or Netherlandish manuscripts.

Three-quarter: borders which extend around three sides of a page.

Full: borders which frame the page on all four sides.

The terms 'foliate', 'floral' and 'floral-acanthus' are also used in a more general sense in the description of individual initials and border motifs. 'Infills' or 'interstices' refer to the section encompassed by the body of the initial. 'Ground' refers to the background within the initial and also the decorative area which surrounds it, according to the context.

The more precise definitions such as 'dentelle' and 'foliate' initials and 'bracket-left and bracket-right borders' are based on the vocabulary of A. Derolez, *The Library of Raphael de Marcatellis*, Ghent, 1979, p.70 and *passim*, and D. G. Farquhar and S. Hindman, *From Pen to Press*, Baltimore, 1974, p.69.

Ruling. Measurements, in millimetres, taken from the recto of a folio and from left to right are given first for the spaces between the vertical rulings, i.e. those on the horizontal plane. These are punctuated by points (.), and are separated by an 'x' from those of the spaces between the rulings on the vertical plane, i.e. from the top to the bottom of the page. Brackets enclose measurements which encompass the text-space. The average ruling unit for the text is calculated by dividing the number of lines of text into the total vertical measurement for the text-space. Calendar measurements

and lines of text etc. are given when they differ from those of the rest of the manuscript.

It should be noted that this formula necessitates following the inverse order of the measurements given at the beginning of the entry for the height and breadth of the page. Example: No. 70. Vellum 215 x 150. Ruling: 8.3.10.3.[90]. 3.20.3.10 x 3.3.20.[8.122.8]. 34.3.14. Lines of text: 18. Ruling unit: 7·7. (Adapted from L. Gilissen, 'Un élément codicologique trop peu exploité. La Réglure' in *Scriptorium*, Vol. 22, 1969, pp.150–161.)

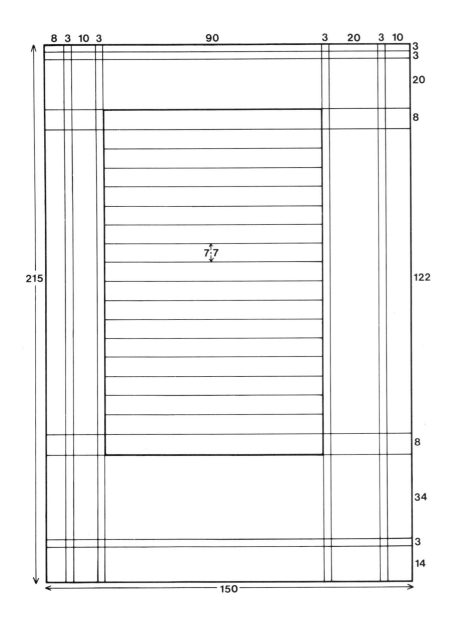

Byzantine Manuscripts

Plate 1, figs. 1–7

No. 1. *Gospels (Tetraevangelium)* Greek
Constantinople?, *c.* 1100
National Gallery of Victoria, MS. Felton 710/5

Vellum, 242 x 174. A – B modern vellum + 254. I[1] (tipped in), II[6] (wants 2–3 and 6), III[2], IV[7] (wants 1–2), V–IX[8], X[2], XI[8], XII[8], XIII[4], single leaf, one missing, single leaf, XIV–XVIII[8], XIX[4], single leaf, one missing, XX–XXVII[8], XXVIII[5] (wants 3–6, 7, 8), XXIX–XXXV[8], XXXVI[4]. Script: Middle Byzantine minuscule hand, in brown ink; tables, first page of each gospel, lists of chapters and chapter titles in gold. Ruling: stylus: 23.[6.110.6.15.6]. 8 x 8.20.[169].23.6.16. Lines of text: 22. Ruling unit: 9. Binding: modern crimson velvet.

Ownership: Inside front cover in pencil is 'xii century'; C. W. Dyson Perrins's book mark: 129 and C. W. Dyson Perrins's book-plate. On flyleaf in pencil is 23/5/09. Inside back cover is C. W. Dyson Perrins's collection sticker: 71.

Text: Greek. Contents: f.1v Dedicatory iambic verse in gold; f.2r–v Epistle of Eusebius to Carpainus; ff.3r–7v Eusebian Canons; ff.8r–9v Kephalaia (list of chapters) for St Matthew; ff.10r–78r Gospel of St Matthew; ff.78v–79v Kephalaia for St Mark; ff.80r–122v Gospel of St Mark; ff.123v–124v Kephalaia for St Luke; ff.125v–197v Gospel of St Luke (missing leaves); ff.198r–252r Gospel of St John; ff.252v–253v tables of lections (in later hand). Marginal reading guides scattered intermittently throughout.

Decoration: The Canon Tables, the text of the first page of each gospel and the lists of chapters are in gold. Gold is also used for uncial titles to each gospel and for initials scattered throughout the text.

Ornamental initials introduce each of the gospel texts: f.10r St Matthew, six-line initial 'B'; bust of youthful Christ Emanuel with crossed nimbus in upper half while in lower half a dog pursues two hares; f.80r St Mark, six-line initial 'A' (fig. 1) is formed by the pillar of a stylite saint with a ladder leaning against it, up which a man – possibly a monk – is climbing, while the saint lowers a basket which rests on the bar of the 'A'; f.125v St Luke; the curves of a four-line initial 'E' (fig. 2) are formed by two hawks who attack the head of a hare which comprises the cross-bar of the letter; f.198r St John, four-line initial 'E', the cross-bar formed by a human arm and hand in blessing gesture.

The upper part of the first page of each gospel is decorated with an almost square foliate headpiece (107 x 110) of intricate design, terminated with decorative palmettes at the upper corners, and flourishes continuing horizontally from the lower corners form supports for framing tree-like palmettes at either side. Ornamental headbands (24 x 103) decorate the first pages of each surviving list of chapters.

The Epistle to Carpainus (f.2r–v) is set within pairs of columns painted to simulate marble, knotted in the centre and decorated with foliate ornament at base and capital. Small *atlante* figures on top of the capitals with outstretched arms support an arch above, the angles of which are filled with foliate decoration finished with palmettes at the upper corners. The Canon Tables (ff.3r–6v) have oblong foliate headpieces (60 x 125) finished with palmettes and topped with a variety of paired animals or birds on either side of ornamental trees or other decorative elements; f.4r (fig. 5) displays a cock bending to peck at one of the dogs that flank the pedestal on which it stands. The headpieces are finished at the lower edges with small flourishes which support vertical palmettes. The Tables are arranged between sets of three columns, sometimes knotted, the ornate capitals of which support *atlantes*.

The decorations are executed on gold backgrounds in shades of blue, red, green and mottled green with added gold.

Programme of Illustration: Folio 1v frontispiece: dedicatory image: the Virgin Hodegetria with the monk Theophanes: dedicatory poem; f.2r–v male *atlantes*: Epistle of Eusebius to Carpainus; f.3r (fig. 3) labours of the months of September, October and November, all with titles: Canon Table 1 (four gospels); f.3v (fig. 4) labours of the months of December, January and February, all with titles: Canon Table 1 (four gospels); f.4r (fig. 5) virtues: prudence, courage, thoughtfulness: end of Canon Table 2 (Matthew, Mark, Luke) and beginning of Table 3; f.4v virtues: thought, knowledge, judgment: end of Canon Table 3 (Matthew, Luke, John) and beginning of Table 4 (Matthew, Mark, John); f.5r virtues: almsgiving, well-doing, kindness of heart: end of Canon Table 4 (Matthew, Mark, John) and beginning of Table 5 (Matthew, Luke); f.5v (fig. 6) virtues: exhortation, repentance, love: Canon Table 5 (Matthew, Luke); f.6r (fig. 7) virtues: wisdom, contemplation, action: end of Canon Table 9 (Luke, John), beginning of Table 10 (Matthew); f.6v virtues: faith, hope, simplicity: end of Canon Table 10 (Matthew), Canon Table 10 (Mark); f.7r three *atlante* figures, unidentified, but one a priest before an altar: Canon Table 10 (Luke); f.7v three *atlante* figures: Canon Table 10 (John); ff.10r, 80r, 125r and 198r in the outer margins of the foliated headpieces at the

beginning of each gospel book: a standing, nimbed prophet holding a scroll: St Matthew: Jeremiah; St Mark: Isaiah; St Luke: Ezekiel; St John: David, all with titles (figs. 1 and 2).

Commentary: This manuscript originally had an evangelist portrait facing the initial page of each gospel and two additional folios of Canon Tables. A page of text is also missing from the end of St Luke's Gospel, together with the list of chapters for the Gospel of St John (between ff. 197v and 198r).

Offsets of the full-page evangelist portraits with elaborate borders can be seen on the first page of the gospels. The first missing folio of Canon Tables, presumably with its decorations of labours of the months from March to August, has been removed from between folios 3 and 4, perhaps because it was badly damaged by damp that has affected other areas of the manuscript slightly. The other missing Canon Table folio between folios 5 and 6 had formed one sheet with the lost folio between 3 and 4. There is little doubt that it contained six additional virtue figures.

As Buchthal (1961) has pointed out, the high quality and lavish decoration of this Byzantine manuscript suggest a metropolitan provenance, and various features of the decoration can be associated with other Constantinopolitan illumination of the late eleventh and early twelfth centuries. It has been proposed that the monk Theophanes, who is depicted on the dedication page (Plate 1) with the Virgin Hodegetria, may have been a monk in the monastery of the Hodegon which was a famous and influential monastery in Constantinople, with an active scriptorium from the mid-eleventh century onward. It was this monastery which reputedly housed the archetype of the Virgin Hodegetria, believed to have been painted by St Luke. Theophanes, who is otherwise unknown, is revealed as the donor, scribe and illuminator of the manuscript by the four-line iambic verse which appears above the frontispiece illumination:

> ἄνασσα πάντων ὡς θεοῦ μήτηρ λόγου
> δοτήρ κατ᾽αὐτὸ καὶ γραφεὺς τῆς πυξίδος
> καὶ τῶν κατ᾽ αὐτὴν ἐργάτης ποικιλμάτων
> σὸς ναζιραῖος οἰκέτης Θεοφάνης,

(O Queen of all as mother of the Divine Word, the donor and writer of the book and painter of the pictures in it is your servant the consecrated Theophanes.)

The dedicatory miniature is therefore an extremely rare and important example in Byzantine illumination, which provides a self-portrait of the donor who also identifies himself as scribe and illuminator. Buchthal believed this was a unique example, but Spatharakis has since pointed out that a similar, though less distinguished, case can be found in a psalter, perhaps dated to the twelfth century, which is now on Mt Athos (Dionysiu 65).[1]

In the Dionysiu psalter the monk Sabbas is identified by dedicatory verse and colophon as scribe, illuminator and donor. But the donor is presented in the more humble posture of *proskenesis* before the Virgin. In the Melbourne manuscript the nimbed Theophanes stands proudly before the Mother of God, bowing slightly in a reverent manner as he offers his jewel-encrusted book toward her outstretched hand. At the same time he receives a blessing from the Christ Child cradled in his mother's left arm.

The sombre browns and greys of the monk's habit and his tall figure are balanced by the regal bearing of the Virgin in her traditional purple cloak (*maphorion*) worn over a blue tunic (*sticharion*). Her stance is secure and relaxed and the Christ Child in his gold garments fits naturalistically into the crook of her arm. An added liveliness and personal quality are provided by the direction of their glances. The dark-bearded Theophanes raises arched eyebrows to gaze at the Virgin, while her side-long glance appears to acknowledge his homage. The bowing pose of Sabbas in the Dionysiu manuscript thwarts such communication between donor and recipient. The quality of the Melbourne image is also evident in the accomplished handling of the drapery of the Virgin which, though decorative and graceful, falls logically according to the requirements of movement.

The fine quality of this frontispiece is enhanced by the burnished gold background and the decorative arches within which the two protagonists are framed. The sweeping arches, decorated with fine blue scalloped design, provide an embracing feature which unifies the composition. Above this, the squared headpiece and triangular portico with its gold finial suggest an imaginative geometrical variation on the traditional 'tempietto' motif found in Byzantine gospel books since the sixth century.

Buchthal has shown that the labours of the months and the virtues in this manuscript have very close parallels in a gospel book now in San Marco, Venice (Marciana gr. Z540), which is almost certainly from the same scriptorium. The surviving labours – for the months of September (the commencement of the civil year in Byzantium) to February – are charming figures. They range in liveliness from the more static January, who holds a pig's head on a platter before him, and February, the old man warming himself before a fire, to the actively working figures which display the occupations of vintager (September), bird-catcher (October), digger in the fields (November) and sower (December) (figs. 3 and 4).

The small collection of monthly labours which survives in Byzantine art shows a remarkable homogeneity and a marked conservatism of the antique images of the months. A similar conservatism may be found in relevant texts. A twelfth-century description of a calendar cycle by the Byzantine novelist Eustathius, although perhaps a conventional 'topos', is therefore useful in elucidating for us the contemporary interpretation of these *atlante* figures. Only in the January image does our truncated series of labours fall out of step with Eustathius' description. Here, instead of describing the man with the pig's head on a platter,

Eustathius pictures hunting imagery. The presentation of the pig's head denotes January in the Marciana manuscript and also in one of the Octateuchs in the Vatican Museum (Vat.gr.747). The other descriptions fit our images very well:[2]

September: A vintager (Buchthal describes him as a harvester) walking with a basket of grapes slung on his back. This image is common to all three Octateuchs which carry labour cycles, and also to the Marciana manuscript.

Eustathius:'The personage who gathers and presses represents the season of vintage and wine pressing.'

October: A bird-catcher; also a walking figure who holds a limestick over his shoulder and a decoy bird on his wrist. This figure of the fowler, a specifically Eastern image in the iconography of the labours, appears in all known Byzantine labour cycles.

Eustathius:'The fowler . . . indicates the period of the year when the birds, becoming cold, take flight towards warmer countries.'

November: The digging man is also found in the Marciana manuscript, although the half-length figures of the Octateuchs present a huntsman with a hare (Smyrna and Vat.gr.746) or a sower (Vat.gr.747).

Eustathius:'Do you see the farmer intent on ploughing? This is the time which a wise man (Hesiod), from the rising of the Pleiades, has already fixed for ploughing.'

December: The sower also appears in the Marciana manuscript holding the bag of seed in front of himself and spreading seed with a wide sweep of his arm (fig. 5).

Eustathius:'The succeeding personage who scatters corn is the sower, who shows in the picture the season of sowing.'

February: An old man seated in profile, warming his hands over a fire. He wears a cloak and a hood. This figure is also found representing February in the Marciana manuscript and Octateuch (Vat.gr.747), while he appears in other Eastern cycles as a representative of January (Octateuchs Vat. gr. 746 and Smyrna).

Eustathius:'This white-haired old man, all wrinkled, near the wide flame of the hearth shows the rough winter season and at the same time the cold old age; winter is not represented by a tender boy but by a bent old man.'

The missing labours in the Melbourne manuscript quite confidently can be assumed to follow the pattern found in the closely related Marciana manuscript in which March is represented by a warrior, April a shepherd, May a flower-bearer, June a mower, July a thresher and August a man affected by the heat of the August dog-days. These calendar images all have strong affinities with surviving Late Antique cycles, although there are variations in the occupations allotted to particular months with certain adaptations being made to make the figures and their activities more appropriate to the medieval Christian world. The occupations pertinent to the working months have become more obviously active and 'labouring' and images such as the January presentation of the pig's head have replaced such common antique images as the January consul. A clue to

the Christian understanding of the February old man warming himself may be found in the fact that the Octateuch cycles begin with March, the beginning of the liturgical year. An inscription accompanying the months in Octateuch Vat. gr. 746 makes the point that March is the first month quite explicitly. Thus Eustathius' comment that a bent old man and not a tender youth represents 'cold old age' may be interpreted as a reference to the passing of the old liturgical year in February.[3]

It has been pointed out by Buchthal that the monastic virtues which decorate the next three folios of Canon Tables are also rare in Byzantine art. They too appear, though in a slightly different arrangement and in complete series, in Marciana gr.Z540. But their appearance here finds a parallel in the monastically inspired milieu of the texts and illustrations of the famous *Heavenly Ladder of John Climacus.* The Climacus text discusses the necessary monastic virtues and the virtues presented in the Marciana and Melbourne gospel books are no doubt influenced both by the Climacus text and by the images which illustrated it. A similar attention to monastic ideals is reflected in such details as the stylite saint which forms the initial 'A' of Mark's gospel text (fig. 1).[4]

The exquisite workmanship of the ornamental details in this manuscript also savours of religious devotion to a holy task. The fine headpieces of the Canon Tables, and particularly those which introduce the gospel books (figs. 1–7) each display individual patterns of *rinceaux* or foliated ornament based on solid geometric designs. Yet the individuality of each design is carefully controlled to ensure a marked harmony throughout the manuscript. Buchthal and Belting have shown that some of the patterns employed here (particularly that for the Gospel of Mark headpiece) were still being used in the Paleologan period in manuscript illumination in Constantinople.[5]

Although the comparisons adduced here and by Buchthal clearly establish the place of this manuscript within the Comnenian period, many features point up the strength of tradition in Byzantine illumination of gospel books. The Canon Tables with their mock 'tempietto' settings, the dedication miniature set within a harmonizing pattern, the addition of the decorative elements of paired birds and animals above the Canon Tables and the Old Testament prophets associated with each of the gospels are all features which can be found as early as the sixth century in the famous Rabbula Gospels manuscript.

The manuscript is known to have been in the Duke of Hamilton's collection and in 1882 was sold by Sotheby's (lot 244) with that collection to the Prussian State Library. It was sold again by the Prussian State Library to Trübner of Strasburg, who auctioned it at Sotheby's on 22 May 1889 (lot 4) when it was acquired by Charles Fairfax Murray. It was purchased by C. W. Dyson Perrins in 1906 and sold to Marlborough Rare Books Ltd in the Dyson Perrins Sale (Sotheby, 9 December 1958, lot 2). It was

acquired for the Felton Bequest (National Gallery of Victoria) on the advice of A. J. L. McDonnell in 1959.

Margaret J. Riddle

Bibliography: Warner (1929), No. 129; Sotheby (1958), pp.13ff.; Buchthal (1961); Åkerström-Hougen (1974), pp.84, 134; Spatharakis (1976), pp.49–51 and 76–78; Buchthal and Belting (1978), pp.76ff.; Eastman (1982), pp.12–20.

Notes
1. See Spatharakis (1976), pp.49–51 and 76–78.
2. Translation of *De Ismeniae et Ismeneo amoribus libellus*, 5ff., ed. R. Hercher *Erotici script. gr. II*, Leipzig, 1859, pp.190ff., 196f., in D. Levi, 'The Allegories of the Months in Classical Art' in *Art Bulletin*, Vol. XXIII, 4 December 1941, p.285.
3. H. Stern, 'Poésies et représentations Carolingiennes et Byzantines des Mois', in *Revue Archéologique*, Vol. 45 (1955), p.173.
4. J. R. Martin, *The Illustration of the Heavenly Ladder of John Climacus* (Studies in Manuscript Illumination, 5), Princeton, 1954.
5. Buchthal and Belting (1978), pp.76f.

Italian Manuscripts

Plate 2, figs. 8–9

No. 2. *Glossed Epistles of St Paul*. Latin
Tuscany, *c.*1200.
State Library of Victoria, ★fo96/B47E

Vellum, 320 x 205. A–B 18c. paper + 151 + C–D 18c. paper. I–XI⁸, XII⁷ (wants 7), XIII–XIX⁸. Catchwords agree, quire signatures and foliation in pencil in arabic numerals. Script: late Caroline minuscule in black ink with red rubrics. Ruling: stylus: 8.33.6.[75]. 7.48.28 x 29.[215].76. Lines of text: 14. (Top line is written on.) Ruling unit: 14. In addition to two side columns of gloss, an interlineal gloss is used within the text itself.

Ownership: On f.1r in a 16c. hand is *3.6 Glossa interlinearis epistolarum ad Romanos*. Inside back cover in an 18c. hand is *foglie N.151, Iniziali N.14 Segnato N.A.P.* Inside front cover in a 19c. hand in pencil is 'from the Imperial Russian Library, St. Petersburg'. An extract from an English bookseller's catalogue, 'no. 1' is pasted on Ar. Inside front cover is 'Public Library, Museums and National Gallery of Victoria, Felton Bequest'. Br, ff.1r and 150v have the stamp 'Public Library of Victoria'. Dv has in modern pencil 'Felton B.T.3.3.33'.

Text: Latin. Contents: ff.1r–151v Epistles of St Paul in Vulgate translation, opening abruptly at Romans IV, 11, and with a gap from Ephesians V, 21 to Philippians I, 13 owing to the loss of a folio between ff.94v and 95v. The text also breaks off on f.150v in Hebrews XII, 18. A few words only of Hebrews XIII, 2 are visible on the mutilated f.151v. The Epistles are accompanied by commentaries taken from the medieval *Glossa Ordinaria*.[1]

Decoration: One- and two-line red and blue capitals occur throughout the text. Nine decorated, and one historiated, initials 'P' introduce the separate epistles. These initials (ranging from 45 x 45 to 25 x 25) are painted in yellow, on blue or red grounds with red outlines. Their interstices contain curving romanesque vine interlace with some zoomorphic motifs. This decoration is rendered mainly in white, with red and green contours and stroking, on contrasting blue or red grounds. The elongated tail of the 'P' usually terminates in a curving foliate motif; on f.126r a long-necked bird drawn in the same colours holds the initial stem in its beak (fig. 9). The shaft and body of the initial are normally decorated with simple designs of horizontal red bands and dots. The 'P' on f.114v (fig. 8) is more elaborate, with a series of solid patterned bands being let into the shaft; the curve of the letter is opened up against the contrasting ground and a knot at the top of the shaft

further indicates the more dynamic and flexible shape of the letter as a whole.

In the historiated initial on f.85v the bust of St Paul is depicted, blue, red and yellow still predominating (Plate 2).

Programme of Decoration: The decorated initials 'P' introduce the epistles as follows: f.24v, I Corinthians; f.75v, Galatians; f.85v, historiated initial, Ephesians; f.100v, Colossians; f.106r, I Thessalonians; f.111v, II Thessalonians; f.114v, I Timothy; f.121r, II Timothy; f.126r, Titus; f.129r, Philomen.

Commentary: This manuscript provides a late example, probably *c.*1200, of a text which was very popular in the early Middle Ages and of which many Tuscan examples survive. The format, initial designs and colour scheme of this particular manuscript follow long-established patterns. They are not sufficiently distinctive to assign to a particular local school, but are clearly late twelfth-century Tuscan. It is possible that originally there were three more decorated initials introducing Romans, II Corinthians and Philippians, sections of the text which are now incomplete.[2]

The notes of ownership indicate that the epistles were in the Imperial Library of St Petersburg in the nineteenth century. They were subsequently offered for sale in England and purchased through the Felton Bequest for the State Library of Victoria in 1933.

Bibliography: Sinclair (1969), pp.356–358; (Felton, 1938), p.80.

Notes
1. Sinclair attributed this gloss to Walafrid Strabo. This is no longer acceptable.
2. For a detailed study of these manuscripts see K. Berg, *Studies in Tuscan Twelfth Century Illumination*, Oslo, Bergen, Tromsö, 1968, and E. B. Garrison, *Studies in the History of Mediaeval Italian Painting*, Florence, vol. I, vol. II, 1960–1962. Several examples are also provided in François Avril and Iolanta Załuska, *Manuscrits enluminés d'origine italienne*, vol. I, VIᵉ–XIIᵉ siècles, Paris, Bibliothèque Nationale, 1980.

Plate 3, figs. 10–11

No. 3. *Gradual*. Latin
Lombardy, second half of 13c.
State Library of New South Wales, Dixson Q 3/1

Vellum, 305 x 230. A–C modern vellum + D–E contemporary vellum + 200 + F–G contemporary vellum + H–J modern vellum. I⁷, II–IV⁸, V⁷, VI–X¹⁰, XI⁸ (wants 5 and 6), XII⁴, XIII¹⁰, XIV–XVI⁸, XVII–XXII¹⁰, XXIII⁶. Flyleaves D, E, F and G are undecorated fragments from other

texts: D – Anon. Passiones 13c. French; E – Missal 15c. Italian; F – Breviary 14c. Italian; G – Unidentified commentary 13c. Italian. Catchwords for ff.32–194. Contemporary foliation in roman figures by scribes. Incorrect modern foliation in pencil in arabic figures in upper and lower right-hand corners. Script: two scribes, (i) ff.32–194: 13c. gothic hand in brown ink; (ii) ff.1–31, 195–200, late 14c. or early 15c. Italian liturgical gothic hand in black ink, both with red rubrics and music in black square notation. Ruling: (i) brown ink, one column of nine groups of four-line red staves with text beneath; (ii) brown ink, one column of eight groups of four-line red staves with text beneath. Binding: 19c. red morocco over wooden boards by J. W. Zaehnsdorf.

Ownership: On f.1r is the rubric 'Graduale Monachorum abbatie de Cornu ordinis Cisterciensis'. Inside front cover are the book-plates of Henry White and Sir William Dixson.

Text: Latin. Contents: ff.1–124v temporal beginning with the first Sunday in Advent and concluding with the votive Mass for the dedication of a church on f.124v. There is a break in the text between f.92v, the sixth feria after the Resurrection, and f.93r, the second Sunday *post albas*; ff.124v–178r proper of the saints; ff.179v–188v common of the saints (ends abruptly); ff.189r–190v litany. The names of Edmundus, Guillermus Bituricensis, Malachias Conerensis and Robertus Cisterciensis have been added in a later hand; ff.191r–194r hymnal, ends abruptly; ff.195r–200v additional propers: f.195r Corpus Christi; f.196r Visitation; f.196v St Anna; f.196v Transfiguration; f.198r Crown of Thorns; f.200r eleven thousand virgins (ends abruptly on f.200v). Certain rubrics additional to that on f.1r, mentioned above, indicate monastic use, e.g. f.34v *Hic inclinatur a conventu ad gloriam patri*; f.82v *Respondeant duo fratres ante gradum presbiterii . . .*; f.185r *in festis quibus non laboramus.*

Decoration: In the thirteenth-century section of the manuscript there are numerous initials in brown, red and blue ink, flourished in blue or red. Six decorated initials introduce the introits for major feasts of the temporal and sanctoral. These initials set on blue grounds have red shafts filled with interlace and curling acanthus-type leaf designs, mainly in green and red. Outlines, parallel stroking and grouped dots are in white.

Programme of Decoration: The decorated initials head the following introits:

f.88v R (75 x 55) *Resurrexi, et ad hoc tecum sum*: Easter (Plate 3)
f.99r V (65 x 48) *Viri Galilaei . . .*: Ascension
f.102r S (55 x 35) *Spiritus domini*: Pentecost
f.106v B (55 x 35) *Benedicta sit . . .*: Trinity Sunday (fig. 10)
f.125v E (60 x 60) *Etenim sederunt*: St Stephen (fig. 11)
f.170r G (45 x 30) *Gaudeamus omnes*: Assumption

Commentary: As the rubrics in the text show, this manuscript is of Cistercian provenance, the fourteenth-century section indicating that it was for the use of the Abbey of Cornu, identified in Sinclair as San Stefano al Corno, in the diocese of Lodi. Its restrained and simple execution, together with its fine script, is consistent with Cistercian products, and the decorated initials provide a good example of late thirteenth-century north Italian work. In the nineteenth century the manuscript belonged to Henry White, Fellow of the Society of Antiquaries, who died in October 1900. Sir William Dixson purchased it from the booksellers Angus and Robertson of Sydney *c.*1912 and bequeathed it to the State of New South Wales in 1952.

Bibliography: Sinclair (1969), pp.93–96; Sinclair (1964b), pp.233–234; (Sydney, 1967), p.30.

Plate 4, figs. 12–23

No. 4. *Roman Missal.* Latin
Umbria, *c.*1290
St Paschal's College, Box Hill, Victoria. Codex
 S. Paschalis

Vellum, 335 x 245. A–B modern paper + 395 + C modern paper. I⁶, II–V¹², VI¹⁰, VII⁸, VIII¹⁰, IX¹², X¹⁰, XI⁶, XII¹², XIII⁶, XIV–XVIII¹², XIX–XX¹⁰, XXI–XXIII¹², XXIV⁸, XXV¹⁰, XXVI–XXXIV¹², XXXV¹⁰, single leaf (attached to single leaf at rear of work), XXXVI⁹, XXXVII⁴, single leaf. Catchwords agree. Modern pagination; 792 pages with Br and Bv pages 1 and 2. Script: rounded gothic hand in black ink with red rubrics. Folios 252r, 252v, 390r–394r are written in a similar but later hand. Black square musical notation on 3- or 4-line red staves occurs in some places. Ruling: brown ink: 27.[70].18.[71].59 x 29.[219–227].87–79. Lines of text: 25 or 26. Ruling unit: 8. Calendar: 21.[14.1.5.14.11.140].39 x 38.[238].59. Lines of text: 35. Ruling unit: 6. Binding: half pigskin, 1848 by Bretherton.

Ownership: Br has 'missale Rom.¹' 'Codex Mss¹'. and the press-marks 'A. B.' in a modern Italian hand. The name 'Payne' in a different modern hand also appears on this page. Inside front cover is a small green seal with lion rampant (the device of Sir Thomas Phillipps) and '12289 PL', together with the binder's label 'Bretherton ligavit 1848'. Three blessing prayers have been added in a late rough hand on f.395v.

Text: Latin. Contents: ff.1r–6v calendar, which includes specific Franciscan feasts: St Francis *qui fuit institutor et rector ordinis fratrum minorum* (3 October), translation of St Francis (24 May), St Anthony of Padua (13 June), St Elizabeth of Hungary (19 November) and St Clare (12 August); ff.7r–389v Roman missal with the rubric on f.7r: *Incipit ordo missalis fratrum minorum secundum consuetudinem romane curie*; f.389v concludes with a prayer in minute script: *Ante conspectum divine maiestatis tue . . .*; ff.390r–394r additional Masses for the feasts of the Visitation, St Louis, bishop and

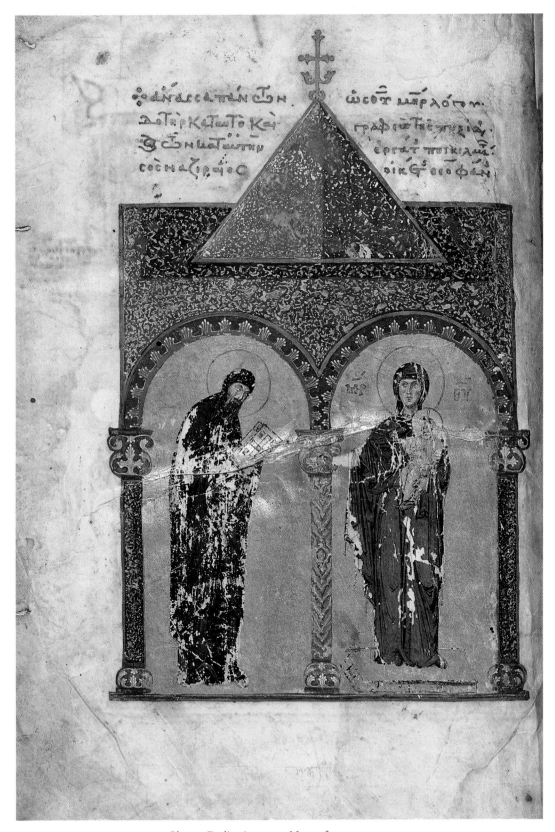

Plate 1. Dedication page. No. 1, f. 1v. 242 x 174

Contingit in hominem mundum inter utenti...
sit cum mundo suo occupationibus, atque...
que, mortuus est homo mundo, et mundo...
quam universi cuiusspiritu, qui alio uten...
tur in suis actibus rapere incipit. Si pa...
ulus mundum capit, nec mundo eum ui...
duo but motui neutri neutrum uidetur.

Ephesii asiani, hic populum confir...
mati in fide, firmat steterat in fide...
ribus operibus, his scribit a Roma de car...
ceris in sompniis epistolam, cuius uiciu...
non est cum insur. Sciens eos bono nar...
git de culpa si neret laudit tum dui...
erat, ut in nullo ad profectus queresce non...
possit ortat adultiora. In credit per...
sui tribulationibus, teneat quae suae ordi...
nationes. Spiritus tu inperfectio erigat in...
tumore, ostendat deus statum ad que di...
gnitate uocati, dicens dilexi, et apostoli...
ipsi. Pro humano genere unus fiat...
pro solam dei gratiam in ita.

Bene dictus, neque agit actio si...
inuen uita et ad deum. Qui bene dicit. Et uitae...
benedicta, quando per christum toti humano...
generi sit data, dicit autem mundi constitutio...
ne eum nullum quidem meruit per ordinatum...
qui tibi grata alio apprehendi separ et in uisu...
r uita culpam facit per ordinatum, qui...
nullo iusto ad eternitate proueniet. Hu...
ris per ordinationum alia his ipse per quin...
sto fac. Alia istud impleuit, ut summa...
noe dui. Uter uti per expertum ordine...
fuerit in. Et benedicit nos in uita nostra in mali...
ledicto i sit in exaltabit ad dando in...
mortalitatem, quod in uitae det ex uitam...
migrati, sic prima per ordinatus erit gratia...

mundo. In christo iesu. neque circumcisio
aliquid ualet, neque preputium sed noua
creatura. Et quicumque hac regulam
secuti fuerint pax super illos, misericordia in spiritu
israel dei. De cetero nemo mihi molestus
sit, ego enim stigmata domini
iesu, in corpore meo porto. Gratia domini
nostri iesu christi cum spiritu uestro fratres. Amen.

PAULUS si post
lus iesu christi per uo
luntatem dei. Scis
omnibus qui sunt
ephesi, et fidelibus in christo iesu.
Gratia uobis et pax a deo patre
nostro, et domino iesu christo. Bene dic
tus deus et pater domini nostri iesu
christi, qui benedixit in omni bene

Plate 2. St Paul. No. 2, f.85v. 320 x 205

30

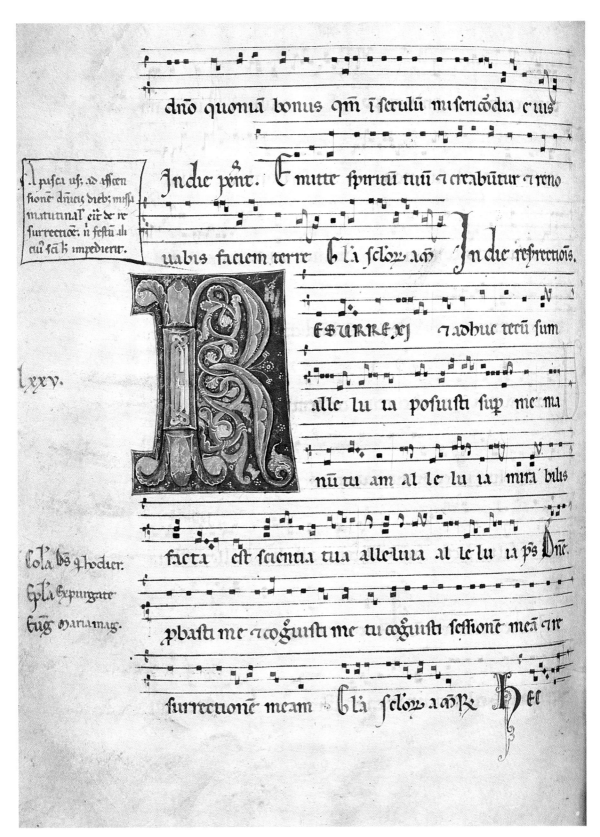

dūo quonī bonus qm ī ſeculū miſericōdia eius

A paſca uſq̄ ad aſſen
ſione dūici dieb: miſſa
matutinal eit de re
ſurrectioē: ñ feſtū ali
cui ſcī h̄ impedieñt.

In die pent. Emitte ſpiritū tuū ⁊ creabūtur ⁊ reno

uabis faciem terre ēv la ſclōz̄ aō In die refrectiōis.

lxxv.

ESURREXI ⁊ adhuc tecū ſum

alle lu ia poſuiſti ſup me ma

nū tu am al le lu ia mira bilis

facta eſt ſcientia tua alleluia al le lu ia p̄s Dñe

Colla b̄s q̄ hodier.
Epl̄a Expurgate
Euḡ maria mag.

pbaſti me ⁊ cognuiſti me tu cognuiſti ſeſſionē meā ⁊ r

ſurrectionē meam ēv la ſclōz̄ aō R̄ Hec

Plate 3. Initial 'R' (introit for Easter). No. 3, f.88v. 305 x 230

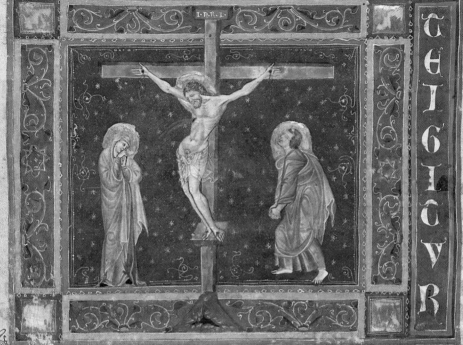

Plate 4. Crucifixion. No. 4, f. 182r. 335 x 245

Plate 5. Nativity. No. 5, f. 5v. (detail)

Plate 6. Initial 'L' (fourth Sunday in Lent). No. 6, f.31r. 475 × 335

Plate 7. Massacre of the Innocents. No. 7, f. 1v. (detail)

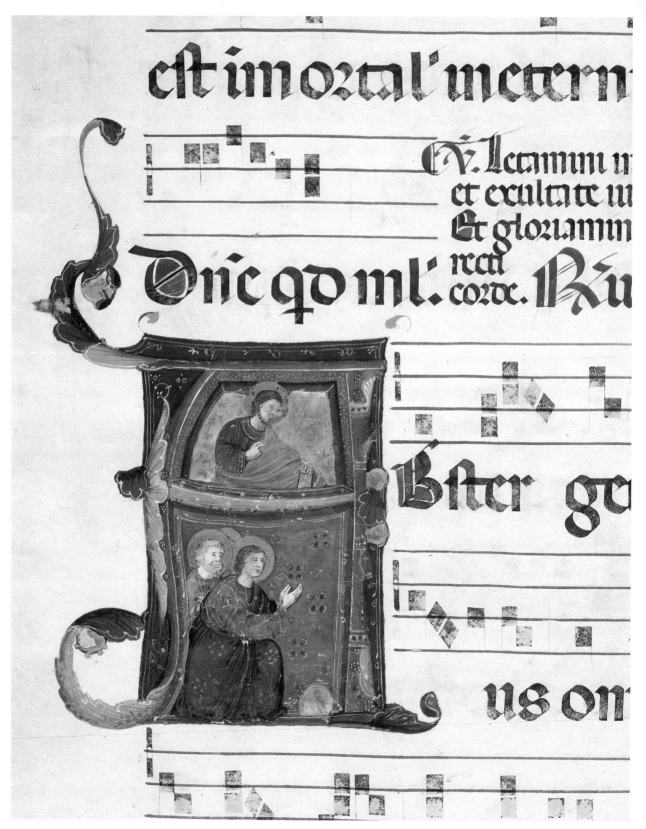

Plate 8. Christ above and kneeling saints below. No. 8, f. 34v. (detail)

confessor, and St Louis, King of France; and Sequences for Easter, Pentecost, Corpus Christi and Requiem Mass; f.252r–252v additional Mass for feast of Corpus Christi.

Decoration: Numerous initials, two lines high, in red or blue with pen-work in alternate colours whose flourishes often extend into the margin occur throughout the text. There are also thirty-seven decorated initials, ranging from two to six lines high, which mark certain sections of the text (see below).

These decorated initials are set in rectangular or square frames, sometimes with indentations, particularly when they outline the vertical extensions of such letters as 'P' or 'I' (figs. 20, 22). The grounds of the frames are predominantly blue filled with white. Rose and mauve fill the shafts of the initials; less frequently shades of grey, blue, yellow or maroon are used. The interstices are often in red or orange-brown, alternating with segments of burnished gold. They are patterned with blue, pink or red spiralling branches, or serrated, curling leaves outlined in white or black. The letter 'I' usually features a more geometric design; that which introduces the Passion reading from St Luke on f.127vb displays a pink fish against a blue ground (fig. 22). The decoration of the initial frequently extends into the margin as elongated, serrated oak leaves. On f.7r (fig. 16) these extensions are developed the length of the columns to form sinewy stem-borders punctuated with knots and grouped circlets.

One historiated initial (40 x 40) heads the second column of f.7r (fig. 18) and one miniature (117 x 158) on f.182r (Plate 4) completes the decoration of the manuscript. The miniature has a rectangular frame with segments outlined in gold and blue. Curling leaves of similar pattern to that found in the decorated initials in shades of blue, red and white on a red ground fill the segments of the frame. Its corners contain squares of burnished gold. The opening words of the canon, *Te igitur*, are arranged vertically on the right of the miniature. Inscribed in white on a red ground outlined in blue, they form part of an extension of the miniature frame. The colours of both historiated initial and miniature are those used for the decorated initials, although the miniature is distinguished by the subtlety of its blue, grey and flesh tones. (See commentary below.)

Programme of Illustration and Decoration: The decorated initials, historiated initial and miniature mark divisions of the text as follows:

f.7ra I (2 lines) *Incipit ordo missalis*: opening rubric (fig. 16)
f.7ra A (5 lines) *Ad te levavi*: introit for first Sunday in Advent (fig. 16)
f.7rb E (historiated) Christ blessing. *Excita Quaesumus*: collect for fourth Sunday in Advent (fig. 18)
f.7rb F (3 lines) *Fratres, scientes*: epistle for first Sunday in Advent (fig. 16)

f.20vb C (5 lines) *Concede quaesumus*: collect for third Mass of Christmas
f.23vb E (5 lines) *Ecclesiam tuam*: collect for St John the Evangelist
f.32rb D (5 lines) *Deus cuius unigenitus*: collect for octave of the Epiphany
f.112va O (5 lines) *Omnipotens sempiterne Deus*: collect for Palm Sunday
f.113va I (9 lines) *In illo tempore*: Passion according to St Matthew for Palm Sunday
f.121ra I (9 lines) *In illo tempore*: Passion according to St Mark for Tuesday in Holy Week
f.127vb I (9 lines) *In illo tempore*: Passion according to St Luke for Wednesday in Holy Week (fig. 22)
f.138va I (9 lines) *In illo tempore*: Passion according to St John for Good Friday
f.154va I (8 lines) *In principio creavit*: first prophecy for Vigil of Holy Saturday
f.173rb P (5 lines) *Per omnia saecula*: introduction to the preface for Christmas (fig. 20)
f.175vb P (5 lines) *Per omnia saecula*: introduction to the preface for Easter
f.180ra P (5 lines) *Per omnia saecula*: introduction to common preface
f.180rb V (8 lines) *Vere dignum et iustum est*: common preface for simple feasts . . . solemn tone
f.181ra P (5 lines) *Per omnia saecula*: introduction to the common preface
f.181ra V (8 lines) *Vere dignum et iustum est*: common preface for double feasts and octaves . . . simple tone
f.182r Crucifixion (miniature) *Te igitur*: canon (Plate 4)
f.189ra D (5 lines) *Deus qui hodierna die*: collect for Easter Sunday
f.205va C (5 lines) *Concede quaesumus*: collect for the Ascension
f.210rb D (5 lines) *Deus qui hodierna*: collect for Pentecost
f.254rb M (5 lines) *Maiestatem tuam*: collect for St Andrew
f.256ra D (5 lines) *Da nobis*: collect for St Thomas Apostle
f.259vb D (5 lines) *Deus qui multitudinem*: collect for Conversion of St Paul
f.267ra D (5 lines) *Deus qui beatum*: collect for St Matthias
f.272va D (5 lines) *Deus qui in praeclara*: collect for Finding of the Holy Cross
f.276vb D (5 lines) *Deus qui nos beati Barnabe*: collect for St Barnabas
f.281ra D (5 lines) *Deus qui praesentem*: collect for Nativity of St John the Baptist
f.284vb D (5 lines) *Deus qui hodiernam diem*: collect for SS. Peter and Paul
f.287va D (5 lines) *Deus cuius dextera*: collect for octave of SS. Peter and Paul (fig. 21)
f.298va F (5 lines) *Famulorum tuorum*: collect for Assumption
f.304ra F (5 lines) *Famulis tuis*: collect for Nativity of the Virgin

f.306rᵃ D (5 lines) D*eus qui nos hodierna*: collect for Exaltation of the Holy Cross

f.308rᵇ B (5 lines) B*eati apostoli*: collect for St Matthew

f.309vᵇ D (5 lines) D*eus qui miro*: collect for St Michael Archangel

f.311rᵇ D (5 lines) D*eus qui ecclesiam*: collect for St Francis of Assisi

f.315rᵇ O (5 lines) O*mnipotens sempiterne deus*: collect for All Saints

Commentary: This missal was executed for Franciscan use, as the opening rubric and the calendar both state. The feasts added on ff.390r–393v are evidence that it was written before 1297 since St Louis, King of France, who features in the additions, was not canonized until that year. Stylistically, a date closer to 1290 is indicated. The decorated initials are based on patterns characteristic of Umbrian illumination in the last quarter of the thirteenth century. The high quality of their execution is marked by a certain restraint, especially as regards detailing and border extensions. Thus the function of the decoration as an aid to the celebrant in the locating of important texts is emphasized. Sections so highlighted, apart from the opening folio, are the collects for major feasts – the first prayer the priest recites aloud from the proper (fig. 21) – the various musical tones at the conclusion of the Offertory and the beginning of the preface (fig. 20), the Passion readings for Holy Week (fig. 22) and the first prophecy for the Easter Vigil. The pen-flourished initials perform a similar function for other readings and prayers, such as the epistles and gospels (fig. 21). The distinctive clarity of this decorative programme is characteristic of Franciscan missals of the period although not exclusive to them.[1]

The miniature of the Crucifixion on f.182r (Plate 4) which introduces the first words of the canon *Te igitur*, the most sacred part of the Mass, gives this manuscript a key place in the history of late *duecento* Umbrian illumination. This was customarily the focal point of decoration for a missal, the depiction of the Crucifixion acting not simply as a marker in the text but as an aid to concentration and contemplation as the celebrant re-enacted the sacred memorial of Christ's death.

The Crucifixion in the missal from St Paschal's College is clearly related to three slightly earlier compositions in a series of Franciscan missals, one of which is at Deruta, Pinacoteca Comunale MS. ss. c.1285 (fig. 12) another at Salerno, Museo del Duomo (fig. 13) and a third which has been recently identified in the Vatican Library, Reg. lat. 2048 (fig. 14). All these miniatures reveal the influence of Cimabue on Umbrian art, especially in the depiction of the Crucified Christ, and they have been attributed to the same master. According to F. Bologna, who first drew attention to the works as a group, the artist worked in Perugia, and his hand has also been identified in a gradual, MS. 16 in the

Biblioteca Capitolare Perugia. Comparison of a historiated initial in the St Paschal's codex with one from the Perugian gradual (figs. 18 and 19) confirms the close relationship between these two artists.[2]

In the Crucifixion of the St Paschal's codex, however, other elements are present. While the debt to the master of the Deruta missal is clear, the artist draws on an older local Assisian tradition for his rendering of St John, as a comparison with a Crucifixion in a missal executed for the Duomo of Assisi in 1273 (fig. 15) persuasively indicates. At the same time, there is a new combination of gothic elegance and emotionalism in the rendering of the scene which finds no forerunners in earlier Perugian or Assisian illumination. Recently, Dr Ciardi-Dupré Dal Poggetto has suggested that this distinctive development may have been influenced by the patronage of Nicholas IV (1288–1293), the first Franciscan pope. Dr Ciardi-Dupré Dal Poggetto recognizes in his gifts donated to the tomb of St Francis – an enamelled chalice by the Sienese Guccio di Mannara and a reliquary of Roman goldsmith work of the finger of St Andrew – a new taste for French gothic, tempered by an Italian classicism, and she singles out the Crucifixion of the St Paschal's codex as one of the earliest works to reflect this strain which was to develop in a rich variety of ways in fourteenth-century Umbrian illumination.[3]

Certainly, the artist has translated the impassioned quality of Cimabue into an idiom infused with elegant beauty. This is achieved, in no small part, by the reduced size of the sorrowing figures of Mary and John silhouetted against the deep blue starred background, together with the subtle colour gradations of their blue and grey draperies with which the flesh tones of the Crucified Christ and even the wood of the Cross discreetly harmonize. The anguish of the scene is both intensified and transmuted by the gold glow of the haloes and the blood that gushes from the wounds of Christ, starkly red against the expanse of blue ground. The private, enclosed grief of the Virgin, towards whom the head of the unseeing Christ gently inclines, contrasts strongly with the impassioned, distraught, overt gesture of St John. The richly coloured frame of the miniature in no way encroaches on the personal drama of the scene.

Thus, while the St Paschal's codex may be added to the group of works related to the Deruta missal (see also figs. 17 and 23), its miniature of the Crucifixion is a singular anticipation of the fusion of local Umbrian and Tuscan elements with a new 'gothic classicism', mediated perhaps by way of Rome.

The missal provides no clue as to its original destination. The prayer, written in minute script as a kind of colophon at the end of the manuscript, must have been for the scribe's satisfaction alone. It is scarcely legible to the naked eye. No name is cited, but God's blessing is asked on the *sacerdos* who wrote the text. Given his close links with Perugian illumination, the artist as distinct from the scribe,

while stimulated by Assisian influences, probably belonged to a Perugian atelier.

It was earlier believed that this manuscript found its way to England from the Cistercian monastery of S. Stefano, Fossa Nuova. A. N. L. Munby has shown, however, that the missal was probably in the collection of the Abbey of Nonantola when its manuscripts were removed some time between 1660 and 1663 to the Biblioteca Sessoriana of the Cistercian Church of Santa Croce in Gerusalemme in Rome. The whole group vanished from there between 1798 and 1818, when they appeared in the stock of the Roman bookseller Gianbattista Petrucci. Sir Thomas Phillipps purchased the volume from the English booksellers Payne and Foss in 1848, and seems to have had it rebound at the time of purchase. The Franciscans of St Paschal's College, Box Hill, acquired the missal in 1949 through the gifts of private donors, when it was sent to Australia as part of a consignment of manuscripts for exhibition and sale by Messrs William H. Robinson Ltd, recent purchasers of the remainder of the Phillipps library.[4]

Bibliography: Sinclair (1969), pp.296–297; Sinclair (1962a), pp.336–337; Sinclair (1964a), p.375; Little *et al.* (1914), pp.9ff.; Kelly (1949a), pp.213–214; Kelly (1949b), pp.74–94; Kelly (1949c), pp.21–25; Ciardi-Dupré Dal Poggetto (1982), pp.358–359; Manion (1982), pp.363–365.

Notes

1. See E. Sesti, 'Aspetti della miniatura umbra nei secoli XIII e XIV', pp.366–368, in *Francesco d'Assisi Documenti e Archivi Codici e Biblioteche, Miniature*, Milan, 1982.
2. See especially F. Bologna, *La Pittura italiana delle origini*, Rome, 1962, pp.118–119; A. Caleca, *Miniature in Umbria, la Biblioteca Capitolare di Perugia*, Florence, 1969, pp. 83–85; Marcella Degl'Innocenti Gambuti, *I Codici medievali della Biblioteca Comunale e Dell'Accademia Etrusca di Cortona*, Florence, 1977, p.13 and *passim*; D. Gordon, *Art in Umbria (1250–1350)*, Courtauld Institute, University of London, unpublished Ph.D. thesis, 1979, p.205; Enrica Neri Lusanna, 'Il miniatore del messale di Deruta e i Corali del San Pietro a Gubbio' in *Francesco d'Assisi . . . (op. cit.)*, pp.178–188; and M. G. Ciardi-Dupré Dal Poggetto (1982), pp. 358–365. M. Avril first indicated the connection between the St Paschal's Codex and the master of the Deruta missal. He also drew attention to the bible in the Bibliothèque Nationale which belongs to this group, Paris B.N. lat. 41 (see fig. 17).
3. See M. G. Ciardi-Dupré Dal Poggetto (1982), pp.358–365.
4. Dr C. de Hamel kindly assisted with this information. See also A. N. L. Munby, *Phillipps Studies*, IV, 1956, p.180 and A. C. de la Mare and J. J. G. Alexander, *Italian Manuscripts in the Library of Major J. R. Abbey*, London, 1969, p.6.

Plate 5, figs. 24–27

No. 5. *Antiphonal*. Temporal. Latin
Central Italy or Bologna?, late 13c.
State Library of South Australia

Vellum, 570 x 395. A modern paper + 180 + B 16c. paper + C modern paper. I–IX[8], X–XIX[10], XX[8]. Catchwords agree, quire signatures. Foliation in 16c. arabic numerals. Folio 180v is blank. Script: rounded gothic hand in black ink, with red rubrics and music in black square notation. Ruling: pale brown ink, one column of five groups of four-line red staves with text beneath. Binding: old calf over oak boards, with modern leather straps.

Ownership: An index is written in a 16c. hand in Latin on Br, headed *Liber Secundus*. Inside front cover is '096 d. Sp. Symon Library 31.10.1945' and the label 'A gift to the Library from the friends of the Public Library of South Australia.'

Text: Latin. Contents: ff. 1r–180r, temporal from Christmas to the octave of the Epiphany.

Decoration: There are numerous pen-flourished initials throughout, blue with red pen-work or vice versa. Other initials are in black ink with flourished designs in black and yellow. One historiated and thirteen decorated initials (from 340 x 110 to 75 x 75) introduce the antiphons as listed below. These initials are set against gold rectangles, outlined in green. They are usually pink in colour except for the 'H' on f.124r (fig. 27), which is a deeper orange hue. The interstices have a wide range of spiral leaf designs or geometric interlace in red, blue, green, grey, pink, yellow and gold on predominantly blue grounds. White parallel stroking and filleted designs are liberally employed. This decoration often extends in leaf form into the margins (figs. 24–27).

There is one historiated initial on f.5v (Plate 5, 180 x 170). Predominant colours here are deep blue and red, offset by white, grey and gold.

Programme of Decoration and Illustration: The decorated initials and one historiated initial mark the divisions of the antiphonal as follows:

f.1r R R*ex pacificus*: first vespers for Christmas

f.5v H (Historiated initial) The Nativity. H*odie nobis*: matins for Christmas (Plate 5)

f.19r D D*ominus dixit*: introit for first Mass for Christmas (fig. 24)

f.24r Q Q*uem vidistis*: lauds for Christmas (fig. 25)

f.30r T T*e cum principium*: vespers for Christmas

f.36r S S*tephanus autem*: matins for St Stephen (fig. 26)

f.51v L L*apidaverunt Stephanum*: lauds for St Stephen

f.57r V V*alde honorandus est*: matins for St John the Evangelist

f.78r C C*entum quadraginta*: matins for Holy Innocents

f.93v H H*erodus viatus occidit*: lauds for Holy Innocents

f.102v E E*cce Agnus Dei*: matins for Circumcision

f.117v O O *admirabile commercium*: lauds for Circumcision

f.124r H H*odie in Jordane baptizat*: matins for Epiphany (fig. 27)

f.152r A A*nte luciferum genitus*: lauds for Epiphany

Commentary: This is a finely decorated antiphonal which probably formed part of a sequence of manuscripts covering the whole temporal cycle of the Church's year, together with the proper and common of the saints. The text in this volume gives no clue to original provenance, since it deals with universal feasts of the Church. The decoration is late thirteenth century. Both the colour and designs of the decorated initials (figs. 24–27), together with the Nativity composition (Plate 5), are consistent with central Italian and some Bolognese work of this period.

The volume once belonged to A. B. Triggs of Yass, whose library was sold in 1945. It was subsequently purchased by the Friends of the State Library of South Australia and donated by them to that institution.

Bibliography: Sinclair (1969), pp.248–249; (Triggs, 1945), lot 1111; Buttrose (1950), p.35; Tyrrell (1952), p.120.

Plate 6, figs. 28–31

No. 6. *Gradual.* Temporal (fragmentary). Latin
Bologna or central Italy, late 13c.–early 14c.
State Library of New South Wales, Rare Books and Special
 Collections, Richardson 274

Vellum, 475 x 335. A modern paper + 83 + B modern paper. I⁸, II⁶, III⁹, IV–VII⁶, VIII⁸, IX⁶, X–XI⁸, XII⁶. Catchwords on ff.12, 21, 29, 54, 63, 81 and 83, none agreeing; a few quire signatures. Contemporary foliation in roman numerals. Many sheets are incorrectly bound and present gatherings are not original. Script: rounded gothic hand in black ink with red rubrics. Ruling: brown ink, one column of seven groups of four-line red staves with black square notation. Lines of text are written beneath. Binding: modern calf over boards.

Ownership: Inside front cover is an extract from an English bookseller's catalogue. Inside back cover is '274'. F.2r has in pencil 'Don Richardson 1928'.

Text: Latin. Contents: ff.1r–83v, temporal from the Nativity to 23rd Sunday after Pentecost.

Decoration: Blue and red initials flourished alternately in red and blue introduce gradual and communion verses. The introit of each Mass, certain tracts and sequences, and the chants for the ordinary of the mass, kyrie, gloria, sanctus etc. are headed by eighty-five decorated initials (average size 60 x 50). They are painted in mauve-pink, orange or grey-blue on deep blue grounds with infills of curling foliate and geometric interlaced designs in contrasting colours of the same palette. White is used for outlines and tracery patterns. Curving leaf projections of the initials sometimes extend into the border. A winged grotesque with a bugle sprouts from the initial on f.3v (fig. 28), and a dragon with extended tail holds up the letter in its mouth on f.6r (fig. 29). In the latter initial the curving leaf forms of the interstices issue from a lion's mouth. On f.38v (fig. 30)

the initial introducing the introit for the Friday for the fourth week in Lent has two large blue confronting fish.

Commentary: Bound now in incorrect order and incomplete, this manuscript was probably once part of a two- or three-volume series of graduals for the proper of the time and proper and common of the saints, characterized by a very detailed decorative programme of high quality. Although the sequence of the text has been disturbed, it is clear that the introit for every Mass began with a decorated initial. These initials may be compared with certain Bolognese and central Italian manuscripts of the late thirteenth and early fourteenth centuries. Large confronting fish treated in similar manner to those on f.38v (fig. 30) appear, for example, in a late thirteenth-century book of legends of the saints now in the Biblioteca Nazionale, Florence (Conv. Soppr. S. Croce C.55), possibly executed in Arezzo. The same combination of a restrained colour scheme with linear precision in the treatment of the designs of the decorated initials, together with a like blend of geometric interlace and foliate forms, characterizes a late thirteenth-century gradual for Dominican use from Bologna, now no. 36° in the library of San Domenico, Bologna.[1]

Nelson M. Richardson bequeathed the manuscript to the State Library of New South Wales in 1928.

Bibliography: Sinclair (1969), pp.137–138.

Note

1. See Ciardi-Dupré Dal Poggetto (1982), pp. 338–339 and fig. 89 for the initial from the Legend of the Saints of S. Croce, Firenze. See P. V. Alce O.P. and P. A. D'Amato O.P., *La Biblioteca di S. Domenico in Bologna*, Florence, 1969, p.150 for MS. 36° of S. Domenico. For late thirteenth- and early fourteenth-century Bolognese illumination, see especially A. Conti, *La Miniatura Bolognese, Scuole e Botteghe 1270–1340*, Bologna, 1981.

Plate 7

No. 7. *Antiphonal* (fragment). Latin
Bologna?, late 13c.–early 14c.
State Library of Victoria, *ef.096/R66L

Vellum, 480 x 340. 7ff. of 1 quire. Foliation 70–76 in a 16c. hand. Script: rounded gothic hand in black ink with red rubrics. Ruling: brown ink, one column of eight groups of four-line red staves with black square musical notation. On f.1v there are only seven staves, with four lines of smaller script of verses and rubrics preceding matins for the Holy Innocents. Binding: modern red calf.

Text: Latin. Contents: the seven folios are a fragment of an antiphonal probably for the temporal as the saints are those whose feasts fall within the Christmas season and are usually contained within the proper of the time. Folio 1r opens abruptly with a reference to the commemoration of the Nativity and of St Stephen at vespers. The fragment ends on f.7v in the middle of antiphons for the feast of St Thomas of Canterbury.

Fig. 1. Gospel of St Mark. No. 1, f.80r. 242 x 174

Fig. 2. Gospel of St Luke. No. 1, f.125r. 242 x 174

Fig. 3. Epistle to Carpainus, and Canon Table 1, September, October, November. No. 1, ff.2v–3r. 242 x 348

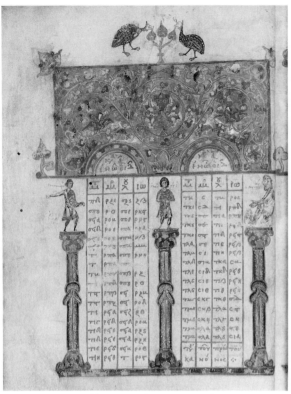

Fig. 4. Canon Table 1, December, January, February. No. 1,
f.3v. 242 x 174

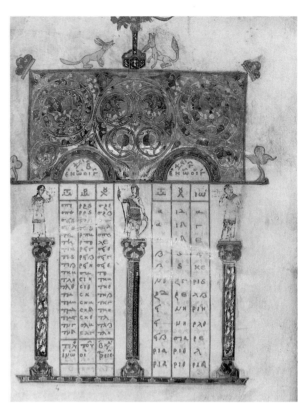

Fig. 5. Canon Table 1, Prudence, Courage, Thoughtfulness. No. 1,
f.4r. 242 x 174

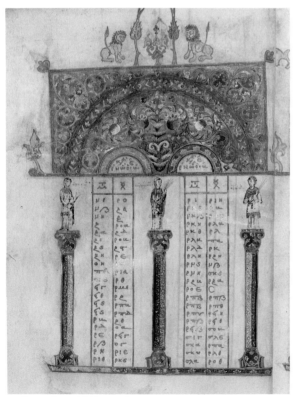

Fig. 6. Canon Table 5, Exhortation, Repentance, Love. No. 1,
f.5v. 242 x 174

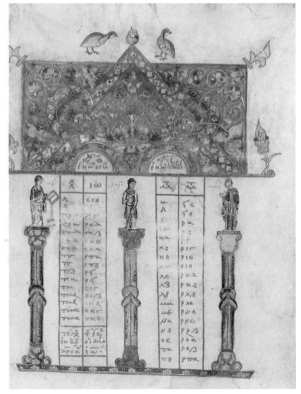

Fig. 7. Canon Tables 9 and 10, Wisdom, Contemplation, Action.
No. 1, f.6r. 242 x 174

Fig. 8. Initial 'P'. No. 2, f.114v. (detail)

Fig. 9. Initial 'P'. No. 2, f.126r. (detail)

Fig. 10. Initial 'B'. No. 3, f.106v. (detail)

Fig. 11. Initial 'E'. No. 3, f.125v. (detail)

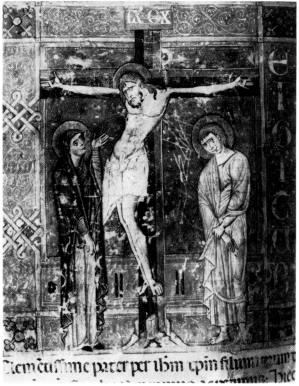

Fig. 12. Crucifixion. Deruta, Pinacoteca Comunale MS. s.s., f. 119v.
(detail)

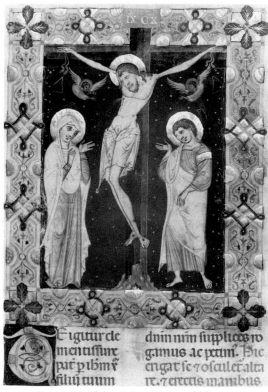

Fig. 13. Crucifixion. Salerno, Museo del Duomo

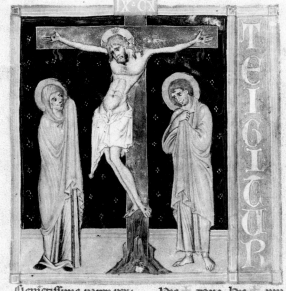

Fig. 14. Crucifixion. Vat. Reg. lat. 2048, f. 129r. 275 x 192

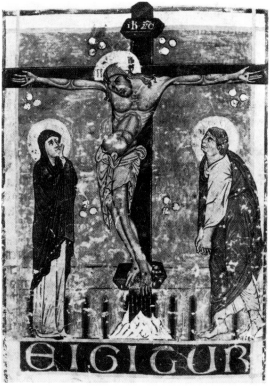

Fig. 15. Crucifixion. Assisi, Archivio Capitolare. MS. 8, p. 236.
375 x 245

Fig. 16. Beginning of temporal. No. 4, f.7r. 335 x 245

Fig. 17. First Epistle of St John. Paris, B.N. lat. 41, f.443v. 370 x 250

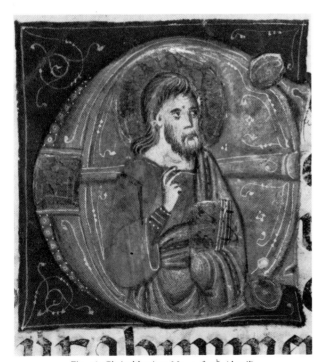

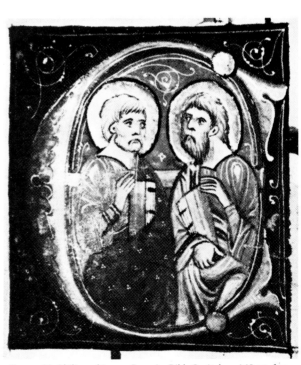

Fig. 18. Christ blessing. No. 4, f.7r^b. (detail)

Fig. 19. SS. Philip and James. Perugia, Bibl. Capitolare. MS. 16, f.21r. (detail)

Fig. 20. Initial 'P'. No. 4, f.173r^b. (detail)

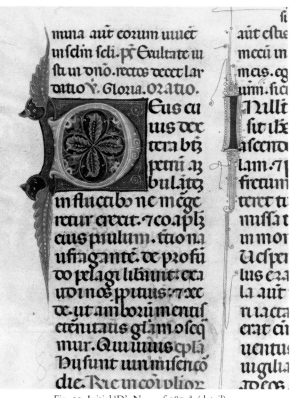

Fig. 21. Initial 'D'. No. 4, f.287v^a. (detail)

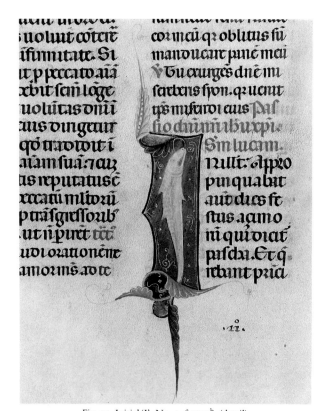

Fig. 22. Initial 'I'. No. 4, f.127v^b. (detail)

Fig. 23. Nativity. Perugia, Bibl. Comunale Augusta, MS. A47, f.1r. 340 × 240

Fig. 24. Initial 'D'. No. 5, f.19r. (detail)

Fig. 25. Initial 'Q'. No. 5, f.24r. (detail)

Fig. 26. Initial 'S'. No. 5, f.36r. (detail)

Fig. 27. Initial 'H'. No. 5, f.124r. (detail)

Fig. 28. Initial 'E'. No. 6, f.3v. (detail)

Fig. 29. Initial 'D'. No. 6, f.6r. (detail)

Fig. 30. Initial 'M'. No. 6, f.38v. (detail)

Fig. 31. Initial 'R'. No. 6, f.63r. (detail)

Fig. 32. Sending of the apostles. No. 8, f.3r. (detail)

Fig. 33. Christ and haloed figure. Bologna, Museo Civico, MS.540, f.30v. (detail)

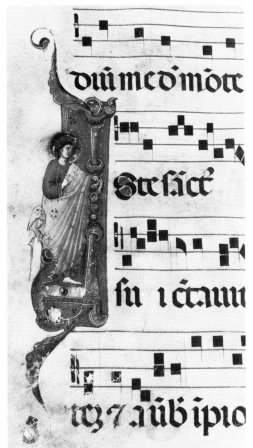

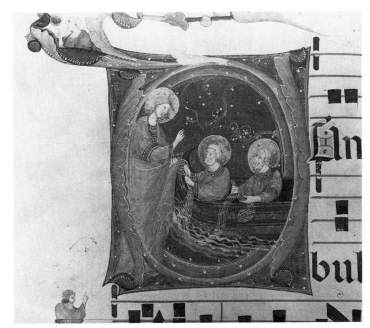

Fig. 35. Calling of the apostles. Bologna, Museo Civico, MS.540, f.211v. (detail)

Fig. 34. Standing haloed martyr. No. 8, f.19v. (detail)

Fig. 36. Christ blessing saints. No. 8, f.71r. (detail)

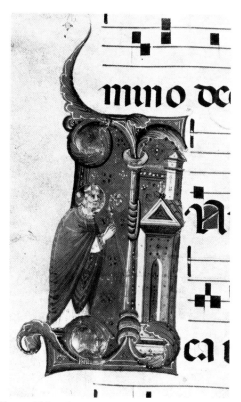

Fig. 37. Bishop dedicating a church. No. 8, f.105v. (detail)

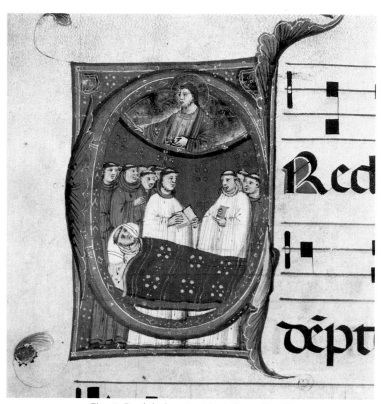

Fig. 38. Death-bed service. No. 8, f.124r. (detail)

Fig. 39. Initial 'P'. No. 8, f.138r. (detail)

Fig. 40. St Stephen, No. 9, f.10v. (detail)

Fig. 41. St John the Evangelist. No. 9, f.13v. (detail)

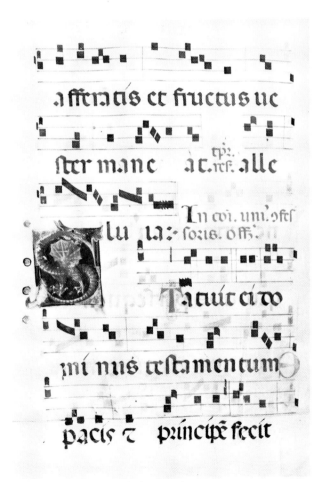

Fig. 42. Initial 'S'. No. 9, f.118v. 400 x 345

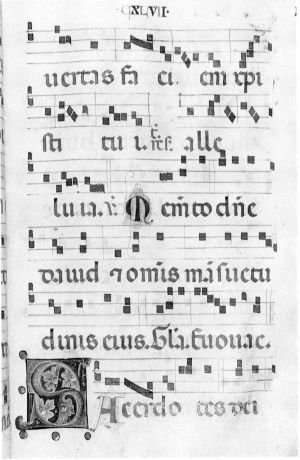

Fig. 43. Initial 'S'. No. 9, f.120r. 400 x 345

Fig. 44. Dedication of boys. No. 11, f.105r. (detail)

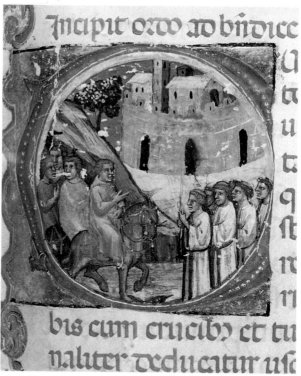

Fig. 45. Emperor greeted by clergy. No. 11, f.123r. (detail)

Fig. 47. Christ appearing to eight people. No. 13. 93 x 115

Fig. 46. Blessing of emperor. No. 11, f.124r. 280 x 200

Fig. 48. Crucifixion. No. 14, f. 34r. 102 x 79

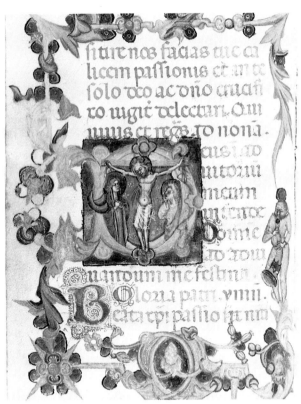

Fig. 49. Death of Christ on the Cross. No. 14, f. 39v. 102 x 79

Fig. 50. Descent from the Cross. No. 14, f. 45v. 102 x 79

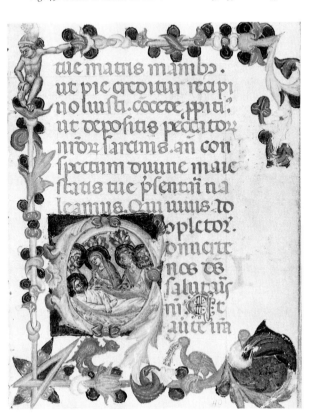

Fig. 51. Lamentation. No. 14, f. 49r. 102 x 79

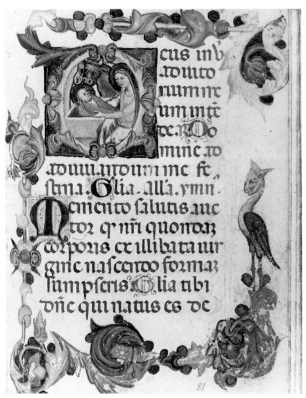

Fig. 52. Nativity. No. 14, f.81r. 102 x 79

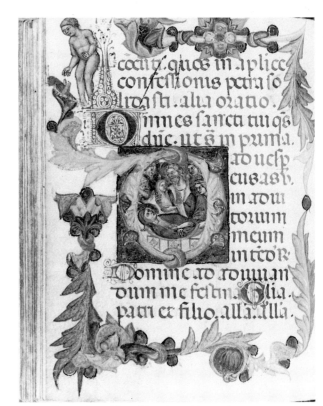

Fig. 53. Dormition of the Virgin. No. 14, f.96v. 102 x 79

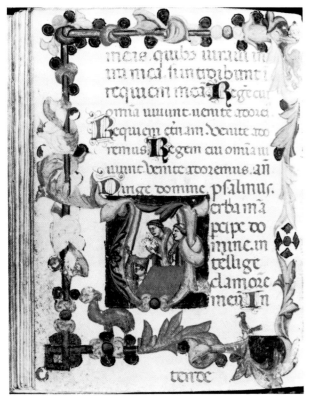

Fig. 54. Death-bed service. No. 14, f.124v. 102 x 79

Fig. 55. Christ blessing. No. 14, f.161r. 102 x 79

Fig. 56. Man with fish. No. 16, f.4r. 57 x 30

Fig. 57. Man clasping foot. No. 16, f.14r. 30 x 20

Fig. 58. Man's head. No. 17, f.3r. (detail)

Fig. 59. Bearded saint. No. 18, f.3r. 70 x 70

Fig. 60. Initial 'E'. No. 22, f.111r. (detail)

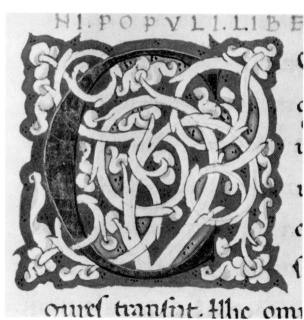

Fig. 61. Initial 'C'. No. 23, f.76v. (detail)

Fig. 62. Title page. No. 24, f.1r. 228 x 165

Fig. 63. Title page. No. 25, f.1r. 292 x 200

Decoration: One-line initials in red and blue flourished in the alternate colour occur throughout. Larger decorated initials, taking up the space between two staves and part of one stave itself introduce certain antiphons. These are coloured pink on blue grounds with simple foliate infills in pink, greyish-blue and red stroked with white.

One historiated initial (95 x 110) introduces the antiphon of the first lesson for matins for the feast of the Holy Innocents on f.1v (Plate 7). Its subject is the Massacre of the Holy Innocents. The initial in red and pale blue is decorated with white tracery, small foliate extensions and a horizontal gold bar. It is set against a rectangular ground, coloured in alternating sections of red and blue with white tracery. The background for the scene within the initial is burnished gold. Above, Herod orders the Massacre; below, the slaughter takes place.

Commentary: While the remaining portion of this antiphonal is too fragmentary to define the full decorative and illustrative programme, it seems to have been originally a lavish production, probably with a series of historiated initials introducing the antiphons for matins of important feasts together with decorated initials marking other sections of the office. The style of the decorated initials and of the figurative scene suggests a possible Bolognese origin. The way in which the separate events of the Massacre are depicted without framing demarcation against the gold ground and their pronounced anecdotal character, together with the summary rendering of facial features in grey with red highlights, the use of repetitive patterning of white dots as a convention for representing chain mail, and the relatively large gesturing hands, all bring to mind the work of certain late thirteenth-century Bolognese illuminators.[1]

The manuscript was purchased by the State Library of Victoria in 1923 from the Melbourne bookseller A.H. Spencer.

Bibliography: Sinclair (1969), pp.342–343.

Note

1. See, for example, A. Conti, *La Miniatura Bolognese, Scuole e Botteghe, 1270–1340*, Bologna, 1981.

Plate 8, figs. 32–39

No. 8. *Antiphonal*. Common of the saints. Latin
Bologna?, *c.*1303–1314
State Library of New South Wales, Rare Books and Special
 Collections, Richardson 273

Vellum, 525 x 365, 155ff. I–VI[10], VII[8], VIII–XI[10], XII[8], XIII[9] (wants 10), XIV–XVI[10]. Catchwords agree. 16c. foliation in arabic numerals. Script: early 14c. rounded gothic hand in black ink with red rubrics. Ruling: brown ink, one column of 4-line staves with black square musical notation and text beneath. Binding: ancient oak boards with calf spine.

Ownership: Folios 1r and 155v have illegible notes in a 15c. hand. Folio 119r has 'P. A. Bernadet' in a 16c. hand. Inside front cover is a label with 'A 1.4'. Inside back cover is an extract from an English bookseller's catalogue, September 1924. Inside front cover is 'Nelson Moore Richardson, Montevideo near Weymouth'. On f.2r is 'Don Richardson 1928'.

Text: Latin. Contents: ff.1r–119r, common of the saints; ff.119r–139r, Office for the Dead; ff.139r–155r, variations of musical chants for invitatory psalm for matins *'venite exultemus'* for each of the feasts of the common of the saints.

Decoration: The manuscript contains many flourished initials, alternately blue with red or red with blue pen-work (fig. 39). There are nineteen decorated initials with designs of leaf and vegetative forms in a rather heavy palette of blue, pink, red, yellow, green and grey. The paint is thickly applied and contours are broadly brushed (fig. 36). There are nine historiated initials: sizes range between 175 x 60, 170 x 90, 165 x 110 and 155 x 105. Their colour range is the same as that of the decorated initials, with gold leaf being used for haloes and segments of the backgrounds.

Programme of Decoration and Illustration: Historiated and decorated initials mark antiphons and responses as follows:

f.1r T A man's bust in a decorated initial. *Tradent enim:* Magnificat at first vespers for common of apostles

f.3r E Historiated: The sending of the apostles. *Ecce ego mitto vos:* first lesson of matins for common of apostles (fig. 32)

f.14r H (75 x 95) *Hoc est praeceptum:* vespers for common of apostles

f.16r J (50 x 95) *Juravit Dominus:* second vespers for common of apostles

f.18r I (50 x 85) *Iste sanctus:* Magnificat for common of a martyr

f.19v I Historiated: Standing haloed martyr. *Iste sanctus:* first lesson of matins for common of a martyr (fig. 34)

f.30r Q (65 x 78) *Qui me confessus:* lauds and little hours for common of a martyr

f.34v A Historiated: Christ above and kneeling saints below. *Absterget Deus:* first lesson of matins for common of several martyrs (Plate 8)

f.47v O (70 x 80) *Omnes sancti:* lauds etc. for common of several martyrs

f.49v I (50 x 85) *Isti sunt sancti:* second vespers for common of several martyrs

f.55r E Historiated: Christ blesses confessors and bishops. *Euge, serve bone:* first lesson of matins for common of bishops and confessors

f.66r E (75 x 80) *Ecce sacerdos:* lauds etc. for common of bishops and confessors

f.69r S (54 x 84) *Similabo eum viro sapienti:* Magnificat at vespers for common of a bishop and confessor

f.71r E Historiated: Christ above blesses groups of saints. E*uge, serve bone*: first lesson of matins for common of a confessor not a bishop (fig. 36)

f.82r D (78 x 83) D*omine, quinque*: lauds etc. for common of a confessor not a bishop

f.87r V Historiated: Angel crowns a virgin. V*eni sponsa*: first lesson of matins for common of a virgin

f.97v H (60 x 95) H*aec est virgo*: vespers for common of a virgin

f.102r D (73 x 84) D*um esset rex*: lauds etc. for common of female saint

f.105v I Historiated: Bishop dedicates a church. I*n dedicatione*: first lesson for matins for anniversary of the dedication of a church (fig. 37)

f.116v D (65 x 33) D*omum tuam*: lauds etc. for anniversary of the dedication of a church

f.119v V (58 x 90) V*enite*: invitatory for matins of the Office of the Dead

f.124r C Historiated: Christ blesses above, service at bedside below. C*redo*: first lesson for matins for Office of the Dead (fig. 38)

f.136v E (75 x 90) E*xsultabunt Domino*: lauds etc. for Office for the Dead

f.138r P (60 x 85) P*lacebo Domino*: vespers for the Office for the Dead (fig. 39)

f.140r V (60 x 90) V*enite*: invitatory for common of apostles

f.143r V V*enite*: invitatory for apostles and evangelists

f.146v V V*enite*: invitatory for common of one or several confessors

f.150r V V*enite*: invitatory for anniversary of dedication of a church

f.153v V V*enite*: invitatory for common of a virgin

Commentary: Both the designs and the colours of the decorated initials (fig. 39) in this antiphonal are characteristic of early *trecento* Bolognese illumination, while the historiated scenes are in the style of Neri da Rimini. Figure types, drapery patterns, architectural structures, even the patterning of grounds and drapery with green dots are all common to the group of manuscripts which has been assigned to Neri and his associates, a miniaturist active *c.*1300–1322 who was a major contributor to the new developments towards gothic naturalism which took place in Italian illumination during the first two decades of the *trecento*, paralleling and interacting with the innovations in fresco and panel painting associated with the influence of Giotto and painters at Assisi and Rimini.

Comparison of compositions from the Sydney antiphonal with those from a manuscript executed by Neri da Rimini for the Church of S. Francesco, Bologna, in 1314 (figs. 32 and 33, 34 and 35) suggests that the Sydney work might be dated around this time, although it lacks the refinement of the Bolognese antiphonal and is the product of an assistant or associate rather than of the master himself.

The standing figure of the martyr on f.19v (fig. 34) reflects the delicate classicizing language, based on a Byzantine inheritance, of Neri's early works, while the more fleshy and naturalistic facial types in such compositions as the blessing of the apostles on f.3r (fig. 32) or for the common of several martyrs on f.34v (Plate 8), the rather homely rendering of the death-bed service on f.124r (fig. 38) and the architectural details in the scene for the dedication of a church on f.105v (fig. 37) indicate the direction of the master's later style.

The text itself yields no indication of the manuscript's provenance; but the presence of greyish-brown habited friars in the initials illustrating the Office for the Dead (fig. 38) and the common for bishops and confessors on f.55r suggests that it was originally destined for a Franciscan foundation. The strong Bolognese influence in the decorative elements, together with the fact that Neri is documented as having worked in Bologna, makes it reasonable at this stage to assign the manuscript to a workshop in that city or associated with it.[1]

Nelson M. Richardson bequeathed the manuscript to the State Library of New South Wales in 1928.

Bibliography: Sinclair (1969), pp.136–137; (Sydney, 1967), p.30; Manion (1982), p.389.

Note

1. For the most recent treatment of Neri da Rimini see Canova (1978), pp.16–21, and M. G. Ciardi-Dupré Dal Poggetto, 'All'origine del rinnovamento delle miniature italiane del Trecento' in *Francesco d'Assisi, Documenti e Archivi ... Miniature*, 1982, pp.385–389.

Figs. 40–43
No. 9. *Gradual*. Sanctoral and common of the saints. Latin Central Italy, late 14c.
Ballarat Fine Art Gallery, Victoria, MS. Crouch 11

Vellum, 400 x 345. 169 + 16c. paper. I^6, II2, III9 (wants 1), IV9 (wants 6), V^9 (wants 7), VI8 (wants 4 and 9), VII7 (wants 2, 8 and 9), VIII7 (wants 1, 4 and 6), IX6 (wants 1, 3, 4 and 5), X^4 (wants 2, 3, 6, 7, 8 and 10), XI4 (wants 1, 3, 4, 8, 9 and 10), XII8 (wants 8 and 9), XIII5 (wants 1, 4, 5, 8 and 9), XIV8 (wants 1 and 10), XV9 (wants 1), XVI7 (wants 1, 3 and 4), XVII10, XVIII9 (wants 4), XIX9 (wants 10), XX9 (wants 1), XXI9 (wants 9), XXII6, XXIII9 (wants 9). Some catchwords which agree. Contemporary foliation in roman numerals and in arabic numerals in later hand. Folio 169v is blank. Script: 14c. rounded gothic hand in dark brown ink with red and blue rubrics and black square musical notation. In some places damaged script has been written over by a 16c. hand. Ruling: black ink, one column of six groups of four-line red staves with text underneath. Binding: 16c. oak boards with bevelled edges and pigskin spine. Cover has central panel with busts, floral designs and full-length apostles in blind.

Ownership: Pasted on to the front cover is a piece of 16c. vellum with the inscription *Liber comprehendens Kyrie Patrem defunctis cum mandatum sequentias.* Inside front cover is 'Ex libris R. A. Crouch'.

Text: This manuscript comprises four fragments. The first consists of one vellum sheet pasted down to the inside of the front cover so that only the verso is visible. It is not included in the tally of folios or in the collation above as it is not decorated and is unrelated in style, script and layout to the principal manuscript.

The second fragment, ff. 1–6, is part of the gradual which forms the principal manuscript (see below). It contains the asperges according to the Dominican rite and its decorative programme is included in the description below. The decoration of its last three folios is unfinished.

The third fragment, ff.7–8, contains the proper for the Dominican saint Vincent Ferrer O.P. (1350–1419). It is a later insertion into the principal manuscript and is written in black ink in a 15c. Italian liturgical gothic hand. Three to six four-line red ink staves with black square musical notation appear on each folio. Pen-flourished initials of a different style from the main manuscript are its only decoration.

Principal fragment, ff.9–169. Text: Latin. Contents: ff.9–117 gradual of the sanctoral, opening abruptly in the feast of St Andrew; ff.118v–163 common of the saints; ff.164r–169v proper for feast of St Thomas Aquinas. The proper of the saints contains Masses for specific Dominican feasts: the translation of St Thomas Aquinas on f.24v and St Peter Martyr on f.40v as well as the feast of St Dominic himself on f.60v and of St Lawrence on f.61v, regularly included in Dominican works.

Decoration: Red and blue initials, finely flourished in the alternate colour, occur regularly throughout the text introducing versicles and responses etc. Decorated initials (from 35 x 30 to 70 x 70), mainly in deep pink or orange-red on blue grounds, filleted with white, and with sections of burnished gold, have curling serrated acanthus-leaf infills and border extensions, together with gold circlets; one has a dragon motif (figs. 42 and 43). There are nine historiated initials of similar design and colouring (figs. 40 and 41). In several cases these initials bear the signs of later re-painting. This is especially so with some of the historiated initials such as that of St Lawrence on f.62v.

Programme of Decoration and Illustration: The nine historiated initials are related to the text as follows:

f.10v E (61 x 74) St Stephen. *Etenim sederunt:* introit for St Stephen (fig. 40)

f.13v I (100 x 50) St John the Evangelist. *In medio ecclesiae:* introit for St John (fig. 41)

f.16v E (71 x 71) Holy Innocents. *Ex ore infantium:* introit for Holy Innocents

f.21v B (70 x 70) Saint's head. *Beatus vir:* tract for common of a bishop and martyr

f.26r S (120 x 120) The Purification. *Suscepimus:* introit for Purification

f.32v D (60 x 60) St Matthias. *Desiderium:* tract for St Matthias

f.38r S (64 x 68) SS. Tiburtius, Valerianus and Maximus. *Sancti tui:* introit for several martyrs in paschal time

f.56r D (70 x 60) St Peter. *Dixit Dominus:* introit for vigil Mass of SS. Peter and Paul

f.62v D (60 x 70) St Lawrence. *Dispersit pauperibus:* introit for vigil Mass of St Lawrence

The twenty decorated initials introduce other introits, tracts and alleluia verses, as well as the asperges and chants from the ordinary of the Mass: gloria, sanctus and agnus dei.

Commentary: This gradual, now damaged and incomplete, was probably executed in central Italy in the middle or late fourteenth century. The decorative foliate border extensions and figurative style of historiated initials such as that of St John on f.13v (fig. 41) suggest an Umbrian workshop. The rendering of the architectural details in the badly damaged scene of the Purification on f.26r may reflect the influence of Assisi. Since the book is now so fragmentary and has several quires misbound it is not possible to reconstruct its full decorative and illustrative programme, but the remnants indicate that this was originally quite detailed and the illumination of high quality.

Both the text and the decoration lay emphasis on feasts specifically honoured by the Dominican order and the manuscript was no doubt originally commissioned for a Dominican foundation. It has been incorrectly referred to as an antiphonal.[1]

The book was presented by Colonel the Honourable R. A. Crouch to the Fine Art Gallery of Ballarat in 1944.

Bibliography: Sinclair (1969), pp.287–289; Sinclair (1968), p.26, pl. viii.

Note
1. See Sinclair (1969), pp.287–289.

Plate 9

No. 10. *Choirbook* (fragment). Latin
Tuscany, 14c.
State Library of Victoria, *f.096/II/1

Vellum fragment of a leaf: 70 x 70. On the verso is a 4-line red stave with black square notation and the letters '-n uis'. It is bound with fragments from three other manuscripts, as f.2r. Binding: 19c. vellum.

Ownership: Inside front cover is the *ex-libris* of Robert Carl Sticht which includes the name of his wife Marion Oak Sticht and the label A. H. Spencer, 86 Bourke St., Mel-

bourne. Inside back cover is an extract from an English bookseller's catalogue, entry no. 678, with the note 'R.S. Ldn. IV.04', together with an extract from a sale cover with the note, 'A. H. Spencer 3.4.23'. Ar has the stamp of the Public Library of Victoria with the same date.

Decoration: Historiated initial 'D'. A bearded saint, half-length frontal view, carrying a book in his left hand. Colours are pink, orange-red, blue and yellow, burnished gold being used for the saint's halo and black or white for outlines. White tracery detailing is also used sparingly.

Commentary: Colour, figurative style and initial decoration all point to fourteenth-century Tuscany as the source of this fragment. The volume of four groups of fragments of which it forms part was purchased by Robert Carl Sticht in London, April 1904. A subsequent owner, the Melbourne bookseller A. H. Spencer, sold it to the State Library of Victoria in April 1923.

Bibliography: Sinclair (1969), p.343.

Plate 10, figs. 44–46

No. 11. *Roman Pontifical* (with later excerpts from *Summa Theologica* of St Thomas Aquinas and *Rules for finding the new moon*). Latin
Central or northern Italy, second half of 14c.
Ballarat Fine Art Gallery, Victoria, MS. Crouch 5

Vellum, 276–280 x 200. A–B modern vellum + 164 + C–D modern vellum. I², II–XVI⁸, XVII⁶, XVIII–XX⁸, XXI⁶, XXII⁴, XXIII². Catchwords agree. Contemporary foliation in roman figures from f.3–162, omitting cxxiii and cxxv. Folios 162v, 163r and 164v are blank. Script: in black ink with red rubrics: ff.1r–2v, 15c. gothic liturgical hand; ff.3r–158r, 14c. rounded gothic hand; ff.158v–162r, 15c. cursive with some book hand elements. *Explicit* for last section on f.162r is dated 1451. Ruling: dry point: ff.1–2: 25.[125].50 x 36.[150].90; ff.3r–158r: 25.[118].57 x 28.[159].93. Ruling on ff.158v–162r virtually invisible. Lines of text (ff.3r–158r): 18. Ruling unit: 6.9. Some pages have 6 groups of 4-line red staves with black square musical notation. Binding: 19c. brown pigskin.

Ownership: On f.164r in a 16c. hand is an extract from the Apocalypse and the Gospel of St Luke. Written in the lower margin of f.162r is *Ioannis Baptiste Detottis 1563 et mi gosto davero contanti l'anno detto*. On f.164r is a lion rampant and 'Sir T.P./Middle Hill/3201.' and a note now erased. On f.1r is 'MSS.Ph.3201' and 'Phillipps MS.3201'. Inside front cover is 'Ex libris R. A. Crouch'.

Text: Latin. Contents: ff.1r–158r pontifical according to the use of the Roman curia. The 15c. addition on ff.1r–2v gives the ritual for the founding of a church and the laying of the foundation stone. The 14c. text begins on f.3r with

the 7 grades for ordination: *Ordo septem ecclesiasticorum graduum . . .*; ff.158v–159r extracts from *Summa Theologica*; ff.159v–162r rules for finding the new moon (dated 1451).

Decoration: Only the pontifical is decorated. Two-line blue and red initials flourished in the alternate colour occur throughout the text. Occasionally a one-line red or blue initial is slightly flourished. Two decorated initials three lines high with infills of serrated leaf sprays and nineteen historiated initials, usually six lines high, mark the beginning of certain rituals and blessings. These initials have small foliate extensions, usually of a contrasting colour, and are set on square or rectangular grounds of heavily burnished gold, outlined in black. The section facing the margin is often variously indented or curved, and from this area develops a border of elongated stem-design punctuated with fine clusters of pointed leaf sprays, knots and gold circlets. This normally extends the vertical length of the margin on the side of the decorated initial. On f.3r (Plate 10) it extends around three sides of the page. Colours for the initial and border decoration are predominantly pink, red, blue, mauve, and brownish-yellow, with gold for grounds, circlets etc. and black and white for outlines and filigree patterns.

Programme of Illustration: The nineteen historiated and two decorated initials six lines high, except where otherwise indicated, illustrate the text as follows:

f.3r O Tonsuring of cleric: *Oremus dilectissimi fratres* (Plate 10)

f.4v H Doorkeeper receives key: *Hostiarum opportet*

f.6r L Lector receives lectionary: *Lectorem opportet legere*

f.7v E Ordination of exorcist: *Exorcistam opportet*

f.9r A Acolyte receives a taper: *Acolitum opportet cerroferarium ferre*

f.11v S Ordination of sub-deacon: *Subdiaconum opportet preparare aquam*

f.14r D Ordination of deacon: *Diaconum opportet ministrare ad altarem*

f.19r S Ordination of priest: *Sacerdotem opportet offerre, benedicere*

f.32r E Bishop receives crozier: *Episcopum*

f.47r D Benediction of an abbess: *Domine deus*

f.48r D Benediction of a nun: *Deus*

f.61r C Benediction of widow professing chastity: *Consolate*

f.63v O Blessing of a church: *Omnipotens*

f.93v E Reconciliation of desecrated church: *Exorcico*

f.98r C (3 lines, decorated) Consecration of altar stone: *Consecra†*

f.102v C (3 lines, decorated) Consecration of paten: *Consecra†*

f.105r O (5 lines) Dedication of boys: *Omnipotens sempiterne Deus* (fig. 44)

Plate 9. A bearded saint. No. 10, f.2r. 70 x 70

·I·

Rdo septem eccliasticorū q̄dui
ct in graoib; ordinādi. set an
ōnia clerieū faciendi qui debet ha
bēre septem annos completos

IRemus dilectif
sim frēs dominū
nrm ihm rpm pro
hoc famulo suo. N.
qui ad deponēda;
comā capitis sui
pro eius amore festinat. ut dēt ci
spm scīn. qui habituz religiois in
eo pptinuz consueet. et amictoi ipe
dimēto ul seculari desiderio cor ei
defendat. ut sicut imutatur uultu.
ita dexteia manus eius uirtutis ci
tribuat incrementa : et ab omni ce
citate spiuali uel humana oculos ei

Plate 10. Tonsuring of cleric. No. 11, f. 3r. 276 x 200

62

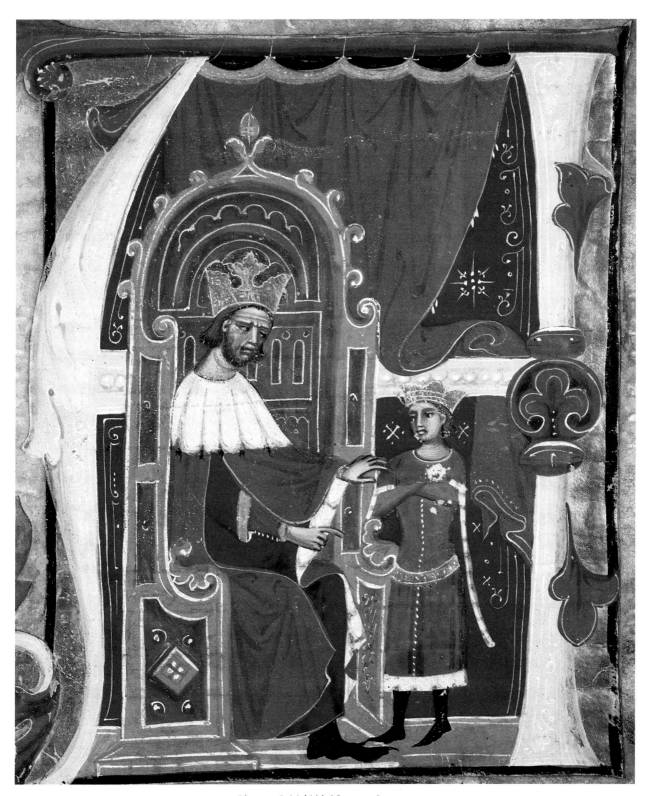

Plate 11. Initial 'A'. No. 12. 182 x 142

Plate 12. Scourging of Christ. No. 14, ff.25v–26r. 102 x 158

Plate 13. Initial 'M'. No. 15, f.68r^a. 340 x 235

Plate 14. Boniface VIII handing down his decretals. No. 17, f.1r. (detail)

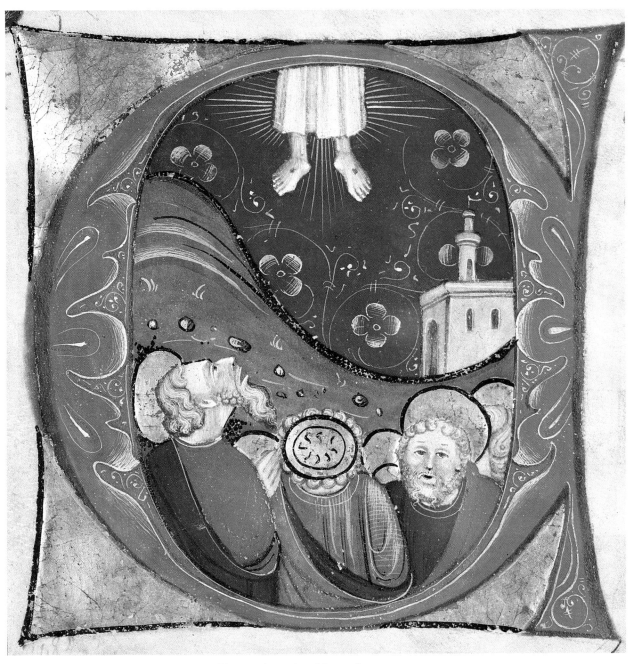

Plate 15. Ascension. No. 19, f. 1r. 105 x 105

Plate 16. Virgin and Child. No. 20, f. 13r. 115 x 80

f.106v I Cleric points to rubric: *Incipit ordo romanus qualiter agendum sit quinta feria in cenium*

f.123r D (8 lines) Emperor greeted by clergy: *Dum rex* (fig. 45)

f.124r E Blessing of emperor: *Ego enim* (fig. 46)

f.131v O Blessing of king: *Omnipotens*

Commentary: It is difficult to determine the precise origin of this manuscript. The decorative programme is systematic and the overall appearance of the book with its delicate borders, fine script, good quality vellum and lavish use of burnished gold indicates an important and homogeneous commission. On the other hand diverse elements are present in both the decorative vocabulary and the compositions of the historiated initials. In some of the scenes (e.g. Plate 10) the forms are finely delineated, drapery patterns relatively soft and often detailed, and the colour contrasts quite subtle. By contrast, other scenes feature the more stocky forms with large heads and heavily applied shadows and highlights that are characteristic of much Bolognese and Paduan work (fig. 46). The scene of the dedication of young boys on f.105r (fig. 44) or that of the emperor being greeted by the clergy in f.123r (fig. 45) reveals still different stylistic trends discernible even in the proportions and modelling of the figures as well as in spatial representation. M. Avril has suggested that this eclecticism may indicate a Roman workshop after the return from Avignon, when a variety of regional styles seems to have been assimilated into the city.

As the marks of ownership indicate, the manuscript at one time belonged to Sir Thomas Phillipps, who purchased it at the sale of Sir George Osborne Page-Turner in 1824. In the early twentieth century it appeared in the sale catalogue of L. S. Olschki. It was subsequently acquired by Colonel the Honourable R. A. Crouch and presented by him to the Ballarat Fine Art Gallery in 1944.

Bibliography: Sinclair (1969), pp.275–277; Sinclair (1962a), p.334; Sinclair (1968), p.17, pl. iii a–d; Olschki (1910), p.78; (Sydney, 1967), p.29, pl. xv.

Plate 11

No. 12. *Choirbook* (fragment). Latin
Venice, 1360–1370
Private collection, Armadale, Victoria

Vellum fragment of a leaf. 182 x 142. Miniature has been mounted but some lines of music are discernible through the mount on the verso.

Decoration: Historiated initial A. An enthroned king in blue tunic and red cloak with ermine cape turns and gestures sideways to a small standing youthful figure, also crowned. The latter, dressed in green, has his orange-clad arms folded across his breast. The pale pink of the initial 'A' is set against a burnished gold rectangle. The ground

within the initial is rich azurite blue patterned in white and draped by a red curtain. The contour of the initial is embellished by leaves in lighter blue and by green ornamental oval projections. White ermine trimming around the garments contrasts with the fine black silhouetted shapes of stocking feet. The throne and floor are rendered in a mellow gold-brown, and flesh tones are precisely modelled in green and grey underpaint and fine white and red highlights.

Commentary: Colour, composition and stylistic characteristics pronounce this initial to be of Venetian origin. In particular it relates closely to a series of initials in the collection of the Cini Foundation, Venice, nos. 2188–2198, attributed to Giustino del fu Gherardino da Forlì and executed after 1360. Both the style and the decorative vocabulary, including such details as the specific designs in white on the blue ground, the shape and sweep of the initial and its accompanying foliage, indicate a common atelier. Distinctive features of this style, as well as the rich contrasts of the colours and the combination of fine linear designs with firm modelling of features, are the proportions of the figures whose large and sometimes elongated heads are related to low-waisted torsos, and the blend of narrative elements in look and gesture with a certain reflective quality. A manuscript closely related to the Melbourne miniature which has been attributed to Giustino del fu Gherardino da Forlì by Levi d'Ancona contains the story of SS. Peter, Paul and Albanus and the legend of the arrival in Venice of Frederick Barbarossa and Alexander III. It is now MS.1, 383 = 1497 of the Museo Correr, Venice.[1]

This miniature was purchased by its present owners in Frankfurt in 1938. The scene may refer to David and Saul, but it has not been possible to identify the particular text it illustrates nor from what particular kind of liturgical choirbook it comes.

Note

1. For the miniatures of Giustino del fu Gherardino da Forlì see Canova (1978), pp.25–28, figs. 46–56.

Fig. 47

No. 13. *Choirbook* (fragment). Latin
Venice?, late 14c.
Private collection, North Melbourne, Victoria

Vellum fragment of a leaf. 93 x 115. Miniature has been mounted and framed, but there are a few traces of red line staves beside the initial, indicating that it was cut from a choirbook.

Decoration: Historiated initial 'V'. The three-quarter-length figure of a haloed Christ emerges from the top right-hand corner, gesturing from a starry blue circle to the group of eight figures who look up to him from below.

These latter are led by a black and white habited Dominican monk. Three of the figures wear short headdresses, coloured green, red and white and in two cases trimmed with white.

Colours of the composition are green, pink, red and blue, offset by white and flesh tones. The initial itself is orange with entwined knots and loops in green and greyish-pink and curling blue leaves. It is set against a burnished gold rectangle (fig. 47).

Commentary: This initial is possibly late fourteenth-century Venetian, to judge from the colour scheme, the manner of combining fine detailing of features with sharp white, green and red highlights, and the treatment of the headdresses. Parts such as the blue background have been slightly restored.

It was sold at Sotheby's on 12 July 1927 with two other miniatures as lot 15. Its present owner purchased it in London in 1951 from Francis Edwards Ltd.

Bibliography: Sotheby (1927), lot 15; Edwards (1951).

Plate 12, figs. 48–55
No. 14. *Book of Hours.* Use of Rome. Latin
Perugia, *c.*1375
State Library of South Australia

Vellum, 102 x 79. A–B + 208. I^{14}, II–V^8, VI6, VII–XIX8, XX4, XXI–XXIV8, XXV10, XXVI6. One quire of four folios is missing between quires VI and VII, i.e. after f. 52. This is noted by modern foliation. Catchwords agree. Modern pencil foliation begins after second folio. This is adhered to here. Script: 14c. rounded gothic hand in brown ink with rubrics and some calendar entries in red. Ruling: pale brown ink: 15.[45].19 x 10.[69].23. Lines of text: 14. Ruling unit: 5. Calendar 8.[8.3.8. 5.2].45 x 12.[67].23. Lines of text: 17. Ruling unit: 4. Edges of decoration cropped. Binding: modern red velvet.

Ownership: On f.2r is the name 'X S Andrea X' written perhaps in a 16c. hand.

Text: Latin. Contents: ff.2v–14v calendar, including St Herculanus of Perugia (1 March), St Mustiola of Chiusi (3 July), and St Zerbonius of Elba (10 October); the calendar also contains a set of verses which occur in several Italian manuscripts since romanesque times; ff.15r–52v office of the Passion and Cross; ff.57v–116r Hours of the Virgin, beginning abruptly with lauds; ff.116r–158v Vigils of the Dead; ff.161r–174v penitential psalms; ff.174v–184v litany of the saints; ff.185r–189r Hours of the Cross; ff.189v–202r votive Mass of the Virgin; ff.203r–206r, O intemerata.

Decoration: Numerous one-line initials in blue or gold flourished in red or blue appear throughout the text. Two-line gold initials with detailed flourishes in red or blue, which often extend along the border of the page, mark the

beginning of psalms etc. Double gold initials 'K.L.', four lines high, introduce the calendar pages.

One three-line decorated initial and nineteen historiated initials six lines high introduce each of the hours of the two major offices and the other main sections of the book. The initials are patterned with foliate, knotted and circle motifs, highlighted with white tracery or dotted designs. These pages all have full borders of curling, deeply serrated leaves, intertwined with stems, knots, bars and interlace, which are inhabited by drolleries, grotesques, animals and male nudes. Predominant colours for both initials and borders are blue, yellow, orange, green and pink with a lavish use of burnished gold, especially for the rectangular frames around the initials and the small schematic leaf-ends and rounded lobes, outlined in black, which are threaded through the border.

Programme of Decoration and Illustration: The historiated initials and the one large decorated initial are related to the text as follows:

f.15r D Betrayal of Christ: matins for Office of the Passion and Cross
f.21v D Christ before Pilate: lauds
f.26r D Scourging: prime
f.29r C Carrying of the Cross: tierce
f.34r D Crucifixion: sext (fig. 48)
f.39r D Death of Christ on the Cross: none (fig. 49)
f.45v D Descent from the Cross: vespers (fig. 50)
f.49r C The Lamentation: compline (fig. 51)
f.57v D Visitation: lauds for Hours of the Virgin
f.81r D Nativity: prime (fig. 52)
f.85v D Presentation in the Temple: tierce
f.89v D Adoration of the Magi: sext
f.93v D Flight into Egypt: none
f.96v D Dormition of the Virgin: vespers (fig. 53)
f.103v C Assumption: compline
f.117v D *Memento mori* – skeleton: first vespers for Vigils of the Dead
f.124v V Clerics praying over death-bed: matins for Vigils of the Dead (fig. 54)
f.161r D Christ blessing – Maiestas: penitential psalms (fig. 55)
f.189v C Virgin of Humility with book: collect for votive Mass of the Virgin
f.203r O (decorated): O intemerata

Commentary: It has been previously claimed in sale catalogues that this manuscript was produced in the papal court at Avignon, a claim resting largely on the misinterpretation of verses and entries in the calendar, which were thought to refer to the so-called Babylonian captivity of the popes at Avignon. In fact, the calendar verses were in general usage throughout Italy and their origins date to a much earlier period. The style of the illumination conforms to Perugian work of the third quarter of the fourteenth

century. Colours, border patterns, drolleries and grotesque motifs as well as the compositions of the historiated initials invite comparison with decoration in the Perugian Guild books (MS, 1, Collegio di Cambio, and MS. 21356, Collegio della Mercanzia), although the illumination of the Adelaide Hours is clearly by a different hand. Bolognese influences are also evident in this manuscript, for instance in the disproportionately large heads of the Christ Child in the Nativity on f.81r (fig. 52) and in the Presentation scene on f.85v, which magnifies the dramatic relationship or confrontation between the chief protagonists, sometimes at the expense of harmonious composition. Such characteristics, readily identifiable in Bolognese art, influenced Perugian illumination in the latter part of the fourteenth century, and Bolognese traits are evident also in the whimsical and sometimes earthy development of the border decoration. Distinctively Umbrian, however, is the colour scheme and the more finely delineated features of the figures, while compositions such as that of the Nativity, with the Virgin seated on the ground holding the Christ Child (fig. 52), or the Crucifixion scenes (figs. 48 and 49) are ultimately derived from Assisian models, by this time widely diffused throughout central Italy. The data of the calendar also, with its specific reference to St Herculanus, bishop of Perugia, and to Tuscan saints such as St Mustiola who were also venerated in Perugia, support the hypothesis that the book was destined for use in that diocese.[1]

This tiny manuscript is also of special interest because fourteenth-century Italian Books of Hours are rare outside the northern courts, where French fashions penetrated more easily. Some Bolognese and Neapolitan examples are known but the Adelaide Hours is, to date, a unique extant example of this genre in fourteenth-century Umbria.

Its programme of illustration, moreover, differs markedly from French Books of Hours. As much importance is given to the Hours of the Passion and Cross as to the Little Office of the Virgin, and both text and illustration indicate a marked Franciscan influence. The emphasis placed, for example, on the various phases of the Crucifixion, the Descent from the Cross and the Lamentation, listed in the details of the programme of illustration above (figs. 48–51), suggests familiarity with the *Meditations on the Life of Christ* by the Pseudo-Bonaventura. It is also pertinent to note that this programme relates closely to a series of late fourteenth-century Hours produced in Lombardy. Little research has been carried out to date on the origins of Italian Books of Hours, in contrast to their counterparts north of the Alps, which Leroquais has shown were frequently appended in the late thirteenth and early fourteenth centuries to psalters. There are some indications that in Italy early versions of the Book of Hours were related also to the missal. Again, in this connection, it is interesting to note that the Adelaide Hours contains a votive Mass in honour of the Virgin.[2]

Other characteristically Italian features of this manu-

script's illustrative programme are the inclusion at vespers and compline for the Hours of the Virgin of both the Dormition and the Assumption respectively, while the use of the *Maiestas* for the introduction of the penitential psalms contrasts with the French pattern of a scene from the life of David (fig. 55). The Virgin of Humility which illustrates the votive Mass in her honour is again Italian in origin.

The lush and exuberant border and the relatively large figure scale in the historiated initials, at the expense of spatial setting or attendant detail, suggest the influence of liturgical choirbooks, one of the most significant categories of Italian manuscripts for the study of illumination in this period. The clerics who feature in the death-bed scene on f.124v (fig. 54) also reflect compositions more frequently found in large monastic choirbooks (compare fig. 38). Nevertheless the illumination has succeeded in expressing a more intimate and contemplative spirit, appropriate to the private devotional prayerbook, in its dramatic emphasis on pathos, tenderness, or emotional conflict in these tiny scenes (Plate 12).

The manuscript appeared for sale in the catalogue of H. P. Kraus in 1956. It was auctioned at Sotheby's on 13 July 1977 as Lot 39. In September 1978, the Friends of the State Library of South Australia acquired it for that institution from the bookseller Alan G. Thomas.

Bibliography: Kraus (1956), pp.12–13; Sotheby (1977), pp.24–25; Thomas (1978), p. 93; Manion (1981a), pp.13–14; Manion (1982b), p.328.

Notes

1. M. Avril first suggested the probable central Italian origin of this manuscript.
2. For fourteenth-century Lombard Hours see M. L. Gengaro and L. C. Arano, *Miniature Lombarde. Codici Miniati dell' VIII al XIV Secolo*, Milan, 1970.

Plate 13

No. 15. Petrarch, *Epistolae Seniles* (fragment). Latin
Padua, late 14c.
Collection of L. F. Fitzhardinge, B.A., M.A., B.Litt.,
 Queanbeyan, New South Wales

Vellum, 340 x 235. A–B modern paper + 100 + C–D modern paper. I–X¹⁰. A quire is missing between ff. 10 and 11. Catchwords agree except between quires I and II. 16c. foliation in arabic numerals: 121–130, 141–230. Script: late 14c. Italian hybrid with gothic proto-humanist elements in black ink with red rubrics. Ruling: light brown ink in two columns of 40 lines. Binding: 18 or 19c. calf over boards. Spine has floral arabesques in blind.

Ownership: Inside front cover is the *ex-libris* of I. I. Middleton.

Text: Latin. Contents: the fragment contains Books IX to XVII of the *Seniles*. Folio 1 opens halfway through the last

letter of Petrarch to Francesco Bruni: *digniore hanc honestet eloquio....* The last ten folios of Book X are missing and the concluding section of Book XVII together with Book XVIII.

Decoration: One-line blue initials occur throughout the text. Three-line blue initials flourished in red with designs extending into the border introduce sub-sections. Eight decorated initials seven lines high introduce Books X to XVII on ff.3v[b], 11r[a], 25r[a], 40r[b], 54v[a], 68r[a] (Plate 13), 81r[b] and 96v[a].

These initials are in mauve-pink and set on squares of burnished gold. They have foliate infills of green, red and blue, with white tracery, stroking and outlines. The curving foliate shape of the initial itself extends into the border, where it is developed along two or three sides of the page. Curving, linked foliate motifs in the same colours as the initial, finely rendered, are interspersed with knots and detached gold circlets outlined in black (Plate 13).

Commentary: This manuscript is a fine example of late fourteenth-century Paduan illumination. The colours and rhythmic ordering of the border are characteristic of high-quality work produced in Padua at this period. The text fits appropriately into this provenance, providing a further instance of Petrarch's popularity in Padua and of the adaptation of decorative motifs and script proper to liturgical texts to the works of a contemporary writer.

The manuscript was sold at Sotheby's London in 1933 to P. M. Barnard, Tunbridge Wells, who the following year sold it to the father of the present owner.

Bibliography: Sinclair (1969), pp.42–43; Sinclair, (1965a), pp.323–325; Sotheby (1933a), No. 14; (Sydney, 1967), p.16.

Figs. 56–57
No. 16. *Canonical text* (fragments). Latin
School of Niccolò da Bologna, second half of 14c.
State Library of Victoria, *f096/Il. 1

Forty-six vellum fragments, approximately: 30 x 25; 25 x 25; 25 x 20; 20 x 20. Script on verso is Italian gothic in black ink. Fragments are bound with those from three other manuscripts. Binding: 19c. vellum.

Decoration: Forty-six historiated initials portray human heads and figures in various poses. The initials, ranging from three to six lines high, are usually set against rectangular grounds of burnished gold. In some cases, it is hard to identify an initial as such, as the figure composition dominates the setting. Colours are green, pink, red, blue and grey with strong use of black and white contrasts; some dark brown is employed for modelling, and flesh tones are built up in greenish-grey with pronounced white and red highlights.

The subjects of the initials are as follows: f.4r initial, man with fish (fig. 56); f.5r 'P', human head; f.6r 'P', bust of a cleric; f.7r 'P', human head; f.8r 'N', friar in profile; f.9r initial, seated maiden; f.10r 'P', female head; f.11r 'P', human head; f.12r initial with bust of youth; f.13r 'G', man's head and shoulders; f.14r initial, seated man clasping right foot (fig. 57); f.15r initial, kneeling figure with sword; f.16r initial, soldier with club and shield; f.17r 'P', human head; f.18r 'P', helmeted head; f.19r 'R', human head; f.20r 'L', head wearing cowl; f.21r 'N', bust in profile; f.22r initial, kneeling figure with arms folded; f.23r 'H', figure peering out of a window; f.24r 'S', human head; f.25r 'H', bust of a man; f.26r 'S', bust of a man; f.27r initial, bust of a man; f.28r initial, naked man, kneeling on right knee; f.29r initial, crouching man with bared buttocks; f.30r 'S', human head; f.31r 'T', tonsured head; f.32r 'P', human head; f.33r 'U', head of old man; f.34r 'H', human head; f.35r 'E', bust of a man; f.36r 'O', human head; f.37r initial, bust of a man; f.38r 'G', human head; f.39r initial, bust of a man; f.40r 'T', human head; f.41r 'S', friar's head; f.42r 'R', bust of a man; f.43r 'T', bust of a man; f.44r 'S', human head; f.45r 'G', cardinal; f.46r 'Q', human head; f.47r initial, bust of a man; f.48r 'E', bust of a man; f.49r 'O', bust of a man.

Commentary: These initials probably come from a canonical text produced by the atelier of Niccolò da Bologna. The delight in movement and caricature, combined with firm modelling and strong colour contrasts, especially to obtain effects of light and shade, is typical of this prolific workshop, and the initials find parallels in numerous intact canonical treatises. Their subject matter is a counterpart to the marginal drolleries popular so much earlier in French, Netherlandish and English work. Fourteenth-century Italian manuscripts also feature marginal drolleries; but lively comments on specific human characteristics and foibles are more markedly concentrated in this type of initial decoration regularly associated with Bolognese legal texts. The style of the initials, with the variety of poses adopted by the figures and the range of expression, indicates a date earlier in the second half of the fourteenth century than that for No. 17, where the style of Niccolò has become more formalized.

For ownership and provenance see pp.59–60.

Bibliography: Sinclair (1969), pp.343–345.

Plate 14, fig. 58
No. 17. Boniface VIII, *Book VI of Decretals* and Giovanni d'Andrea, *Glosses on Book VI.* Latin
Bologna, late 14c.
Fisher Library, University of Sydney, New South Wales, Nicholson 32

Vellum, 450 x 275. A–B modern paper + 127 + C–D modern paper. I–XII[10], XIII[7]. Catchwords agree, quire

signatures. 16c. foliation in arabic numerals. Script: late 14c. Italian gothic in black ink with red rubrics. Ruling: brown ink. Two columns of commentary varying from 80 to 86 lines frame the decretals. *Explicits* for both text and commentary occur on f.127v. Binding: 19c. calf over boards.

Ownership: On Av is a pencil note in English in a 19c. hand together with extracts from two English booksellers' catalogues; one with the entry no.87 states that the manuscript has '180 leaves of vellum'. On ff. 1r[a] and 127v[b] is the no.171; on f.1r[b] is '1/8' and on f.127v[b] is 'K/8'. Inside front cover is '366' and the book-plate of Sir Charles Nicholson, Bart., together with the note 'Presented to the Library of Sydney University by Charles A. Nicholson and Sydney H. Nicholson Aug. 1, 1937'.

Text: Latin. Contents: Commentary begins on f.1r. Text of Boniface with preface begins on f.1v.

Decoration: One- and two-line initials in blue or red, flourished alternately in red or blue, occur throughout the text. Decorated initials, two to four lines high, mark sub-sections in the manuscript. Painted in pink, they are set on square gold grounds and have simplified foliate infills in red and green on blue grounds. From ff.1r to 10v historiated initials of the same size and colouring contain heads of men or women in profile, three–quarter or full face (fig. 58).

Folio 1r contains a miniature (215 x 135) (Plate 14). Pope Boniface VIII is shown handing down his decretals in the form of a scroll to a kneeling figure on the left. A notary sits writing below him and a kneeling figure on the right also holds up a written scroll. The frontally seated pope is vested in white habit and red pallium and is attended by cardinals and other members of the curia on either side. A pink architectural canopy with frontally foreshortened sides and cusped inner blue section suggesting the starred vaulting of a church surmounts the scene. The figures are enclosed in a marble-type screen from which hangs a patterned green curtain. Beneath, the letters BONIFACIUS are executed in gold on a blue ground with red, green, grey and mauve foliate infills. The colours of the miniature are rich red, green, blue and yellow, tempered by pink and softer grey-blues and brown, with much white used in under-garments, books etc., and for highlights on drapery and faces. In the upper pyramid-shaped section, the canopy and screen projections are set against a ground of burnished gold.

Commentary: This manuscript is one of the many surviving examples of a popular canonical text produced in numerous Bolognese workshops throughout the fourteenth century. Decoration of both miniature and historiated initials is in the style of Niccolò da Bologna, although not by the master himself. The treatment of architectural details, the firm modelling and somewhat fixed and staring expression of the faces, together with their deep green underpainting and heavy red and white highlights, as well as the solid, inflexible character of figures and drapery, indicate an advanced stage of Niccolò's atelier. Thus, the book may be dated towards the end of the fourteenth century.[1]

While the style, format and programme of decoration may be compared with numerous examples held in libraries throughout the world, it is interesting to note that considerable variation obtains in the rendering of the subject matter of miniature and initials in these works. The elements in this miniature of Boniface handing down his decretals, the writing notary and two kneeling figures offering a scroll, while common to other examples, are organized here to produce maximum hierarchical effect.

The manuscript was presented to the Library of Sydney University by Charles A. Nicholson and Sydney H. Nicholson, 1 August 1937.

Bibliography: Sinclair (1969), pp.224–225; (Sydney, 1967), p.14.

Note
1. For Niccolò da Bologna and the illustration of canonical texts, see A. Melnikas, *The Corpus of the Miniatures in the manuscripts of the Decretum Gratian*, Rome, 1975; Elly Cassee, *The Missal of Cardinal Bertrand de Deux*, *A Study in fourteenth-century Bolognese miniature painting*, Florence, 1980.

Fig. 59
No. 18. *Choirbook?* (fragment). Latin
Northern Italy? late 14c.–early 15c.
State Library of Victoria, *f096/Il. 1

Vellum fragment of a leaf: 70 x 70. On the verso is a 4-line red stave with the letters '– bus gra –'. It is bound with fragments from three other manuscripts as f.3r. Binding: 19c. vellum.

Decoration: Historiated initial 'S'. A half-length bearded saint with crossed hands looks heavenwards. Colours are red, green and blue, with initial shape in pink, thickly lined with burnished gold. Washed gold is also used for highlights of drapery. In the thick beard and hair of the figure, black is used to suggest tonal contrast. It also gives some indication of light and shade in the draperies. White tracery patterns the blue ground and the leaf shape of the initial has unobtrusive white outlines.

Commentary: The strongly modelled forms of this fragment, together with the particularly expressive pose of the figure, suggest northern Italian work of the late fourteenth or early fifteenth century. Bolognese influences are present, and the initial also anticipates to some degree the style of Cristoforo Cortese as seen in the initial fragment of the Cini Collection, n.2171, fig. 73 in the catalogue of G. M. Canova.

For ownership and provenance see No. 10, pp.59–60.

Bibliography: Sinclair (1969), pp. 343–344.

Note

1. See Canova (1978), no. 73, pp. 35–36, and nos. 73 and 73a.

Plate 15

No. 19. *Psalter?* (fragment). Latin
Lombardy, 15c.
State Library of Victoria, *f096/II. 1

Vellum fragment of a leaf: 105 x 105. On the verso in a round gothic hand in black ink are the words *cythara in [cythara et voce ps]almi in tubis [ductilibus et voce tu]be cornice [iubilate in conspect]u regis domini.* It is bound with fragments from three other manuscripts as f. 1r. Binding: 19c. vellum.

Decoration: Historiated initial 'C': *The Ascension*. Christ disappears into the heavens, only his feet and lower section of his white draped form being visible against a blue sky patterned with white flowers and fine curving tendrils. Below, before a green curving landscape and pink building, are grouped the apostles, shown in varying attitudes of profile, back and front view. The upper portion of their bodies or simply heads and gold haloes emerge from the containing frame of the initial, which is pink with white-shaded foliate and tracery decoration, and is set on a square of burnished gold (Plate 15).

Commentary: This initial is clearly Lombard in style. The palette with its particular intensities of pink, blue, green and red, together with the blond tones of faces and hair, is readily identifiable. Typical, too, of Lombard work are the finely pointed features, the sharp outlines and the rather large heads of the figures in proportion to their bodies, discernible even in this partial view. The iconographical form of the Ascension with the disappearing Christ, of early medieval English origin, is widespread in Europe by this time.

Stylistically the initial can be compared with two initial-fragments depicting the Resurrection, and God appearing to a saint in a landscape, now in the collection of the Cini Foundation, Venice, nos. 2201 and 2202 (figs. 87 and 88 in the catalogue of G. M. Canova). These initials compare also in size (94 x 104 and 84 x 102) and probably came from a similar book. In addition to shared elements of style and composition, the distinctive flowers on the blue ground of the Melbourne fragment appear also on the curved forms of the letters in the Venetian initials. Professor Canova has placed the Venetian fragment in the second half of the fifteenth century. It is reasonable to date this initial therefore c. 1450.[1] For ownership and provenance see No. 10, pp. 59–60.

Bibliography: Sinclair (1969), no. 208, I, pp. 343–344.

Note

1. See Canova (1978), p. 51 and figs. 87–88.

Plate 16

No. 20. *Book of Hours*. Use of Rome. Latin
Florence, second half 15c.
Ballarat Fine Art Gallery, Victoria, MS. Crouch 2

Vellum, 115 x 80. A + B modern vellum + 248 + C + D modern vellum. I^{12}, II–XIX10, XX8, XXI–XXIV10, XXV8. Catchwords agree, quire signatures, many of which are trimmed. Modern pencil foliation. Script: 15c. Italian liturgical gothic hand in black ink, with red rubrics. Ruling: light brown ink, 14.[43].23 x 15.[65].35. Lines of text: 13. Ruling unit: 4. Calendar: [16.14.39.11] x 15.[73].27. Lines of text: 16. Binding: 19c. dark brown pigskin.

Ownership: Inside front cover is an engraved buckler with the motto ANIMO ET FIDE and the interlaced monogram EWB. On Ar in pencil is written 'Officium B.M.V. Italian Ms 15th century with five illuminated pages' and 'Ex libris R. A. Crouch'.

Text: Latin. Contents: ff. 1r–12v calendar, with feasts in red of Maria ad Nives (5 Aug.) and in black of SS. Bibiana, Pudentiana, Reparata and Zenobius; ff. 13r–102r Hours of the Virgin; ff. 103r–162r Vigils of the Dead; ff. 162v–197r Hours of the Passion; ff. 201r–214r penitential psalms; ff. 214v–226r litany, with St Reparata in red; ff. 226v–229v Hours of the Cross (*Officium parvum*); ff. 231r–244r fifteen psalms of degrees.

Decoration: One- and two-line initials alternating in red and blue occur throughout the text. They are flourished in mauve and red respectively. Five historiated initials introduce the major sections of the book. They are seven lines high except for the last, on f. 226v, which takes up six lines. These initials are painted in green, dark blue, light and dark pink on squares of burnished gold and are embellished with foliage-type scroll-work. Full borders of the tendril style surround the pages with the historiated initials. They are composed of floral motifs in green, blue and pink with large gold balls and a thickly drawn vine-like stem. In the bas-de-page of f. 13r is a blank eight-sided shield surrounded by a laurel wreath and supported by two *putti* (Plate 16).

Programme of Illustration: The scenes in the historiated initials are related to the text as follows: f. 13r 'D' Virgin and Child; matins for the Hours of the Virgin; f. 103r 'D' Death as crowned skeleton with scythe: Vigils of the Dead; f. 163r 'D' *Imago Pietatis* – suffering Christ: Hours of the Passion; f. 201r 'D' David with harp: penitential psalms; f. 226v 'P' bare cross: Hours of the Cross.

Commentary: This late fifteenth-century Book of Hours was probably executed in Florence or a smaller neighbouring centre. The old-fashioned scroll designs of the historiated initials, the unsophisticated adaptation of the contemporary 'tendril' border and the laboured figure style all

brand it as a product from an undistinguished workshop. The programme of illustration is an abbreviated version of the double-page type characteristic of many contemporary de-luxe Florentine Hours such as No. 33 (Plate 23, figs. 76–79). Iconographic themes common to both books are presented here in much more simplified form. For 'the triumph of Death' the figure of a skeleton with appropriate attributes suffices and the Pietà scene which often introduces the Hours of the Cross in Florentine Hours is replaced by the rendering of a bare cross.

The owners to whom the buckler and monogram belong have not been traced. Colonel the Honourable R. A. Crouch presented the manuscript to the Ballarat Fine Art Gallery in 1944.

Cecilia O'Brien

Bibliography: Sinclair (1969), pp.272–273; Sinclair (1968), p.14, pl. ii.

Plate 17

No. 21. Aristotle, *Ethics* (translated by Leonardo Bruni). Latin
Florence, *c.*1430–1440s
Fisher Library, University of Sydney, New South Wales, Nicholson 24

Vellum, 265 x 175. A–B 16c. paper + 120 + C–D 16c. paper. I–XII¹⁰. Catchwords agree; quire signatures. Script: formal humanistic hand in brown ink with red rubrics. Ruling: dry-point, one column of 29 lines. Binding: 16c. of thick paper with title on spine and the number '704'.

Ownership: Folio 1r contains an unidentified shield (see below). On the left of this is an effaced word which may be 'Regi' and to the right after another effaced word are the initials 'C.P.'. Inside front cover is the book-plate of Sir Charles Nicholson, Bart., together with an extract from an English sale catalogue with the number '44'.

Decoration: Twelve initials in burnished gold, each five lines high, introduce the preface on f.1r, the dedication to Pope Martin V on f.4r and each of the ten books of the *Ethics*: ff.5r, 15v, 23v, 35v, 47v, 60r, 68v, 82r, 95r, and 107r. They are decorated with white-vine and are set in grounds of bright blue, with green and faded red infills, which are patterned with gold dots. Where the white-vine projects into the border or around the frame of the initial it is outlined in blue.

On the lower margin of f.1r is a painted shield, *party per fess or and gules* embellished with white-vine decoration on a faded blue ground with red and green infills.

From the initial on f.5r (Plate 17) delicate hairline stems extend into the upper margin. They sprout small gold circlets and a blue flower. Two butterflies drawn in the same hairline technique, with painted blue and yellow wings, hover, one in the top margin attached to the blue

flower, the other in the left border at the base of the white-vine extension of the initial.

Commentary: This simple yet effective type of white-vine decoration with small curving projections into the border or around the initial frame occurs in Florentine work of the third and fourth decades of the fifteenth century. The border on f.5r (Plate 17), with the finely rendered butterflies, is an interesting example of an early inclusion of naturalistic motifs in what is still essentially an abstract scheme of decoration.

Dr A. C. de la Mare has suggested that the scribe may be Domenico Paolini, who was active in Florence at this time.

The extract from the bookseller's catalogue within the front cover probably indicates how Nicholson acquired the work. It is one of the group of manuscripts presented by the Nicholson family to the Fisher Library in 1924.

Bibliography: Sinclair (1969), pp.215–216; (Sydney, 1967), p.9.

Fig. 60

No. 22. Francesco Barbaro, *De Re Uxoria*; Plutarch (translated by Guarino da Verona), *De Liberis Educandis*; and Basil the Great (translated by Leonardo Bruni), *De Legendis Gentilibus*. Latin
Florence, *c.*1440
Fisher Library, University of Sydney, New South Wales, Nicholson 4

Vellum, 192 x 135. A–B modern paper + 128 + C–D modern paper. I–V¹⁰, VI⁸, VII–VIII¹⁰, IX⁸, X–XIII¹⁰, XIV². Catchwords agree. Script: formal humanistic hand in black ink with red rubrics. Ruling: dry-point, one column of 20 lines. Prickings in outer margins. Binding: 19c.

Ownership: Folio 34v has 'Antonius' in a 16c. hand. Inside front cover is the book-plate of Sir Charles Nicholson, Bart.

Decoration: Twelve initials in burnished gold, two or two and a half lines high on bi-coloured grounds of red and blue with fine washed gold tracery, mark sub-divisions of the first work, *De Re Uxoria*. Three gold initials, three and a half lines high, decorated with white-vine, mark the major divisions of this text on ff.4v, 14v, and 18v.

Four gold initials, four lines high, also decorated with white-vine, introduce *De Re Uxoria* on f.1r; *De Liberis Educandis* on f.82r; Bruni's preface to his translation of *De Legendis Gentilibus* on f.111r (fig. 60) and the translation itself on f.112v. All seven initials decorated with white-vine have faded red and green infills and are set on blue grounds. Small gold dots in clusters of three pattern both infills and grounds.

Commentary: Dr A. C. de la Mare has identified the scribe of this manuscript as Giovanni da Stia, who was active in

Florence *c.*1438–1465. The bold yet finely modelled white-vine and the rich, intense colours of the initial decoration are characteristic of Florentine humanistic book illumination at this time.

The manuscript was presented to the Fisher Library in 1924 by the Nicholson family.

Bibliography: Sinclair (1969), pp.180–182; (Sydney, 1967), p.18.

Plate 18, fig. 61

No. 23. Leonardo Bruni, *History of the Florentine People.*
 Latin
Florence, 1465
Fisher Library, University of Sydney, N.S.W., Nicholson
 15

Vellum, 345 x 235. A 18c. paper + B contemporary vellum + 204 + C contemporary vellum + D 18c. paper. I–XIII¹⁰, XIV⁸, XV–XX¹⁰, XXI⁶. Catchwords agree, quire signatures. Foliation in contemporary red arabic numerals. Present fly-leaves B and C are 15c. fragments of a commentary on Aristotle's *Ethics.* Script: formal humanistic hand in brownish-black ink with red rubrics. F.203r has *explicit: Leonardi Arretini historici aeloquentissimi historiarum populi Florentini liber duodecimus et ultimus foeliciter finit ab Amerigo Corsino transcriptus anno domini M°CCCC°LX°IIII° menso februario summo pontifice paulo.* Ruling: dry-point, one column of 36 lines. Binding: 18c. russia.

Ownership: Inside front cover is the book-plate of Augustus Frederick, Duke of Sussex and the number, VI-E.a.14. Inside both front and back covers is the book-plate of Sir Charles Nicholson, Bart.

Decoration: Twelve burnished gold initials, six lines high, introduce the books of the *History* on ff.2r, 17v, 38v, 53v, 76v, 100r, 119v, 136r, 156v, 172v, 182r, and 195v. They are enclosed in white-vine decoration and set against grounds of bright blue with pink and dark green infills, patterned with small gold dots in clusters of three. The curling white-vine is tinted in places with yellow.

A decorative border and one historiated initial (60 x 55) introduce the preface on f.1r (Plate 18). The border which encloses the text on three sides is composed of fine, symmetrically ordered twining green stems interspersed with foliate and floral motifs together with birds, tiny winged *putti*, vases and gold circlets with hairline extensions. In the centre of the lower margin four small winged *putti* hold a gold circle which bears traces of a metal stamp, although the surface has been erased. The predominant colours are delicate shades of pink, blue, green, yellow and gold with touches of brown and light red.

The elaborately decorated initial on f.1r contains in its centre a three-quarter-length portrait of the author, Leonardo Bruni. He is crowned with a laurel wreath and holds before him an open book.

Commentary: At least three other manuscripts have been assigned to Amerigus Corsinus, the scribe who signed this manuscript. He and his older brother Philippus, who also transcribed classical texts, were active in Florentine humanist circles in the second half of the fifteenth century. Dunston has argued that this particular manuscript may be a precocious work executed when Amerigus was only thirteen years old. This would not be exceptional, since Florentine scribes often learnt their trade at an early age.

The decoration, both of border and initials, is of a high standard and is characteristic of the school of Francesco d'Antonio del Chierico, active in Florence from *c.*1452 to 1484. This illuminator was instrumental in bringing about the transition from the simple white-vine decoration of Florentine classical texts to the 'tendril' type of border and initials: a more ornate and colourful style encompassing both naturalistic and classical motifs which had completely supplanted the white-vine by the last quarter of the fifteenth century. This manuscript is a good example of the mid-phase of this development, containing as it does finely wrought white-vine initials of mature style (fig. 61) in combination with the newly introduced 'tendril' border (Plate 18).

Del Chierico was usually responsible for more sumptuous and comprehensive decorative programmes, such as in the Medici *Aristotle* (MS. Laur.Plut. 71,7), and the figure style of the portrait in the historiated initial on f.1r of our manuscript lacks the refinement of his usually delicate facial modelling. It suggests the hand of an assistant or associate rather than that of del Chierico himself.

The *explicit* gives the date according to the Florentine calendar; therefore the work was actually completed in 1465. The family of Sir Charles Nicholson presented the manuscript to the Fisher Library in 1924. Nicholson seems to have purchased it from H. Bohn in the 1850s. Bohn, in his turn, had acquired the book in 1844 at an auction by Evans of part of the library of the Duke of Sussex, sixth son of King George III. The manuscript's provenance cannot be traced back beyond the Duke, whose armorial book-plate, together with presumably his library press-mark, are still preserved inside the front cover.

Bibliography: Sinclair (1969), pp.196–198; (Sydney, 1967), p.15; Dunston (1968), pp.46–50, pls. 11–13.

Fig. 62

No. 24. Aeneas Silvius Piccolomini, *De Liberorum
 Educatione.* Latin
Naples, second half of 15c.
Fisher Library, University of Sydney, New South Wales,
 Nicholson 6

Paper, 228 x 165; watermark is a bird in a circle. A–B modern paper + 58 + C modern paper. I–V¹⁰, VI⁸. Catchwords agree; a few quire signatures. Foliation in

ARISTOTELIS ETHICORVM · LIBER · PRIMVS INCIPIT

OMNIS ARS. ONIS q; doctrina. similiter
autem & actus a̅ lecto bonum quoddam appe
tere uidetur. Qua pp bene ostenderunt summū
bonum: quod omnia appetunt. Videtur aute̅
inter fines differentia quedam. Alij nanq; su̅t
operationes. Alij preter eas opera aliqua. Quo4 uero fines
sunt aliqui preter actiones. in ijs potiora sunt opera q̅ ope-
rationes. Sed cuom multi sint actus & artes & scientie.
fit & ut multi sint fines. Nam medicine quide̅ sanitas
Hauicularie uero nauigium. Rei militaris aut uictoria.
E conomice uero diuitie. Quot aut sunt huiusmodi subuna
aliqua uirtute. quemadmodum ars freno4 faciendorū
& alie omnes que ad structuram equo4 pertinent. sub
equestri consistunt: Ipa̅ uero equestris & omnis bellica +
actio sub re militari: Eodemq; modo alie subalijs. Itcuin
ctis autem fines ea4 que magis principes sunt. omnibus
inferioribus sunt ante ponendi. Nam illo4 gratia istos
persequimur. Nihil autem refert utrum operationes ip̅e
fines sint actiuum: uel preter ipsas aliud quiddam. quem
admodum inijsque appellantur scientie. Sигitur agibili-
um finis quispiam est quem pp seip̅m uelimus. alia uero
ppillum. nec o̅mia pp aliud optamus. nam sic ininfinitu
esset progressus. uanaq; & stulta resultaret cupiditas. ma-
nifestum est id esse summ bonum & optimum. Atq; hu
ius nimi4 cognitio aduitam nostram multum conferret.
ac uelut sagitarij signum habentes. facilius quod oportet

Plate 17. Initial 'O'. No. 21, f. 5r. 265 x 175

Plate 18. Title page. No. 23, f. 1r. 345 × 235

Plate 19. Title page. No. 26, f. 1r. 272 x 186

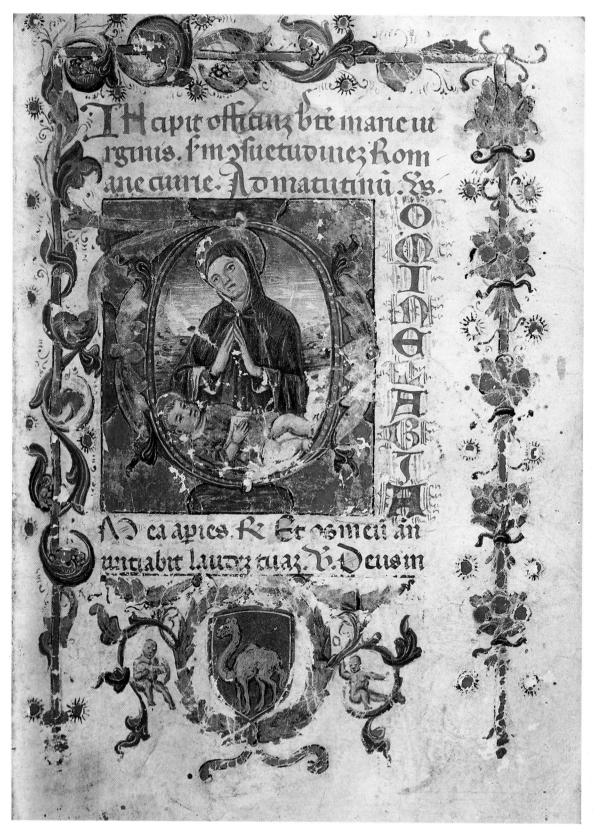

Plate 20. Virgin and Child. No. 27, f.1r. 154 x 110

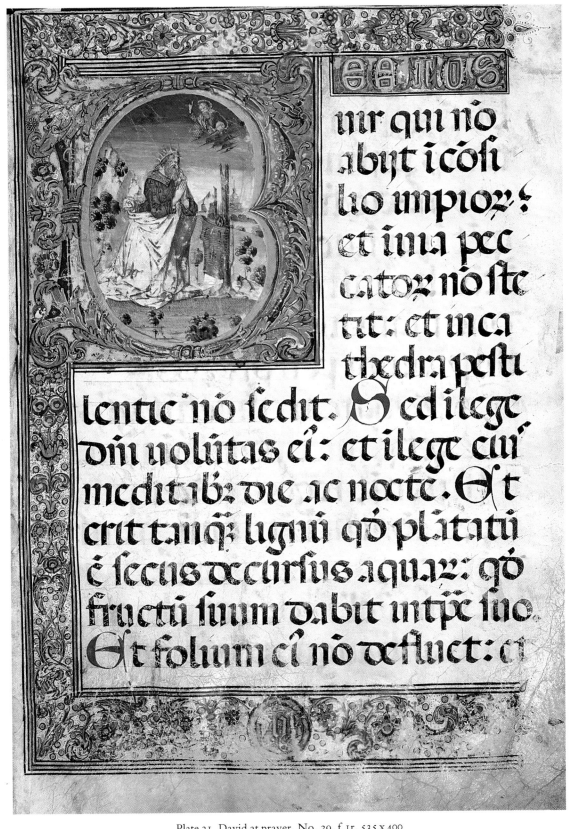

Plate 21. David at prayer. No. 29, f. 1r. 535 x 400

RIGO IMPERATORIS HA-
DRIANI VETVSTIORA
PICENTIBVS POSTERI
or ab hispanensibus manat. siquidem hadria
ortos maiores suos apud italiam Scipionum
temporibus resedisse. in libris uite sue Ha
drianus ipse commemorat. Hadriano pater Aelius Adrianus cogno
mento afer fuit. consobrinus Traiani imperatoris. mater Domitia
Paulina gadibus orta. soror Paulina nupta Seruiano. uxor Sabina
atauus Marillinus qui primus in sua familia senator populi romani
fuit. Natus est rome nono klendas februarias. Vespasiano septies
& Tito quinquies consulibus ac decimo ætatis anno patre orbatus.
Vlpium Traianum pretorium tunc consobrinum suum qui postea impe
rium tenuit. & Celium Tacianum equitem romanum tutores habuit
imbutus que impensius grecis studiis ingenio eius sic ad ea declinante
ut a nonnullis greculus diceretur. Quintodecimo anno ad patriam re
diit ac statim militiam iniit uenando usq. ad prehensionem studiosus
Quare a Traiano abductus a patria & pro filio habitus. nec multo post de
cemuir libus iudicandis dans atq. inde tribunus secundæ adiutricis
legionis creatus. Post hoc in asteriorem Moesiam translatus extremis
iam Domitiani temporibus ibi a mathematico quodam de futuro impe
rio id dicitur compertisse quod a patruo magno Aelio Hadriano peri
tiam celestium callente predictum esse compererat. Traiano a Ner
ua adoptato ad gratulationem exercitus missus germaniam superio
rem translatus est. ex qua festinans ad Traianum ut prius nuntiaret
excessum Neruæ a Seruiano sororis uiro qui & sumptibus & dare ei
alieno eius obuolato Traiani editum in eum mouit. diu deteritus fractoq.
consulte uehiculo tardatus pedibus iter faciens eiusdem Seruiani bene
ficio ad Traianum ante uenit. fuitq. in amore Traiani. nec tamen ei per
pedagogos puerorum quos Traianus impensius dilogebat. gallo fauente ei
defuit. Quo quidem tempore cum solicitaretur de imperatoris erga se

Plate 23. David at prayer. No. 33, f. 107v. 147 x 100

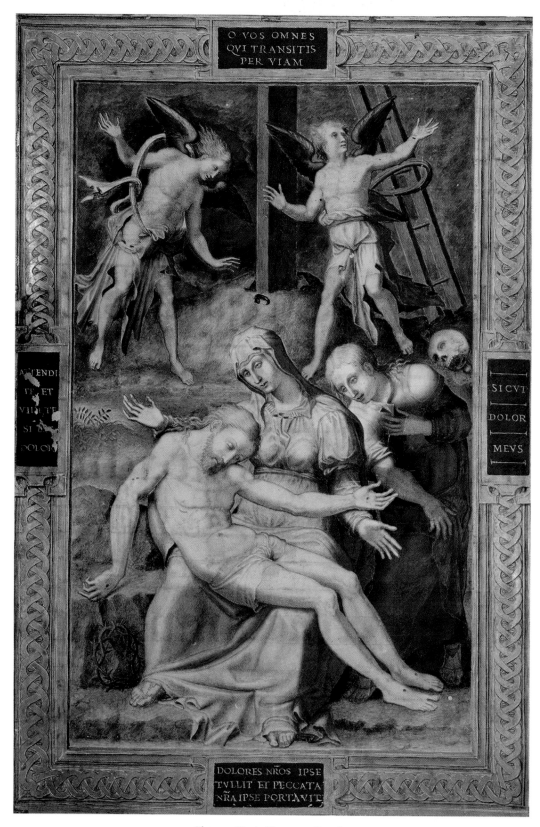

Plate 24. Pietà. No. 34. 248 x 165

contemporary arabic numerals. Script: humanistic hand with rapid elements in black ink. Ruling: dry-point, one column varying from 25 to 30 lines. Binding: 19c.

Ownership: Folio 1r has a coat-of-arms in middle of lower margin (see below). Inside front cover is the book-plate of Sir Charles Nicholson, Bart.

Decoration: Folio 1r (fig. 62) has a gold initial 'S' about five lines high which is decorated with white-vine on a green and red ground. The text on this opening page is framed by a white-vine border outlined on three sides in gold and in black ink. On the right margin, the border is less structured, consisting of curving extensions of the white-vine from the top and lower borders. Gold studs punctuate this right-hand border, and a large, rather gaudy green parrot inhabits its centre. The coat-of-arms set in the lower margin is a shield *quarterly, 1 and 4 sable* [actually grey] *with cross azure, 2 and 3 paly of four being or, sable* [actually grey] *argent, sable.*

Commentary: The style of the initial and decorative border on f.1r is late fifteenth-century Neapolitan. While Tuscan, Paduan-Roman and Franco-Flemish decorative motifs were all absorbed into Neapolitan workshops, the Florentine humanist white-vine style is the dominant model for this manuscript. It is handled here, however, with less subtlety, and the studs and tail-pieces are bolder, than those found in contemporary Florentine work. The parrot in the border is a favourite motif of Neapolitan illuminators. The coat-of-arms in the lower border is Aragonese; but it does not accord exactly with any of the family versions reproduced by de Marinis in *La Biblioteca napoletana dei re d'Aragona*, Milan, 1947–1952.

Bibliography: Sinclair (1969), pp.183–184; (Sydney, 1967), p.19.

Fig. 63

No. 25. Cicero, *Epistulae ad familiares.* Latin
Milan, *c.*1470
Australian National University, Canberra. Classics
 Department Museum, 77–06

Vellum, 292 x 200. A + B vellum + 190 + C + D vellum. I–XIII⁸, XIV², XV⁴. Catchwords agree. Early foliation omitting ff.73 and 77. Script: 15c. Italian humanist round in dark brown ink with red ink headings. Ruling: dry-point, one column of 32 lines. Binding: 19c. red morocco gilt which incorporates 17c. Parisian red morocco gilt binding bearing the arms of Anne of Austria.

Ownership: In the lower margin of f.1r is an erased coat-of-arms flanked by the initials IO and FR. On f.27v is an inscription by a 16c. schoolboy, *Carolus de bovis* and *bonus puer.* 16c. scribbles and names appear on ff.6r, 105r, 124v, 178r and v. Inside the front cover is the book-plate of Sir

Thomas Phillipps with his arms, inscribed 'Sir T.P./ Middlehall No.917'. On f.Av in 19c. pencil is 'Celotti, Thorpe': and 'Saec 15'.

Decoration: One-line initials are in red ink. There are numerous two-line initials in blue or burnished gold flourished with purple or red ink. The first book is prefaced on f.1r by an eight-line 'E' initial in burnished gold on white-vine infilled with red, green and blue. The next fifteen books are introduced by seven-line burnished gold initials with white-vine. Folio 1r has a full border of ink hairline sprays incorporating gold trefoil leaves, acorns, pine cones and strawberry-like fruits (fig. 63). The upper section contains a silver IHS monogram, and the lower one an erased coat-of-arms surmounted by an eagle standing on a pile of books and holding a silver scroll in its beak.

Commentary: The manuscript's decoration, with its combination of white-vine initials and fine hairline flourishing in the borders, is typically Milanese. It has been noted that in style its illuminations resemble those in known works of the Ippolita Master who was active in Milan in the last half of the fifteenth century.[1]

The manuscript has suffered damage at the hands of a class of sixteenth-century schoolboys who dampened all of the large initials and many of the smaller ones in order to obtain offsets on adjacent pages. Although unfortunate, the damage serves to remind us of the pre-eminent place given to Cicero's letters in the humanist curriculum of the time.

Because of the erasure of the original arms and the peculiarly Milanese custom of recording the initials of the two Christian names rather than those of the Christian name and surname, the manuscript's original owners have remained unidentified. Abatè Celotti sold the manuscript at Sotheby's on 14 March 1825, and it has been suggested that this manuscript was among those purchased by the dealer from the Bossi family of Milan. On that occasion it was bought by Thorpe, who sold it to Sir Thomas Phillipps. It was no. 917 in that collection and was subsequently auctioned at a Phillipps sale at Sotheby's on 28 November 1967, when it was bought by Maggs. On 13 July 1977 it was again auctioned at Sotheby's, when it was purchased by the Classics Department of the Australian National University, Canberra.[2]

Cecilia O'Brien

Bibliography: Sotheby (1977), p.55; Green (1981), Entry 77-06, p.123 (contributed by Dr Valerie Flint).

Notes
1. Sotheby (1977), p.55. See also E. Pellegrin, *La Bibliothèque des Visconti et des Sforzas Ducs de Milan*, Florence and Paris, 1969, pl. 154 (Turin Bibl. roy. MS. Var. 75, c.1476).
2. Sotheby, *op. cit.*

Plate 19
No. 26. Leonardo Bruni, *La Prima Guerra Punica*
 (anonymous translation). Italian
Veneto, 3rd quarter of 15c.
Fisher Library, University of Sydney, New South Wales,
 Nicholson 9

Paper, 272 x 186; watermark is three hills with a cross. A
18c. paper + 64 + B 18c. paper. I–VIII⁸. Catchwords
agree. Foliation in contemporary arabic numerals. A
gathering is missing between the first and second quires.
Script: formal humanistic hand in dark brown ink with red
rubrics. Ruling: dry-point, one column of 28 lines. Bind-
ing: old calf.

Ownership: Folios 1r and 64b have in a 16c. hand *Est fratris
fabali de Laude (& Amicorum eius Ego sum)*. An extract from a
19c. bookseller's catalogue on Ar mentions that the manu-
script belonged to the late T. S. Walker. Inside front cover
is the book-plate of Sir Charles Nicholson, Bart. A shield
with a coat-of-arms, flanked by initials, appears on f. 1r (see
below).

Decoration: Four initials of burnished gold, eight lines
high, enclosed in white-vine decoration, with infills of
green and deep pink, and blue grounds, patterned with
yellow dots, usually in clusters of three, mark the opening
and major sections of the text on ff. 1r, 2r, 17v, and 37v.
 A decorative border which develops from the pattern of
the initial partially fills the left margin of f. 1r. At the base of
f. 1r two winged *putti* hold a shield, *party per fess nebuly sable
and argent*, on a deep blue ground with green fronds. Gold
initials 'G' and 'C' flank the shield, one on either side (Plate
19).

Commentary: The decorative elements of this manuscript
indicate a north Italian workshop. The *putti* with their
elongated bodies have a Paduan flavour, and the white-vine
decoration is more three-dimensional than that which
characterizes contemporary Florentine work. The way in
which natural foliage seems to sprout from the vine is also
common to several manuscripts known to have been
executed in Padua. Dr A. C. de la Mare notes that the script
accords with products of the Veneto region. The coat-of-
arms has not yet been satisfactorily identified.
 The extract from the nineteenth-century sale catalogue
indicates that before the book was acquired by Sir Charles
Nicholson it had belonged to T. S. Walker, whom Sinclair
has identified as Thomas Shadford Walker (184?–1886), a
Liverpool doctor and bibliophile. It is one of a group of
manuscripts presented by the Nicholson family to the
Fisher Library in 1924.

Bibliography: Sinclair (1969), pp. 187–188; (Sydney, 1967),
p. 15, pl. iv.

Plate 20
No. 27. *Book of Hours*. Use of Rome. Latin
Ferrara, second half of 15c.
National Library of Australia, Canberra, Clifford
 Collection MS. 1097/6

Vellum, 154 x 110. A old vellum + 141 + B old vellum. I–
III⁸, IV⁶, V–VII⁸, VIII¹⁰, IX⁷, X–XIV⁸, XV⁶, XVI–XVIII⁸.
Catchwords agree, some quire signatures. Folio 141r is
blank. Script: Italian gothic liturgical hand in black ink with
red rubrics. Ruling: brown ink, one column of 14 or 15
lines. Binding: 18c. mottled calf.

Ownership: On f. 141v in a late 15c. hand almost washed
out is a prayer, *Oratio post divinum officium*. There is also an
illegible signature on this page and erasures on ff. 9r, 17r,
22v and 55r. Inside back cover in a 19c. hand is 'No. 30'.
Inside front cover are the words: 'Mary E. Kavanagh left
this book to her nephew Lord Clifford 1898'.

Text: Latin. Contents: ff. 1r–40v Hours of the Virgin with
the rubric *secundum consuetudinem Romane curie*; ff. 14v–53r
variations of the Hours; ff. 53r–62r penitential psalms;
ff. 62v–69v litany, including SS. Bernardine, Clare and
Elizabeth of Hungary; ff. 70r–96v Vigils of the Dead;
ff. 96r–100r Hours of the Cross; ff. 100v–103v prayers in
honour of Christ and the Virgin; ff. 104r–112r votive Mass
in honour of the Virgin with various commemorations,
including SS. John the Baptist, Mark, various apostles, SS.
Anthony of Padua, Francis and Bernardine of Siena;
ff. 112v–140v various prayers.

Decoration: One-line red and blue initials alternate
throughout the text; some black initials are touched with
yellow. In the section containing various prayers, between
ff. 112r and 140v, initials one and two lines high are
flourished blue with red or red with pink. Nine decorated
initials eight lines high were designed to preface the Hours
of the Virgin from lauds on, the penitential psalms and the
Hours of the Cross. These are, however, unfinished.
 An historiated initial of the Virgin and Child, ten lines
high, introduces the Hours of the Virgin on f. 1r (Plate 20).
 This is an elaborately decorated page framed by a fine
rectangular gold border on three sides entwined with
slender curling acanthus leaves along the left and upper
margins and small ribboned nosegays of flowers and foliage
on the right. The historiated initial is set against a ground of
burnished gold and red, and in the lower margin an azure
shield with a camel, once gold, is enclosed within a laurel
wreath. Two small *putti* sit within the curving leaf fronds
which extend from the wreath.
 Colours in both the historiated initial and the border
decoration are consistent; lilac, blue and green predomi-
nate; flesh tones are a warm muddy brown. In the
landscape setting to the image of the Virgin and Child
green pales to yellow, and the blue sky softens to a filmy
white towards the horizon.

Commentary: The saints commemorated in the votive Mass and in the litany of this manuscript indicate Franciscan influence. This is not, however, unusual in Italian Books of Hours and does not necessarily indicate Franciscan patronage. The inclusion of St Bernardine of Siena (canonized 1450) confirms the stylistic evidence for a date for the decoration of the manuscript in the second half of the fifteenth century.

Both colour and decorative elements on f.1r indicate Ferrarese influence, although it is not possible to state with certainty the precise origin of the work. The particular devotional image of the Virgin praying with raised hands over a recumbent Christ Child stretched out on her lap, which has anticipatory overtones of the Pietà theme, seems to have been favoured especially in the northern courts of Italy.

The National Library of Australia acquired the manuscript from the Clifford family in 1964.

Bibliography: Sinclair (1969), pp.27–30.

Fig. 64
No. 28. *Psalter*. Latin
Central Italy?, second half 15c.
State Library of New South Wales, Dixson 38/1

Vellum, 135 x 100. A 17c. paper + 78 + B–H, 17c. paper. I–IX⁸, X⁶. Catchwords agree. Foliation in pencil in arabic numerals. Script: 15c. Italian liturgical gothic with cursive elements in black ink with red rubrics. Ruling: light brown ink: 22.[31].7.[31].9 x 13.[90].32. Lines of text: 28. Ruling unit: 3.2. Binding: 17c. black pigskin over boards.

Ownership: On Av in a 17c. hand is *Questo salmista e del luogo di santo juliano del'Aquila.* On Hv is '94' in same hand. Inside front cover is the book-plate of Sir William Dixson.

Text: Latin. Contents: f.1r–1v invitatories and hymns for the Sundays of the year from the second Sunday after the Epiphany to Septuagesima and from 1 October to Advent; ff.1vᵃ–64vᵃ psalter; ff.64vᵃ–66vᵃ litany, including SS. Francis, Anthony of Padua, Bernardine of Siena (1380–1444, canonized 1450), Clare and Elizabeth of Hungary; ff.66vᵃ–78vᵃ hymnal, including hymns for the feasts of SS. Clare and Francis, the Stigmata, Transfiguration and Corpus Christi.

Decoration: One-line versal initials alternating in blue and red occur throughout. Two-line initials introduce psalms, hymns, prayers etc. Thirteen initials, eight lines high, in gold, blue or red are set in large rectangles finely flourished in red or blue. The flourishes extend into the vertical margins, or columns. These initials mark the main divisions in the liturgical psalter and introduce the hymnal. They occur on ff.18rᵃ, 24rᵇ, 29vᵃ, 34vᵇ, 42rᵃ, 48rᵃ, 55vᵇ, 57rᵇ, 58rᵃ, 58vᵇ, 59rᵇ, 61rᵇ and 66vᵃ.

Two decorated initials (30 x 30) introduce the invitatories

on f.1rᵃ and Psalm 1, *Beatus vir*, on f.1vᵃ (fig. 64). They have pink shafts with leafy fronds of rich green and blue which extend into the border and are set against heavily burnished gold grounds which also develop into a border along part of the vertical and lower margin. The initials have floral, bud and foliate infills in pink, green and red on deep blue grounds. The border sprays terminate in gold leaves and circlets. A parrot of the same bright colours perches on the top of the border on f.1vᵃ (fig. 64).

Commentary: The saints in the litany and special feasts honoured in the hymnal indicate that this psalter was made for Franciscan use. As in No. 29, the psalms are arranged here for recitation in the Divine Office and are accompanied by the appropriate rubrics, hymns, responses, antiphons etc. This book, however, small in size, would have been read by one person and not placed on the lectern for shared and public use. Although its decoration is restricted, the manuscript is a fine production. Its vellum is soft and absorbent; script, layout and calligraphic flourishing are executed with skill and care. The colourful and somewhat flamboyant style of the two decorated initials provides an effective and striking introduction to the otherwise restrained work.

The note on Av indicates that the manuscript was in San Juliano in Aquila in the Abruzzi in the seventeenth century. It seems to have received a catalogue number at that time and the binding also probably dates from this period. Nothing is known about the book's earlier provenance; its decoration would be consistent with a central Italian, perhaps Abruzzese, provenance.

A letter deposited with the manuscript dated 11.4.1922 from Messrs Angus and Robertson, booksellers of Sydney, states that it was purchased from Messrs Henry Stevens, Son and Stiles, London. It was subsequently acquired by Sir William Dixson, who bequeathed it to the State Library of New South Wales in 1952.

Bibliography: Sinclair (1969), pp.99–100, and (1964a), p.377.

Plate 21, fig. 65
No. 29. *Psalter* (fragment). Latin
Ferrara?, late 15c.
State Library of New South Wales, Mitchell, D.89

Vellum, 535 x 400. A modern paper + 30 + B modern paper. I⁶, II⁴, III–IV¹⁰. Folios 1–10 are misbound and should read ff.7–8, 1–6, 9–30. Catchwords agree except between quires II and III. Vellum labels mark the outer edges of certain folios. Script: 15c. Italian liturgical gothic in black ink with red rubrics. Ruling: brown ink: 47.[203].60 x 47.[364].124. Lines of text: 15. Ruling unit: 24. Binding: modern brown buckram folder.

Ownership: Inside front cover is '497'.

Text: Latin. Contents: a fragment from a conventual psalter with psalms ordered according to the Divine Office and accompanied by antiphons, responses and rubrics for particular hours or nocturns etc. They are prefaced by invitatories, and hymns for matins on ff.7–8 (originally ff.1–2). Folio 7r also contains the following *incipit: In nomine domini nostri ihesu christi et gloriose virginis marie et ad honorem sancti francisci et sancti antonii. Amen.*

Decoration: Simple one-line red and blue versal initials occur alternately throughout the text. Black initials are often quite elaborately developed and pen-flourished (fig. 65). Five decorated initials three to four lines high introduce hymns and psalter divisions. The shafts and bodies of the capitals are richly elaborated with curving foliate forms, and their interstices contain floral and interlace motifs (fig. 65). The initials are set on gold square or rectangular grounds, and are coloured blue, mauve, green and red, with white tracery and black and white outlines and shading. The grounds within the initials vary from gold to deep blue and black.

On f. 1r the opening psalm *Beatus vir* is introduced by a historiated initial (190 x 165) showing David at prayer in a landscape (Plate 21). The page is further embellished by the decorative treatment of the remaining letters of the word *Beatus*. These are rendered in the colours and style of the larger decorated initials of the manuscript and are set against a gold panel. A rectangularly framed border extends around three sides of the page. It is composed of tendril and floral motifs interspersed with gold circlets. A wreath in the centre of the lower margin contains the monogram YHS. Colours for the border and historiated initial accord with those of the decorated initials although the landscape scene is appropriately treated with greater subtlety in the rendering of colour gradations.

Commentary: This manuscript, now showing signs of much wear, and too fragmentary to warrant detailed treatment of its decorative programme, must have originally formed part of a richly decorated psalter designed for use in the communal recitation of the Divine Office. Sinclair has noted that the *incipit* with its reference to SS. Francis and Anthony suggests that the book was originally destined for a Franciscan house. The style of the initials and border decoration, especially the motifs of heavy round floral clusters and ribbon-interlace, together with the richly contrasting blue, black and gold grounds, indicates a Ferrarese origin although these devices were widespread by the late fifteenth century. Nor does the style of the historiated initial establish the provenance of the manuscript with great precision. The figure of David is amply modelled with a firm *contrapposto* twist and the illuminator is also able to render the landscape with an assured sense of recession, producing a hazy distance and a sky lightening towards the horizon. At the same time he preserves the convention of gold-tipped coulisse bunches of foliage

around the kneeling David who dominates the scene. These features indicate production at a well advanced stage of the fifteenth century, probably some time during the last three decades, although they provide no special clue to a particular workshop.

The number '497' within the front cover of the psalter refers to its place in J. T. Hackett's collection. It was sold at auction in 1918 and acquired by the State Library of New South Wales, where it forms part of the Mitchell collection.

Bibliography: Sinclair (1969), p.124; Sinclair (1964a), p.376; (Sydney, 1967), p.23; (Hackett, 1918), pp.50–51.

Figs. 66 and 67
No. 30. *Choirbook* (fragments). Latin
Northern Italy, late 15c.
Baillieu Library, University of Melbourne, Victoria

Two vellum fragments of leaves, 68 x 90 and 78 x 90 of historiated initials, 'L' and 'I' respectively (figs. 66 and 67). On the verso of each fragment are sections of four-line staves of music with black square notation.

Decoration: Both initials are in mauve with white tracery and circlet designs. They have olive-green bands which in the case of the 'I' develop into an acanthus-type capital surmounting the column formed by the initial. They are set within frames of burnished gold, outlined in black. The subjects of the initials are: 'L', martyrdom of St Lawrence (fig. 66); 'I', standing group of saints including a mitred bishop with crozier, and St Bernardine of Siena (fig. 67), identified by the symbol of a rayed sun on his breast, and holding a cross. All the men saints seem to hold books. The women are less obtrusive; the figure in red could be St Mary Magdalen.

In both scenes blue, red and green predominate with light flesh tones being used for faces, hands and the naked body of St Lawrence on the gridiron. Black and gold are effectively used for contrasts, together with white for the modelling of drapery folds, beards etc. In the landscape setting of the martyrdom scene, varying shades of green and blue, lightened with white, contrast with the more strongly defined colours of the protagonists, and give some sense of aerial perspective.

Commentary: These fragments, plainly cut from the same choirbook, are North Italian in style. The proportion of the figures with their large heads in relation to the size of their bodies, and the many French elements of the landscape such as winding paths, distant turreted vistas and white-lined blue clouds suggest Lombard work. The scene in the initial 'I' probably refers to a feast for a group of saints, possibly All Saints. St Bernardine of Siena (canonized 1450) is the only one who is clearly identifiable. A date in the last quarter of the fifteenth century is indicated.

The fragments were acquired by the Baillieu Library from the English bookseller Alan G. Thomas in 1974.

Bibliography: Thomas (1973).

Plate 22, figs. 68–74

No. 31 *Scriptores Historiæ Augustæ*; Eutropius, *Breviarium ab Urbe Condita* (translation and additions by Paul the Deacon); Paul the Deacon, *Historia Romana*. Latin

Florence, *c.*1479

State Library of Victoria, ⋆f096.1/Au4

Vellum, 378 x 250. A contemporary vellum + 216 + B contemporary vellum. I–XXI¹⁰, XXII⁶. Catchwords agree. Quire signatures, many of which are trimmed. Pagination in 16c. hand. Prickings for vertical margin-rulings appear at the top of most folios. Script: Florentine 15c. formal humanistic hand in black ink. Ruling: dry-point: 41.8.[123].8.7ó x 42.7.[236].7.86. Lines of text: 36. Ruling unit: 7. Binding: 15c. Italian. Red morocco on wooden boards. Blind tooled in five panels of interlace cable patterns.

Ownership: The arms and devices of the Medici appear in the borders of the title page on f.1r (Plate 22, see below). Written in a 16c. hand inside front cover is '269', combined with two pieces of sealing wax impressed with the arms: a shield with mantel surmounted by a crown and blazoned *quarterly and 4 with six palle, 2 and 3 per pale a plain cross and a two-headed splayed eagle, over all a shield per pale, the sinister also per pale, the dexter indistinct*, surmounted by a papal tiara and ombrellino. Written inside the front cover in Sir Thomas Phillipps's hand in pencil is 'The paintings are supposed to be done by Julio Clovio, Lucca sale 1671 Sotheby July 18, 1825. Payne Feb. 1826. 566.' and 'the arms at the bottom of the 1st page of the Volume are I believe those of the Medici family.' The fly-leaf is marked, 'Thos. Phillipps/Middle Hall/1828'. Underneath is his lion rampant with the legend 'Sir T. P./Middle Hall/2163 a2. 902.' On the spine is his number '2163'.

Text: Latin. Contents: ff.1r–159r *Scriptores Historiæ Augustæ*; ff.159v–195v Eutropius, *Breviarium ab Urbe Condita*, which includes – f.159v Dedicatory letter of Eutropius to Valens; f.160r *Primus in Italia . . .*, addition by Paul the Deacon to first book, followed by the first book of Eutropius proper; ff.196r–213r Paul the Deacon, six books of *Historia Romana*; f.213r has the colophon *Anno ab incarnatione domini MᵒCCCCᵒLXXᵒVIIIᵒ et XXIᵃ Ianuarii opus hoc celeberrimum ruri apud florentiam consumatum est die autem Iovis hora vero diei XXIᵃ. Laus honor imperium et gloria sit omnipotenti Ihesu cristo per infinita seculorum secula. AMEN. OMNIUM RERUM VICISSITUDO EST*; ff.214r–215v 16c. Index.

Decoration: Rubrics are in red ink capitals one line high. Sub-sections are headed by two-line burnished gold initials on square grounds divided into red, green or blue sections patterned with fine gold filigree.

Eighty-one historiated initials occur throughout the text at the beginning of each chapter. Except for the 'O' on f.1r (fig. 68) which is 60 x 50, they are all of standard size, namely six lines high. Each initial follows the shape of fairly stolid roman capitals. Modelling and shading are attempted, with each initial being executed in two different colours, which helps to give an illusion of three-dimensionality. Colour combinations include emerald-green and gold, light and dark blue, and red and blue. Most of the grounds on which the initials are set are highly patterned burnished gold. A few have grounds of divided colour with gold filigree work similar to that employed for the smaller decorated initials.

The title page f.1r (Plate 22) has a magnificent three-sided border inhabited by numerous winged *putti*. At the top of the left-hand section of the border stands a long-haired angel dressed in violet robes. In front of this figure is a gem cluster. In the centre of its gold mounting is a ruby, and surrounding this are four pearls, two diamonds and two emeralds. The *putti* stand on a ground of ochre-coloured earth which is strewn with pebbles, feathery leaves and flowers. The border is of the ruled-panel type outlined in gold but with horizontal terminations of delicate tendril clusters of flower and foliate motifs. The arms and devices of the Medici form a prominent part of this border decoration. A green trunk pruned of its branches extends the complete length of the three-sided panel. White scrolls, now somewhat discoloured, inscribed *Le Tens Revient*, wind around its trunk. In the lower margin four *putti* support three shields emblazoned with the Medici arms. The central shield, encircled by a laurel wreath is charged: *or, six palles gules and one azure charged with three fleur-de-lys*, and is also surmounted by a *fleur-de-lys*. The eight-sided shields on either side are charged: *or, eight palle gules and one azure*.

From the eighty initials on the other folios extend partial tendril borders, of symmetrically disposed floral motifs rendered in shades of pale green, yellow, pink and blue, further embellished by gold circlets and fine brown pen-flourishes (fig. 70). On folios with two or more initials the tendril border joins them, sometimes extending the length of the margin (figs. 73 and 74). In two instances on ff.10v and 125r the borders are enclosed by gold fillets, forming regular panels (fig. 69).

Programme of Illustration: Eighty-one historiated initials containing the portraits of Roman Imperial figures precede the chapters.

A portrait of Hadrian derived from a coin fills the large 'O' initial on f.1r. The eighty other initials contain renderings of figures in various attitudes and modes of dress but these portraits do not correspond to known Roman images drawn from coins or statues. Three of these emulate coins:

f.10v Coin portrait of Julius Capitolinus (author) inscribed JULIUS CAPITOLINUS, T: Life of Antoninus Pius; f.88r coin portrait of helmeted figure, N: Lives of the Two Maximini; f.125v coin portrait of female, N: Life of Victoria.

In addition to the sixteen 'portraits' preceding each chapter of Eutropius and Paul the Deacon, there are several in the *Scriptores Historiæ Augustae* itself which do not strictly introduce the actual biographies of emperors: f.115v emperor portrait, 'S': introduction to the Thirty Tyrants; f.122v emperor portrait, 'A': '*Alexander . . .*' sub-section of the Life of Aemilianus; f.145v emperor portrait, 'C': prologue to the Life of Probus; f.152r emperor portrait, 'M': prologue to the Lives of Firmus, Saturninus, Proculus and Bonosus; f.155r emperor portrait, 'F': introduction to Lives of Carus, Carinus and Numerian.

Commentary: This Medicean manuscript is one of the few Renaissance texts of the Augustan History which has a full programme of illustration, and appears to be the only manuscript so treated which also contains the Roman Histories of Eutropius and Paul the Deacon.

The colophon on f.213r provides both the manuscript's date and the identity of its scribe. The same formula is used in a number of other Florentine manuscripts dating from 1469 to 1492. The scribe has been variously identified as Sinibaldi or Alessandro Verrazano (1453–1510), yet neither uses the OMNIUM RERUM motto in their signed works. Indeed one of the OMNIUM RERUM manuscripts, Paris B.N. MS. NA. 1.2455, has the signature of Neri Rinuccini. Although both Sinibaldi's and Verrazano's scripts are quite similar to that employed in the OMNIUM RERUM series of manuscripts, slight idiosyncrasies in these manuscripts point to the hand of a third scribe whom it would seem logical to identify as Rinuccini.[1]

The numerous imperial portraits in the manuscript show the subjects as flesh-and-blood creatures. These 'emperors' are variously presented in profile (fig. 68), three-quarter face (fig. 70) or full face and in most a half-length figure is portrayed in preference to the bust. The costuming, posture and attributes of each emperor offer the artist the opportunity to imbue the manuscript with much variety. Unexpectedly, comparison with numismatic material makes it apparent that the overwhelming majority of the 'portraits' bear no resemblance to known coins and medals of the Roman emperors nor to those of the pretenders chronicled in the text. The only exception is the portrait of Hadrian on f.11 (fig. 68), which is a reversed image of a Roman denarius widely known in the Renaissance and used by contemporary artists as a model.[2]

In this regard the manuscript's programme differs significantly from the three other fully illustrated Italian Renaissance texts of the Augustan History: Rome Bibl. Naz. Centrale MS. Vitt. Em. 1004; Turin, Bibl. Naz. MA. E. 111.19; and Vatican MS. Vat. Lat. 1903. The majority of the portraits in these manuscripts illuminated in other Italian centres depend on Roman coins.

The types employed by the Florentine artist enable him to convey a flavour of antiquity and imperial authority suitable to the subject matter without an assiduous study of numismatic portrait-sources. An example of one type used frequently in the manuscript is furnished by the portrait of Victorinus on f.117r (fig. 72). He is depicted as an old man with long greyish-white hair and a full beard. This type, although it imbues the subject with a dignified, even stately appearance, is not Roman in origin. Rather, it has marked affinities with renderings of prophets and apostles in contemporary Florentine liturgical manuscripts. Another type which frequently occurs has a more numismatic 'feel' to it. This is the hook-nosed, middle-aged man presented in profile. A third type often employed is that of a clean-shaven young man with dark hair (fig. 73).

The three historiated initials on ff.10v, 88r and 125r, which purport to be of bronze coins or medals, in actual fact owe more to contemporary art than to any genuine Roman model. The coin-portrait of Victoria on f.125r is of particular interest as it is the only female portrait in the manuscript, the artist having mistakenly portrayed Zenobia as a man! Victoria's elegant *quattrocento* style, costume and coiffure have little in common with the severe, matriarchal appearance of actual coins of Roman empresses, but the inclusion of this coin-portrait, albeit a pastiche composition, demonstrates some attempt on the part of the illuminator to fulfil textual demands, since Victoria's biography records, falsely, that she had many coins minted in her reign.

The coin portrait of Julius Capitolinus on f.10v (fig. 69) also warrants attention. His aquiline nose, sloping forehead and unruly hair surmounted by a laurel wreath suggest both Roman coins and contemporary Italian medals of humanists such as Guarino da Verona. This portrait is the only one in the manuscript to be accompanied by an inscription and to represent one of the authors rather than the subjects of the biographies. Its inclusion may be due to a specific instruction on the part of an editorial adviser.

Elegance of technique, precision in fine detail and command of colour harmonies distinguish the illumination of this manuscript. It is not surprising therefore that it has been consistently attributed to some of the finest Italian miniaturists; in 1825 Sotheby's identified the illuminator as Attavante. Sir Thomas Phillipps later suggested, though quite mistakenly, Julio Clovio. Durrieu's attribution to Francesco d'Antonio del Chierico, made in 1888, comes closer to the mark.[3]

The manuscript's artist, however, lacks some of del Chierico's refinement and although he does exhibit a knowledge of contemporary monumental art, certain of his figure types and the occasional use of the old-fashioned liturgical serif in some of the initials (fig. 70) indicate that this artist was firmly rooted in the tradition of religious illumination. Certain stylistic devices and motifs used

appear also in folios of a breviary now in the Bargello, Cod. 68. These include the specific type of 'tendril' border, the motif of the angel holding a gem cluster in the upper left-hand border of f.1r, the old man 'type' employed in many of the portraits and the peculiar way of rendering hands.

Mirella Levi D'Ancona has identified the artist of the Bargello breviary as Mariano del Buono di Jacopo (1433–1504). The treatment of hands in another documented miniature by Mariano, in the *Libro delle Ordinamenti degli Otto de Guardi e Balia* in the Archivio di Stato, Florence, is also similar to that in some of the Augustan History portraits. It seems probable therefore that this manuscript comes from Mariano's workshop. This would explain, too, its mixture of tradition and innovation, for Mariano owed much to the example of older illuminators such as Bartolomeo Varnucci (1410–1479) and Ser Ricciardo di Nanni (1430–1480). At the same time he shared commissions with a younger generation of Florentine illuminators, including Gherardo del Fora (1446–1497) and Attavante (1452–1520).[4]

The manuscript was produced in the aftermath of the Pazzi conspiracy, and its patron was in all probability Lorenzo the Magnificent. The presence of a central blue *palle* in the coat-of-arms and the use of the *Le Tens Revient* motto on f.1r in themselves indicate a Medicean manuscript dated after 1469. Both Lorenzo and his son, Piero, used this motto and form of arms. Sinclair in his discussion of the manuscript opts for Lorenzo's ownership because of Piero's youth. The imagery of the title page corresponds closely to that employed in Pulci's poetic description of Lorenzo's 1469 Giostra: the jewels, *putti* with laurel wreaths, the blooming and withering roses and the *fleur-de-lys* mentioned in the poem all appear on this folio.[5]

The *Le Tens Revient* motto and the motif of the pruned tree may not only have functioned as Lorenzo's *ex-libris* but also have been deliberately included because the manuscript dealt with the biography of Roman emperors. Both the French phrase and the vernal motif have *renovatio* and Augustan implications of which Lorenzo was well aware and which he indeed exploited. The *fleur-de-lys* which figures on the armorial bearings had been recently conferred on the Medici by the King of France and were prized by that family for their implicit association with kingship. Thus the use of these motifs in the manuscript underline the typological link between its owner and the classical rulers chronicled in its text. Specifically Medicean imagery, however, seems confined to the title page and none of the 'portraits' clearly depicts a member of the Florentine family.

No record of the manuscript can be found in the 1495 inventory of the Medici library, but the unidentified arms on the wax seals on the inside cover with their *palle* and papal tiara suggest that it was still in the possession of a member of a collateral branch of the Medici family in the sixteenth century.[6]

The manuscript re-appeared in England after the Napoleonic Wars. Abaté L. Celotti, who in 1816 acquired it with the collection of Don Tommaso de Lucca, sold it to Sotheby's on Tuesday 26 July 1825. The large sum which Thorpe paid on this occasion testifies to the manuscript's unique quality and value. Thorpe, in turn, sold the manuscript to Payne & Foss; in February 1826 Sir Thomas Phillipps acquired it. Before Phillipps's collection was dispersed by his testators, Paul Durrieu examined the manuscript at Cheltenham in 1888. In this scholar's opinion, it was one of four manuscripts which constituted the artistic cream of the huge collection. For some decades it remained in the possession of Mr Fitzroy Fenwick, Phillipps's heir and grandson. It was eventually purchased from him as part of a bulk lot by W. H. Robinson and in 1947 Robinson sold it to the State Library of Victoria.

Cecilia O'Brien

Bibliography: Sinclair (1969), pp.370–373; Sinclair (1962a), p.334; Sinclair (1962b), p.280; Sotheby (1946), p.21; Durrieu (1889); O'Brien (1982); Ullman (1960), pp.122–123; (Sydney, 1967), p.10.

Notes

1. T. de Marinis, *La Biblioteca napoletana dei re d'Aragona*, Milan, 1947–1952, Vol. I, pp.87, 94–95, Vol. II, p.184. B. L. Ullman, *The Origin and Development of the Humanistic Script*, Rome, 1960, p.123.
2. J. A. Dobrick, 'Ghirlandaio and Roman Coins' in *Burlington Magazine*, 1981, pp. 356–357.
3. Durrieu (1889), pp.383–385, 417–418.
4. Mirella Levi D'Ancona, *Miniature e miniatori a Firenze dal XIV a XVI secolo*, Florence, 1962, pp.175–177.
5. Pazzi Conspiracy, 26 April 1478; the manuscript is dated January 1478 by the Florentine calendar, and therefore 1479 by the New Style.
6. E. Piccolomini, 'Inventario della Liberia Medicea Privata Compilato nel 1495' in *Archivio Storico Italiano*, ser. III, 1874, Vol. II, pp.51–94.

Fig. 75

No. 32. *Roman Missal* (fragment). Latin
Italy. Late 15c.
University Library, University of New South Wales,
MS. 4

Vellum, 320 x 230. A modern paper + 29 + B modern paper. I[9] (wants first leaf), II–III[10]. Catchwords agree, quire signatures, modern incorrect pencil foliation in arabic numerals. Script: late 15c. Italian liturgical gothic in black ink, with red rubrics. Ruling: light brown ink, 15 lines of text in one column, or five red ink four-line staves with musical notation. Binding: 19c. calf on boards.

Text: Folio 1r starts midway through the gloria at *Tu solus Dominus* and continues with ordinary of Mass; f.12r canon; f.24v postcommunion; ff.25r–29v first and second Good

Friday lessons with tracts, breaking off in St John's Gospel after *Egressus est iesus cum discipulis suis.*

Decoration: There are numerous one-line initials in red or blue ink. These are pen-flourished in mauve and red respectively. Two-line decorated initials preface important sections of the missal. These initials are painted in deep blue or light and dark pink with orange internal outlines. They are embellished with scroll-type vegetation in contrasting colours and set on square burnished gold grounds further embellished with bold floral designs in pink, blue and green. Tripartite marginal sprays containing green leaves, gold circlets and brown ink pen-work sprout from the left-hand side of the initials.

A larger six-line initial prefaces the *Te igitur* of the canon on f.12r (fig. 75). It is in blue and orange and has elaborate vegetative serifs in pink, green and blue. Although, like the smaller decorated initials, it is set on a burnished gold ground this initial is richer in appearance owing both to the strong colour contrast provided by an infilled ground of solid black and the presence of a central gem cluster consisting of a ruby set in gold and surrounded by eight diamonds. The initial is accompanied by a half-border with bright blue, deep pink and green floral motifs interspersed with brown pen-work and many gold circlets.

Commentary: The eclectic nature of the decoration employed in the fragment makes it difficult to locate it precisely. The use of the jewel-cluster device, the rich colour scheme and, to a certain extent, the presence of scroll-like vegetative flourishing would suggest a northeast Italian origin, perhaps Venice or Ferrara. However, the marginal sprays, half-border and the rather two-dimensional character of the capitals have central Italian qualities.

The early history of the fragment is to date unknown. It was purchased from Mr P. Storry of Mosman, N.S.W., by the University Library in 1965.

Cecilia O'Brien

Bibliography: Sinclair (1969), p.53; (Sydney, 1967), p.27.

Plate 23, figs. 76–80
No. 33. *Book of Hours.* Use of Rome. Latin
Florence, *c.*1495
National Gallery of Victoria, MS. Felton 869/5

Vellum, 147 x 100. 241ff. I³, II¹², III¹¹, IV–XI¹⁰, XII¹¹, XIII¹⁰, XIV⁸, XV¹¹, XVI–XIX¹⁰, XX¹¹, XXI¹⁰, XXII⁸, XXIII¹¹, XXIV¹², XXV³. Catchwords agree. Modern incorrect foliation in arabic numerals. Script: late 15c. Florentine formal humanistic in black ink; calendar in red and black. Ruling: dry-point: 18.[47].35 x 21.[78].48. Lines of text: 13. Ruling unit: 6. Calendar: 18.[47].35 x 23.[89].35. Lines of text: 16. Binding: modern green sealskin.

Ownership: In the lower margin of f.16v are the arms of the Albizzi, painted over those of the Strozzi (see below). In the lower margin of the adjacent page, f.17r, the arms of the Acciaiuoli appear (see below). Inside the front cover is the book-plate of C. W. Dyson Perrins, together with the number '91'. This number also appears on the spine.

Text: Latin. Contents: ff.4r–15v calendar with the feast of St Francis (4 October) in red. Entries in black include SS. Anselm, Boniface, Clare, John Orsini and Gatien of Tours; ff.17r–97v Hours of the Virgin; ff.98v–102r Mass of the Virgin; ff.108r–120v penitential psalms; ff.121r–136v litany. Saints include Louis of Toulouse, Julian, Benedict, Francis, Anthony, Dominic, Clare and Elizabeth; ff.137r–186v Vigils of the Dead; ff.188r–213v Hours of the Passion; ff.217r–221v Hours of the Cross; ff.223r–227v Hours of the Holy Ghost; f.227v *Explicit officium sancti spiritus anno domini MCCCCLXXXXV mensis martii.*

Decoration: Verses begin with burnished gold initials, one line high, set on square grounds of rich red, green or blue which are repeated in sequence throughout the manuscript. Two-line gold initials preface the beginning of prayers and psalms. These are set on grounds which combine two of the three colours used for the smaller initials. Delicate gold filigree patterns further enrich the coloured squares on which the two-line initials are set. A gold 'S' five lines high infilled with green and red on a square blue ground introduces the Mass of the Virgin on f.98v. Seven historiated initials in burnished gold, each five lines high, mark the opening of the Hours of the Virgin from lauds to compline; and the Hours of the Holy Ghost begin with a nine-line historiated initial (fig. 79). All these initials are set on square grounds of blue, patterned with gold.

The manuscript also contains five magnificent double-page openings with a full-page miniature on the verso and a historiated initial with the *incipit* of the text in gold ink on richly stained blue, crimson, purple or emerald-green vellum on the adjacent recto leaf.

Two distinct styles of border decoration are employed throughout the manuscript. The single-page openings have delicate tendril-style borders on the left-hand side of the folio. In these, conventionalized floral and vegetative forms are symmetrically disposed around an imaginary axis (fig. 79). Flowers and foliage are painted in shades of blue, pink, red and green and are accompanied by numerous gold circlets and fine brown pen flourishes. The double-page openings (Plate 23 and fig. 78) have richly ornamented, full borders with vegetative scrolls in gold, crimson, purple and royal blue set against equally richly coloured grounds. Motifs gleaned from the antique abound: gem clusters, *putti* supporting vases, sphinxes, tritons, monstrous hybrids and masks. Each of these full

borders contains eight inset medallions. The small medallions at the tops of the pages have religious symbols; the six set into the two side margins of each page depict either half-length biblical figures or decorative motifs, while the larger bas-de-page medallions are vignettes related in theme to the folio's main illustration.

Programme of Illustration: Illustrations are related to the text as follows:

ff.16v–17r Double-page opening. Verso: Annunciation. Six side medallions: half-length male nimbed figures, some of whom hold scrolls. Upper medallion: IHS. Lower medallion: shield supported by two *putti*, with arms *sable two concentric rings or* (Albizzi), which have been painted over others, *or on a fess gules three crescents argent* (Strozzi). Recto: **D**, Virgin and Child. Six side medallions of half-length nimbed male figures. The three on the left bear scrolls inscribed RVBVM QVEM, PULCHRA ES and ECCE MARIA. Upper medallion: IHS. Lower medallion: coat-of-arms, *argent a lion rampant azure langued gules* (Acciaiuoli): matins for the Hours of the Virgin (fig. 76).

ff.29v, 44r, 49r, 53v, 57v, 62r D, half-length female nimbed figures usually holding torch and on f.44r also a book: lauds, prime, tierce, sext, none and vespers.

f.70v C, half-length female nimbed figure with torch: compline.

f.107v–108r Double-page opening. Verso: David at prayer in landscape. Border medallions: IHS upper centre; hermit in prayer outside cave, lower centre (Plate 23). Recto: **D**, David with harp. Border medallion: IHS upper centre, David with head of Goliath, lower centre: penitential psalms.

ff.136v–137r Double-page opening. Verso: raising of Lazarus. Border medallions: three half-length nimbed male figures in left border. Cross-crosslet, upper centre; nimbed male Franciscan, lower centre. Recto: **D**, Triumph of Death. Border medallions: three half-length nimbed male figures in right border. Silver cross fleury, upper centre; skeleton with scroll *Mementis mortis*; lower centre: Vigils of the Dead (fig. 77).

ff.187v–188r Double-page opening. Verso: Agony in the Garden. Border medallions: three half-length nimbed male figures in left border; cross fleury, upper centre; kiss of Judas, lower centre. Recto: **D**, Christ carrying the Cross. Border medallions: three half-length nimbed male figures in right border; cross fleury, upper centre; Christ crowned with thorns, lower centre: Hours of the Passion (fig. 78).

ff.216v–217r Double-page opening. Verso: Crucifixion with Virgin and St John. Border medallions: three Marys in separate medallions in left border; SS. John and Joseph of Arimathea in separate medallions in right border; pelican feeding offspring with blood, upper centre; Suffering Christ (*Imago Pietatis*) lower centre. Recto: **D**, Pietà. Border medallions: three half-length nimbed male saints in right border; flagellation post and scourge, centre of right border; *Arma Christi*, three nails and crown of thorns, upper centre; John at the Sepulchre, lower centre: Hours of the Cross.

f.223r D, Pentecost: Hours of the Holy Ghost (fig. 79).

Commentary: The style and format of this manuscript are typical of Florentine Hours of the late *quattrocento*, and specific features of the illumination place it within the *œuvre* of Gherardo (1446–1497) and Monte (1448–1529) di Giovanni del Fora otherwise known as di Miniato. These particular Hours are distinguished from many similar contemporary products by their high standard of execution. It is highly probable that the manuscript was specifically ordered as a de-luxe commission by a member of the Strozzi family and involved the direct participation of the masters of the workshop.

The scribe, a follower of Sigismondo de Sigismondi of Carpi, gives in the final *explicit* (f.227v) the date 'anno domini MCCCCLXXXXV mensis martii'. As the Florentine calendar began on the feast of the Incarnation (25th March) it is possible that the manuscript was finished in either 1495 or 1496. The fact that it originally bore the arms of the Strozzi (f.16v now overpainted) and those of the Acciaiuoli (f.17r) suggests that it may have been commissioned in anticipation of the marriage of Filippo Strozzi's niece, Lucrezia di Lorenzo Strozzi, to Roberto de Donato Acciaiuoli in 1496, perhaps by the heirs of Filippo Strozzi who, before his death in 1491, seems to have had extensive dealings with the del Fora workshop, since contracts for a similar series of Hours and the magnificent Bodleian Pliny (Douce 310) establish a connection between this patron and these particular artists.[1]

The manuscript seems to have changed hands rapidly, however, if indeed it ever reached Lucrezia and Roberto. On f.16v the arms of the Albizzi have superseded those of the Strozzi, which indicates that the book came into the possession of Roberto's brother, Alessandro Acciaiuoli who had married Maria d'Antonio di Luca Albizzi in 1493. The change of ownership must have occurred within a short time-span, since Alessandro's Albizzi wife died in 1496.

The manuscript's illuminations reflect the varied concerns which informed the taste of Renaissance patrons and the diverse influences active on Florentine artists at the time. In the first place they demonstrate the pervasive sway of the mendicant ideal on Renaissance culture. Both the calendar and the litany have a slight Franciscan bias, and most of the miniatures offer images for quiet contemplation. The Annunciation (fig. 76), the Crucifixion (f.216v), and the Carrying of the Cross (f.188r, fig. 78) are depicted with clarity and a minimum of elaboration.

In the subsidiary medallions of the double-page openings the imagery has a penitential emphasis with such themes as

the *Arma Christi*, the Hermit and the *Memento Mori*. The clear, legible humanist script and the hierarchical nature of the manuscript's decorative programme attest to the Florentine patron's delight in order, clarity and beauty, which was stimulated by humanist manuscripts of classical texts. The abundance of *all' antica* motifs in the manuscript's borders also highlights the role of the antique in contemporary Florentine book decoration. At first the desire to imitate the antique had led to the introduction of the white-vine decoration and the new formal humanist hand in classical texts. By the end of the century antiquarian researches had furnished illuminators with a horde of genuinely antique models, as the border motifs in this manuscript demonstrate. For much of the century a division between secular and religious illumination existed, yet the popularity of antique motifs with patrons who often owned the original Roman coins and artefacts from which illuminators drew their inspiration eventually ensured their inclusion in devotional manuscripts for the wealthy laity if not in strictly liturgical texts for church use.

Gherardo's and Monte's illuminations demonstrate their familiarity with both traditional Florentine modes of book decoration and recent innovations in monumental and miniature painting. The partial 'tendril' borders which accompany the historiated initials in the single page openings are late examples of the type first employed by del Chierico in the early 1470s. The squat, rather conventional figures of the apostles in the Raising of Lazarus (fig. 77) or the Agony in the Garden (fig. 78) provide striking contrasts to the gracefully rendered Virgin Annunciate (fig. 76). The latter composition, with its double-arched loggia setting, distant landscape vista and glimpse of an interior with a red bed, follows a pattern common to Florentine painting. Yet here the skilful handling of light and aerial perspective bears out Leonardo da Vinci's commendations of Master Gherardo's shadow effects.[2]

More specific features of the manuscript's illuminations suggest a link between the di Giovanni brothers and their contemporary, Ghirlandaio. In the full borders of the manuscript, motifs relatively new to Florentine illumination occur. Some of these decorative devices, such as the gem clusters and the chiaroscuro scrolls of vegetation, seem to be adaptations of motifs employed by Venetian illuminators. However, other more 'classical' forms like the sphinxes, grotesque hybrids and masks had their origins in Roman wall painting. Nero's Golden House, unearthed in 1481, furnished a treasury of such motifs and Ghirlandaio's drawings of these wall paintings became available to Florentine illuminators such as the di Giovanni through copies in the Codex Escurialensis. As the Codex was produced in 1494, the use of these motifs in the present manuscript indicates that its illuminators were well in touch with current artistic trends.[3]

The minute studies of grasses and other botanical forms which appear in the foregrounds of both the David scene (Plate 23) and the Agony in the Garden (fig. 78) bear witness to an almost Flemish attention to naturalistic detail. The portrait-like rendering of David (Plate 23) further suggests that these artists were acquainted with northern oil paintings imported by patrician Florentines with banking interests in northern Europe. This knowledge of northern art again connects the di Giovanni brothers with Ghirlandaio. In a Corvinian manuscript executed by them there is a rendering of St Jerome (Vienna Nat. bibl. MS. cod. lat. 930) which is a copy of a Flemish portrait of the saint, possessed by the Medici at this time. Ghirlandaio seems to have made an independent copy of the same Flemish work. Vasari records that Gherardo studied the engravings of Schonauer. The fine rendering of foreground detail in this manuscript's miniatures may be compared with the German artist's 'Flight into Egypt'. Similar engravings seem to have been studied in Ghirlandaio's studio in the 1490s.[4]

The finesse and sophistication of these miniatures invite comparison with major commissions undertaken by the di Giovanni brothers for the great patrons of the age, Matthias Corvinus, the Strozzi and the papal court. A comparison of the Gethsemane miniature with, for instance, that in the Vatican missal (MS. Barb. lat. 610) executed by Monte in 1507 reveals that in each there is the same degree of sophistication, elegance, attention to detail and mastery of colour and design (figs. 78 and 80). Thus, while the di Giovanni workshop produced a whole series of Hours related in content and style to the present work, other examples such as Bodleian MS. Douce 9, and that in the Rothschild collection, Waddesdon Manor No. 16, lack some of its refinements and suggest greater participation by workshop assistants.

The fortunes of this manuscript after the fifteenth century are unknown until its reappearance in the early years of the twentieth century, when it was purchased from G. W. Davis of London by C. W. Dyson Perrins in 1910. It is described in George Warner's catalogue of this collection. In 1960 it was purchased at Sotheby's for the National Gallery of Victoria through the Felton Bequest.

Cecilia O'Brien

Bibliography: Sinclair (1969), pp. 318–320; Warner (1929), pp. 205–207; Sotheby (1960), pp. 105–107; Lindsay (1963), p. 72; Delaissé, Marrow and de Wit (1977), pp. 346–347; O'Brien (1982b), pp. 52–63.

Notes
1. Archivio di Stato, Florence, *Carte Strozziane ser. 3.78, a Raccolta de parentadi della famiglia Strozzi*. See also R. Sales, *The Strozzi Chapel by Filippino Lippi in Santa Maria Novella*, Ph.D. thesis, University of Pennsylvania, 1976, p. 77, note p. 171 and Appendix A.
2. *Notebooks* of Leonardo, trans. E. Mac Curdy, London, 1938, Vol. II, p. 335.

3. See Nicole Dacos, 'La Découverte de la Domus Aurea et la formation des grotesques à la Renaissance' in *Studies of the Warburg Institute*, London, 1969, pp.61–62.
4. See C. Csapodi and K. Csapodi-Gardonyi, *Bibliotheca Corviniana*, Shannon, 1969, p.322, and Vasari, *Lives . . .*, Everyman ed., Vol. II, p.67. He probably means Monte, not Gherardo.

Plate 24

No. 34. *Roman Missal* (fragment)
Rome, mid. 16c.
Australian National Gallery, Canberra

Vellum, 248 x 165. Script: on verso, five lines in Italian rounded gothic liturgical hand and five lines of musical notation on a four-line stave in red ink; from the common preface to the canon of the Mass.

Decoration: A full-page miniature of the Pietà in Mannerist style. Draperies are rendered in electric green, pinks and blues; lilac and intense blue fill the sky in the background. Greyish, light flesh tones are contrasted with more naturalistic hues of green and brown for vegetation. The full border is painted in gold and black; inset into it are four inscriptions in gold capitals on alternating red and blue grounds. These texts consist of a Holy Week antiphon, *O vos omnes, qui transitis per viam,/ attendite et videte. Si est dolor similis/ sicut dolor meus./ Dolores Nostros ipse tulit et peccata Nostra ipse portavit.*

Commentary: This leaf is from a missal, probably illuminated for the papal court and possibly for use in the Sistine Chapel. It has been attributed to Apollonio de' Bonfratelli (active 1532–1572) who worked for Pius IV and Pius V. Apollonio signed a similar leaf depicting the Adoration of the Shepherds: APOLLONIUS DE BONFRATELLIS DE CAPRANICA CAPELLÆ ET SACRISTÆ APOSTOLICÆ MINIATOR FECIT ANNO DOMINI MDLXIV SEDENTE PIO IV PONTIF. OPT. MAX. DE MEDICIS MEDIOLANENSE (British Library MS. Add. 21412). The format of the page, the centralized composition, the elongated angels and Michelangelesque central figures of the Canberra leaf strongly resemble those in the signed fragment. The compositional debt to Michelangelo's Pietà is obvious, as is the miniaturist's acquaintance with the work of Pontormo. As Turner has noted, 'The Italian miniaturists of the sixteenth century cannot rank as original artists, they were increasingly under the influence of the full-scale painters of the day.' Indeed, the papal court in the mid-sixteenth century was the last stronghold of the dying art of illumination.[1]

Although un-numbered, this fragment was part of the Phillipps collection, which contained another leaf from the same missal (Bib. Phillippica. NS. Medieval, VIII, 614). A group of related miniatures, some signed by Apollonio, from dismembered papal service books appeared in the Celotti sale of 1825. This leaf may have been acquired by Sir Thomas Phillipps around the same time. It was purchased by the Australian National Gallery from Sotheby's in 1976.

Cecilia O'Brien

Bibliography: D'Ancona (1925), p.92; Sotheby (1976), Lot 893.

Note
1. D. H. Turner, 'The Eric Millar Bequest to the Department of Manuscripts' in *British Museum Quarterly*, Vol. XXXIII, 1968, p.36.

Italian Short Entries

Fig. 81
No. 35. Boethius, *de Musica*; Pseudo-Hucbald, *Musica Enchiriadis*. Latin
North Italian? 11c.
State Library of Victoria, ★091/B63

Vellum, 305 x 210. A modern paper + B modern vellum + C contemporary vellum + 56 + D modern vellum + E modern paper. Diagrammatic drawings in green, orange and brown ink (fig. 81).

Bibliography: Sinclair (1969), pp.381–382.

Fig. 82
No. 36. Ptolemy, *Almagest* (translation) and other astronomical and astrological treatises. Latin
Italy, 13c.
State Library of Victoria, ★f091/P95A

Vellum, 360 x 240. A modern paper + B contemporary vellum + 193 + C contemporary vellum + D modern paper. Folios 1–173v contain decorated initials on burnished gold grounds, usually with simplified foliate patterns in red, green or blue, outlined or stroked in white. The shafts of the initial 'P' are often set against contrasting

coloured grounds with white crosses or dot-and-line motifs. The initial on f.1r is slightly more elaborate and features a grotesque (fig. 82). Several other astronomical and astrological treatises or extracts thereof are appended to the thirteenth-century text. They date from the fourteenth to the fifteenth century. *The Theory of the Planets*, ff.176r–183r, has fine fourteenth-century pen-flourished initials in red and blue. This book was once in the library of S. Marco, Florence.

Bibliography: Sinclair (1969), pp.382–386; (Victoria, 1956), p.129; Sinclair (1962a), p.336; Sinclair (1963), pp.396–399.

Fig. 83

No. 37. Bernard of Parma, *Casus Longi super Decretales*. Latin
Northern Italy, second half of 13c.
Fisher Library, University of Sydney, New South Wales, Nicholson 26

Vellum, 340 x 215. A modern paper + 55 + B modern paper. Initials in red and blue, flourished in the alternate colour throughout, with flourishes extending along the margins. One historiated initial on f.30rᵃ, nine lines high, introduces the second book of the treatise. It shows a three-quarter-length figure. A long-tailed bird extending into the margin holds the initial in its beak. The initial is coloured light brown and green and is set on a deep blue ground filletted with white. The figure who expounds the text is dressed in red and brown with black cap and white hair. The bird is painted in the same brown tones as that of the initial (fig. 83).

Bibliography: Sinclair (1969), pp.217–218; (Sydney, 1967), p.13.

Fig. 84

No. 38. Alan of Lille, *Theological Rules*. Latin
Italy, first half 15c.
St Patrick's College, Manly, New South Wales. M.S.1.

Vellum, 183 x 128, A–B modern paper + 108 + C–D modern paper. Three-line initials in red and blue flourished with the alternate colour occur throughout. Three decorated initials four lines high mark divisions in the text on ff.40v, 47v and 99r. These are in red and blue and are set on gold grounds with infills of foliate and floral motifs and simple interlace. Sprays of leaves and gold circlets extend into the margin (fig. 84).

Bibliography: Sinclair (1969), pp.55–56; Sinclair (1964b), p.235; (St. John's College, 1881), p.7; Roper (1916), p.125.

Fig. 85

No. 39. Bartholomeo Pisano O.P., *Cases of Conscience*.
Latin
Dominican Friary, SS. Giovanni e Paolo, Venice, 1470
Fisher Library, University of Sydney, New South Wales, Nicholson 14

Vellum, 136 x 100. A contemporary vellum + 366 + B modern paper. Initials in red and blue, flourished in the alternate colour head each alphabetical section. The prologue on f.1rᵃ is introduced by an initial 'Q' (30 x 30) painted blue and outlined in white. It is set within a square decorated with foliate motifs in white shaded with yellow, with a patterned border extending on three sides. The interstices of the initial comprise symmetrically bifoliate and tendril motifs again in white shaded with yellow on a deep purple ground.

This manuscript is signed and dated by the scribe on f.361rᵃ: brother 'Georgius bosch' of SS. Giovanni e Paolo Venice, 17 May 1470.

Bibliography: Sinclair (1969), pp.195–196; (Sydney, 1967), p.17.

Fig. 86

No. 40. St Jerome, *Regulae Monacharum*; Anon., *Tract on Oratory*; Leone Battisti Alberti, *Trivia Senatoria*. Latin
Northern Italy, 1471
Fisher Library, University of Sydney, New South Wales, Nicholson 18

Paper, 140 x 100. A–B modern paper + 78 + C–D modern paper. Seven roughly decorated initials on ff.1r, 41r, 45r, 49v, 52r, 55r and 56r coloured red and set on red grounds entwined with white-vine decoration and green and red floral motifs touched with yellow. Folio 1r has a full border of similar motifs with a sketch of a kneeling St Jerome set into the centre of the lower margin. The decoration gives the impression of having been modelled on contemporary woodcuts. It is included here despite its crude quality since the first part of the manuscript is dated on f.40v '13ᵃ aprillis 1471 in vigilia pasce'.

Bibliography: Sinclair (1969), pp.202–203; (Sydney, 1967), p.11.

Fig. 87

No. 41. Breviary (fragment). Latin
Ferrara, *c*.1460–1480
Private Collection, Melbourne

Vellum leaf, 270 x 200.

Decoration: The decoration consists of six two-line initials in burnished gold on alternating squares of red or blue penwork, and on the recto a four-line initial containing a half-length depiction of St Benedict holding a crosier, prefacing

the readings for his feast. This gold initial is attached, by means of leaf scrolls, to a pink central bar which takes the form of a slender pillar. In the left-hand margin is another pillar in green and gold which is divided into three by tiny pink floral cusps. Another bar divides the two columns of text on the verso. Extending from these pillars into the upper and lower margins are pen-line flourishes embellished with sprays of gold circlets, tri-lobe leaves and large pink and blue flowers. The left-hand border of the verso sheet is also filled with the same type of ornamentation. The leaf's decoration has been attributed to Taddeo Crivelli; its range of colour and the use of certain decorative motifs link it with the Ferrarese school and with such works as the Bible of Borso d'Este. However, the light marginal sprays and the heavy, upturned face of the saint point to an artist who was also familiar with the Lombard tradition.

The leaf was purchased from the bookseller Alan G. Thomas in 1967, and is part of a manuscript formerly belonging to the Llangattock family which was auctioned at Christie's on 8 December 1958 (Lot 190). According to a late nineteenth-century note inside the manuscript it was looted from a Spanish library during the Napoleonic Wars. Various leaves of this breviary have been offered for sale since 1958, including one with a commemoration and portrait of St Maurilius, the seventh-century bishop of Ferrara, and another with a miniature based on a medal of Leonello d'Este, both of which confirm Ferrarese origin.[1]

Cecilia O'Brien

Bibliography: Thomas (1967); Christie (1958); Sindona (1961); Sotheby (1983).

Note

1. Sotheby (1983), lot 133.

English Manuscripts

Plate 25

No. 42. *Antiphonal* (fragment). Use of Sarum. Latin
Southern England, early 14c.
Geelong Church of England Grammar School, Corio,
 Victoria

Vellum, 330 x 215. One folio. Script: 14c. English gothic
liturgical hand in black ink with red rubrics on recto and
verso. Ruling: black ink, one column of nine groups of
four-line red staves with black square notation and lines of
text written beneath. In one section of the recto, four lines
of text appear between the two musical staves.

Text: Latin. Contents: recto opens abruptly with anti-
phons, psalms etc. for the office of matins for Christmas.
The responsory for the first nocturn continues on to the
verso. Both text and chants are a variation of Sarum use.[1]

Decoration: Black initials are touched with red and some-
times slightly flourished. At the base of the recto of the
folio is one historiated initial, introducing the extract from
the prologue to St John's Gospel. It is rectangular in shape
and rests on the lower bar border with the text above it.
The scene is the Nativity with Mary reclining on a bed
holding the Christ Child against a triple-arched tessellated
backdrop. As a marginal development of the scene along
the lower border, there is a stag and a haloed St Joseph who
cooks over a brazier.

 The recto page is also decorated by a bar border which
extends from the historiated initial along part of the vertical
and lower margin, terminating in tendrils with sprouting
ivy-type leaves around the top and right-hand margins.
This bar border is gold in colour, decorated with white and
outlined in black. It has small cusped sections around the
historiated initial and where it develops into a leaf-bearing
stem. Colours for the historiated initial and related margi-
nal figures are mid-blue, gold, and touches of pink in
Joseph's headdress (Plate 25).

Commentary: The decorative design and colouring of the
border of this antiphonal fragment are typical of early
fourteenth-century English illumination, and may be com-
pared with manuscripts from the group associated with the
Queen Mary psalter. The splendid psalter Corpus Christi
College Cambridge MS. 53, for instance, dated prior to
1315, has a similar blue and gold diapered background for
the large illuminated initial on f.169v; and the historiated
initial of the Geelong folio is a simplified version of the full-
page Nativity miniature on f.8r of the Cambridge psalter.
The blue drapery which swathes the Virgin, her inclined
head, the tender relationship between herself and the Christ

Child, together with the trefoil framing arch above them
are common both to the small initial and the more elaborate
large-scale miniature. In both versions Joseph wears a blue
cape and pink cap. Whereas in the psalter he is present at the
Nativity scene proper, on the Geelong page he is depicted
as a marginal figure preparing food for the Christ Child
according to popular legend.[2]

 It is possible therefore that the Geelong folio once
belonged to an antiphonal contemporary with the Cam-
bridge psalter and other members of the Queen Mary
psalter group and may indeed have been produced in the
same atelier.

 The early provenance of the folio is unknown. It was
presented at an undisclosed date by Professor Ruskin to the
Geelong Grammar School.

Bibliography: Sinclair (1969), pp.307–308.

Notes

1. See *Antiphonale Sarisburiense*, ed. W. H. Frere, London, 1966.
 They are not identical with this facsimile edition, but are closely
 related. Thanks are due to Mrs Veronica Condon and Sister
 Paula of the Carmelite Monastery, Kew, for information on the
 text. Acknowledgement is also due to Mr Michael Collins Perse
 of Geelong Grammar School, who kindly made the pages
 available for inspection.
2. See M. R. James, *Descriptive Catalogue of the Manuscripts in the
 Library of Corpus Christi*, Vol. I, Cambridge, 1912, no. 53, p.105.
 See also L. Sandler, *The Peterborough Psalter in Brussels and Other
 Fenland Manuscripts*, London, 1974, pp.123–126.

Plate 26, figs. 88–93

No. 43. *Breviary.* Use of Sarum. Latin
England, *c.*1350
Baillieu Library, University of Melbourne, Victoria

Vellum, 100 x 67. A–C, 17c. paper + 256 + D–F 17c.
paper. I⁸, II⁹, III⁸, IV⁷, V¹⁰, VI⁷, VII⁸, VIII⁸, IX⁴, X⁶, XI–
XIII⁸, XIV⁶, XV¹², XVI⁴, XVII¹⁰, XVIII⁸, XIX⁸, XX⁹,
XXI⁶, XXII⁷, XXIII⁸, XXIV⁷, XXV⁸, XXVI¹², XXVII–
XXVIII⁷, XXIX–XXXI⁸, XXXII⁶, XXXIII⁸. Script:
ff.1r–234r 14c. English gothic book hand. At f.85r the
script becomes slightly smaller and more constricted, and
the number of lines per page is increased, suggesting a
change of scribe. Folios 234r–256r late 15c. English gothic
book hand. Ruling: red ink. Folios 1r–84v: 8.[23].7.[22].7
x 4. 81. 15. Lines of text: 33. Ruling unit: 2.5. Folios 85r–
234v: 6.[22].7.[23].9 x 4.[82].14. Lines of text: 35. Ruling
unit: 2.3. Folios 235r–256r: 7.[23].6.[21].10 x 7.[82].11.
Lines of text: 35. Ruling unit: 2.3. Edges severely cropped.
Binding: late 17c.–18c. dark green morocco, spine is later;

there are remains of green ties. On spine in gold is 'Heures Ms in Membranis'.[1]

Ownership: On Ar is '1 Class 5 shelf 33'. On ff.245v and 246r is 'William B Saltome', possibly in a 16c. hand; on Ev and Fr is a list of saints mentioned in the litany in pencil in modern hand.

Text: Latin. Contents: ff.1r–73v psalter with canticles and Athanasian creed; ff.73v–76v litany; ff.77r–218v sanctoral; ff.219r–233v common of the saints; ff.234r–256v additional propers of the feast of the Visitation and Transfiguration (fifteenth century).

Decoration: One-line versal initials in blue or burnished gold occur throughout. They are alternately flourished with red or mauve (up to f.84v) and blue (from f.85r). On ff.1r–84v the pen-flourishes often continue into the margin as lacy patterns, a few of which contain sketches of caricatured heads.

Numerous two-line initials introduce sections of the text. They are of burnished gold, set against blue and pink grounds, with infills of white tracery. Larger initials of the same design, three lines high, mark many of the offices and lessons in the sanctoral. 'O' and 'I', similarly patterned and embellished with black cusped outlines, have shafts extending along the margin for a length of six to ten lines.

There are two foliated initials: the first, three lines high, introduces Psalm 2 on f.22r; the second, six lines high, marks the beginning of the common of the saints on f.219r.

The psalter and sanctoral contain eighteen historiated initials of which one is six lines, ten are seven, and four are eight lines high (13 x 15 to 19 x 20). These letters have blue or pink spines with white ornamentation of dots, circles, crosses etc., and are set in narrow gold frames outlined in black. Sixteen initials have central grounds of burnished gold with circular clusters of tooled dots; one contains a grey-green ground with gold clusters, and another has a red ground with gold spray ornament. Figures are drawn in black ink and painted in blue, pink, red and white with occasional touches of orange and green, hair being tinted brown or grey (Plate 26).

Pages containing historiated initials are decorated with bar-baguette borders. Where the initial is in the left column or at the base of the page the bar continues around the perimeter, partially or entirely enclosing the text and sometimes branching a short way into the central margin. Where the initial is in the right column the bar sometimes extends the full length of the central margin and then continues around the edge. Colours of the borders are the same as those for the historiated initials, green being used only with the red daisy-bud motifs. No two border designs are the same and within the limited palette variety is achieved by the different combinations of colours, white highlighting and by the addition of small gold circlets with hairline tails distributed at irregular intervals.

The ribbon-bars are relieved of rigidity by various ornamental devices. Curving sprays of ivy or sprigs of paired daisy buds branch out or in towards the text, and when the borders are not completely four-sided the bars terminate in meandering foliate tendrils. Corners are articulated by cusped foliate medallions and the outer vertical borders are often fringed with long, furled, serrated leaves. The four-sided borders on ff.1r, 157v, 162v, 173r and 185r are punctuated by strap-work medallions placed at the centre of the outer bar and (except for f.1r) in the lower or upper horizontal segments (fig. 88).

Grotesques inhabit the borders of ff.112v, 136r and 162v. On f.42r there is a pen-sketched bird in the margin (fig. 91).

Programme of Illustration: The psalms marking the eight divisions of the psalter are introduced by historiated initials as follows:

f.1r B David playing harp: *Beatus vir*, Psalm 1 (fig. 88)
f.11r D David, crowned, kneeling before God, pointing to his eyes: *Dominus illuminatio mea*, Psalm 26 (fig. 90)
f.16v D David pointing to his tongue: *Dixi custodiam*, Psalm 28
f.22v D King David with a fool: *Dixit insipiens in corde*, Psalm 52
f.28r S God above, Jonah cast out of whale below: *Salvum me fac*, Psalm 68
f.35v E David playing bells: *Exultate Deo*, Psalm 80
f.42r C Two clerics chanting: *Cantate Domino quia*, Psalm 97 (fig. 91)
f.49v D Trinity: *Dixit Dominus*, Psalm 109

In the sanctoral ten historiated initials relate to the text as follows:

f.77r U Crucifixion of St Andrew: *Unus ex duobus*: antiphon for first vespers for feast of St Andrew (fig. 92)
f.84v G Meeting of Anna and Joachim: *Gaude mater ecclesia*: antiphon for first vespers of Immaculate Conception
f.112r O Annunciation: *Oriet sicut sol salvator mundi*: antiphon for first vespers of Annunciation in paschal time
f.113r D St John the Baptist: *Descendit Angelus*: antiphon for first vespers of Nativity of St John the Baptist
f.136r Q SS. Peter and Paul: *Quem dicunt homines*: antiphon for first vespers for SS. Peter and Paul
f.157v D St Lawrence: *Da quaesumus*: collect for first vespers of St Lawrence
f.162v V Assumption: *Vidi speciosam sicut columbam*: antiphon for first lesson of matins for Assumption
f.173r H Nativity of the Virgin: *Hodie genetrix virgo semper Maria*: antiphon for first vespers of Nativity of the Virgin
f.185r E St Michael: *Excelsi regis*: antiphon for first vespers for dedication of St Michael
f.213v A St Catherine: *Ave virginum gemma Katerina*: antiphon for first vespers of St Catherine.

Commentary: This small manuscript is part of a portable breviary. Both the initials and borders suggest that it was probably illuminated in England around the middle of the fourteenth century. While they show a continuing reliance on decorative patterns which were developed earlier in the century in the group of manuscripts associated with the Queen Mary psalter, the freedom characteristic of the earlier works is at times replaced in the Melbourne breviary by crisper, more rigid and concentrated forms, a tendency which emerges in English illumination a short time before the middle of the century.[2]

Despite the constraints imposed by the manuscript's small dimensions, the artist has adopted a sturdy figure canon, creating blocky forms which fill almost the entire height of the framed field and usually occupy the immediate foreground. Heads and hands are disproportionately large. Faces with broad brows and pointed chins, often in three-quarter view, reveal a long nose with a nostril cleft like a rounded 'W'; in full face the nostrils are splayed flat. This particular stylistic idiosyncrasy may have arisen through the illuminator's misinterpretation of larger compositions such as those in the Queen Mary psalter, the Chertsey breviary or the psalter in Corpus Christi College, Cambridge, MS. 53, in which nostrils are often indicated by finely sketched wavy lines, discontinued at the curl. This characteristic the less gifted illuminator of the Melbourne breviary seems to have conventionalized into his distinctive 'W'. It is also his habit to add a vertical red fleck to the line of the mouth, introducing thereby a spot of bright colour to the tiny countenances rather than on the cheeks which is more usual. Hands are usually differentiated in size, the larger one making angular gestures, while the other has fingers and thumbs out flat.[3]

The dramatic content of the scenes is often emphasized, as in the crucifixion of St Andrew on f.77r (fig. 92), and some sense of depth is achieved by the placement of objects like the altar before the kneeling David on f.11r (fig. 90). Certain figures also seem to project in front of the text, their garments falling down over the framing letter as is the case with the two chanting clerics on f.42r (fig. 91).

The decoration of the tiny gold backgrounds with detailed tooled motifs characteristic of the more splendid manuscripts of the period, together with some of the stylistic features mentioned above, may indicate that the artist was accustomed to working on or from larger books.

Small breviaries with such detailed decorative programmes have not survived in great numbers from this period; but a manuscript in the Bodleian, MS. Laud Misc. 3A, is marked by similar elements (figs. 89, 93). Not only do the two manuscripts relate closely stylistically; but the text of each book is complementary, the Oxford volume containing the calendar and the temporal and the Melbourne work, as already stated, comprising the psalter, sanctoral and common of the saints. Indeed, close inspection has revealed that these two manuscripts are in fact parts of one original volume. While the Oxford section measures 115 x 75, its borders not being so severely cropped and catchwords being still visible, the inner rulings of both manuscripts match exactly and the last leaf of the calendar in Bodl. MS. Laud Misc. 3A has an offset of a *Beatus* initial and border which conforms precisely with that on the beginning of the psalter of the Melbourne book, leaving no doubt that originally the two manuscripts were one volume.[4]

Both the sanctoral and the temporal are characterized by a certain degree of variation in the selection of parts of the office to be illustrated, a feature which Lucy Sandler has pointed out is not uncommon among early fourteenth-century English breviaries, by contrast with their contemporary French counterparts.[5]

The temporal, calendar and litany in the Oxford book are of general Sarum use, with no distinctive local saints marked for special veneration. The Sarum feast of relics appears on 8 July. Since the change to July from September for this feast dates from 1319, this year provides a firm *terminus ante quem* for the execution of the breviary. However, an argument for a later date, which has already been advanced on stylistic grounds, is strengthened by the fact that in the Bodleian section an historiated initial marks the feast of Corpus Christi on f.153r. The observation of this feast did not become obligatory in the diocese of Canterbury until 1332. Given the stylistic association with the Queen Mary psalter group of manuscripts which probably issued from the London area, it seems reasonable to conclude that the Oxford–Melbourne book was produced in south-east England, probably around the middle of the fourteenth century.

When the manuscript was divided is not known, but this must have been prior to 1640, since the Bodleian portion is in a binding of Archbishop Laud's and is dated and signed by him on f.3r. The fifteenth-century folios at the back of the Melbourne section could have been appended at the time the book was split.

The name inscribed on ff.245v and 246r indicates that in the seventeenth and eighteenth centuries the Melbourne breviary belonged to William B. Saltome, probably a member of the family of Abernethy, Lords Saltoun. Marks on the front and back leaves show that the book was sold at Sotheby's in May 1958, and that it came into the possession of Arthur Howard who then sold it to Maggs in 1973. It was purchased from Maggs in 1974 by the Friends of the Baillieu Library, University of Melbourne, who donated it to that library.

Bibliography: Maggs (1974), p.13; Riddett-Smalley (1976).

Notes

1. Ms R. Riddett-Smalley was the first person to make a detailed study of this manuscript, for an honours thesis in 1976 (see Bibliography). Much of the information provided here is based

Plate 25. Nativity. No. 42. 330 x 215

Plate 26. Nativity of the Virgin. No. 43, ff. 172v–173r. 100 x 134

Plate 27. Vein Man and Zodiac Man. No. 44, f. 5r. 264 x 157

tother þat was drye and withoute hume: ʒhe made wex greene aʒayn
and ber leuys. floo and fruyto. Of þat also ʒhe made thyne at þe ne[ce]
essite of Architriclyno. and many sich wondirfull mirtacions. of whilk
it wer to longe to hold plemeut. Also me list nought to forʒett of þe
surʒyne childynge whilk ʒhe maydo conceyue with outen sede of man.
wherof ʒhe did mykil aʒayner me. And when ʒhe made sich thynges
I haue suffrid to longe. wherof I spowe þiuely. And now or now spak
I ne made noise þerof. wherof me sore forthynker. ffor men oft seggis may
to mykil. and be to longe still and slepe to mykil. ffor by cause I haue
holdyn me still: ʒhe be now commyn aʒayne. for to make new thynges
by whilk ʒhe excite me right now to chide with þow. with right þerto
ire and wreth. And wele I tol þhow. þat ne wer ʒhe or þerto a lady.
ʒhe shuld right sone haue þe werd. and at þow I wil witt. and sithen
I wold tech þow. to remewe so myne vsaʒes with outen warnynge
and callynge of me.

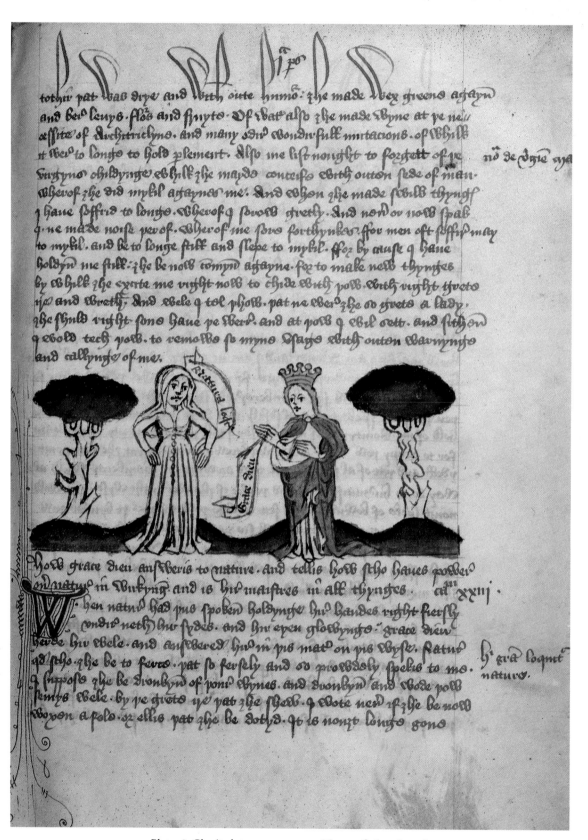

How grace dieu answeris to nature. and tellis how sho haues power
on natuys in wirkyng. and is hir maistres in all thynges. cm xxiij.

When natur had þus spoken holdynge hir handes right fersly
vndir neth hir sydes. and hir eyen glowynge. grace dieu
herde hir wele. and answered hir in þis mat on þis wyse. natur
qð sho ʒhe be to fers. þat so fersly and os prowdoly spekis to me.
I suppose ʒhe be dronkyn of þoni þynges. and dronkyn and wode þow
semys wele. by þe grete ire þat ʒhe shew. I wote neu if ʒhe be now
woxen afole. or ellis þat ʒhe be doth. it is nouʒt longe sono

Plate 28. Charity between two trees. No. 45, f.18r. 265 x 185

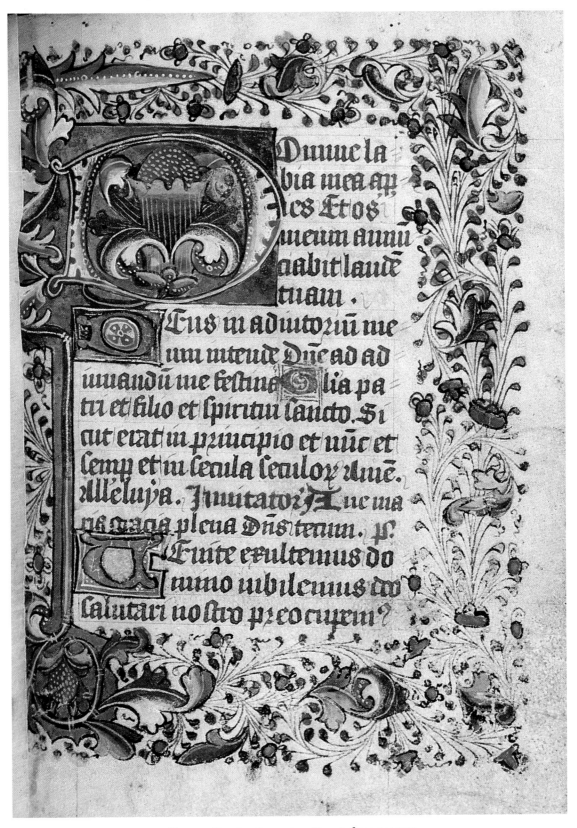

Plate 29. Opening for matins. No. 46, f. 13r. 142 × 95

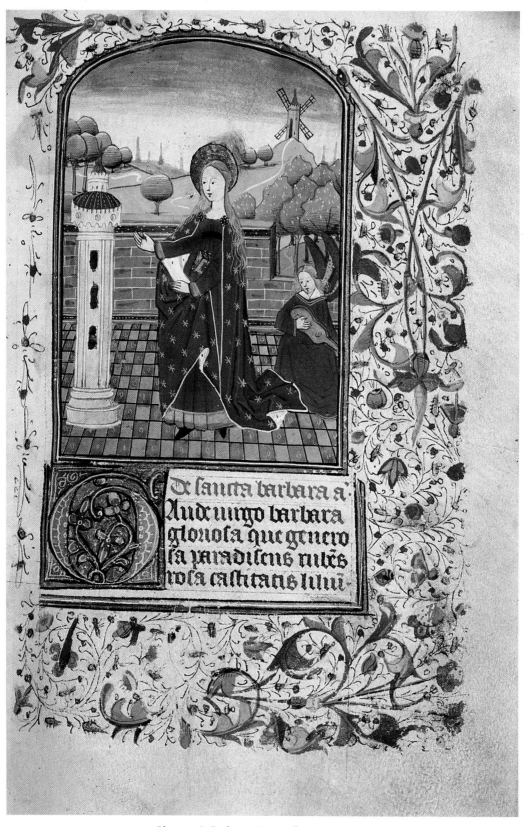

Plate 30. St Barbara. No. 54, f.23r. 195 x 140

	d		Sce brigide virg
vj	e	iiij	Purifica bte marie virg
viij	f	iij	Sci blasii epi
viij	g	ij	Sci gilberti sfess
x	A	Nõ	Sce agathe virgi
vvj	b	viij	Sator vedasti et amandi.
v	c	vij	
	d	vj	
viij	e	v	
ij	f	iiij	Sce scolastice virg
	g	iij	
v	A	ij	
	b	Idus	
vviij	c	vvj	Sci valentini psbii
vij	d	vv	
	e	viij	Sce uliane virg t mris
vv	f	viij	
iiij	g	vij	
	A	vj	
vij	b	v	
j	c	iiij	
	d	iij	Cathedra sci petri
w	e	vij	Sci mathie apli
	f	vj	

Plate 31. February: man cutting wood. No. 56, f.2r. 345 × 235

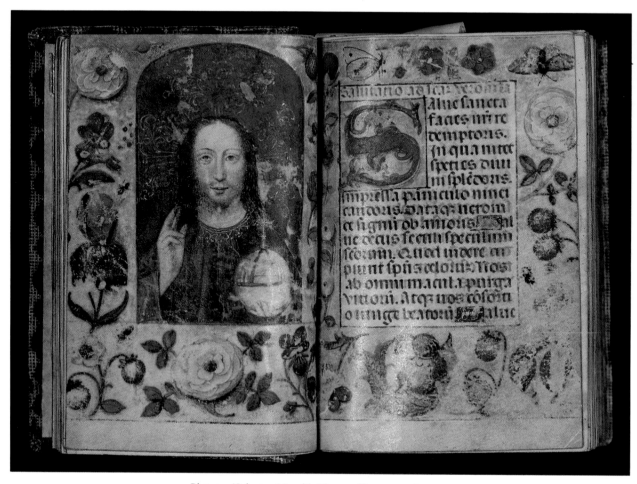

Plate 32. 'Salvator Mundi'. No. 57, ff. 11v–12r. 87 x 112

on her analysis. Subsequent research has strengthened and, in particular instances, confirmed her original conclusions. Her important contribution to the location of this manuscript within the context of fourteenth-century English illumination is here acknowledged.

2. See Riddett-Smalley (1976), pp.27, 38 and 42 *et passim*; and No. 42, p.98, for further discussion and bibliography of the Queen Mary psalter group.

3. For the Chertsey breviary, Bodl. MS. lat. liturg. e6, e37, e39 and d42, see J. Alexander, 'English Early Fourteenth Century Illumination: Recent Acquisitions' in *Bodleian Library Record*, Vol. IX, 1974, pp.72-80. For the Cambridge psalter see No. 42, p.98.

4. For Bodl. MS. Laud Misc. 3A see Pächt and Alexander (1966), no. 642; *Latin Liturgical Manuscripts and Printed Books. Guide to an Exhibition held during 1952*, Bodleian Library, 1952, no. 71, p.39. Ms Riddett-Smalley first noted the similarity with the Melbourne breviary. Mr M. Michael, University of London, drew attention to the offset of the initial. He is currently preparing a pamphlet on certain Bodleian manuscripts in which reference will also be made to the identity of the Melbourne–Oxford book.

5. See L. F. Sandler, 'An Early Fourteenth-Century English Breviary at Longleat' in *Journal of the Warburg and Courtauld Institutes*, Vol. XXXIX, 1976, pp.1-19.

Plate 27, figs. 94-95

No. 44. *Calendar*. Latin
North-eastern England, 15c.
Ballarat Fine Art Gallery, Victoria, MS. Crouch 4

Vellum. Five folios are folded in half horizontally, then vertically into four with edges turned in towards the centre (fig. 94). Folios 1-4 are attached at one end to a rounded tab of vellum. Dimensions when folded (with tab): 160 x 41; (without tab) 132 x 41. Dimensions of open sheets ff. 1-4: 264 x 164; f. 5 is a separate sheet, having been dislodged. Dimensions: 264 x 157. Script: English gothic book hand in brown ink. Calendar in brown and blue.

Text: Latin. Contents: f. 1r calendar for February, March, with tables for telling the time, tables of eclipses, the movements of the sun and moon and the conjunction of the planets; the Dominical letter and movable liturgical feasts; f. 1v(a) calendar for January; f. 1v(b) 'Januarius, Ffebruarius, Marcius' (fig. 95); f. 2r calendar for May, June; f. 2v(a) calendar for April; f. 2r(b) 'Mayus' (April, June rubbed); f. 3r calendar for August, September; f. 3v(a) calendar for July; f. 3v(b) 'Julius, Augustus, September'; f. 4r calendar for November, December; f. 4v(a) calendar for October; f. 4v(b) 'October, November, December'. The twelve calendar months have special feast days marked in blue and other entries in brown. Distinctive names include: SS. Benedict, David, Chad, Oswin, Cuthbert and his Translations, SS. John of Beverley, Dunstan, Commemoration of Bede, William of York, Botulph, Alban, Boisilus, Oswald, Aidan, Wilfrid of York, and Hilda. Folio 5r(a)

Ymago venarum; f. 5r(b) *Ymago signorum*; f. 5v *Ad notitiam huius kalendarii est sciendum quod prima linea descendente secundum longitudinem ponitur numerus dierum . . .* (instructions for using the tables).

Decoration: Each calendar month is headed by an illuminated initial with marginal feathered sprays terminated by green buds (fig. 95). On f. 5r there are two drawings. The upper consists of two concentric circles inside which a naked figure stands in a frontal position against a green ground. Red lines connect his body to fifteen medallions contained within the outermost perimeter. The lower illustration is an outline of a man with the twelve signs of the zodiac painted in blue or brown over the appropriate anatomical regions of his body (Plate 27).

Programme of Illustration: This consists of the two schematic figures. The upper figure illustrates the Vein Man who is depicted as Microcosmic Man. The lower figure is Zodiac Man. These illustrations were consulted in conjunction with the information available in the tables.

Commentary: This almanac is a very unusual type of medieval manuscript, a folded *vademecum* whose contents present the calendrical requirements of astrological medicine. The figurations of the Vein Man and the Zodiac Man on f. 5r are integral parts of this medical reference book since they provided information necessary to the medieval physician for the prognosis and treatment of ailments. To modern minds the two illustrations encapsulate medieval beliefs that man was a microcosm within the fixed celestial cosmos and that his physical well-being was governed by astronomical forces.

The Ballarat manuscript should be added to a small group of fifteenth-century portable calendars, discussed by H. Bober, which also contain twin illustrations of the Vein Man and Zodiac Man. They are London B.L. MSS.Add.28725, Harley 5311, Stowe 1065. Among Bober's collection of illustrated material, several examples depict the Vein Man within a series of concentric circles, a configuration which was intended by the medieval authors to connote Man as Microcosm, within the Macrocosm. The Ballarat version belongs in the same category.[1]

As Bober pointed out, such folded calendars were often contained in cases, an example of which has been described in a recent Sotheby catalogue. The Ballarat manuscript with its rounded vellum tab was in all probability similarly endowed.[2]

The saints marked for veneration indicate that the calendar was executed for a patron who lived in north-eastern England. The manuscript was presented by Colonel the Honourable R. A. Crouch to the Ballarat Fine Art Gallery in 1944.

Bibliography: Sinclair (1969), pp.274-275; Sinclair (1968), p.36, pl. xii.

Notes

1. H. Bober, 'The Zodiacal Miniature of the Très Riches Heures of the Duke of Berry – its Sources and Meaning' in *Journal of the Warburg and Courtauld Institutes*, Vol. XI, 1948, pp. 1–34. Bober points out that M. R. James had earlier described another manuscript of the same class formerly belonging to Samuel Pepys (see p. 26, n. 6. In connection with the Ballarat Vein Man, see especially Pl. 3 c, d).
2. Sotheby (1982), pp. 100–102.

Plate 28, figs. 96–103

No. 45. Guillaume de Deguilleville, *Pilgrimage of the Life of Man* and *Pilgrimage of the Soul* (anonymous adaptations).
English, Latin and French
Lincolnshire, mid-15c.
State Library of Victoria, *096/G94

Vellum, 265 x 185. A old paper + 217 + B old paper. I–IX¹⁰, X⁵ (1 and 5 are conjugates with 2, 3, 4 separate leaves sewn between), XI–XXII¹⁰, XXIII². Catchwords agree; quire signatures. Modern foliation. Script: mid-15c. English cursive book hand in brown ink with rubrics, chapter numbers and some marginal notes in red. There are two scribes. The main hand was responsible for all except ff. 96r and 96v. His name 'Benett' is written on ff. 77v, 95v and 215v; the initial 'B' appears on f. 125v. Ruling: brown ink; 17.[128].40 x 16.5.[179].5.60. Lines of text: 34. Ruling unit: 5.5. Edges trimmed but prickings still visible. Binding: 17c. calf over boards.

Ownership: Folio 1r has the name 'Cawsod' in a 15c. hand. Folios 1r and 215v bear the signature of Sir John Roucliffe, Kt. Folio 212v has the name 'Arfferton' (?). There are brief notes referring to the text in a 16c. hand on f. 216r and on f. 217v in a 17c. hand. Inside the front cover is the bookplate of the Clifford family and the motto *Semper Paratus*. On Bv is 'Felton Bequest 19.12.36'.

Text: English, Lincolnshire dialect. Marginal glosses in Latin; scrolls in Latin, French and English. Contents: ff. 1r–95v *Pilgrimage of the Life of Man* with the rubric on f. 1r: 'Here bigynnes ye prologue opoun ye buke whilk is named Grace dieu translate out of ffraunch in to ynglyssh as it folowes'; ff. 96r–215v *Pilgrimage of the Soul*.

Decoration: Some letters throughout the text are touched with red. Fifteenth-century English-style blue initials ranging from one to three lines high with red pen-work mark sections of the text. From the larger of these initials which head chapter divisions extend long red marginal flourishes (Plate 28).

Sixty-eight unframed pen and ink drawings, nine to sixteen lines high and fully the width of a column of text, are interspersed throughout the manuscript. Usually they are situated above a rubric, although sometimes the rubric precedes the illustration. These drawings seem to be in the same ink as the text. Scrolls designed to identify the figures

or the action appear in most of the compositions. They have been left blank, however, from f. 49r on (except for f. 92r). Up to f. 57r some of the drawings are tinted red, brown, yellow, dark green and blue; several of these appear to have been left unfinished (Plate 28). All later drawings are in pen and ink only.

Programme of Illustration: The drawings follow closely the literal meaning of the section of the text which they accompany. For the *Pilgrimage of the Life of Man* the subjects of the thirty-five scenes are as follows: f. 1r Vision of the New Jerusalem (fig. 96); f. 2v Grace Dieu appears to Pilgrim; f. 4r Grace Dieu leads Pilgrim to her house; f. 7r The sacrament of matrimony: Moses gives the tonsure; f. 8v Grace Dieu with Moses who ordains priest; f. 11v Grace Dieu and official with Moses who administers the sacrament of the Eucharist; f. 13r Dame Nature argues with Grace Dieu; f. 15v Pilgrim sees Dames Charity and Penance with Moses; f. 18r Charity between two trees (Plate 28); f. 20r Moses and official administer the sacrament of the Eucharist; f. 22r Dame Nature with Aristotle and Sapientia; f. 25r Grace Dieu presents Pilgrim with staff and scrip; f. 28r Grace Dieu shows Pilgrim his armour; f. 34v Pilgrim meets Memory; f. 36r Pilgrim with Dame Reason and the churl Rude Intent; f. 40r Pilgrim is led by Dame Reason; f. 45v Pilgrim meets Labour and Idleness at a forked road (fig. 97); f. 47r Labour wields a spade (his scroll reads 'Labor e occupato'), Pilgrim is led by Idleness; f. 49r Sloth captures Pilgrim with leg rope; f. 51r Pilgrim is accosted by Pride, who rides on the shoulder of Flattery; f. 57r Pilgrim meets Envy, on whose back ride Treason and Detraction; f. 61r Pilgrim meets a hag, Ire; f. 63r Pilgrim meets Avarice, a huge monster with many arms; f. 70v Pilgrim meets Gluttony and Venus riding a sow; f. 74r Grace Dieu enters: Pilgrim kneels to the Virgin; f. 78r Grace Dieu shows Pilgrim the Rock of Penitence (fig. 98); f. 79r Pilgrim crossing a sea is confronted by Satan and Heresy; f. 81v Pilgrim meets Maid Youth; f. 84v Youth carries Pilgrim on her back across the sea; f. 85r Pilgrim is rescued by Dame Tribulation who rides the waves (fig. 100); f. 86r Grace Dieu escorts Pilgrim to the Ship of Religion; f. 88r Pilgrim meets Discipline, Poverty and Abstinence; f. 90v Pilgrim is met by two messengers; f. 92r Infirm Pilgrim is met by Misericordia holding a rope noose; f. 93r Death climbs on to Pilgrim's bed, Grace Dieu and cross appear behind him.

The Pilgrimage of the Soul is illustrated by the following thirty-three scenes: f. 97v Soul is conveyed by guardian angel to the Judgment Seat: devil is behind; f. 100r Soul before the Judgment Seat; f. 110r Sinderis, the Worm of Conscience; f. 111r Justice at the court speaks against the Soul; f. 116r Mercy pleads for the Soul; f. 118r Mercy questions Justice; f. 120v Justice, Reason and Truth pray for release of souls; f. 123r Council is held between accessories and the judge; f. 124v Angels lead souls to Paradise; f. 127r Soul moves towards Paradise, with angels making music;

f.129r Hell mouth, souls with fiends; f.130r Souls are led to Hell; f.133r Prayers of Holy Church comfort souls in Purgatory; f.134r Angels apply the ointment of grace; f.136r Soul is shown fire of Purgatory; f.139r Angel with soul in Purgatory; f.140r Soul chained to a table and its cruel executors; f.140v Guardian angel shows Soul field of dead bodies; f.143v Soul is shown disputation among fiends; f.146r Hell-torments; f.147v Spiked wheel, torment for committers of treason; f.149v Torment for robbers and usurers; ff.150v, 151v, 152r more Hell-torments; f.154r The green tree and the dry tree, people beneath with apples (fig. 101); f.161v The two trees; f.166r Vision of asses buried in tombs (fig. 102); f.167v Soul is licked by Lady Doctrine; f.174r Knight on horse-back with statue; f.182v Knight in armour before lady; f.186r Souls led to gate of Heaven; f.206r Adam and Eve and many descendants beneath the tree of Paradise (fig. 103).

Commentary: In 1331 Guillaume de Deguilleville, a French Cistercian monk, composed the allegorical poem *Le Pélerinage de la Vie Humaine*, which he was later to reshape into a much enlarged version. The story, presented as a dream, tells of a pilgrim on the journey of life, participating in the seven sacraments and grappling with the seven deadly sins. His mentor is a beautiful woman, Grace Dieu, who guides him through all his trials until death intervenes. At that point the narrator is awakened from his dream by the monastery bell calling him to matins.

Deguilleville's second allegorical poem, *Le Pélerinage de l'Ame*, composed between 1355 and 1358, continues in the same vein. The soul of the Pilgrim undergoes judgment and is sent to Purgatory, where it has a vision of Hell. Then, helped by its guardian angel, it overcomes torments and perplexities and finally enters Paradise, where it is instructed by St Michael in the meaning of the harmony of the firmament and in the nature of the Trinity. At this juncture the poet is awakened by a burst of light from on high.[1]

The Melbourne manuscript version of de Deguilleville's poems is of unusual literary and art-historical interest. It contains one of the only two extant illustrated English prose adaptations of the *Life* and one of the eight such versions of the *Soul*.

Only the Melbourne book combines both allegories in one volume. There are some indications, however, that it may have been originally designed as a pair of companion volumes. Benett, the main scribe, signed his name when he finished transcribing the *Life*, which ends on f.95v, the last page of the short quire X. The second scribe, who was responsible for only ff.96r and 96v, began the text of the *Soul* on the first leaf of a new quire, leaving space for a rubric and illustration which were never supplied. Benett then resumed his task, signing his name once more on f.215v. Apart from the one blank space on f.96r the programme of illustration is complete and is entirely the

work of one artist. But, given the signatures of Benett at the end of each of the poems, and the fact that the text of the *Soul* begins on a new quire, it is possible that the two works were planned as twin volumes, which were not united in their present state until the seventeenth century re-binding.

A second English version of de Deguilleville's poems exists as a pair of volumes: namely the only other surviving prose rendering of the *Life*, now in Oxford (Bodl. Laud Misc. MS. 740), and a copy of the *Soul*, now Spencer MS. 19 in the New York Public Library, both dated *c*.1430. This set was probably made for a patron who lived in Lincolnshire. While the reason for the temporary change of scribes in the Melbourne book is not known, both wrote in Lincolnshire dialects; hence this work too was probably produced near Lincoln.[2]

Nevertheless, despite this common northern provenance, the extensive and consistent system of illustration in the Melbourne manuscript bears no relationship to the Oxford–New York work, nor indeed to any of the other extant English versions of the *Soul*. Some features suggest that the artist may have had access to an illustrated continental example. The availability of such models is quite feasible given the trading connections between northern England and the Continent at this time. There are drawings in the *Soul*, for instance, which accompany sections of the text always illustrated in French versions but not in the other English cycles. This is the case with the scene of the angel showing the Soul a field of dead bodies on f.140v, and of Adam and Eve with their descendants under a tree on f.206v (fig. 103). In the *Life*, too, are compositions which seem to be based on an earlier Continental prototype. If we compare, for example, 'Grace Dieu showing Pilgrim the Rock of Penitence' on f.78r (fig. 98) with the same scene in a French miniature accompanying a printed edition of *Le Pélerinage de la Vie Humaine* of 1499 (fig. 99) it is clear that both artists worked from a similar model when interpreting the allegorical text, although the result is very different in each case. Indeed, such a comparison highlights the curiously individual style of the artist of the Melbourne manuscript.[3]

His vigorous and confident drawings emphasize expressive line and contour and there is little attempt to model form. Colour, where it is applied, only varies and enlivens the surface plane of the composition (Plate 28). There is virtually no sense of illusionistic depth, and apart from a few schematic trees, backgrounds are neither articulated nor implied (fig. 101). Often the pictures are naïve conceptions characterized by the robust qualities of folk art. When Pilgrim meets Labour and Idleness at a forked road on f.45v (fig. 97), since the pathways do not recede, the encounter takes place as though on a map. Again, in the *Soul*, the allusion to the tombs of asses on f.166r is accompanied by an oddly flat design (fig. 102), almost a caricature, which gives no sense of a churchyard space as occurs in other

versions. An amusing example of the artist's literal approach to the text appears in 'Tribulation riding the waves' on f.85r (fig. 100), where the Dame is shown actually seated astride the water.

It is clear that this manuscript was produced according to orthodox workshop procedures; that is, the text was written first, with the scribe leaving marginal directions for the flourisher, for beside each decorated initial there remains a tiny guiding letter. The drawings must have been added later since they overlap the red marginal flourishes in places. Despite this clear ordering of activities, however, the uniform nature of the ink used for the text and the drawings, together with their labelled scrolls, does not preclude the possibility that scribe and artist may have been the same person, particularly since the artist as such seems an amateur. No other example of his work is known.[4]

Inscribed scrolls (which the artist evidently grew tired of completing) do not appear in the other English versions of the *Life* and the *Soul*. They are features, however, of contemporary English wall paintings, and the illustrator could have borrowed this idea from the monumental medium.

The manuscript, made from tough and partly faulty vellum, was clearly not designed as a sumptuous object, unlike its richly decorated counterpart in Oxford and New York. It could have been produced for a north-country parson, one of the many who turned to such devotional literature for material to enliven their sermons. It is tempting to speculate as to whether the name 'Cawsod' on f.1r refers to the original owner. Since later in the century the manuscript belonged to Sir John Roucliffe of Cowthorpe, South Yorkshire, whose signature appears on ff.1r and 215v (fig. 96), Sinclair has suggested an alternative hypothesis: namely that the book may have been made for Guy Roucliffe, Sir John's grandfather, who died in 1460. Sir Brian Roucliffe, presumably heir to his father Guy's possessions, bequeathed his library to his son John in 1495.

It is not known when the book entered the library of the Clifford family of Chudleigh, nor for how long it remained with them. It was acquired through the Felton Bequest for the State Library of Victoria in 1936 from the bookseller, W. H. Robinson.

Bibliography: Sinclair (1969), pp.364–368; Maddocks (1980); Sinclair (1964b), p.235; (Felton, 1938), pp.9–10; Smalley (1954); (Victoria, 1956), p.91; Robbins and Cutler (1965), pp.xix, 6, 28, 29, 30, 60, 121, 145, 146, 154, 181, 204, 263, 277, 280, 281, 289.

Notes

1. For de Deguilleville, see E. Farfal: 'Guillaume de Deguilleville, Moine de Chaalis' in *Histoire Littéraire de la France*, T.XXXIX, Paris, 1962, pp.1–132; S. L. Galpin, 'On the Sources of Guillaume de Deguilleville's Pélerinage de l'Ame' in *Publications of the Modern Language Association*, Vol. XXV, 1910, pp.275–308; R. Tuve, *Allegorical Imagery*, Princeton, 1966, pp.155–161.

2. See Pächt and Alexander (1973), no. 925, p.81.

3. Michael Camille, Department of History of Art, University of Cambridge, has kindly supplied information on the manuscripts of the *Soul*. He is preparing a doctoral thesis on the subject.

4. This is confirmed by Kathleen Scott, who is preparing a comprehensive work on fifteenth-century English illumination.

Plate 29, fig. 104

No. 46. *Book of Hours*. Use of Sarum. Latin and English
England, first half of 15c.
National Library of Australia, Canberra, Clifford
 Collection, MS. 1098/2

Vellum, 142 x 95. A modern paper + B–D contemporary vellum + 166 + E contemporary vellum + F modern paper. I[12], II–XIII[8], XIV[6], XV–XX[8], XXI[4]. Catchwords agree. They are not confined to the ends of gatherings but often appear on succeeding leaves. Script: 15c. gothic liturgical hand in brown ink, with red rubrics, calendar in red and brown. Ruling: brown ink: 16.[50].29 x 22[76]44. Lines of text: 17. Ruling unit: 4. Calendar: 11[5.4.5.6.42]. 22 x 22[76]. 44. Lines of text: 16 or 17. Ruling unit: 4–5. (uneven). Folios 89v–92v and 166r–166v are blank. Prickings in many outer margins. Binding: 15c. English, with modern strap and clasp.

Ownership: 'Liber John Vernelli' is written in a 16c. hand on f.165r; f.166r has 'Liber Johannis' with surname effaced. Excerpts from prayers in a 16c. hand appear on Dr and f.164v and in another 16c. hand on f.89r.

Text: Latin, with the prayer 'Fifteen O's' in English. Contents: ff.1r–12v calendar with special feast days in red including translation of St Hugh of Lincoln (6 October), St Edmund (16 November) and St Thomas of Canterbury (29 December); regular entries include numerous English saints with no specific regional emphasis; St Gilbert of Sempringham has been added in a later hand; ff.13r–52v Hours of the Virgin. The following commemorations and suffrages occur at lauds: f.29v St Michael; f.29v St Thomas of Canterbury; f.30r St John the Baptist; f.30v St Peter; f.30v St John the Evangelist; f.31r St Lawrence; f.31v St Nicholas; f.31v St Catherine; f.32r St Margaret; f.32r All Saints; f.33r For Peace; ff.53r–54v *O intemerata*; ff.55r–57v *Obsecro te*; ff.58r–89r additional prayers, including prayers to the wounds of Christ on ff.61r–65v; ff.93r–104v penitential psalms; ff.105r–111v litany, including SS. Birinus, Afra, Edith and Prisca; ff.112r–148v Vigils of the Dead; ff.149r–165v commendations of souls.

Decoration: Three types of illuminated initials and a series of borders are the chief decorative elements of this manuscript. They are systematically applied to emphasize the hierarchical ordering of the text. Numerous one-line blue or gold initials with contrasting red or blue pen-work mark the beginning of verses and sentences. There are blue and gold line-fillers and line-endings with spiralled patterns in

Fig. 65. Initial 'P'. No. 29, f.7v. (detail)

Fig. 64. Initial 'B'. No. 28, f.1v. 135 x 100

Fig. 66. Martyrdom of St Lawrence. No. 30. 68 x 90

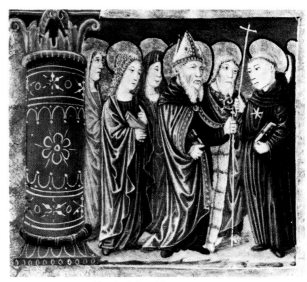

Fig. 67. Saints. No. 30. 78 x 90

Fig. 68. Hadrian. No. 31, f.1r. (detail)

Fig. 69. Julius Capitolinus.
No. 31, f.10v. (detail)

Fig. 70. Verus. No. 31, f.22v. (detail) Fig. 71. Diademeneus. No. 31, f.62v. (detail)

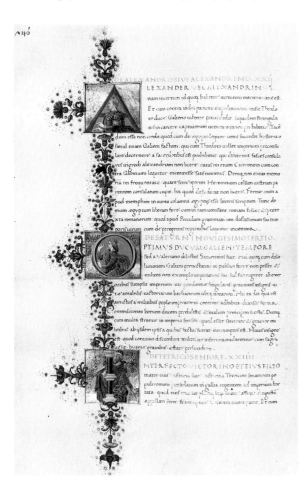

Fig. 72. Victorinus Senior. No. 31, f. 117r. (detail)

Fig. 73. Titus and Censorius. No. 31, f. 125v. 378 x 250

Fig. 74. Alexander, Saturninus and Tetricus. No. 31,
f. 122v. 378 x 250

Fig. 75. Initial 'T'. No. 32, f. 12r. (detail)

Fig. 76. Annunciation. No. 33, f. 16v. 147 x 100

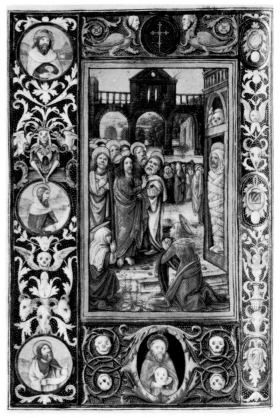

Fig. 77. Raising of Lazarus. No. 33, f. 136v. 147 x 100

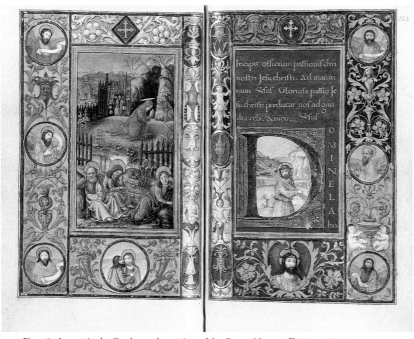

Fig. 78. Agony in the Garden and carrying of the Cross. No. 33, ff. 187v–188r. 147 x 200

Fig. 79. Pentecost. No. 33,
f. 223r. 147 x 100

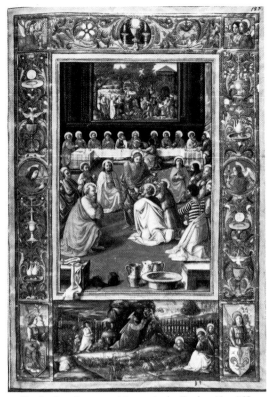

Fig. 80. Last Supper and Agony in the Garden. Vat. MS. Barb. lat. 610, f.185r. 390 x 280

Fig. 81. Musical diagrams. No. 35, f.7r. 305 x 210

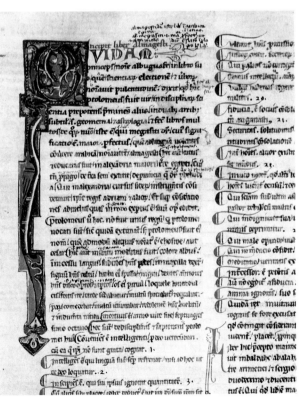

Fig. 82. Initial 'Q'. No. 36, f.1r. (detail)

Fig. 83. Author portrait. No. 37, f.30r². (detail)

Fig. 84. Initial 'P'. No. 38, f.40v. 183 x 128

Fig. 85. Initial 'Q'. No. 39, f.1r. (detail)

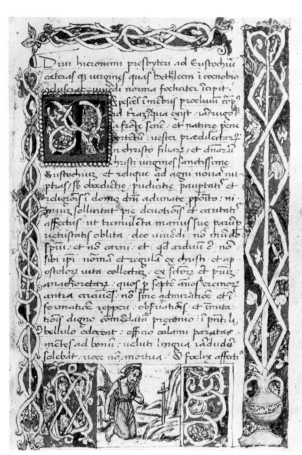

Fig. 86. Title page. No. 40, f.1r. 140 x 100

Fig. 87. St Benedict. No. 41. 270 x 200

Fig. 88. *Beatus* page. No. 43, f.1r. 100 x 67

Fig. 89. Massacre of the Innocents. Oxford, Bodl. MS. laud misc. 3A, f.42v. 115 x 75

Fig. 90. David pointing to his eyes. No. 43, f.11r. (detail)

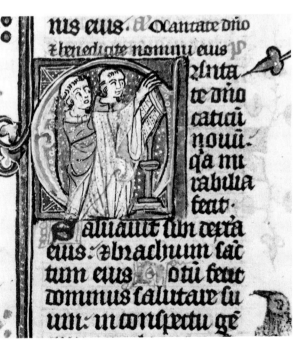

Fig. 91. Chanting clerics. No. 43, f.42r. (detail)

Fig. 92. Crucifixion of St Andrew. No. 43, f.77r. (detail)

Fig. 93. Pentecost. Oxford, Bodl. MS. laud misc. 3A, f.145v. (detail)

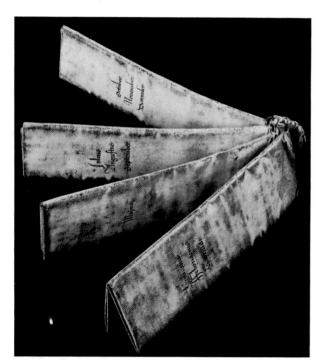

Fig. 94. Folded calendar. No. 44

Fig. 95. Calendar. February, March.
No. 44, f.1v(b). 264 x 164

Fig. 96. Vision of the New Jerusalem. No. 45, f.1r. 265 x 185

Fig. 97. Pilgrim meets Labour and Idleness. No. 45, f.45v. 265 x 185

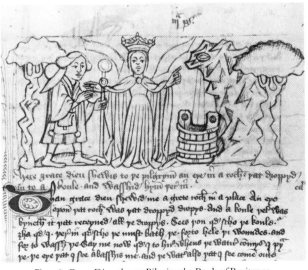

Fig. 98. Grace Dieu shows Pilgrim the Rock of Penitence.
No. 45, f.78r. (detail)

Fig. 99. Grace Dieu shows Pilgrim the Rock of Penitence. *Le Pélerinage de la Vie Humaine*, Verard edition, Paris, 1499. (detail)

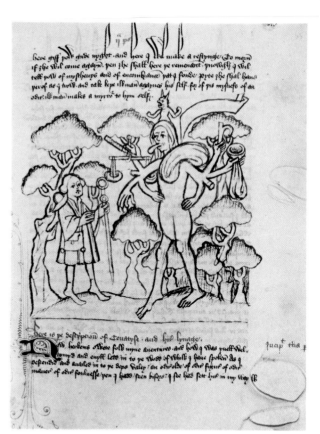

Fig. 100. Pilgrim rescued by Dame Tribulation. No. 45,
f.85r. 265 x 185

Fig. 101. The green tree and the dry tree. No. 45, f.154r. 265 x 185

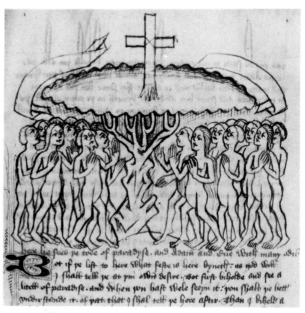

Fig. 102. Vision of asses buried in tombs. No. 45, f.166r. (detail)

Fig. 103. Tree of Paradise. No. 45, f.206r. (detail)

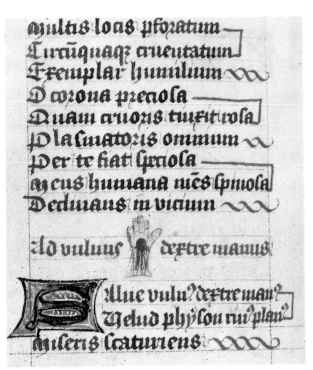

Fig. 104. Wound of Christ. No. 46, f.63r. (detail)

Fig. 105. Initial 'A'. No. 47, f.1r. (detail)

Fig. 106. Initial 'E'. No. 48, f.31r. 270 x 135

Fig. 107. Initial 'D'. No. 49, f.25r. 182 x 125

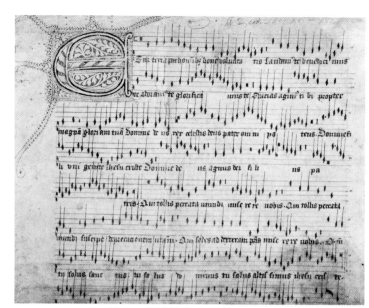

Fig. 109. Initial 'E'. No. 51. 218 x 320

Fig. 108. Initial 'S'. No. 50, f.43r. 228 x 148

Fig. 110. Initial 'M'. No. 52, f.15r. (detail)

Fig. 111. Initial 'D'. No. 53, f.131v. 136 x 90

Fig. 112. St John the Baptist. No. 54, f.15r. 195 x 140

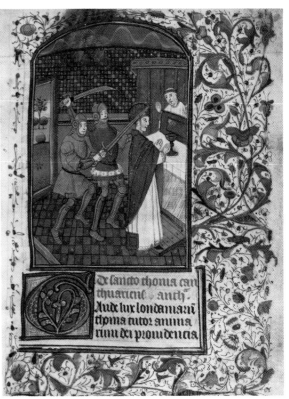

Fig. 113. St Thomas of Canterbury. No. 54, f.16r. 195 x 140

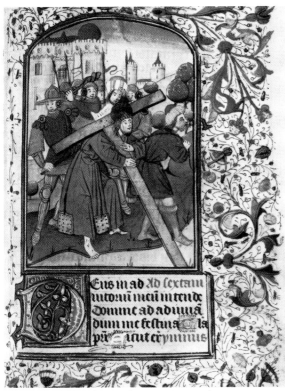

Fig. 114. Christ bearing the Cross. No. 54, f.44r. 195 x 140

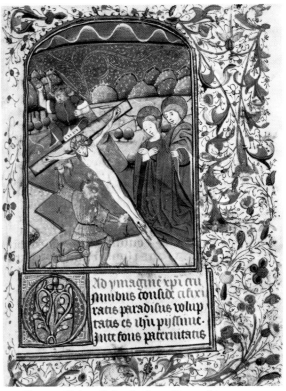

Fig. 115. Christ nailed to the Cross. No. 54, f.65r. 195 x 140

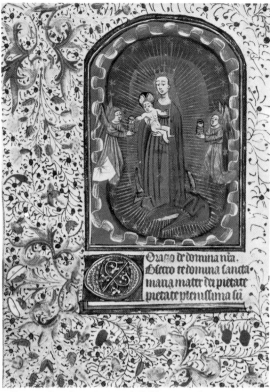

Fig. 116. Standing Virgin and Child. No. 55, f.24v. 188 × 132

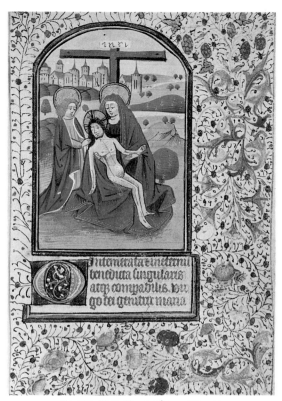

Fig. 117. Pietà. No. 55, f.27r. 188 × 132

Fig. 118. Annunciation. No. 55, f.37r. 188 × 132

Fig. 119. Visitation. No. 55, f.49v. 188 × 132

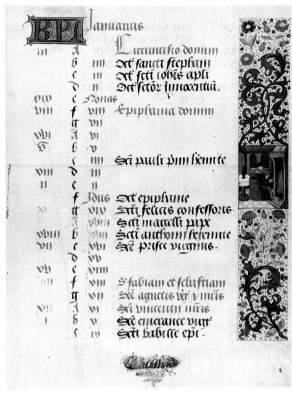

Fig. 120. January. No. 56, f.1r. 345 x 235

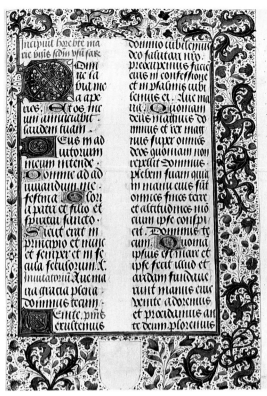

Fig. 121. Hours of the Virgin: matins. No. 56, f.13r. 345 x 235

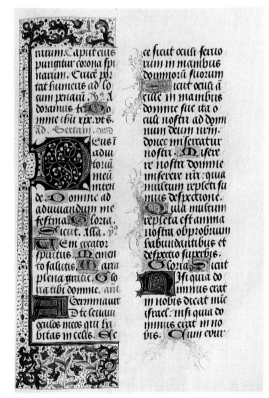

Fig. 122. Hours of the Virgin: sext. No. 56, f.26r. 345 x 235

Fig. 123. Litany. No. 56, f.40r. (detail)

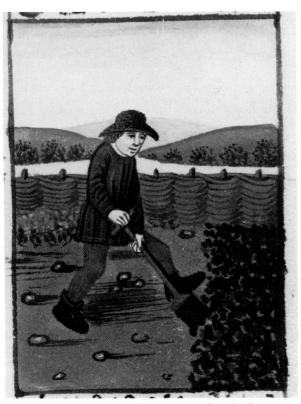

Fig. 124. March: man digging. No. 56, f.3r. (detail)

Fig. 125. April: man holding flowers. No. 56, f.4r. (detail)

Fig. 126. June: man scything. No. 56, f.6r. (detail)

Fig. 127. November: man gathering acorns. No. 56, f.11r. (detail)

red ink. Two-line gold initials on blue and rose-red cusped rectangular grounds with white pen-work introduce individual psalms, prayers etc. Eleven illuminated initials, three to six lines high, preface the main divisions of the text. These are of pomegranate or pine-cone design, in bright blue, green, orange, red and white on burnished gold grounds. They are accompanied by borders composed of feathered sprays terminating in gold or green circlets, interspersed with heavy pink and blue acanthus scrolls modelled with white highlights. A full border introduces matins for the Hours of the Virgin on f.13r (Plate 29).

Simpler panel borders together with illuminated initials preface the following sections: f.21r lauds; f.31v commemoration of St Nicholas, f.38v tierce; f.41r sext; f.43r none; f.45v vespers; f.48r compline; f.53r *O intemerata*; f.93r penitential psalms; f.149r commendation of souls. On ff.62r–64v, prayers in honour of Christ's Passion are illustrated by seven schematic drawings outlined in brown ink and often streaked with red (fig. 104).

Programme of Illustration: The subjects of the schematic drawings, the only illustration in this manuscript, are as follows: f.62r a cross: prayer to the sacred wood of the Cross; f.62r Crown of thorns: prayer to the Crown of thorns; ff.62v and 63r a hand: prayer to the wounded right and left hands of Christ respectively; f.63v a heart: prayer to the bleeding heart of Christ; ff.64r and v two feet: prayers to the wounds in the left and right feet of Christ.

Commentary: This Book of Hours, still in its original binding, is a good example of early fifteenth-century English illumination. The heavy acanthus forms of the borders, and bright colouring of the initials indicate a probable date of *c.*1420–1430 for its execution. Since the saints listed in the calendar and litany were widely venerated throughout England, and the Sarum liturgical use predominated, the text provides no guide to the precise origins or destination of the book. Its good quality but limited range of decoration is likewise based on widespread models. The prayers to the wood of the Cross and the wounds of Christ etc. often feature in devotional works of this period made for English clients either locally or in Netherlandish workshops. They are more amply illustrated in No. 57 of this catalogue.[1]

Before its purchase by the National Library of Australia in 1964, this volume belonged to the Clifford family of Chudleigh. Apart from the references noted above to 'John Vernelli' nothing further is known of its provenance.

Bibliography: Sinclair (1969), pp.15–18.

Note
1. For a discussion of medieval English devotional practices, related to the physical suffering of Christ, see W. Sparrow Simpson 'On the Pilgrimage to Bromholm in Norfolk' and 'On the Measure of the Wound in the Side of the Redeemer' in *Journal of the British Archaeological Association*, Vol. 30, 1874, pp.52–61; 357–374.

English Short Entries

Fig. 105
No. 47. Eadmer, *Life of St Wilfrid*; Bede, Excerpt from *Historia Ecclesiastica*. Latin
England, mid-12c.
Ballarat Fine Art Gallery, Victoria, MS. Crouch 10

Vellum, 225 x 160. A–C modern paper + 37 + D–F modern paper. One initial on f.1r in red, blue and green (fig. 105).

Bibliography: Sinclair (1969), pp.285–287; de Ricci and Wilson (1936–1940), Vol. II, p.1997; Sinclair (1962), p.337; (Sydney, 1967), pp.11–12.

Fig. 106
No. 48. *Statutes of England*; Britton, *Registrum Parvum*; Radulphus de Hengham, *Summa Parva*; *Fet Asaver*. Latin and French
London, 1333
State Library of Victoria, ★091/G79

Vellum, 270 x 175. A–B modern paper + 166 + C–D modern paper. Illuminated initials in blue and pink patterned with white tracery on gold grounds with ivy-leaf border extensions, sometimes with grotesques and tendril or floral motifs (fig. 106).

Bibliography: Sinclair (1969), pp.376–381; Sinclair (1965c), pp.250–251.

Fig. 107

No. 49. *Vigils of the Dead* (fragmentary), *liturgical psalter and canticles* (fragmentary)

England, late 14c.

State Library of South Australia

Vellum, 182 x 125. A–B modern vellum + 88 + C modern vellum. One-line blue initials, flourished in red, pink, green and gold patterned with white tracery and with infills of foliate and interlaced tendril design mark liturgical divisions of the psalter on ff.16v, 25r, 40r, 49v, 58v and 69v. From the initials extends a three-sided bar border in the same colours with grotesques and ivy-leaf clusters; it terminates on the fourth side in sprays of leaves and flowers (fig. 107).

Bibliography: Sinclair (1969), pp.246–247.

Fig. 108

No. 50. *Psalter, with canticles, litany and Vigils of the Dead.* Latin

Southern England, late 14c.

National Library of Australia, Canberra, Petherick Collection, MS. 1172

Vellum, 228 x 148. A contemporary vellum + 111. One-line initials in blue and red, flourished in the alternate colour and line-fillers in blue and red. Two-line initials in gold, blue and red introduce each psalm. Double initials 'KL' in gold, red and blue introduce calendar pages. Five-line initials in blue or pink with white tracery and foliate and bud infills on gold grounds mark liturgical divisions of the psalter on ff.7r, 22r, 43r, 54r, 63v and 74r. Three-sided bar borders of the same colour extend from these initials. They are decorated with spiky ivy-leaf branches and floral buds. The borders develop on the fourth side of the page into sprays of spiky ivy-leaves (fig. 108). One page with decorated initial and border is missing before f.35r.

Bibliography: Sinclair (1969), pp.9–10.

Fig. 109

No. 51. *Choirbook* (fragment). Latin

England, early 15c.

National Library of Australia, Canberra, Rex Nan Kivell Collection MS. 4052/2/1

Vellum fragment of one folio with polyphonic music on six staves of gloria. A pen-flourished initial 'E' introduces the cantus E*t in terra* (fig. 109). Other fragments of the same manuscript are located in Oxford (Magdalen College, MS. 267, ff.89–92; Bodleian Library, University College MS. 192, and MS. Don B. 31); and Cambridge (University Library MS.Add.5963). The four leaves now at Magdalen College were all taken from books bound by the Nether-landish binder Nicolas Spierinck, who worked in Cambridge between 1505/6 and 1530. According to Margaret Bent, the original manuscript included polyphonic settings of the ordinary of the Mass, antiphons and isorhythmic motets. Of the Mass settings, no kyries have yet appeared; the above fragment in the National Library of Australia contains the only glorias; credo settings are among the Oxford and Cambridge fragments; no sanctus has yet appeared, but the recent acquisition by the Bodleian Library is from an agnus dei. The antiphon fragments are at Oxford, and the motet fragments at Cambridge. A fragment of one of the motets was offered for sale at Sotheby's in April 1983. Initials with similar decoration may be seen in two credo *incipits* (Oxford, University College MS. 192, f.27ar, and Cambridge, University Library, MS.Add.5963 (8) r) reproduced in the article 'Sources, MS. I,6' by Stanley Boorman in *The New Grove Dictionary of Music and Musicians*, London, Macmillan, 1980.

J. A. Stinson

Bibliography: Bukofzer (1958), pp.1–18; Bent (1974), pp.257–262; Anderson and Dittmer (1981), pp.1–2; Sotheby (1982), p.8; Sotheby (1983), p.176; Stinson (1982).

Fig. 110

No. 52. *Gospels*, Vulgate; Nicolas de Lyra O.F.M., *Postillae Litterales in Evangelia; Theological Treatise* (fragment); *Commentary on Gospel of St Mark* (fragment). Latin

England, early 15c. (1436?)

Fisher Library, University of Sydney, New South Wales, Nicholson 1

Vellum, 386 x 270. A–C 18c. paper + D–G contemporary vellum + 246 + H contemporary vellum + I–K 18c. paper. There are five distinct English scribes.

The last two fragments are undecorated. The gospels and treatise of Nicolas de Lyra have initials in red and blue decorated alternately with blue and red pen-work. One illuminated initial remains, three others have been excised. This initial introduces St Mark's Gospel on f.15r. It is in burnished gold on a blue ground with pink and white infills and a tendril border extension with gold circlets and blue and white buds (fig. 110).

The treatise of Nicolas de Lyra has an *explicit* with the date 1436 and the signature of the religious, Robert Makworth, who borrowed his exemplar from Wystan Porter of the Augustinian Priory of the Holy Trinity at Repton.

Bibliography: Sinclair (1969), pp.171–175; Sinclair (1964a), pp.369–370; (Sydney, 1967), p.14.

Fig. 111
No. 53. *Prayer-book*. Latin
England, 15c.
National Library of Australia, Canberra, Clifford
 Collection, MS. 1097/7

Vellum, 136 x 90. A–B 17c. paper + C contemporary
vellum + 209 + D–E 17c. paper.
 There are two scribes. The second hand begins on f.130r.
This section contains the penitential psalms, litany, Vigils
of the Dead and variations for the Hours of the Virgin,
devotions regularly associated with a Book of Hours. The
litany indicates the use of Sarum. One-line blue and red
initials throughout. Two-line initials introduce psalms etc.
They are in blue or red, finely flourished in the alternate
colour with elaborate marginal extensions. Five-line initials
in blue and red, with yet more elaborate flourished designs
forming border extensions, introduce major divisions of
the manuscript, for example, the penitential psalms on
f.131v (fig. 111).

Bibliography: Sinclair (1969), pp.34–35.

Netherlandish Manuscripts

Plate 30, figs. 112–115

No. 54. *Book of Hours.* Use of Sarum. Latin

Southern Netherlands, *c.*1450–1470

National Library of Australia, Canberra, Clifford
 Collection, MS. 1097/9

Vellum, 195 x 140. A–B modern paper + 126 + C–D
modern paper. I⁴, II², III–IX⁸, X¹⁰, XI–XV⁸, XVI (wants
5), XVII (wants 7). Catchwords agree. Folios 72v and 126v
are blank. Prickings in outer margins. Script: 15c. gothic
liturgical hand in black ink, with red rubrics; calendar in
red and black. Ruling: red ink: 22.[75].43 x 22.[115].58.
Lines of text: 21. Ruling unit: 5.5. Calendar: 22.[9.3.9.54].
43 x 27.[118].50. Lines of text: 33. Ruling unit: 4. Binding:
16c. calf with spine and edges repaired.

Ownership: On f.1r in a 16c. hand against 10 January is
Natales mei Tho. Ravi; on f.5r in another 16c. hand against
18 September is 'Richard Ravenhill, died *ora pro ...*'; on
f.21v in a later hand was 'Ioannis(?) Salisbury', now almost
erased. On f.126r in a 16c. hand is *Henricus octavus dei gratia
Anglie ffrancie ... uis harford salutem. Precipimus tibi quod
uenire, facias coram Baronibus de scaccario ...*

Text: Latin. Contents: ff.1r–6v calendar with special feast
days in red, including SS. Augustine, Eligius (twice),
Thomas of Canterbury (twice), Cuthbert, Remigius and
Bavon, Hugo, Edward the Confessor, Edmund (bishop),
and Edmund (king); feasts in black include the translation
of St Hugo of Lincoln, the translation of St Cuthbert; SS.
Guthlac, Alphegius, Oswald, John of Beverley, Swithin,
Firmin, Bertin and Bavo; ff.7r–12v the fifteen O's; ff.13r–
23v prayers in honour of the Trinity, SS. John the Baptist,
Thomas of Canterbury, George, Christopher, Anne, Mary
Magdalen, Catherine and Barbara; ff.24r–52r Hours of the
Virgin *secundum usum anglorum* with short Hours of the
Cross inserted at the end of each hour from lauds on;
commemorations of the following are included at lauds:
Holy Ghost, Trinity, the Cross, SS. Michael, John the
Baptist, Peter and Paul, Andrew, Lawrence, Stephen,
Thomas of Canterbury, Nicholas, Mary Magdalen,
Catherine, Margaret, All Saints and prayer for peace;
ff.52v–72v hymns and devotions, including texts in
honour of the Virgin, and the Passion; ff.73r–77v peniten-
tial psalms; ff.78r–78v psalms of degrees; ff.79r–85v litany,
including SS. Edward the Confessor, Cuthbert, Swithin,
Alphege, Scholastica, Gertrude of Nivelles, Ursula and
Apollonia: Vigils of the Dead; ff.86r–102r commendation
of souls; ff.112v–116v psalms for the Passion; ff.117r–125v
psalter of St Jerome (lacks first and last folios).

Decoration: Two-line dentelle initials and line endings in
blue or red and gold are a consistent part of the textual
decoration. The main divisions of the text are introduced
by foliate initials, five lines high, beneath the large minia-
tures. Bracket-left or bracket-right borders decorate pages
containing small miniatures; full borders surround the large
miniatures. Borders consist of botanical motifs and slender
sprays of acanthus in red, pink, blue and green, inters-
persed with long, spidery, black curlicues pointed sparing-
ly with gold. Small square miniatures six lines high (30 x
30), and large miniatures, gently arched at the top (96 x 70)
have gold and black ruled frames. The apical arches are
serrated. Miniatures are painted in shades of blue, grey,
green, scarlet, dull pink, yellow (used sparingly) and white.
Burnished gold is used for haloes and some background
details. Three types of background are present: naturalistic
blue skies paling towards the horizon (Plate 30, fig. 112);
diapered patterns of gold, blue and red (fig. 113); pink
backgrounds with gold scrolls or squares (fig. 115).

Programme of Illustration: The first ten of the twenty-six
large miniatures introduce prayers to Christ, the Trinity
and the saints, as follows: f.7r Christ, standing, with orb:
fifteen O's; f.13r the suffering Trinity; f.15r St John the
Baptist (fig. 112); f.16r martyrdom of St Thomas of
Canterbury (fig. 113); f.17v St George; f.18v St Christ-
opher; f.20v St Anne; f.21r St Mary Magdalen; f.22r St
Catherine; f.23r St Barbara (Plate 30).

The subjects of the remaining large miniatures illustrate
the text as follows: f.24r Agony in the Garden: matins for
Hours of the Virgin; f.29v Betrayal: lauds; f.39r Christ
before Herod: prime; f.42r Flagellation: tierce; f.44r Christ
bearing the Cross: sext (fig. 114); f.46r Crucifixion: none;
f.48r Deposition: vespers; f.50r Entombment: compline;
f.53r Virgin and Child: *Omnipotens sempiterne deus qui
gloriose Virginis ...*; f.62r Presentation of Mary in the
Temple: *virgo templum trinitas ...*; f.65r Christ nailed to the
Cross: *Omnibus consideratis paradisis ...* (fig. 115); f.68v
Crucifixion: seven last words of Christ; f.73r Last Judg-
ment: penitential psalms; f.86r burial service: Vigils of the
Dead; f.102r souls carried to heaven in a sheet: commenda-
tions of souls; f.112v instruments of Passion (*Arma Christi*):
psalms for the Passion.

Nine small square miniatures introduce prayers as fol-
lows: f.65v the Cross: prayer to the sacred wood of the
Cross; f.65v Christ crowned with thorns: prayer to the
Crown of thorns; ff.66r, 66r, 66v, 66v and 67r a right hand,
left hand, heart, right foot and left foot streaming blood:
prayers to the five wounds of Christ; f.67r Virgin and

Child: *Maria plasma nati*; f.67v St John the Evangelist: *Iohannes evvangelista tu sacrarii sacrista....*

Commentary: This Book of Hours was made for an English patron, as is indicated by the *incipit* for the Hours of the Virgin, *secundum usum anglorum*, the inclusion of devotions popular in England such as the fifteen O's and the prayers to the wounds of Christ, together with the English saints in both the calendar and litany.[1]

The manuscript, however, is one of the many produced in the Low Countries for the English market. The page layout, script and mode of decoration are all consistent with Flemish productions of the late fifteenth century.[2]

Its programme of illustration, instead of following contemporary French or Flemish models, highlights meditation on the Passion, the Virgin's role as mother of God and the theme of salvation, in keeping with a schema widespread in Books of Hours for the use of Sarum.

The decoration is in the so-called Vrelant style, a title characterizing the products of a Flemish workshop which used well-defined compositional patterns painted in distinctive colours. Fine-quality representatives of this style contain delicately modelled figures based on Flémallian prototypes; the numerous workshop editions which were produced in large numbers for English export as well as for local needs reflect such origins in varying degrees.[3]

The miniature of St Barbara in this manuscript is an example of a standard product of the workshop (Plate 30). The saint's tall, high-waisted figure is boneless, the folds of her robes are sharply angled and her gesture stereotyped. Her round face is characterized by beady black eyes and a small mouth. The selection of colours, too, is typical of the general palette with contrasted hues of cornflower blue and vermilion, slate-blue-grey, dull pink, green and white.

Traditional Flemish compositions are reflected in scenes from the Passion such as the nailing of Christ on the Cross on f.65r (fig. 115) and Christ on his way to Calvary on f.44r (fig. 114). The spike-block worn by Christ is, however, imported from Dutch manuscripts, and its presence is limited, in the main, to Flemish books for the English market. The lantern placed beside John the Baptist on f.15r (fig. 112) is another Dutch motif. By contrast to its Dutch prototypes, however, the accompanying prayer does not refer to the saint as 'lantern for the Lord'.[4] It is possible therefore that this motif was included for English patrons without an understanding of its contextual meaning.

The artist of the Canberra Hours has a limited ability to paint spatial landscapes even when he depicts 'naturalistic' skies with pale horizons. Large foreground figures dominate the scene, and background components – hills, castles, trees, the windmill – are plotted up to the horizon line as decorative motifs (Plate 30, figs. 112 and 114). In landscapes surmounted by outmoded diapered backgrounds, spatial realism is virtually denied (fig. 115). Although interior settings may appear at first glance to be more

realistic, they too contain motifs which are awkwardly co-ordinated. In the martyrdom of St Thomas, for example (fig. 113), the floor tiles do not converge and the diagonally placed altar is not related to the tall canopy behind it.

This conservative approach to space indicates a continued reliance on old-fashioned workshop patterns; and the borders, which are quite sparsely ornamented with botanical motifs by contrast to later examples, are consistent with a date of *c.*1460–1470 for the manuscript.

One of the two folios missing from this Book of Hours preceded f.177r, supplying the introductory text of St Jerome's psalter. In all probability it was illustrated by a miniature depicting the saint.[5]

The early owners whose marks appear on various pages have not been identified and it is not known when the book passed into the Clifford library. The manuscript was bought by the National Library of Australia from the Clifford family in 1964.

Bibliography: Sinclair (1969), pp.35–38; Marrow (1979), p. 227; (Sydney, 1967), p.24.

Notes

1. Sinclair suggests that the book was made in England, but since his study much research has been carried out on the Flemish export of books to England.
2. Examples of these manuscripts are plentiful, especially in English and some American libraries. See, for example, MS. James 54 in M. H. R. James, *Fitzwilliam Museum. Catalogue of Manuscripts*, Cambridge, 1895, pp.134–138. In that manuscript the programme of text and illustration is in most respects identical to that of the Canberra book.
3. See J. D. Farquhar, *Creation and Imitation. The Work of a Fifteenth-Century Manuscript Illuminator*, New York, 1976, for the state of the 'Vrelant' question. The author discusses several high-quality representatives of this style. One Book of Hours in the Walters Library, Baltimore (W. 197), which is mentioned only briefly on p.190, contains apposite examples of well modelled, tall Flémallesque figures.
4. Marrow, *op. cit.*, pp.171, 226–228ff.; *idem*, 'John the Baptist, Lantern for the Lord: New Attributes for the Baptist from the Northern Netherlands' in *Oud Holland*, Vol. 83, 1968, pp.3–12.
5. This was first suggested by J. Pearse, Canberra, who is preparing a thesis on this manuscript.

Figs. 116–119

No. 55. *Book of Hours*. Use of Rome. Latin
Southern Netherlands, *c.*1450–1470
St Patrick's College, Manly, New South Wales, MS. 6

Vellum, 188 x 132. A–B 16c. paper + C–D contemporary vellum + 122 + E–F contemporary vellum + G–H 16c. paper. I⁶, II–XV⁸, XVI⁴. Script: 15c. gothic liturgical hand in black ink with red rubrics; calendar in red and black. Ruling: pale red ink: 22.[68].42 x 24.[106].58. Lines of text: 20. Ruling unit: 5. Calendar 20.[12.3.1.45].51 x 25.[113].50. Lines of text: 34. Ruling unit: 3.5. Binding: old black calf.

Ownership: On Cr–Dv and Fv, in contemporary 15c. hands, prayers are inscribed including the words *me peccatricem et culpabi . . . et indignam et negligentem et obnoxiam.* On Er–Fr and ff.122r–122v are several prayers in Latin and a rubric in Italian in a late 15c. or early 16c. Italian hand. On Gr in a 16c. or 17c. hand there are two brief descriptions of the contents of the book in Italian and then in French. On Br is 'This beautiful vellum ms. of the 14th century was presented to me by Mr. Henry Austin in Jan. 1890 and is now given by me to the library of St. Patrick's College, Manly. Sydney. 10 Feb. 1890. †Patrick Francis Cardinal Moran'.

Text: Latin. Contents: ff.1r–6v calendar; ff.7r–12r gospel sequences; ff.12v–16v Hours of the Cross; ff.17r–20r. Hours of the Holy Ghost; ff.20v–23v Mass of the Virgin; ff.24v–26v *Obsecro te . . .*; ff.27r–28v *O intemerata . . .*; ff.29r–36v commemorations of saints; ff.37r–76r Hours of the Virgin; ff.77r–82r variations; ff.82v–89v penitential psalms; ff.90r–94r litany, including SS. Genevieve, Denis, Gereon, Bavo, Amand, Vaast, Remigius, Eligius, Bertin, Winnoc, Ursula, Gertrude of Nivelles, Audomarus, Quentin and Aldegundis; ff.95–122r Vigils of the Dead.

Decoration: Throughout the text there are blue one-line initials, some with red pen-work, and two-line dentelle initials. Line-endings of blue or pink curlicues with gold dots are used sparingly. Foliate initials, four lines high, introduce the main divisions of the text beneath the large miniatures. A ruled gold-and-black horizontal line separates the text from the lower decorated border. Pages containing small miniatures have bracket-left borders. Large miniatures are surrounded by full borders of similar design, with sprays of acanthus in pink, red and blue with white dotted spines, floral sprigs and occasional strawberries. Their interstices are filled with meandering black hairlines terminated by gold circlets. Small miniatures (50 x 45) are framed by plain gold and black ruled lines. The outer vertical lines extend to the end of the text. Large miniatures (95 x 70) have similar frames. All the miniatures are executed in blue, vermilion, white, grey and green with yellow used sparingly. Burnished gold is used for haloes.

Programme of Illustration: The programme for the twenty large miniatures is as follows: f.7r St John on Patmos; f.8v St Luke; f.10r St Matthew; f.11v St Mark: gospel sequences; f.12v Crucifixion: Hours of the Cross; f.17r Pentecost: Hours of the Holy Ghost; f.20v seated Virgin and Child with two angels: Mass of the Virgin; f.24v standing Virgin and Child with two angels of the Passion: *Obsecro te . . .* (fig. 116); f.27r Pietà: *O intemerata . . .* (fig. 117); f.37r Annunciation: matins for Hours of the Virgin (fig. 118); f.49v Visitation: lauds (fig. 119); f.56v Nativity: prime; f.59v Annunciation to the shepherds: tierce; f.62v Adoration of the Magi: sext; f.65v Presentation: none; f.68v Massacre of the Innocents: vespers; f.73v

Flight into Egypt: compline; f.77r Coronation of the Virgin: variations for the Hours of the Virgin; f.82v Last Judgment: penitential psalms; f.95v funeral service in a church: Vigils of the Dead.

Sixteen small miniatures introduce the commemorations in honour of the saints as follows: f.29r St John the Baptist; f.29v St Peter; f.30r St Paul; f.30v St John the Evangelist; f.31r St Andrew; f.31v St James; f.32r St Stephen; f.32v St Lawrence; f.33r St Vincent; f.33v SS. Cornelius and Cyprian; f.34r St Martin; f.34v St Nicholas; f.35r St Christopher; f.35v St Victor; f.36r St Gregory; f.36v St Barbara.

Commentary: This manuscript is an average product of a fifteenth-century Flemish illuminator's workshop which adopted compositions of the so-called 'Vrelant' style (see also No. 54). The litany includes saints venerated in Flanders, Brabant and northern France, indicating that the book was intended for local use, and the programme of illustration follows frequently used Flemish patterns. Scenes of the Infancy cycle, which introduce the Hours of the Virgin, have the Massacre of the Innocents at vespers – a variant also found in some northern French Hours (see No. 84). The penitential psalms, however, are illustrated by a miniature of the Last Judgment, which is less usual in conventional French programmes.

Stylistically this workshop product is related to the Flemish Book of Hours now in Canberra (see No. 54). The figures are tall, flat stereotypes with expressionless round faces and beady black eyes (fig. 119). The depiction of interior space is largely unconvincing (fig. 118). Landscape motifs are highly conventionalized, such as pink castles with blue turrets and round or conical trees in green fields leading up to high horizon lines (figs. 117 and 119).

On the other hand these landscapes are spatially more realistic than those of the Canberra miniatures. Naturalistic blue skies fade gradually down to the horizon, and tonal modulations from foreground greens to mid-ground yellows simulate distant views. Figures beneath the horizon line do not dominate the foreground exclusively but are set slightly back into the pictorial space (compare figs. 117, 119, with figs. 112, 114 and 115). Although the artist has adopted a similar palette to the one used for the Canberra miniatures there is a different tonal balance of colours, with reds used to greater effect.

The variations just described indicate that these stylistically related manuscripts were possibly made in different centres in the southern Netherlands.

The inscriptions in the Manly book suggest that it may have been owned at an early stage by a woman, since two Latin prayers, written in the fifteenth century, are in the feminine form. It later passed into Italian and then French hands. In 1890 Mr Henry Austin gave the manuscript to Cardinal Moran, who presented it the same year to the library of St Patrick's Seminary, Manly.

Bibliography: Sinclair (1969), pp.72–74.

Plate 31, figs. 120–127
No. 56. *Book of Hours.* Use of York. Latin
Bruges, late 15c.
State Library of Victoria, *fo96/R66 Hb

Vellum, 345 x 235. A old vellum + 72 + B old vellum. I–II⁶, III–IV⁸, V⁶, VI–VIII⁸, IX⁶. One catchword, agreeing, after VI. Modern foliation. Prickings in outer vertical margins. Script: Late 15c. *lettre-bâtarde*, in black ink, with red rubrics; calendar in red and black. Ruling: red ink: 30[67].20[69].49 x 47.[236].62; lines of text: 26. Ruling unit: 9. Calendar: 32[20.8.2.17.108].48 x 47.[236].62. Binding: old bevelled oak boards, with worn brass bosses; spine 19c. pigskin.

Ownership: In the lower margin of f.1r is the signature 'Lumley' scribbled over by a later hand. Ar has the note in modern pencil 'With the book-plate of Lord Amherst of Hackney, see de Ricci Catalogue page 101'. This book-plate is pasted inside the front cover beneath the label 'Felton Bequest'. Inside back cover is a pencil note 'Felton Bequest 1933. Wm. H. Robinson'; on Ar, Br and f.72v is the stamp 'Public Library of Victoria'.

Text: Latin. Contents: ff.1r–12v calendar, with special feast days in red including deposition of St John of Beverley (7 May), deposition of St William (8 June), St Wilfrid (12 October) and St Martin (11 November). Entries in black include SS. Vaast and Amand, SS. Cuthbert, Dunstan, Basil, and Swithin, translation of St Thomas, St Oswald, translation of St Cuthbert, SS. Edward, Wilfrand, Willibrord and Edmund; ff.13r–34v Hours of the Virgin, with the rubric *secundum usum sarum*; ff.35r–39v penitential psalms; ff.40r–44r litany, including SS. Alban, Oswald, Edmund, Germain, Augustine, Wilfrid, 'Willerine', Cuthbert, Swithin, Samson, Edmund, Jerome, Edward, Leonard, Benedict, Egidius, Anthony, Austreberta, Hilda, Everildis and Ethelreda; ff.44v–64v Vigils of the Dead; ff.65r–72v commemorations.

Decoration: Three types of illuminated initials and a group of acanthus-style borders establish a hierarchical system of decoration. Sentences begin with one-line blue or gold capitals with infills and surrounds of filigree pen-work, alternately red and blue. Where such initials are on the top line or at the beginning of a line of text, flourishes extend into the borders. Prayers are introduced by two-line dentelle initials. The main divisions of the Hours are marked by foliate initials, four or five lines high, with burnished gold grounds and infills of vines and leaves in red, blue and white with touches of green and yellow. From lauds on, every foliate initial is attached to a bracket-left border: ff.17v, 22v, 24v, 26r (fig. 122), 27v, 29v, 31v, 35r, 44v and 65r. The border which frames the first page of matins on f.13r includes a small shield, the heraldic details of which have been completely erased (fig. 121). All borders have outlines ruled in red. Their broad panels are of late fifteenth-century conventional Franco–Flemish design, with heavy blue acanthus leaves, furled in bronze or red, white dotted spines and red veining. Floral motifs in red, green and blue fill the interstices. Bunches of blue grapes feature in the calendar borders for February and June (Plate 31). The perpendicular arms of the bracket-left borders consist of gold and coloured bars with outer hairline tracery terminating in gold ovoids or tri-lobed white, red or blue forms (fig. 122). The rubrics for tierce, sext, none and compline, and the litany (fig. 123), have short line-endings in red, blue or gold.

Programme of Illustration: Illustration is confined to the calendar pages which contain rectangular vignettes (46 x 37) depicting the labours of the month: f.1r January, man warming himself (fig. 120); f.2r February, man cutting wood (Plate 31); f.3r March, man digging (fig. 124); f.4r April, man holding flowers (fig. 125); (May has been excised); f.6r June, man scything (fig. 126); f.7r July, man harvesting; f.8r August, man threshing; f.9r September, man treading grapes; f.10r October, man sowing grain; f.11r November, man gathering acorns (fig. 127); f.12r December, two men slaughtering pig.

Commentary: This manuscript is one of only six known extant Hours for the use of York from the fifteenth century. The incorrect rubric *secundum usum sarum* on f.13r suggests that the scribe was more familiar with the Sarum text, the form usually required for English clients. Nevertheless, all the textual modifications for York usage exemplified in the fourteenth-century Madresfield Hours are incorporated correctly. In the calendar some York feasts have the highest grading: St John of Beverley, St William and the translation of St Wilfrid, although others have been omitted: St Wilfrid (24 April) and the York feast of relics (19 October). The litany conforms to that established for York. The misspelling of 'Willerine' for Willelme is a scribal error characteristic of Netherlandish products.[1]

The physical appearance of the manuscript is extremely unusual for Books of Hours, which were customarily smaller, with the text written in single columns. Its distinctive format points to a workshop generally engaged with the production of large secular manuscripts, for which there was a wide demand in late Burgundian circles. In fact, there is a close similarity between this York Hours and a group of manuscripts from the library of Raphael de Marcatellis, abbot of St Bavon, Ghent, from 1478 to 1507.[2] Albert Derolez has recently shown that this Burgundian cleric, who spent much of his life in Bruges, commissioned from the local Bruges craftsmen over sixty secular books, which are distinguished both by their large dimensions and by the uniformly high quality of their execution. Moreover, their text, often set out in two columns, has a

hierarchical system of decoration identical with that of the Melbourne manuscript. Borders in these books also compare closely with those described above, while miniatures in the Marcatellian works are related stylistically to the calendar pictures of the Melbourne manuscripts. The stocky figures have the same distinctive faces with prominent nose, square jaw-line, fleshy mouth, ruddy complexion and wide-set beady eyes. Interior settings and landscapes have similar conventions, and the range and treatment of colour are also consistent.

It is therefore possible to assign the Melbourne manuscript with some confidence to an atelier probably located in Bruges which also worked for the abbot of St Bavon. A *terminus ante quem* is perhaps indicated by the fact that the calendar does not include the feasts of the Transfiguration or the Name of Jesus (6 and 7 August), established in York in 1489.

The singular format of this Book of Hours suggests a special commission. The large dimensions and general clarity of the text may even indicate its design for a particular function, such as group prayer in a family chapel, rather than for strictly individual use. Alternatively, it might be argued that Raphael de Marcatellis, a bibliophile with a taste for very large books covering a wide range of subjects, ordered it as a collector's item for his own library. It must be noted, however, that Derolez's researches reveal the abbot as interested almost exclusively in commissioning secular texts.

Furthermore, the sixteenth-century signature 'Lumley' on f.1r provides some clue to the manuscript's original provenance, although it has also led to misinterpretation (fig. 120).

Seymour de Ricci's brief description of the book when it was MS. 19 of Lord Amherst's collection contains the following statement, 'on the first page is the signature Lumley (about 1590) of John Lord Lumley whose direct ancestor Thomas married Elizabeth Plantagenet, the daughter of Edward IV. The manuscript which contains eleven very beautiful small miniatures and many illuminated borders was apparently executed at Bruges about 1471 in Colard Mansion's shop either for Edward IV or for Caxton's patron Lord Arundel whose manuscripts belonged later to Lord Lumley. From T. W. Bramston's collection.'

Lord Lumley's fifteenth-century forbear, Thomas, a distant kinsman of Edward IV, succeeded to the family estates in Yorkshire and Durham in 1432. However, it was not Thomas, as stated by de Ricci, but his son George (d.1509) who married Edward IV's natural daughter Elizabeth. It is true that both father and son were active Yorkists to whom the king showed favours; but there is no evidence to relate either of them specifically to Edward's exile in Bruges in 1471; and a later date for the manuscript, *c.*1478–1479, is indicated on stylistic grounds.[3]

De Ricci refers to Lord Arundel as the alternative first owner of the book because his library was merged with that of John Lord Lumley in 1557. However, the marks of the two owners were at that time placed in their respective books. Later, after the duke's death, Lumley's name was affixed to Arundel's books. Since Arundel's name does not appear on the York Hours, de Ricci's alternative hypothesis cannot be sustained.

In fact, the cumulative evidence, both historical and stylistic, suggests that the Hours was commissioned directly for a member of the Lumley family from a Bruges atelier which worked also for Raphael de Marcatellis. It is pertinent to note in this regard that de Marcatellis, a natural son of Philip the Good, had certain links through marriage with the Lumley family. He was a brother-in-law of Margaret of York, who in turn was a half-sister of Elizabeth, wife of George Lumley. The picture therefore emerges of a Bruges atelier executing manuscripts destined for two patrons, who probably knew each other. On present evidence, any attempts to be more precise about the nature of the commission are speculative.

John Lord Lumley's library was catalogued after his death in 1609. Since the York Hours is already referred to in this inventory as in private ownership, it was probably one of the hundred or more books which he is known to have given away late in life. The manuscript re-appears in the nineteenth century, according to de Ricci, in the collection of T. W. Bramston and was later acquired by Lord Amherst (1835–1908). It was purchased through the Felton Bequest from the bookseller W. M. Robinson for the State Library of Victoria in 1933.

Bibliography: Sinclair (1969), pp.353–354; de Ricci (1906), p.101; Jayne and Johnson (1956), pp.5–14 and 304; Backhouse (1975), p.9.

Notes

1. Mr Nicholas Rogers, Emmanuel College, Cambridge, kindly supplied this information about the scribe.
2. See A. Derolez, *The Library of Raphael de Marcatellis*, Ghent, 1979.
3. See E. Milner and E. Benham, *Records of the Lumleys of Lumley Castle*, London, 1904. p.21.

Plate 32, figs. 128–130

No. 57. *Book of Hours.* Use of Rome. Latin
Ghent(?), *c.*1490
State Library of New South Wales, Mitchell 1/7b

Vellum, 87 x 56, A + 191 + B. A, B modern paper. I[1] (wants 1, 3, 4), II–VI[4], VII[5], VIII[4], IX[3] (wants 4), XVI–XVIII[4], XIX[1] (wants 2), XX[2], XXI[3] (wants 1), XXII[2], XXIII[3] (wants 1), XXIV[2], XXV[3] (wants 1), XXVI[2] (wants 1, 4), XXVII[8], XXVIII[5] (wants 1), XXIX[3], XXX[5], XXXI–XXXV[4], XXXVI[3] (wants 4), XXXVII[3] (wants 1), XXVIII[8], XXXIX[6], XL[3], XLI–XLII[8], XLIII[6], XLIV[7] (wants 4), XLV[4], XLVI[8], XLVII[5] (wants 6, 7, 8). Within the text the following pages are blank: ff.10v, 11r, 13v, 14r,

22v, 23v, 36r, 41v, 64v, 66v, 76v, 94v, 103v and 104r. Folios 52–64 and 65–66 have been misbound. Script: late 15c. gothic liturgical hand in dark brown ink, with rubrics in red; calendar in brown and red. Ruling: pale red ink: 5.[36].15 x 9.[51].27. Lines of text: 16. Ruling unit: 3. Calendar: 10.[7.0.5.3.0.5.23].12 x 10.[51].26. Lines of text: 17. Ruling unit: 3. Miniatures are rubbed, edges severely cropped. Binding: old rose velvet.

Ownership: Folio 1r has the imprint of the seal of the Mitchell Library.

Text: Latin. Contents: ff.1r–10r calendar. First half of January, second half of March, all of April and first half of May are missing. In the remaining sections special feasts, in red, include St Germain, translation of St Thomas, SS. Lawrence, Clement and Nicaise; entries in black include SS. Blaise, Amand, Boniface, Eligius and Bernardine, translation of St Martin, SS. Francis, Egidius, Bertin and Nicaise; ff.12r–13r *Salve sancta facies*; ff.15r–22r Mass of the Virgin; ff.24r–93r Hours of the Virgin, with Hours of the Cross and of the Holy Ghost inserted between ff.31r and 41v (Hours of the Cross, and sext, none and compline for Hours of the Virgin lack their first folios); ff.95r–103r variations for Hours of the Virgin; ff.105r–116r penitential psalms; ff.116v–125v litany, including SS. Francis, Bernardine, Elzearius, Jerome, Nicholas and Benedict; ff.126r–163v Vigils of the Dead (first folio lacking); f.164r *Obsecro te*; f.168r *O intemerata*; ff.171r–180v psalter of St Jerome; ff.181r–191v canticle of St Athanasius and other devotions.

Decoration: Throughout the manuscript there are one- and two-line grisaille initials on brown grounds. The main divisions of the Hours are marked by five-line pink or gold initials of twisted branch design, which cast shadows on their gold or blue square grounds. There is one historiated initial seven lines high, painted blue on a rose-pink rectangular ground. Pages containing the largest initials have full borders of naturalistic fruit, flowers, insects, peacocks and other birds. These motifs are painted in blue, mauve, pink, rose, green and white; they are strewn over brushed gold grounds, and they cast shadows. These full borders appear on folios 12r, 15r, 24r, 37r, 42r, 67r, 72r, 82r, 95r, 105r and 171r. Five miniatures painted in graduated tones of blue, pink, rose-red, grey, brown and white are also framed by full borders which match those on the facing page (Plate 32).

This coupling occurs on ff.11v–12r, 14v–15r, 23v–24r, 36v–37r and 104v–105r. One historiated initial, blue on a rose ground, is set within a two-sided border of similar design on f.164r. It is now badly rubbed. The reverse sides of the miniature pages are blank.

Programme of Illustration: The five large miniatures (58 x 38) and one historiated initial, seven lines high, illustrate the text as follows: f.11v Christ with orb, *Salvator Mundi: Salve sancta facies* (Plate 32); f.14v Virgin and Child: Mass of

the Virgin (fig. 128); f.23v Annunciation: matins for Hours of the Virgin; f.36v Pentecost: Hours of the Holy Ghost; f.104v David at prayer: penitential psalms; f.164v Pietà. Historiated initial: *Obsecro te.*

Commentary: This small book is no longer intact and its miniatures are not in pristine condition. Nevertheless, its decorative elements, textual contents and the particular methods by which it was produced and compiled confirm its relationship with a series of splendid and innovative illuminated Books of Hours, executed for imperial and aristocratic patrons in Germany, Burgundy, Spain and the Netherlands in the late fifteenth and early sixteenth centuries.

Following the pioneering study of Otto Pächt on the Master of Mary of Burgundy, the leading artistic personalities, characteristics and localization of this large Flemish atelier have been the subject of intense scholarly research and debate. The cumulative evidence at this stage points to a prolific workshop which was probably under the direction of Alexander Bening, an illuminator who is recorded as active mainly in Ghent from 1469 until 1519.[1]

The composition of the *Salvator Mundi* on f.11v (Plate 32) of the Sydney Hours, modest though this work is, may be compared with that in the Hours of Queen Isabel la Catolica, now in the Cleveland Museum of Art (fig. 129) and with another splendid example from the Manderscheid Hours, formerly in the library of Prince Fürstenberg of Donaueschingen (fig. 130). The Sydney miniature is closer to the Manderscheid version in the way in which its plain blue background acts as a foil to the softly modelled head of Christ with his filigree gold halo. The treatment of the face, however, with its broad planes, round chin and stubble beard, though less subtle, echoes that of the Cleveland Hours (fig. 129). In all three miniatures, the orb in Christ's left hand has two tiny parallel white streaks, a motif which simulates the reflection of a double window outside the picture space. This small detail, often present in miniatures from the Bening workshop, is adapted from contemporary Flemish panel paintings.[2]

The other miniatures of the Sydney Hours also reflect workshop models common to both de-luxe manuscripts and simpler works such as Bodleian Douce MSS. 8, 12 and 20 and Walters Gallery Baltimore W MS. 428. As P. de Winter has pointed out, devotional images such as the *Salvator Mundi* or the half-length Virgin and Child on f.14v (fig. 128) reflect the indebtedness of the miniaturists to contemporary Ghent panel painters.[3]

The compilation of this manuscript is also characteristic of a highly organized Flemish workshop. The irregular quires, ranging from three to fourteen folios, and the tipped-in miniature pages with compositions always painted on the verso and facing text pages framed by matching borders, reflect a division of labour which allowed scribes and miniaturists to work independently.

The presence in the Sydney Hours of six recto pages with full borders at lauds, prime, tierce, vespers, and at the beginning of the variations of the office and additional prayers, indicates that originally the manuscript probably had tipped-in miniatures prefacing these sections. It is also likely that sext, none and compline of the Hours of the Virgin, which now begin imperfectly, were introduced by double pages with a miniature facing the opening lines of text, both being framed by decorated borders. In its original state, therefore, this manuscript would have been quite copiously illustrated.

The Book of Hours was formerly owned by James Thompson Hackett and was purchased by the Mitchell Library at the sale of 1918.

Bibliography: Sinclair (1969), pp.121–123; (Hackett, 1918), p.49; Sinclair (1964a), p.376.

Notes

1. See especially A. H. van Buren, 'The Master of Mary of Burgundy and his colleagues: The State of Research and Questions of Method' in *Zeitschrift für Kunstgeschichte*, Vol. 38, 1978, pp.286–309 and de Winter (1981), pp.342–427.
2. For discussion of this motif see J. Bialostocki, 'The Eye and the Window. Realism and symbolism of light reflections in the art of Albrecht Dürer and his predecessors' in *Festschrift für Gert von Osten*, Cologne, 1970, pp.159–176.
3. See de Winter, *op. cit.*, pp.387ff.

Figs. 131–133

No. 58. *Book of Hours*. Use of Rome. Latin and French Southern Netherlands, late 15c.
State Library of Victoria, *096/R66 Hf

Vellum, 146 x 110. A–B modern paper + 265. I–II⁶, III⁸, IV⁶, V–XV⁸, XVI⁶, XVII–XXI⁸, XXII⁷ (wants 4), XXIII⁷ (wants 4), XXIV⁸, XXV⁷ (wants 5), XXVI⁹ (wants 10, 2 added sheets replace 7, 8 excised), XXVII⁸, XXVIII⁷ (wants 6), XXIX–XXXII⁸, XXXIII⁹ (wants 1), XXXIV⁷ (wants 1), XXXV⁴. Modern foliation. Script: late 15c. *lettre-bâtarde* in black ink (XII, XIII, XXXIV, XXXV are by a second scribe in faded brown ink), rubrics in red, calendar in black and red. Rulings: red ink: 14.[81].15 x 16.[94].36. Lines of text: 16. Ruling unit: 5. Calendar 25.[10.2.6.2.35].30 x 19.5.[86].36. Binding: old tooled calf over boards, metal clasp, catch missing.

Ownership: *Disco Pati* is written in black ink in the scrolls of the borders of ff.57r, 61r, 74r, 124r, 125r, 165r, 174r, 207r, 208r, 209r, 213r, 220r and 256r. Br carries the stamp 'Public Library of Victoria 11 Oct. 1926'.

Text: Latin, calendar and some rubrics in French. Contents: ff.1r–12v full calendar; entries in red include SS. Omer (8 June, 9 September), Eloy (25 June), Margaret (20 July), Louis (25 August) and Bertin (9 September); in black are SS. Amand (twice), Vaast, Winnoc, Willibrord and

Medard; ff.13r–21r Hours of the Cross; ff.21r–26v Hours of the Holy Ghost; ff.27r–86v Hours of the Virgin; ff.87r–93r variations for Hours of the Virgin from Advent to Nativity; ff.99r–110r penitential psalms; ff.110v–120v litany; ff.121r–152v commendations of souls; ff.153r–198v Vigils of the Dead; ff.199r–265v additional prayers. Gaps occur in the text between ff.211–212 and ff.254–255. Three rubrics list indulgences for recitation of certain of the additional prayers at Mass (ff.211v, 221v, 222r).

Decoration: Throughout the book there are numerous one-line initials in gold or blue with black or red pen-work, many two-line dentelle initials, and occasional three- and four-line initials in pink and white floral designs. The main divisions of the text are introduced by five- or six-line initials in blue or pink with white tracery on brown, buff, blue or pink rectangular grounds, with infills of naturalistic flowers and birds. All text pages have panel borders, mostly of naturalistic motifs on grounds of blue, green, pink, straw-yellow or dark grey, the colour changing at each quire. Quire IV has borders of acanthus design in semi-grisaille. Motifs are traced through from recto to verso.

The five- and six-line initials are associated with full borders composed of insects, birds, flowers, grotesques and stylized acanthus leaves strewn on coloured grounds, usually yellow; one is black (ff.13r, 21r, 27r, 45r, 57r, 61v, 66r, 70r, 74r, 82r, 99r, 121r, 153r). These decorated pages mark the main divisions of the Hours. Full borders also surround the five large miniatures and one historiated initial which introduce certain prayers. The borders of the calendar contain small zodiacal signs, and there are rectangular scenes of the labours of the month in the lower margins of the calendar recto pages.

Programme of Illustration: Depictions of the labours of the months (33 x 31) are as follows: f.1r January, man feasting; f.2r February, man warming himself; f.3r March, man digging; f.4r April, man ploughing; f.5r May, two people in tub; f.6r June, man chopping trees; f.7r July, man scything; f.8r August, woman reaping; f.9r September, man treading grapes; f.10r October, man gathering acorns; f.11r November, man cutting wood; f.12r December, man wielding axe above kneeling ox.

Large miniatures (75 x 55) and one eight-lined historiated initial introduce prayers as follows: f.199r a vision of the suffering Christ: *Domine ihesu christe qui hanc sacratissimam carnem* (fig. 131); f.200v St Veronica with the sudarium: *Salve sancta facies . . .* (fig. 132); f.202v the Crucifixion: *O domine ihesu christe adoro te . . .*; f.208r the Trinity, as God the Father holding the crucified Christ, a dove above: *Deus pater et filius et spiritus sanctus*; f.214v Christ displaying his wounded side (historiated initial): *Domine ihesu christe qui septem verba*; f.264v Mary Magdalen as a penitent hermit: *Maria ergo unxit pedes . . .* (fig. 133).

Commentary: This manuscript is a product of a modest atelier probably located in the region of St Omer. It reflects methods of book production in the late fifteenth century and a knowledge of contemporary trends in naturalistic decoration in the southern Netherlands. After assembly into quires the leaves of text were decorated with panel borders, the ground colours of which change at each gathering. The full borders, which do not show the same variation in colour and are of slightly higher quality, seem to have been treated as a separate decorative unit. The small illustrations of the labours of the months are perfunctory renderings of conventional patterns, and the heavy mannered style of the main miniatures suggests a date of *c.*1500.

The book, however, is not entirely conventional, since the programme of illustration is associated with the additional prayers rather than with the main divisions of the Hours. References to indulgences, the large number of additional prayers, and the programme of illustration itself may point to a client who required a book stressing the penitential aspects of devotion. This may also account for the actual subjects depicted.

Images of the suffering Christ and of St Veronica presenting the Holy Face (figs. 131 and 132) were associated with indulgences in the late fifteenth century, when it was believed that prayers recited before such pictures were as efficacious as actual pilgrimages to the shrines where the relics were kept.[1]

Similar importance may have been attached to images of the penitent Mary Magdalen, exemplified on f.264v (fig. 133). Indeed, this depiction of the saint as a hermit attended by an angel, kneeling in front of a rocky cave in a landscape setting, is probably a reference to the Magdalen shrine in the grotto of La Sainte-Baume in Provence, where, according to legend, the saint withdrew after the Crucifixion to spend the last years of her life in seclusion. This medieval shrine was especially popular in France and the southern Netherlands at the time this manuscript was produced.[2]

The miniature on f.199r (fig. 131), which presumably shows the patron kneeling before a vision of the suffering Christ, is in keeping with the general emphasis on penitential devotion. The seriousness of his intent is reflected in the motto *Disco Pati* (I learn to suffer) which occurs in thirteen borders of the manuscript (fig. 131).

The book formerly belonged to J. T. Hackett and was acquired from his widow in 1926 by the State Library of Victoria.

Bibliography: Sinclair (1969), pp.347–351; Sotheby (1923), p.85.

Notes

1. A. Chastel, 'La Véronique' in *Revue de l'Art*, Vol. 40/41, 1978, pp.71–82, and C. Bertelli, 'The Image of Pity in Santa Croce in Gerusalemme' in *Essays in the History of Art Presented to R.*
Wittkower, ed. D. Fraser, H. Hibbard and M. J. Lewine, London, 1967, pp.40–55, 46f.
2. M. D. Orth, 'The Magdalene Shrine of La Sainte-Baume in 1516. A series of miniatures by Godefroy le Batave B.N. Ms.fr.24.955' in *Gazette des Beaux-Arts*, Dec. 1981, pp.98, 193–214. A Book of Hours *c.*1490, MS. J57 in the Fitzwilliam Museum, Cambridge, provides an interesting parallel. It contains a range of Flemish border designs which mirror those in the Melbourne manuscript but are more delicately rendered. Its suffrages include a prayer to Mary Magdalen which is accompanied by a miniature on f.32v, closely related to the Melbourne version. The saint, a naked penitent, stands before a rocky cave in a landscape which contains in the background a prominent castle. This miniature provides added evidence for the contemporary popularity in Flanders of the Provençal Magdalen shrine.

Fig. 134

No. 59. *Privileges of the Cistercian Order, Carta Caritas Posterior, Libellus Antiquarum Diffinitionum.* Latin
Northern Netherlands, *c.*1480
State Library of New South Wales, Mitchell 1/7a

Vellum, 190 x 135. A modern paper + B contemporary vellum + 99 + C contemporary vellum + D modern paper. I⁶, II³, III⁷, IV–XII⁸, XIII¹⁰, XIV¹. A few quire signatures. Contemporary foliation from ff.9r to 99r in roman numerals omitting XLVII and XCI. Modern numbers in lower left-hand corner of recto on first leaf of each quire. Script: 15c. gothic hand in brown ink. Ruling: brown ink: 16.[92].27 x 23.5.[112].5.45. Lines of text: 26. Ruling unit: 5. Prickings in outer margins. Binding: 19c. brown calf.

Ownership: On Ar in 19c. pencil is 'To be sent to T. H. Turner Esq., 6 Symonds Inn Chancery Lane'. Inside back cover is the book-plate of David Scott Mitchell.

Decoration: Flourished initials, three, five and eight lines high, blue with red pen-work and red with blue pen-work alternately, occur throughout the work.

One historiated initial 'B' in burnished gold (100 x 90) on f.9r introduces text of the privileges: *Bonum inpretiabile est libertas* (fig. 134). It depicts a vision of the Virgin and Child by St Bernard. Two inscribed banderoles read *Ave regina celorum ave mater* and *Mostra te esse matrem Bernadus* (sic). Colours are brownish-pink, green, red, white and blue. The vertical column of text on the right of the initial alternates in red and blue. The smaller label 'Bernardus' is in blue.

Commentary: The historiated initial which is the chief decoration of this monastic book of privileges, rules etc. illustrates a medieval legend associated with St Bernard. While the saint was reciting a marian hymn before a statue of the Virgin she is said to have appeared before him as he came to the words *Mostra te esse matrem* – Show thyself a

mother. Pressing her breast she let three drops of milk fall on to his lips.[1]

The artist interprets the legend quite literally and the three droplets of milk are clearly visible on the Virgin's breast as St Bernard kneels before her in Cistercian habit. Features such as the fluted shape of the burnished gold letter, the Virgin's tall gold crown, the child-like round faces and the somewhat muddy colour scheme indicate Dutch illumination of modest provincial origin. The miniature may be compared with work in a Dutch manuscript dated 1484 now in Vienna (Nat. bibl. S.n. 12874).[2]

Although details of the text are not discussed here, it may be noted that a second scribe took over the work on f.49r at the beginning of quire VIII and the measurements of the vellum, together with the ruling for the text, vary slightly in the second section.

By the nineteenth century the manuscript was in England. It seems to have been acquired at sale by the T. H. Turner referred to above. Later it belonged to David Scott Mitchell, who bequeathed it as part of his library to the state of New South Wales in 1907.

Bibliography: Sinclair (1969), pp.107–109; Sinclair (1964b), pp.235–236; (Sydney, 1967), pp.20–21.

Notes

1. For the legend of St Bernard see M. Warner, *Alone of All Her Sex. The Myth and the Cult of the Virgin Mary*, New York, 1976, pp.197ff.
2. See Pächt and Jenni (1974), fig. 321.

Plate 33, figs. 135–138

No. 60. *Commentaries on Isaiah*. Latin and Greek
Roermond, Limbourg, 1497
State Library of Victoria, *fo96/J483

Vellum, 345 x 234. A–B modern paper + 258 + C–D modern paper. I⁷ (wants 2), II–VIII⁸, IX⁷ (wants 6), X⁸, XI⁸ (wants 4 & 6), XII⁸, XIII⁷ (wants 4), XIV–XV⁸, XVI⁸ (wants 4), XVII–XIX⁸, XX⁸ (wants 1 & 7), XXI–XXVIII⁸, XXIX⁸, XXX–XXXII⁸, XXXIII⁶. Catchwords after I, X and XIX; quire signatures throughout. Modern foliation by tens. Prickings in all outer margins. Script: late 15c. Netherlandish hybrid book hand in black ink, with red rubrics. Ruling: brown ink: 22.[74].20.[74].44 x 35.[241].69. Lines of text: 41. Ruling unit: 6. Binding: late 15c. Netherlandish calf binding with a central panel divided into lozenges by diagonal fillets in fours, with rosettes in the lozenges. Each cover has holes for five studs, now lost; two brass clasps on front cover, with brass strengtheners on outer corners. A rectangular plaque on front cover carries title in contemporary hand *Explanationes divi Iheronymi doctoris prophetam in isaiam*. Spine 19c. calf.

Ownership: Folio 1r bears the stamp of the Public Library of Victoria with the date 1 April 1902.

Text: Latin, some Greek, glossed. Contents: 18 books of commentaries with prefaces. *Incipits* of the commentaries occur on ff.1v, 11v, 24v, 38v, 49v (Books 1–5), f.82v (Book 7), ff.111r, 126v, 137v, 151r, 165r, 179r, 194v, 207v, 223r, 239v (Books 9–18). Commentaries 1, 4 and 6 open abruptly. The end of the colophon on f.258r has been excised. The present inscription concludes with: *Anno gratie millesimo quadringentesimo nonagesimo septimo tertio nonas aprilis ad honorem dei.*

Decoration: Throughout the text there are initials, two or three lines high, flourished in red and blue alternately. The preface on f.1r is introduced by a seven-line historiated initial (40 x 47) in a semi-grisaille and mauve acanthus design on a beige ground (fig. 137). Other colours are wine-red, mauve, green and grey and apricot. The texts of the fifteen books begin with six- or seven-line decorated or flourished initials associated with borders or marginal extensions. Three styles can be distinguished.

The first style has decorated initials in pink, tangerine, green or blue, with white pen-work, painted on grounds of burnished gold or silver (now tarnished). Botanical motifs modelled with white paint fill the central grounds. These initials extend into borders of spiralling acanthus scrolls with interlaced knots and stylized floral-bud terminals, and short pink hairlines terminated by petalled forms. This type occurs on ff.11v, 24v, 38v, 49v, 111r, 126v, 137v, 151r and 207v (Plate 33, fig. 135). *Ihesus Maria* is inscribed in the border of f.126v. The borders on ff.111r, 126v, 137v and 151r, are incomplete.

The second style appears on ff.82v and 165r (fig. 136). Blue initials are drawn on pink rectangular grounds and filled with white acanthus designs. Borders have sprigs of naturalistic flowers, thistles, pea-pods and insects strewn over beige grounds. On f.82v a pig is dancing with a monkey, a second monkey plays the bagpipes, and a third blows bubbles.

The third style occurs on ff.179r, 194r, 223r and 239r (fig. 138). Six-line initials in blue ink have spines containing small white circles, fluted square crosses and leaf motifs. Pink filigree pen-work fills the central ground and extends into the adjacent margin.

Programme of Illustration: This is confined to the one historiated initial which introduces the preface on f.1r. St Jerome is depicted as a cardinal in a cloister which opens on to a landscape background (fig. 137).

Commentary: This manuscript has no positive marks of identification. Nevertheless it presents certain distinctive features which indicate that it was made for use in a Dutch Carthusian monastery situated in Roermond in the province of Limbourg.

The spiralling acanthus decoration and richly illuminated initials follow Dutch patterns with their three-dimensional modelling and distinctive blond palettes. Although the

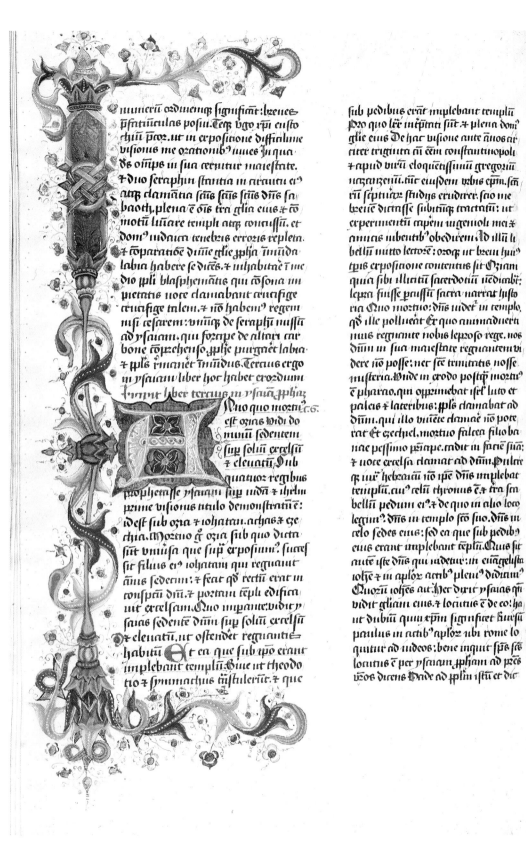

Plate 33. Initial 'A'. Book Three. No. 60, f.24v. 345 x 234

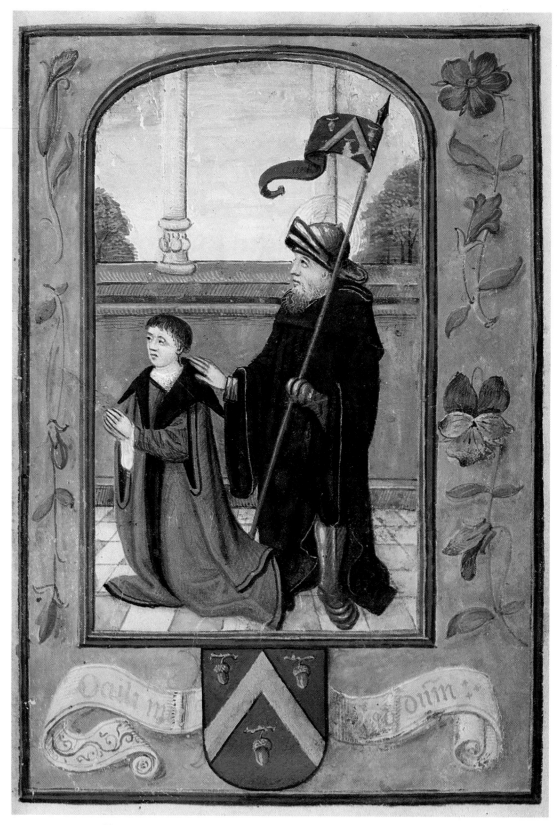

Plate 34. St William of Maleval with a kneeling figure. No. 61, f.2r. 156 x 96

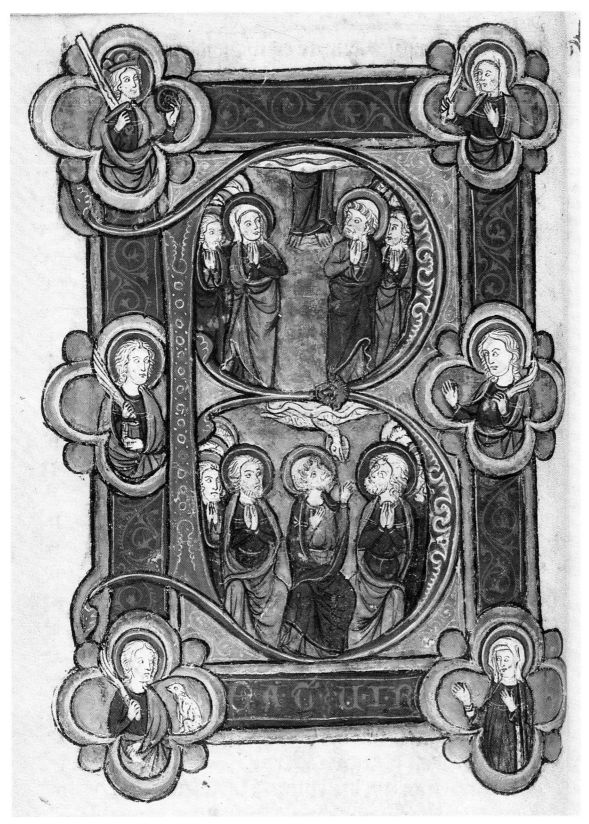

Plate 35. *Beatus* initial. No. 69, f. 19v. 170 x 122

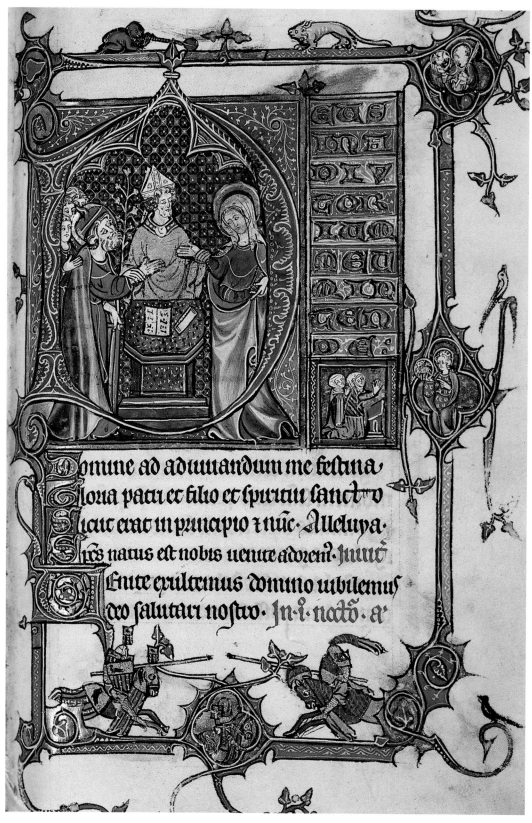

Plate 36. Marriage of Joseph and Mary. No. 70, f.7r. 215 x 150

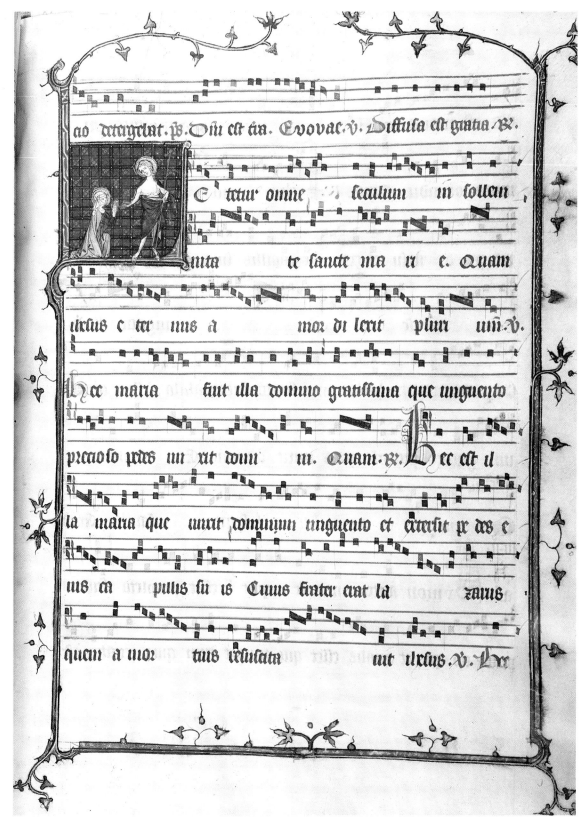

ao dtangelat. P. Osu est ta. Evovac. v. Diffusa est gratia. R.

Setetur omne seculum in sollem

nita te sancte ma ri e. Quam

uersus e ter uus a mor di levit plur uis. v.

Hec maria fuit illa domino gratissima que unguento

preciofo predes un xit domi ni. Quam. R. Hec est il

la maria que unxit dominum unguento et extersit pe des e

ius ca pillis su is Cuius frater erat la zarus

quem a mor tuis resuscita uit ursius. v. He

Plate 37. Christ and Mary Magdalen (Noli me Tangere). No. 71, f.287r. 285 x 200

145

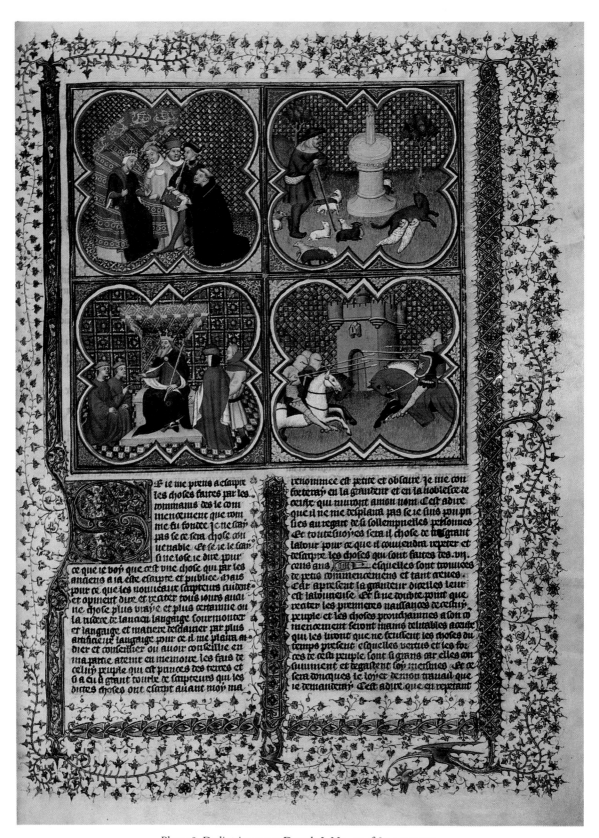

Plate 38. Dedication page: Decade I. No. 72, f.8r. 440 x 325

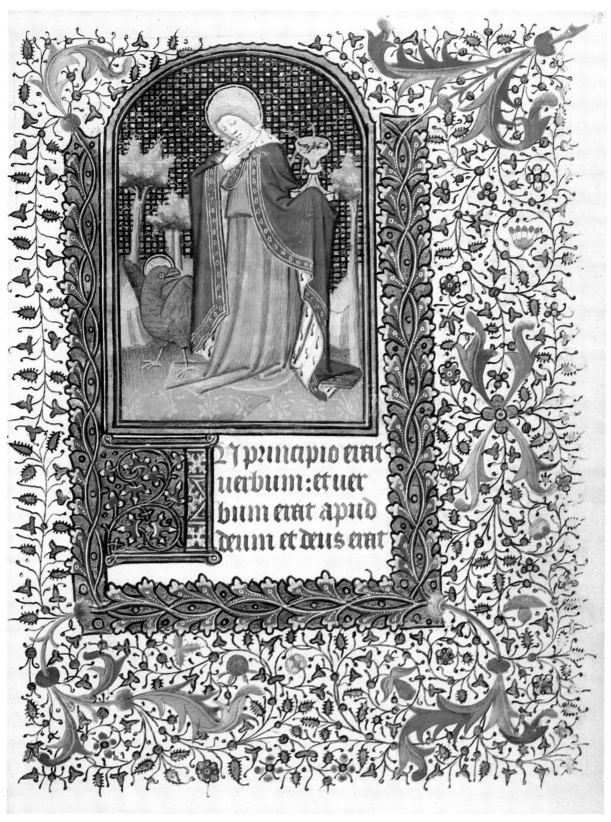

In pmapio erat
uerbum: et uer
bum erat apud
deum et deus erat

Plate 39. St John. No. 74, f.13r. 195 x 140

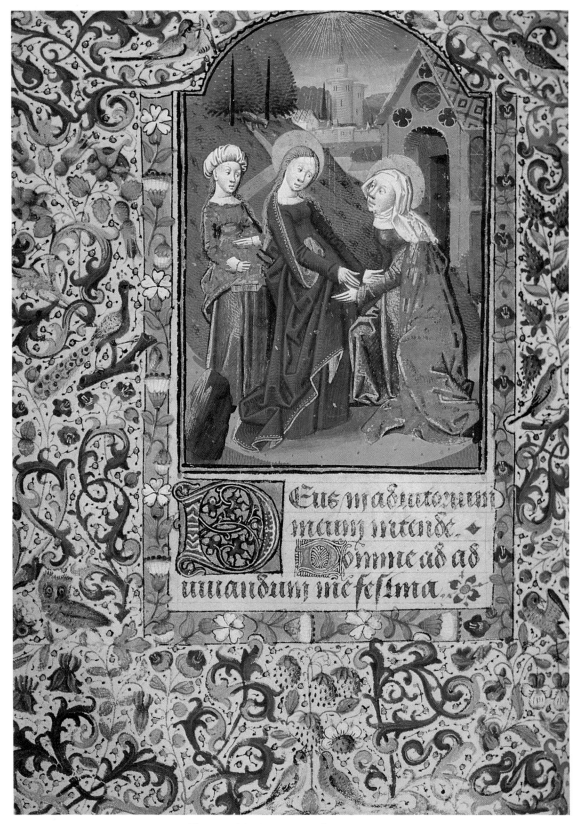

Plate 40. Visitation. No. 77, f. 56v. 170 x 119

second type of border, on ff.82v and 165r, reflects the influence of Bruges–Ghent naturalism, traditional Dutch motifs such as hanging pea-pods have been incorporated. The exuberant, somewhat amateurish execution of these colourful features points to a provincial workshop outside the mainstream of manuscript illumination. Moreover, the variation in designs and uneven quality of execution indicate the activities of several craftsmen, the most talented of whom painted the delicately modelled figure of St Jerome on f.1r (fig. 137).

Among the collection in the Vienna National Library, Pächt and Jenni have identified several Carthusian manuscripts from Roermond, dating from *c*.1470, which are distinguished, in part, by their decorative pen-work. The initials on ff.179, 194, 223 and 239 of the Melbourne book compare closely with four examples cited by these authors: Vienna Nat.bibl. cod. 13537 (f.185r); cod. 13654 (f.278r); S.n. 12789 (f.1r); and S.n. 12790 (f.8r).[1] In addition, the hybrid script of the Melbourne manuscript is similar to that in Vienna Nat.bibl. s.n. 12790, although slightly more slanted; and both scribes have adopted the *punctus flexus*, a punctuation mark characteristic of fifteenth-century Carthusian script.[2] Finally the appearance of the contemporary binding of the Melbourne manuscript conforms in most details (including the shape of the clasps) to that of another member of the Viennese Carthusian group, cod. 15239.

It is probable, therefore, that the Melbourne copy of St Jerome's *Commentaries* was made in 1497 for the monastic library in Roermond. The subsequent history of the manuscript before its arrival in Melbourne is unknown. At some stage three folios introducing commentaries one, four and six were excised. They were probably decorated in conformity with the practice observed for the other fifteen commentaries.

The book was purchased from a dealer, Mr Bennett, by the State Library of Victoria in 1902. This is the earliest known date for an illuminated medieval manuscript to have entered an Australian public library.

Bibliography: Sinclair (1969), pp.324–326.

Notes

1. See Pächt and Jenni (1975), figs. 278, 279, 280, 284. For a detailed account of scribal practices and books produced by Carthusians, see, R. Marks, *The Medieval Manuscript. Library of the Charterhouse of S. Barbara in Cologne. Analecta Carthusiana*, pp.21–22, 1974. See fig.275 for the binding referred to in the text above.
2. This was pointed out by Dr Christopher de Hamel.

Plate 34, figs. 139–142

No. 61. *Prayer-book.* Latin and Middle Netherlandish
Northern Netherlands, *c*.1510–1525
Ballarat Fine Art Gallery, Victoria, MS. Crouch 12

Vellum, 156 x 96. A modern vellum + 70 + B modern vellum. I¹, II⁸, III⁶, IV–V⁸, VI–IX⁶, X¹, XI⁸, XII⁶. Foliation in modern pencil with arabic numerals. Folios 15v and 69v–70r are blank. Script: Burgundian hybrid hand in dark brown ink, with rubrics in red, calendar in red and brown. Ruling: red ink: 19.[53].24 x 16.[88].52. Lines of text: 17. Ruling unit: 5. Calendar 18.[10.4.3.36].25 x 17[89].50. Binding: 19c. black pigskin.

Ownership: Folio 2r has a coat-of-arms and inscribed scroll (see below). Folio 14v carries the cyphers W and M; f.30v has a marginal scroll inscribed 'DEN TIJT SAL COMEN'. Inside front cover is 'Ex libris R. A. Crouch'.

Text: Middle Netherlandish and Latin. Calendar, prayers and rubrics in Middle Netherlandish. Contents: ff.2v–14r calendar; special feast days in red include SS. Margaret, William of Maleval, Division of Apostles (1st July); entries in black include SS. Blaise, Constantine, Gertrude of Nivelles, Anselm, Helena, Godehard (4 April), Godfroet (5 April) (*sic*), Boniface, Rombaud, Amalberga, Roch, Egidius, Remigius, Bavo, Lebuin, Livinus, Pontianus, Lambert, Servatius, Hubert, Willibrord, Four Sleepers and King David; ff.14v–31r prayers; ff.32r–41v penitential psalms (in Latin); ff.42r–48r litany (in Latin) including St Roch; ff.48r–68r additional prayers.

Decoration: Red and blue initials, one or two lines high, are present throughout the book. Three- and four-lined brushed gold initials in acanthus-scroll design over grounds of grey, black, jade-green or blue introduce prayers in the body of the text and below two miniatures on ff.1v and 57r. The penitential psalms and one prayer are prefaced by six-line initials of the same form, on deep blue rectangles with indented gold frames. One small miniature (30 x 36) is surrounded by a similar frame.

There are nine large arched or rectangular miniatures (93 x 56 to 53 x 50) edged with brown or gold ruled lines. Five are accompanied by several lines of text. They are all surrounded by rectangular frames (122 x 83) which display four types of decoration as follows: three borders are composed of naturalistic long-stemmed plants in red, blue, white, mauve and green, strewn over apricot-yellow grounds (ff.1v, 2r, 30v). On f.2r there is an armorial shield: *azure a chevron three acorns or*, a scroll with the words *Oculi Mei Semper ad Dominum* (Plate 34) and on f.30v a kneeling figure and scroll. The second type of border is Italianate, with candelabra, vases, grotesque heads and winged amorini *all'antica* in brushed gold on a deep maroon ground. 'W & M' is inscribed on a base plaque on f.14v (fig. 139). Miniatures on ff.31v, 49v and 57v are accompanied by a third style of border: acanthus and floral meanders in gold

or silver over strong red, blue or brown grounds (fig. 142). Appropriate declamatory phrases, inscribed in gold Roman capitals on dull lilac grounds, constitute the fourth type (ff.48v and 64v, fig. 141).

Miniatures and borders are executed in contrasting colour schemes. Interior settings are dominated by warm yellow, greens or reds and white. In external scenes pictorial depth is moderated by broken tones of violet grey.

Programme of Illustration: The subjects of the nine large miniatures and their accompanying texts are as follows: f.1v the Agony in the Garden; f.2r St William of Maleval with a kneeling figure: calendar (Plate 34); f.14v St Margaret with a dragon: prayer to St Margaret (fig. 139); f.30v St Nicholas blessing three naked figures: prayer to St Nicholas; f.31v David in prayer: penitential psalms; f.48v Virgin and Child standing on a crescent, with legend in border REGINA CELI LETARE ALLELVYA QVIA QVEM MERVISTI PORTARE ALLELVYA OR: prayer to Mary Mother of God (fig. 141); f.49v half-figure of Christ with emblems of the Passion (Arma Christi): prayers of St Gregory; f.57r monogram of the Name of Jesus within concentric circles, bearing the legend DIE NAME IHESUS SI GEBENEDIJT ENDE SIJNDER LIEVER MOEDER MARIA VAN NU TOT IN DER EWICHEIT AMEN: prayer to the holy name of Jesus (fig. 142); f.64v St Anne with the Virgin and Child, with legend in border O ANNA Ŭ DERDER HOECHST VERHEVEN MET GOD DAER BOVEN INT EWICH LEVEN AMEN: prayer to St Anne (fig. 143).

The small miniature on f.59v depicts the Crucifixion with St John and the Virgin. It introduces a prayer *Ich bidde dy o alder beminshe heere iesu christe om der groter lief den wille....*

Commentary: The decorative elements of this book establish its relationship with a series of late manuscripts from the northern Netherlands which Byvanck attributed to an atelier in Leiden. These manuscripts include Liège Univ. Libr. MS. Wittert 33 (*c.*1510), Munich Staatsbibl. MS. germ. 76 (1524), Vienna Nat.bibl. S.n. 13236, Cambridge Fitzwilliam Museum MS. J. 144 (*c.*1515), and MS. McClean 99 (1526). A book of prayers in the Archiepiscopal museum in Utrecht, ABM MS. 14, can also be added to the same group.[1]

Pächt and Jenni have described some salient features which differentiate these books from related products of the Bruges–Ghent school. Dutch artists freely interpreted contemporary border patterns in strong colours to create new effects. Some borders are strewn with naturalistic botanical forms over warm yellow grounds which imitate Flemish brushed gold work; others exhibit plastically modelled acanthus and floral meanders in gold or silver, over richly toned contrasting grounds. Miniature compositions are executed in harmonizing broken colours, and lilac-grey tonalities create pictorial depth in landscape vistas. Figures have rounded contours modelled by thin films of paint; women have full, demurely expressive faces with lowered eyelids in lightened tones.

These workshop trademarks are also found in the Ballarat book. Its borders, for example, repeat botanical motifs of the Munich Hours; its gold and silver acanthus designs are in the Cambridge Hours; the same red colour frames a miniature in the Utrecht prayer book. Figures conform stylistically to other representative examples although their execution by comparison lacks subtlety. For example, the facial features and modelled form of St Margaret on f.14v are related to the figure of the saint in the Utrecht miniature (figs. 139 and 140).

The influence of the printed medium is also evident in the Italianate border design on this folio (fig. 139) and in the symbolic diagram of the Sacred Monogram on f.57r (fig. 142). The Virgin and Child on a crescent moon, a popular image, which also appears in the contemporary French Book of Hours, No. 88, f.27v, reflects woodcut models which were circulating widely from the beginning of the sixteenth century (fig. 141).[2]

The psalms and litany in Latin indicate that this volume may be a fragment from a longer book of devotions. Many Dutch Books of Hours were written entirely in the local language, while others contained the offices, psalms and litany in Latin with only the calendar and additional prayers in Netherlandish. It is possible therefore that the Ballarat text initially adhered to one of the conventional patterns, with an Hours of the Cross or a Passion sequence (in Latin) after the calendar. The Agony in the Garden, which now faces the donor portrait somewhat incongruously at the beginning of the volume, may then have been placed after the calendar to introduce such a text. Under those circumstances a more traditional devotional image such as the Virgin and Child may have faced the portrait of the donor.

The miniature on f.2r depicts the owner with his patron saint, who is identified as William of Maleval by the suit of armour and grey beard (Plate 34). This Flemish saint and St Margaret are both marked for special veneration in the calendar, and 'W & M' are intertwined on a plaque at the base of the miniature depicting St Margaret (fig. 139). There seems little doubt therefore that the manuscript was commissioned by a husband and wife, named William and Margaret. Although it has not been possible to identify the owners' armorial shield, the saints venerated in the calendar indicate a provenance within the ambit of Cologne. The book was owned in the early twentieth century by Colonel the Honourable R. A. Crouch, who presented it to the Ballarat Fine Art Gallery in 1944.

Bibliography: Sinclair (1969), pp.289–291; Sinclair (1968), pp.11 and 28, pl. viii and frontispiece; (Sydney, 1967), p.31.

Notes
1. A. W. Byvanck, *La miniature dans Les Pays-Bas Septentrionaux*, Paris, 1937, pp.111ff., figs. 259, 260, 261; Pächt and Jenni (1974),

Vol. I, pp. 106–107, figs. 99, 100, Vol. II, figs. 298–302, plate ix; J. Brassine, *Deux livres d'heures Néerlandais. Réproduction des 25 miniatures du ms. Wittert 33 et des 12 miniatures du ms. 34 de la Bibliothèque de l'Université de Liège*, Brussels, n.d. See also W. de Vreese, 'Verluchte Handschriften in het Aartsbissehoppelijk Museum to Utrecht' in *Het Gildeboek*, Vol. 6, 1923, pp. 201–221,

207–209ff. The Utrecht book is at present attributed to Cologne and dated *c.*1540; but an earlier dating (*c.*1510–1520) and, for some of the miniatures, a Dutch provenance, are more probable.

2. See D. E. Rhodes, 'Two editions of Pelbartus de Temesvár' in *British Museum Quarterly*, Vols. XX–XXI, 1955–1959, pp. 57–59, pl. xxix.

Netherlandish Short Entry

Figs. 144–146

No. 62. *Pauline and Canonical Epistles*, Vulgate. Latin
Southern Netherlands or France, second half of 15c.
Fisher Library, University of Sydney, New South Wales,
Nicholson 3

Vellum and paper, 212 x 145. A–B modern paper + 188 + C–D modern paper. The first, two middle and last folios are vellum, the others are paper. The flourished and decorated initials and borders are unusual in their diversity. Three styles are evident: red and blue pen-flourished initials with infills of elaborate bird-design in sepia as on f.98v (fig. 144); a standard mid-to-late fifteenth-century type of decorated initial as on f.134r in blue or pink with white tracery on a gold ground and with simplified infills of

curling tendrils and trefoil leaves; these initials are accompanied by an equally standard panel border of green leaves with red and blue fruits and flowers (fig. 145); and decorated initials as on f.157r set on burnished gold grounds with indented or jigsaw corners with infills of less usual design such as an opening bud enclosed by branches and leaves. The marginal sprays are comprised of sinewy, curling leaves and fine hairline tendrils. Brownish pinks and lighter greens are a marked contrast to the glowing gold of the initial setting (fig. 146).

Bibliography: Sinclair (1969), pp. 178–180; (Sydney, 1967), p. 22.

German Manuscripts

German Short Entries

Fig. 147
No. 63. Eusebius, *Ecclesiastical History* (translated by
 Rufinus of Aquila). Latin
Germany, 15c.
State Library of New South Wales, Mitchell 1/7a

Paper, 274 x 207. A modern paper + 156 + B modern
paper.

There are two scribes but decoration is consistent. One-
and two-line blue and red initials flourished in the alternate
colour. Eleven illuminated initials, six to eight lines high,
on ff. 1r, 15r, 28r, 44v, 59v, 77v, 95v, 108v, 119v, 129v and
145v. These are in blue, red and green with white tracery
on gold grounds indented at the corners. Infills have
strapwork, foliate or floral motifs. On f. 1r fine tendrils
with leaves and a flower extend into the border (fig. 147).

Bibliography: Sinclair (1969), pp. 106–107.

Fig. 148
No. 64. *Breviary*. Latin
Germany, 15c.
National Library of Australia, Canberra, Clifford
 Collection, MS. 1097/8

Vellum, 123 x 85. 336ff.

Two blue initials, eight lines high, flourished in red, with
flourishes extending into the border on ff. 8r (fig. 148) and
8v. The initial on f. 8r has also a green leafy infill.

Bibliography: Sinclair (1969), pp. 34–35.

Fig. 149
No. 65. *Psalter and breviary*. Latin
Cologne, 15c.–16c.
State Library of New South Wales, Rare books and Special
 Collections, Richardson 228

Vellum, 112 x 73. A modern vellum + B–C modern paper
+ D–O 16c. paper + 472 + P–S 16c. paper + T–V
modern vellum.

Decoration contemporary with the fifteenth-century
script consists of one-line red and blue initials sometimes
touched with gold, and illuminated initials, three lines
high, in green, pink and blue on gold grounds with border
extensions of leaf and floral motifs. The book is a curiosity
in that it has been re-decorated in the sixteenth century, for
the most part in a very coarse manner. On ff. 114v, 115v
and 131v, decorative motifs from another manuscript have
been pasted in. Folio 115v contains a large historiated
Italian initial of a funeral service, enclosed by a crudely
rendered Renaissance frieze. The Italian initial is probably
fourteenth or early fifteenth century (fig. 149). The litany
suggests a Cologne provenance.

Bibliography: Sinclair (1969), pp. 135–136.

Fig. 150
No. 66. *Prayer-book*. German
Cologne, 15c.
Ballarat Fine Art Gallery, Victoria, MS. Crouch 13

Vellum, 115 x 80. 240 + A contemporary vellum.

Sixty-one initials two lines high, and seven initials four
or five lines high in burnished gold with red, green, grey or
blue grounds and infills. Motifs range from tracery scrolls
to floral and foliate designs. Flourishes extend into the
borders, and on the pages with the large initials (ff. 1r, 28r,
32v, 37r, 41v, 129r and 156v) the borders are also punctu-
ated by gold circlets with hairline motifs (fig. 150).

Bibliography: Sinclair (1969), pp. 291–293.

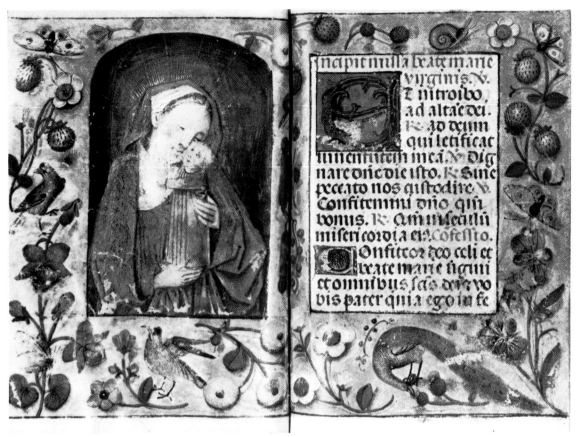

Fig. 128. Virgin and Child. No. 57, ff. 14v–15r. 87 x 112

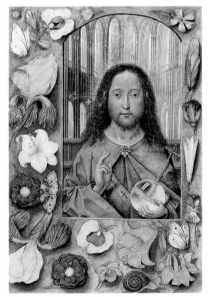

Fig. 129. 'Salvator Mundi'. Hours of Queen Isabel la Catolica, Cleveland Museum of Art, f. 14v. 226 x 152

Fig. 130. 'Salvator Mundi'. Manderscheid Hours, ff. 14v–15r. 115 x 150

Fig. 131. Vision of the suffering Christ. No. 58, f.199r.
146 x 110

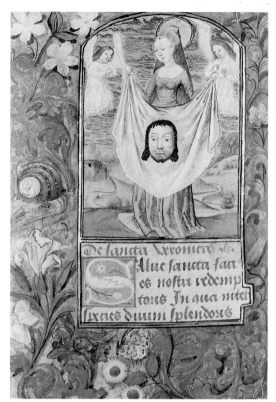

Fig. 132. St Veronica with sudarium. No. 58, f.200v.
146 x 110

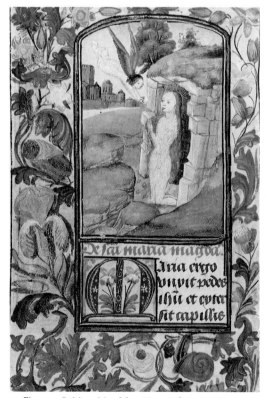

Fig. 133. St Mary Magdalen. No. 58, f.264v. 146 x 110

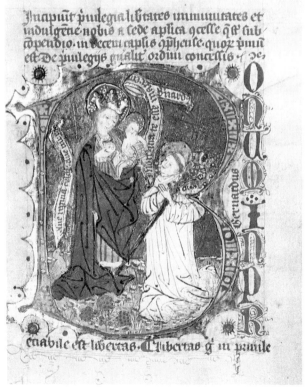

Fig. 134. St Bernard's vision of the Virgin and Child. No. 59,
f.9r. (detail)

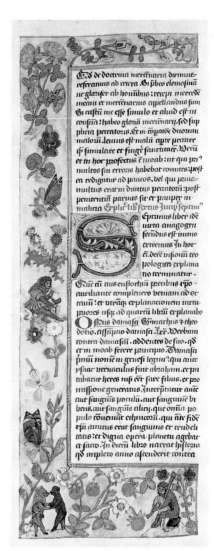

Fig. 135. Initial 'V' and border decoration. No. 60, f.38v. (detail)

Fig. 136. Initial 'S' and border decoration. No. 60, f.82v. (detail)

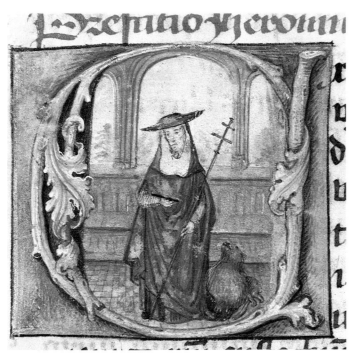

Fig. 137. St Jerome. No. 60, f.1r. (detail)

Fig. 138. Initial 'D'. No. 60, f.179r. (detail)

Fig. 139. St Margaret. No. 61, f.14v. 156 x 96

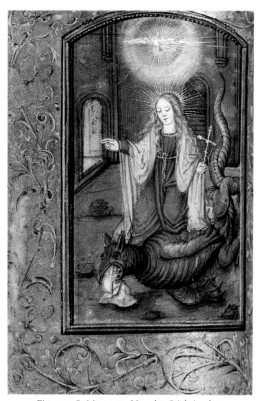

Fig. 140. St Margaret. Utrecht, Stichting het Catharineconvent, MS.14, f.50r. 116 x 81

Fig. 141. Virgin and Child. No. 61, f.48v. 156 x 96

Fig. 142. Monogram of Name of Jesus. No. 61, f.57v. 156 x 96

Fig. 143. St Anne with Virgin and Child. No. 61, f.64v.
156 x 96

Fig. 144. Initial 'P'. No. 62, f.98v. (detail)

Fig. 145. Initial 'M'. No. 62, f.134r. (detail)

Fig. 146. Initial 'N'. No. 62, f.157r. (detail)

Fig. 147. Initial 'M'. No. 63, f. 1r. (detail)

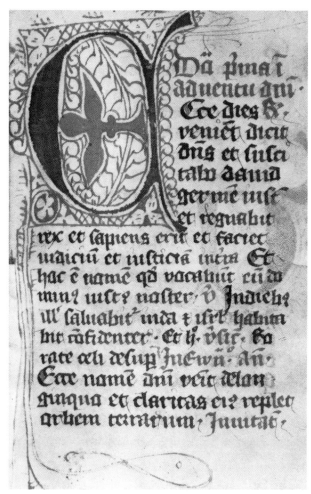

Fig. 148. Initial 'E'. No. 64, f. 8r. 123 x 85

Fig. 149. Funeral service. No. 65, ff. 115v–116r. 112 x 146

Fig. 150. Initial 'H'. No. 66, f. 41v. (detail)

Fig. 151. Initial 'P'. No. 67, f.70v. 130 x 90

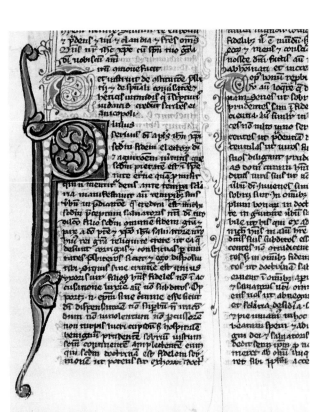

Fig. 152. Initials 'T' and 'P'. No. 67, f.511v. (detail)

Fig. 153. Initial 'I'. No. 68, f.1r. 162 x 110

Fig. 154. Initial 'F'. No. 68, f.81v. (detail)

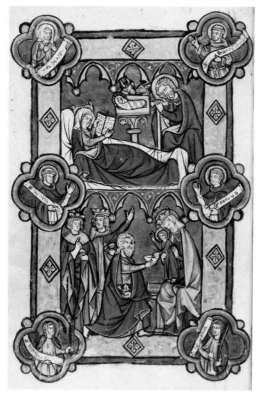

Fig. 155. Nativity, and Adoration of the Magi. Paris,
B.N. MS. lat. 1077, f.9v. 187 x 123

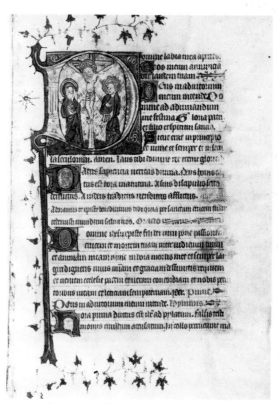

Fig. 156. Crucifixion. No. 69, f.1r. 170 x 122

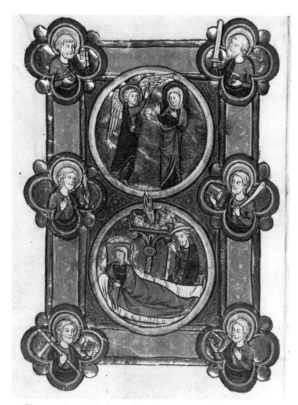

Fig. 157. Annunciation and Nativity. No. 69, f.17v. 170 x 122

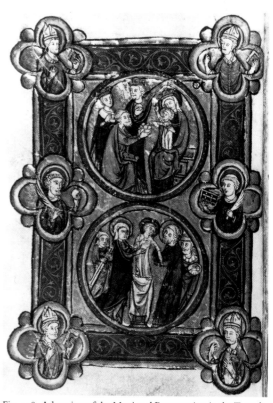

Fig. 158. Adoration of the Magi and Presentation in the Temple.
No. 69, f.18v. 170 x 122

Fig. 159. Massacre of the Innocents. No. 69, f.53v. (detail)

Fig. 160. Christ (*above*), Jonah and the whale (*below*). No. 69, f.63v. (detail)

Fig. 161. Thomas testing the wound of Christ. No. 69, f.121v. 170 x 122

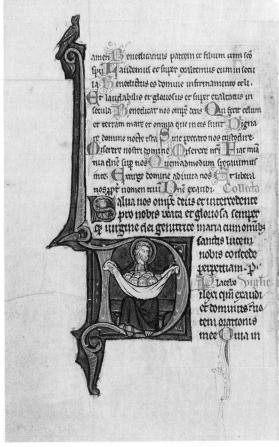

Fig. 162. Bosom of Abraham. Paris, B.N. MS. lat. 1077, f.183v. 187 x 123

Fig. 163. *Beatus* page. Oxford, Bodl. MS. Douce 118, f.7r. 215 x 150

Fig. 164. Presentation of the Virgin. No. 70, f.1r. 215 x 150

Fig. 165. Annunciation. No. 70, f.5v. (detail)

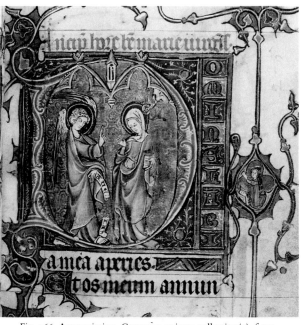

Fig. 166. Annunciation. Germany, private collection(1), f.24r. (detail)

Fig. 167. Annunciation to the shepherds. No. 70, f. 29r. 215 x 150

Fig. 168. Annunciation to the shepherds. Germany, private collection (1), f. 73r. 130 x 93

Fig. 169. Trinity. Oxford, Bodl. MS. Douce 118, f. 127r. (detail)

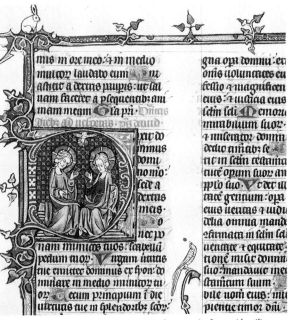

Fig. 170. Trinity. Paris, B.N. MS. lat. 1029A, f. 45v. (detail)

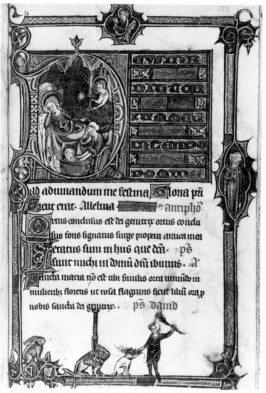

Fig. 171. Nativity of the Virgin. No. 70, f.123r. 215 x 150

Fig. 172. The illuminator's inscription. Oxford, Bodl. MS. Douce 118, f.142r. 215 x 150

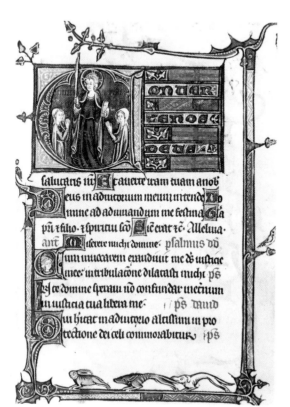

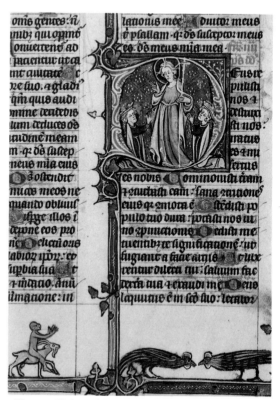

Fig. 173. Cross-nimbed figure holding palm. No. 70, f.138r. 215 x 150

Fig. 174. Christ with kneeling patrons. Paris, B.N. MS. lat. 1029, f.27r. (detail)

Fig. 175. Page with flourished initials. No. 71, f.401r. 285 x 200

Fig. 176. Translation of St Dominic. No. 71, f.266v. (detail)

Fig. 177. St Dominic and the ladder. No. 71, f.294v. (detail)

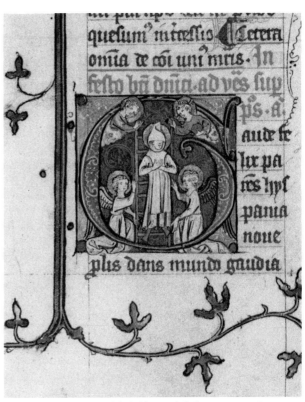

Fig. 178. St Dominic and the ladder. Sotheby's, 4 June 1974, Lot 2919, f.406v. (detail)

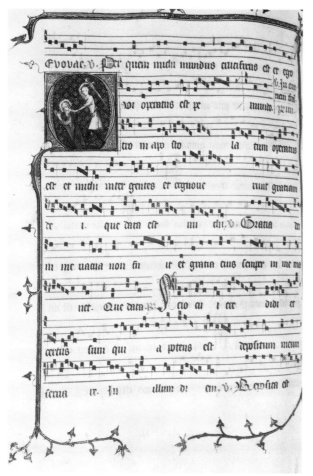

Fig. 179. Martyrdom of St Paul. No. 71, f.281v. 285 x 200

Fig. 180. Martyrdom of St Peter Martyr. Sotheby's, 4 June 1974, Lot 2919, f.357v. 215 x 153

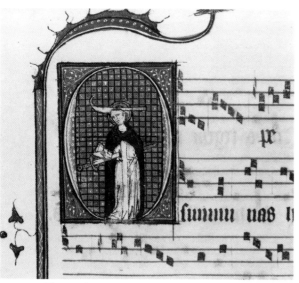

Fig. 181. St Peter Martyr. No. 71, f.257v. (detail)

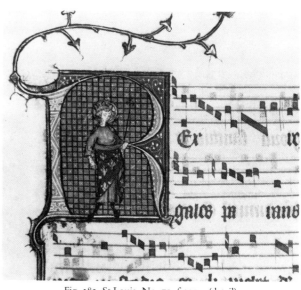

Fig. 182. St Louis. No. 71, f.311v. (detail)

Fig. 183. Introduction to Decade II. No. 72, f.212r. 440 x 325

Fig. 184. Introduction to Decade III. No. 72, f.377r. 440 x 325

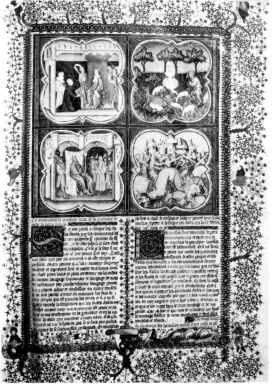

Fig. 185. Introduction to Decade II. Paris, B.N. MS. fr.271, f.1r. 420 x 310

Fig. 186. Dedication page: Decade I. Geneva, Bibl. publ. et univ. MS. fr.77, f.9r. 455 x 320

Fig. 187. Frusinate punished. No. 72, f. 188r. (detail)

Fig. 188. Messenger from Caerites. No. 72, f. 137v. (detail)

Fig. 189. Appius speaking before the consuls. No. 72, f. 102r.
(detail)

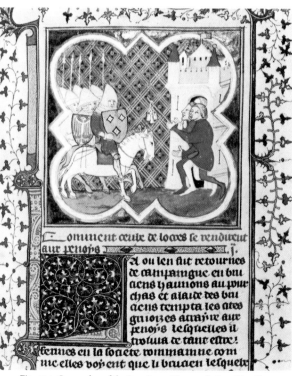

Fig. 190. Surrender of the Locrians. No. 72, f. 261r. (detail)

French and Franco–Flemish Manuscripts

Figs. 151–152

No. 67. *Bible*, Vulgate and *The Interpretations of Hebrew Names*. Latin

France or southern England?, second half of 13c.

State Library of Victoria, ★091/B47C

Vellum, 130 x 90. A–C modern paper + 595 + D–F modern paper. I²¹, II²³, III–IV²⁴, V²⁰, VI–VII²⁴, VIII²², IX²⁴, X¹⁴, XI¹⁶, XII¹², XIII–XX²⁴, XXI²², XXII²⁰, XXIII²², XXIV²⁶, XXV¹⁴, XXVI¹⁸, XXVII²⁴, XXVIII⁹. Quire I lacks three sheets, quire II one, and quire XXV one or more. A few catchwords. Modern foliation in arabic numerals by tens. Script: 13c. gothic book hand in black ink with red rubrics and running book titles alternately in red and blue. Ruling: light brown ink: 12.[30].3.[30].15 x 11.[2.88.2].27. Lines of text: 48. Ruling unit: 2. Binding: 19c. half calf boards.

Ownership: On ff.245rᵃ–248vᵇ in a gothic hand is a list of *incipits* of epistles and gospels for the temporal, the sanctoral and the common of the saints. The latter breaks off with *Residuum quere in fini libri* – although nothing now remains at the end of the book. Names in the sanctoral include SS. Iacobinia, Iulita, Thomas of Hereford, Alban, Denis, Michael *in monte*, and Edmund Rich of Canterbury. On f.137r in a 16c. hand is 'Johannes Chippingdale'. On f.248v in another 16c. hand is 'Johannes Anderson'. Folio 299v has 'Ihesus Christ' in a 16c. hand. Notes in Latin commenting on Isaiah appear on f.305r. On f.495v are scribbles in a 16c. hand which seem to refer to predictions of the prophets and end with the name 'Johannes Tevyonere'(?). On f.595v in a 19c. hand is 'No. 8'.

Text: Latin. Contents: ff.1rᵃ–544vᵇ the books of the Bible, opening abruptly in Exodus II, 22 to the Apocalypse, and including prologues attributed to Jerome, Rabanus, Maurus, Marcion, Peter Lombard and the Pseudo-Jerome. The Epistle of Jude breaks off abruptly on f.538vᵇ at verse 24 and the Apocalypse opens abruptly on f.539rᵃ at V, 2; ff.545rᵃ–595vᵇ the interpretation of Hebrew names.

Decoration: Throughout the text there are numerous small pen-flourished initials in red and blue. In addition there are forty-two larger red and blue initials flourished in alternate colours, and seventy-five decorated initials, averaging seven or eight lines in height, which preface individual books and prologues throughout. The decorated initials are in blue, red and white set against blue grounds and from them vertical leafy fronds sometimes extend into the border. Their interstices are filled with curving foliate and grotesque bird and animal shapes (figs. 151, 152).

Commentary: Several scholars, including the late N. R. Ker, and Dr Adelaide Bennett, have tried to distinguish between French and English bibles of this period according to the particular prologues incorporated with the scriptural texts and the order of the books as well as noting the precise features of script and decoration.[1] Definite attribution of many books of this genre is still difficult, however, especially in the absence of larger illustrative features. There seems to have been a very close interchange between workshops in England and France at this time, with models being readily interchanged.

St Thomas of Hereford, who is mentioned in the sanctoral, died in 1282 and was not canonized until 1321. However, the sanctoral seems a slightly later addition, and although marks of ownership indicate that this book was early used in England, it is prudent to leave open the question of an English or French origin. The volume was acquired by the State Library of Victoria on 3 April 1912.

Bibliography: Sinclair (1969), pp.331–338.

Note

1. See N. R. Ker, *Medieval Manuscripts in British Libraries*, Vol. I, Oxford, 1969, pp.vii–viii, p.96; and A. Bennett, *The Place of Garrett 28 in 13th Century English Illumination*, Ph.D. thesis, Columbia University, 1973, Ann Arbor, 1980.

Figs. 153–154

No. 68. *Bible*, Vulgate. Latin

France, second half of 13c.

National Library of Australia, Clifford Collection MS. 1097/1

Vellum, 162 x 110. A–B old paper + 307 + C–D old paper. I¹³, II–XIX¹⁶, XX⁶. Quire I is lacking its first three sheets. A few quire signatures remain. Script: 13c. gothic hand in brown ink with red rubrics, and running book titles and numbers alternately in red and blue. Ruling: brown ink: 2 columns each of 51 to 54 lines. Prickings in inner margins. Binding: English 17c. red morocco with gilt corner-pieces and coiled rope with an anchor bearing the initials W.C.

Ownership: As well as the monogram on the cover, the lower margin of f.1r has the stamp 'C' surmounted by a coronet. Inside front cover is the book plate of the Clifford family: *chequy or and azur, a fesse gules* supported by two wyverns and the motto *semper paratus*.[1]

Text: Latin. Contents: ff.1r–307vᵇ the books of the Bible from Genesis to the Apocalypse including prologues chiefly

attributed to St Jerome. Folio 307v[b] concludes with the Oratio Manasse (*sic*): *Domine deus omnipotens patrum nostrorum abraham. . . .*

Decoration: Red and blue initials flourished in the alternate colour and whose flourishes extend into the margin introduce individual books throughout (fig. 154). The book of Genesis on f. 1r is introduced by a decorated initial 'I' which expands into a border extending the full length of the page. Two grotesques and curving foliate tendrils in brown, blue and green, outlined in black and shaded with white, are set within a rectangular panel which forms a tapering indented tail at the base of the page (fig. 153).

Commentary: This manuscript is a modest example of a type of French bible widespread in the second half of the thirteenth century, in which it was customary for the Genesis page to be the chief feature of the decoration.

As the marks of ownership indicate, the manuscript belonged to the Clifford family, originally of Chudleigh, and was acquired by the National Library of Australia in 1964.

Bibliography: Sinclair (1969), pp. 11–14; (Sydney, 1967), p. 21.

Plate 35, figs. 155–162
No. 69. *Psalter-Hours.* Latin and French
Liège, mid 1270s
State Library of Victoria, *096/R66

This manuscript is bound with three 14c. fragments of Books of Hours. The general description and notes on ownership include these; but only one fragment is sufficiently decorated to warrant further mention. It is discussed briefly as an appendix to the main entry on p. 173.

Vellum, 170 x 122. A contemporary vellum + 270 + B–C contemporary vellum. [I[8], II[1], 14c. fragment], III[6], IV[4], V–XV[8], XVI[7] (lacks 1), XVII–XXV[8], XXVI[4], XXVII–XXIX[8], XXX[2], [XXXI[9], XXXII[6], XXXIII[9], XXXIV[10], XXXV[4], 14c. fragment], [XXXVI–XXXVII, 14c. fragment]. Modern incorrect arabic foliation, 1–269, a leaf having been missed between ff. 58 and 59. Binding: 16c. calf over boards, gilt tooled in Lyonnais style, in calf case by Gruel *c.*1887.

Ownership: On Br–Bv in a 15c. French hand notes record an account by Simon le Gloux of the capture of Hugues Henry in 1443, his death in 1444 and that of his wife Marguerite de Loyesme in 1482. Inside front cover in a 16c. hand is *Remond. ex legato domini Ionnis Remondi. Lambert . . . ex legato domini nocolai lambert patris mei . . . maire et bailly.* Notes on members of the Bégat family from 1537 to 1548 appear in French on Bv–Cv.

Psalter-Hours 13c.: This begins at quire III. Some quire signatures. Foliation 10–52 in 14c. arabic numerals and 18–215 in contemporary roman numerals. One folio between

58 and 59 unnumbered. Folios 16r, 17r and 18r are blank. Script: gothic book hand in black ink with red and blue rubrics; calendar in black and red. Ruling: black ink: 22.[72].28 x 17.[105].48. Lines of text: 24. Ruling unit: 4.5. Calendar: 12.[11.3.10.3.55].28 x 9[112].49. Lines of text: 33. Ruling unit: 3.

Text: Latin and French. Contents: ff. 10r–15v calendar; entries in red include SS. Servatius, Remacle, Lambert, Hubert, and Remigius; entries in black include translation of St Lambert, SS. Arnulf, Vedast, Amand, Quentin and Foillan. A Lambertum verse occurs in March and April; f. 16v Easter table with Lambertum verse, inscribed MCXL; f. 19r French poem: *Une faisselet de myre . . . et mes amis a moi . . .*; ff. 19v–121r psalter; ff. 121v–127v six canticles; ff. 127v–130v litany, including SS. Lambert, Remacle, Hubert, Servatius, Gertrude and Afra; the petitions include the words *ut clerum et plebem sancti marie sanctique Lamberti martyris conservare digneris* on f. 129r; ff. 131r Hours of the Nativity of the Virgin entitled *Cursus beate [Marie]*: commemorations at lauds in honour of the Cross, apostles, SS. Lambert, Nicholas, Catherine and All Saints; ff. 163v–181v Vigils of the Dead; ff. 182r–190r psalter of the Virgin: *Ave porta paradysi . . .*; f. 190v *Veni Creator spiritus*; ff. 191r–200r abbreviated Hours of the Purification; ff. 200v–207v abbreviated Hours of the Annunciation; ff. 207v–216v abbreviated Hours of the Assumption.

Decoration: One-line red and blue versal initials occur throughout. Only very occasionally are they flourished in the alternate colour when relating to a margin, as on f. 87v. Flourishes occur in relation to the border on f. 19v (Plate 35). There are some two-line initials of the same type at the beginning of hymns etc. within the hours, as on f. 151r. The text is written in a solid block without line-endings, P–S rubrics dividing the psalms (fig. 161).

Three-line dentelle initials introduce the psalms and other subdivisions of the devotions. Twenty-four historiated initials, usually ten lines high, preface the main divisions of the book. They are closely related in style and colour to the dentelle initials, with their shafts in pink or blue and the scenes within the initials themselves set against burnished gold grounds. Narrow square gold frames, outlined in black, project into the margins as a simple bar border, the pink or blue of the initial surrounds also being extended as part of this decoration. Small grotesque heads, usually in white, are incorporated into some of these borders, and the latter terminate in a curling tail or zig-zag prolongation of the initial frame (figs. 159 and 160). On f. 20r, Psalm 2, the initial tail frames the page and a boy with a bow shoots at a bird in the upper right of the border. The pink and blue 'KL' headings of the calendar pages have similar bar extensions, and the twenty-four calendar miniatures, two decorating the side of each page, are set in burnished gold diamonds on pink or blue quadrilobes

Circlets of blue or pink further ornament the corners of the diamond shapes.

Three full-page miniatures are divided into two roundels and framed by a border whose pattern matches that of the decorated initials. Six quadrilobe-shaped medallions with half-length figures are set into these borders (Plate 35, figs. 157 and 158). Folio 19v, which incorporates the *Beatus* initial for Psalm 1, contains the letters for the opening words of the psalm in the lower section of the border (Plate 35).

The predominant colour scheme throughout the decoration is pink, blue, red, gold and white, with some green and brown, and a bright orange-red appearing in the full-page illustrations (Plate 35).

Programme of Illustration: The twenty-four medallions of the labours of the months and signs of the zodiac illustrate the calendar as follows: f.10r man feasting, Aquarius, January; f.10v man pruning, Pisces, February; f.11r man hoeing, Aries, March; f.11v man with two flowering branches, Taurus, April; f.12r man playing viola, Gemini, May; f.12v man with basket picking fruits, Cancer, June; f.13r man with scythe, Leo, July; f.13v man with sickle, Virgo with mirror, August; f.14r man treading grapes, Libra, September; f.14v man sowing, Scorpio, October; f.15r man with hog on shoulders, Sagittarius, November; f.15v man killing ox, Capricorn, December.

The subjects of the three full-page miniatures which follow the Easter table are: f.17v Annunciation/Nativity. Border medallions: St Peter, upper left; St Paul, upper right; St Bartholomew, centre right; St John the Evangelist, lower right; St Andrew, lower left; St James the Less, centre left (fig. 157); f.18r blank; f.18v Adoration of the Magi/Presentation in the Temple. Border medallions: bishop saints, upper left, right and lower right and left; tonsured deacon saints, centre right and left (fig. 158); f.19r poem in honour of the Passion: *Une faisselet de myre*; f.19v B (historiated initial). Ascension/Pentecost: Psalm 1: *Beatus vir* (Plate 35).

The twenty-four historiated initials illustrate psalms, prayers etc. as follows:

f.20r Q David playing harp: *Quare fremuerunt*, Psalm 2

f.35r D Christ healing a blind man: *Dominus illuminatio mea*, Psalm 26

f.45r D Flight into Egypt: *Dixi: Custodiam*, Psalm 38

f.53v Q Massacre of Innocents: *Quid gloriaris*, Psalm 51 (fig. 159)

f.54r D First Temptation of Christ: *Dixit insipiens in corde*, Psalm 52

f.63v S Christ above/Jonah in the Whale below: *Salvum me fac*, Psalm 68 (fig. 160)

f.75v E David playing bells: *Exultate Deo*, Psalm 80

f.86r C Two clerics singing: *Cantate Domino quia*, Psalm 97

f.87v D David in prayer below/God above: *Domine exaudi et clamor*, Psalm 101

f.98r D Trinity: *Gnadenstuhl* or throne of God; *Dixit Dominus*, Psalm 109

f.121v C Thomas testing the wounds of Christ: *Confitebor tibi domine*, canticle (fig. 161)

f.131r D Virgin and Child: matins for Hours of the Virgin (combined with Office for the Nativity)

f.140v D Betrayal: lauds

f.145v D Christ before Pilate: prime

f.151r D Scourging of Christ: tierce

f.153v D Carrying of Cross: sext

f.155v D Crucifixion: none

f.158v D Deposition: vespers

f.161r C Three Marys at the Tomb: compline

f.163v D Bosom of Abraham: Vigils of the Dead

f.183r A Kneeling Theophilus before the Virgin: psalter of the Virgin, *Ave porta paradysi*

f.191r D Presentation in the Temple: abbreviated Hours of the Purification

f.200v D Annunciation: abbreviated Hours of the Annunciation

f.207v D Coronation of the Virgin: abbreviated Hours of the Assumption

Commentary: In a dissertation on the so-called psalters of Lambert-le-Bègue, Dr Judith Oliver has identified thirty-seven psalter-hours produced in the diocese of Liège between *c.*1250 and the first decades of the fourteenth century. She convincingly places the Melbourne manuscript in a group which was executed between 1260 and 1270, during which time the predominantly Germanic style of earlier examples was infused with new trends from gothic France and Flanders. Her paradigm for this group is Paris B.N. MS. lat. 1077 (figs. 155 and 162).

The results of Oliver's thorough research and Sinclair's earlier contributions to the study of some of the specific texts in these manuscripts establish the artistic and devotional context of the Melbourne manuscript. Several of these books, but by no means all, seem to have been made for the Béguines, a semi-religious order of women who flourished in Liège at this period. It should be noted, however, that the Melbourne psalter-hours does not contain devotions associated with the Mass which appear in many of the manuals executed for Béguine patrons.

This group of manuscripts is of special interest on account of the local, regional nature of their textual contents and because of the distinctive features of their illustrative programmes.

While the books vary in their selection of texts, they share for the most part the following distinguishing characteristics. In addition to the more or less standard elements of calendar, psalter and canticles, litany and Vigils of the Dead (for the use of Liège) they contain a detailed Easter table composed in honour of St Lambert, patron saint of the diocese, a selection of poems in Walloon French which precedes the psalter, and the so-called *Aves* or Latin

psalter of the Virgin, a 150-stanza composition in honour of Mary. Perhaps one of the most interesting textual features which invites further research is the variety of Offices or Hours in honour of the Virgin; these represent a stage before the crystallization of the Little Office as the regular component of fourteenth- and fifteenth-century Books of Hours. The Liège group might be fruitfully compared with other regional variations during this developmental period.

The Hours in the Melbourne manuscript entitled *Cursus beate Marie* is a mixture of the breviary office for the feast of the Nativity of the Virgin with what was to develop into the regular Little Office. The Hours of the Purification, Annunciation and Assumption are all abbreviated versions of the longer breviary offices for these feasts which commence with first vespers, a practice reserved in the breviary for important feasts.

This selection of offices invites comparison with the text of No. 70, the Aspremont psalter-offices from Verdun, where five full offices are abstracted from the breviary. They include those for the feasts in the Liège book together with the office for Christmas. Such a comparison is all the more striking since these two books differ in so many other respects – iconographically, stylistically and in overall textual contents. Thus they indicate the richness and variety of local devotional prayer-books of the late thirteenth and early fourteenth centuries, and at the same time the importance of the breviary in the development of a manual for lay or semi-religious patrons.

The iconography and programme of the Liège psalter-hours have also a strong regional flavour, reflecting, as mentioned above, from *c.*1260 on, the absorption of new Flemish and French influences into a basic Germanic tradition. In the calendar of the Melbourne book, as in B.N. MS. lat. 1077, the labours for September and October are reversed. The full page miniatures which precede the psalter are devoted to New Testament scenes and are linked to the psalter itself by the *Beatus* page illustration which completes the cycle. The historiated initials within the psalter section integrate themes from the life of Christ, such as the Massacre of the Innocents on f.53v (fig. 159), with the more regular French programme which relates to David or the first verse of the psalm. A specific characteristic of this group is the illustration of Psalm 2, in addition to the more regular ten liturgical divisions.

In the Melbourne book the introduction of the canticles with a depiction of Christ and doubting Thomas (fig. 161) continues this blend of Old Testament text and Christian overlay, so much a part of medieval devotional literature, but quite distinctively treated in this psalter-hours group. The psalter of the Virgin on the other hand draws on a contemporary medieval theme for its imagery showing the cleric Theophilus, from the popular 'Miracles of Notre Dame', kneeling before the Virgin.

Prophets, apostles and the saints specially honoured in the region, who in later Books of Hours will often be represented in individual miniatures accompanying specific *memoriae* or commemorations, here occupy the medallions of the full-page miniatures, once more intermingling Old and New Testament typology with local hagiography (Plate 35, figs. 157 and 158).

The illustration of the longest office of the Virgin – after an introduction by an image of the Virgin and Child at matins – with a Passion cycle, reflects the long tradition of associating the canonical hours for prayer with Christ's suffering and death, a relationship which will continue to develop in varying ways in later Books of Hours, side by side with an elaboration of the Infancy cycle and themes more specifically related to the Virgin.

Stylistically, if one compares the Melbourne manuscript with B.N. MS. lat. 1077 (figs. 155 and 162), the increasing development towards a freer, more sinuous Gothic style is evident in the Melbourne work. The greater freedom of line in both the drawing of faces and the treatment of drapery, together with a warm palette, is particularly evident in the full-page miniatures (Plate 35, figs. 157 and 158), while the use of roundels as a framing device for the individual scenes has filtered through from stained-glass compositions, and was already a feature of large thirteenth-century Parisian manuscripts such as those of the *Bible Moralisée*. Thus the Melbourne psalter-hours, as Oliver has argued, represents a later phase of the workshop which produced B.N. MS. lat. 1077 and should be dated well into the 1270s.

The notes on the end fly-leaves of the book indicate that it was owned in the fifteenth century by Simon Le Gloux and later in the sixteenth by the Bégat family of Châtillon-sur-Seine. Sixteenth-century owners, according to the inscribed names, seem to have included John Remond and later in the seventeenth century it belonged to the Lambert family. It must be noted, however, that since the binding is sixteenth-century the notes concerning owners could refer to one of the accompanying fragments. In 1862 the book was in the collection of J. Techener in Paris and in that of Leon Techener in 1887. It was sold at Sotheby's in 1933 by an anonymous owner to Gabriel Wells of New York and subsequently purchased by William Robinson in 1934. In 1936 it was acquired through the Felton Bequest for the State Library of Victoria.

Bibliography: Sinclair (1969), pp.358–363; Sinclair (1964c), pp.5–10; Sinclair (1965b), pp.24–25; J.J. Techener (1862), Pt. I, no. 152, pp.227–232; Meyer (1873), p.238; Meyer (1900), pp.528–529; L. Techener (1887), Pt. II, p.4; Gilbert (1930–1934), p.9; Sotheby (1933a), lot 252; Robinson (1934), pp.14–15; Oliver (1976), pp.125–140, 404–407 *et passim*; (Sydney, 1967), p.23.

Appendix. Book of Hours Fragment
Metz? second half of 14c.

The nine folios which precede the Liège psalter-hours are written in black ink in a gothic liturgical script. They contain: f.1r Hours of the Cross; f.2r Hours of the Holy Ghost; f.3r gospel sequences; f.4v Passion according to St John; ff.5r–9v various prayers. Folio 1r (fig. 156) has a historiated initial of the Crucifixion (39 x 38). It has some affinities with works from Metz.

Note

1. See Oliver (1976). Much of the information in this entry is based on Dr Oliver's very detailed study of these manuscripts. She suggests that a more appropriate title for the group would be 'Mosan Manuscripts'.

Plate 36, figs. 163–174

No. 70. *Offices of the Virgin*. Latin
Lorraine, *c.*1290–1310
National Gallery of Victoria, MS. Felton 171/3

Vellum, 215 x 150. A + B 16c. vellum + 139 + C + D 16c. vellum. I⁴ (wants 3–6, misbound in IX), II–VI⁸, VII⁷ (wants 1), VIII⁸, IX¹¹ (wants 7; 4ff. from I inserted after 6), X–XV⁸, XVI⁴, XVII⁸, XVIII⁷ (wants 6), XIX². Catchwords agree. Modern pencil foliation in arabic numerals acknowledges position of misbound leaves. Older black ink foliation in roman numerals, now largely trimmed from upper right margin, included end leaves, differing therefore by two from pencil foliation. Script: a not very formal gothic hand which grows less regular towards the end of the manuscript, in black ink with red rubrics. Instructions for rubrics and historiated initials in black ink in contemporary cursive remain visible in several places. Ruling: plummet: 8.3.10.3.[90].3.20.3.10 x 3.3.20[8.122.8]. 34.3.14. Lines of text: 18. Ruling unit: 7·7. Binding: 16c. calf over oak boards, stamped with Renaissance designs.

Ownership: Coats-of-arms of Joffroy d'Aspremont and Isabelle de Kievraing form part of the original decoration throughout the manuscript (see below). On f.139v notes decipherable only under ultra-violet record the following dates in a 17c. hand: 6 May 1623, marriage of Marie Amie, daughter of Reinolde Kempe and Maurice Tuke; 27 March 1624, birth of Marie Tuke, eldest daughter, baptized 4 April; 14 June 1626, birth of Marie Tuke, second daughter, baptized 28 June; 11 September 1628, birth of Dorothie Tuke, third daughter, baptized 23 September; 19 October 1629, birth of Elizabeth, youngest daughter, baptized 28 October; 11 November 1629, death of 'my dear wife' (Marie Amie) . . . 'being borne the 21 Sept. 1598'. Ar has in pencil '1254/3 National Gallery of Victoria'.[1]

Text: Latin, rubrics in French and Latin. Contents: offices for five feasts of the Virgin taken from the breviary, with nine lessons for matins; each office begins with vespers and compline for the vigil of the feast; ff.1r–37v Christmas; ff.38r–54r the Purification (lauds end and prime begins imperfectly with the loss of one folio after f.48); ff.54v–69v the Annunciation (compline ends imperfectly with the loss of one folio after f.49); ff.70r–122v the Assumption; ff.123r–139r the Nativity of the Virgin (sext ends and none begins imperfectly with the loss of one leaf after f.135r).

Decoration: One- and two-line initials in blue, red or burnished gold occur throughout the text. They contain foliate and tracery designs, figures, heads, animals and the coats-of-arms of Joffroy d'Aspremont: *gules a cross argent*, and Isabelle de Kievraing: *or a chief bendy of six argent and gules*. Their leafy terminations and irregular format together with that of the fields against which they are set harmonize with the border decoration and often coalesce with it. Line-fillers with the same patterns as the initials are prevalent throughout.

Four larger foliate and forty-eight historiated initials, ranging from five to thirteen lines high, set in decorated rectangular frames, introduce the hours of the offices. Except for the foliate initial on f.47v, beside the initial is set a pattern of letters, usually in burnished gold, alternating with bands of line-fillers to form the opening words of the verses for each hour. Cusps and ivy-leaf fronds grow from the large initials to form part of the border.

Most pages have a bar border. On pages with large initials this is usually a three-quarter frame terminating in two ivy-leaf fronds on the fourth side. Folios 1r, 7r, 11r, 41v, 70r and 123r have full borders with inserted medallions containing small scenes or figures (Plate 36 and fig. 164). These more elaborately decorated pages occur in the first office for Christmas, or mark the beginning of the later offices. Only the office for the Annunciation on f.57r is introduced by the simpler three-quarter frame. Most regular pages of text have bar borders along one side-margin which usually develops into a wavy frond at the bottom of the page and sometimes also at the top.

All borders are lavishly populated with grotesques, drolleries and images of a knight and lady bearing the Aspremont or Kievraing arms, now mostly painted over. Figures bearing shields or mantles etc. with other coats-of-arms also occur, though less frequently. The marginalia include references to local proverbs, caricatures of the clerical, religious and medical professions as well as specific allusions to the text, and purely decorative hybrids, animals, birds etc.

Colours for all this decoration are uniform throughout, namely blue, pink and orange-red, with liberal use of burnished gold, white tracery and black outlines. The scenes of the historiated initials are set on grounds of burnished gold with tooled designs, or tessellated patterns in deep blue, red and white (Plate 36).

Programme of Illustration: The initials marking the divisions of the offices are illustrated as follows:

f.1r D (13 lines) Presentation of the Virgin: vespers for vigil of Christmas. Border medallions: Crucifixion, upper right; Virgin and Child, centre right; kneeling lady with Kievraing arms, lower right; knight on horseback with Aspremont arms, lower centre (fig. 164).

f.5v D (9 lines) Annunciation: compline for vigil; (fig. 165)

f.7r D (12 lines) Marriage of Joseph and Mary: matins for Christmas. Beneath patterned letters of opening verses, two kneeling ladies with Kievraing arms on first. Border medallions: saint with palm and dove, upper right; saint with lamb, centre right; mounted knight with Aspremont arms, not painted over, lower centre (Plate 36).

f.11r P (10 lines) Nativity: first lesson for matins. Border medallions: kneeling man with Aspremont shield, centre right; angel with scroll, upper left near initial.

f.29r D (10 lines) Annunciation to the Shepherds: prime (fig. 167)

f.30r D (8 lines) Circumcision: tierce

f.31v D (9 lines) Adoration of the Magi: sext

f.33v D (7 lines) Flight into Egypt: vespers

f.37v C (5 lines) Lady at prayer: compline

f.38v D (7 lines) Massacre of the Innocents: vespers for vigil of Purification

f.40v C (6 lines) Lady at prayer: compline for vigil

f.41v D (9 lines) Presentation in the Temple: matins for Purification. Border medallions: martyr with palm and book, upper centre; Aspremont shield, lower centre

f.47v D (5 lines) Foliate initial with lion's head in centre: lauds

f.49r D (7 lines) Mounted knight at prayer: tierce

f.50r D (7 lines) Virgin and Child: sext

f.50v D (7 lines) St Peter Martyr: none

f.51v D (7 lines) Christ before lady at prayer: vespers

f.53v C (7 lines) Christ in Majesty: compline

f.54v D (7 lines) Isaiah and the Virgin: vespers for vigil of Annunciation

f.56r C (7 lines) Lady at prayer: compline for vigil

f.57r D (7 lines) Annunciation: matins for Annunciation

f.63r D (7 lines) Foliate initial with lion's head in centre: lauds

f.64r D (7 lines) Nativity: prime

f.65r D (7 lines) Annunciation to the shepherds: tierce

f.66r D (7 lines) Knight at prayer: sext

f.67r D (7 lines) St Cecilia and lady at prayer: none

f.68r D (7 lines) Adoration of the Magi: vespers

f.69v C (7 lines) Lady at prayer: compline

f.70r D (9 lines) Death of the Virgin: vespers for vigil of Assumption. Border medallions: angel playing rebec, upper centre; kneeling lady, centre right

f.74r C (7 lines) Knight at prayer: compline for vigil

f.78v D (9 lines) Assumption: matins for Assumption

f.92v D (8 lines) Knight at prayer before altar with Virgin and Child: lauds

f.100r D (7 lines) Foliate initial with lion's head in centre: prime

f.108v D (7 lines) Lady at prayer: tierce

f.112v D (8 lines) Lady at prayer before altar with Virgin and Child: sext

f.116r D (7 lines) Foliate initial: none

f.120r D (7 lines) Coronation of Virgin: vespers

f.121v C (7 lines) Knight at prayer: compline

f.123r D (9 lines) Nativity of the Virgin: vespers for vigil of Nativity of the Virgin. Border medallions: St John, upper centre; standing lady, centre right (fig. 171)

f.125r D (7 lines) Lady at prayer: compline for vigil

f.126r D (7 lines) Nativity of the Virgin: matins for Nativity of the Virgin

f.132r D (7 lines) Christ in Majesty: lauds

f.133r D (7 lines) A bishop saint: prime

f.134r D (7 lines) Man at prayer before saint: tierce

f.135r D (7 lines) Lady at prayer: sext

f.136r D (7 lines) Virgin and Child: vespers

f.138r C (7 lines) Standing cross-nimbed figure holding palm, with kneeling ladies on either side: compline (fig. 173)

Commentary: Eric Millar established in 1925 that this manuscript formed part of a larger work, and he convincingly identified a psalter, now Bodleian MS. Douce 118, as its companion piece (figs. 163, 169 and 172). Both sections were probably originally bound together, with the Melbourne Offices following the litany which now concludes MS. Douce 118.[1]

As a private prayer-book of the late thirteenth or early fourteenth century, the Oxford–Melbourne work is of considerable interest. It represents a particular stage in the transition from the psalter and breviary to the devotional work which was to become so popular with the laity in the fourteenth and fifteenth centuries. Instead of the Little Office of the Virgin, which was the basic ingredient of the developed Book of Hours, we have here virtually a miniature breviary with five full offices appended to the psalter and litany. Some examples of such breviary extracts were listed by Leroquais and more recently, as discussed in relation to No. 69, pp.171–172, J. Oliver has studied a large group of psalter-hours or offices produced in the Liège diocese between c.1250 and c.1320.

The combination in the Aspremont manuscript, however, of the office for Christmas with those for the four feasts of the Virgin which occur more regularly in the Liège group, together with the fact that all the Aspremont offices are given in full, make this book quite distinctive. Nor is its style, format, or programme of illustration related to the Liège group.

That the original owner belonged to the Aspremont-Kievraing family is evidenced by the coats-of-arms so prevalent throughout the decoration. While images of both

knights and ladies at prayer frequently occur, the alteration of the text to the feminine plural on f.99v suggests that the book may have been primarily designed for use by the lady of the house and her female relatives.

Joffroy d'Aspremont is recorded as taking part in the Tournoi de Chauvency in 1285. Present also were his young wife Isabelle de Kievraing, his sister Mauchaut and sister-in-law Agnes. A lady with Aspremont arms appears eight times in the Melbourne manuscript and there are also three representations of a knight with Kievraing arms, all of which would seem to allude to the relations of Joffroy and Isabelle. Since Joffroy succeeded to the title Aspremont between 1278 and 1282 and is said to have died at the battle of Courtrai in 1302, the work has been customarily dated *c.*1290–1302. It seems prudent, however, in the light of current researches into northern French and Flemish ateliers, to allow for the possibility of a slightly later dating on stylistic grounds. There is little to prevent this if the manuscript were indeed commissioned for Isabelle.[3]

The lords of Aspremont, who owned lands in Namur and Lorraine, were related by ties of marriage to the de Bar family, prominent in French political and church history throughout the thirteenth and fourteenth centuries. The marriage of Joffroy's son Gobert to Mary, the sister of Renaud de Bar, after 1295 is the most pertinent link in the present context. Furthermore, both the Aspremont and Bar clans had incumbents in the bishoprics of Verdun and Metz during this period, a fact which is also relevant to the provenance of our manuscript. From 1297 to 1302 John II of Aspremont was bishop of Verdun. Renaud de Bar was a canon of the Verdun cathedral and of the college of St Madeleine in the same city in 1301. The following year he was named provost of St Madeleine, and a few weeks later he was elected bishop of Metz. His sister, Marguerite de Bar, was abbess of the Benedictine convent Saint-Maur in Verdun from 1288 until her death in 1313.

A group of manuscripts illuminated for Renaud de Bar in the late thirteenth and early fourteenth centuries contain Aspremont arms while those of de Bar feature in the Oxford–Melbourne work. The artists involved in the decoration of the Renaud de Bar manuscripts seem to reflect a variety of artistic influences current in Verdun and Metz, not least a strong English strain. P. de Winter and K. Carlvant have recently discussed such elements, and all the de Bar works are at present being researched by K. Davenport.[4]

It is inappropriate to pre-empt Miss Davenport's conclusions; but it may be said at this stage that while for the most part the decoration of Renaud's manuscripts is distinct from that of the Oxford–Melbourne book, certain local Verdun elements are common to both, and it is to Verdun that one should turn for the atelier which produced the Aspremont psalter-offices.

Two other manuscripts can be assigned to the same workshop: a breviary, probably executed for Marguerite de Bar when abbess of St Maur, Paris B. N. MS. lat. 1029a (figs. 170 and 174) and a Book of Hours sold by Kraus in 1980, now in a private collection in Germany (figs. 166 and 168).

Comparison of compositions in the Melbourne offices with those in the Book of Hours (figs. 165 and 166; 167 and 168) highlights the characteristics of this local style, in particular its vigorous, expressive quality communicated in the sinewy twist of bodies, the curl of draperies, the play of gestures and the specific turn of facial features. The same energy and verve extend also to the marginal decoration, which has a rugged spontaneity despite the repeated use of common motifs. These qualities are most discernible in the later sections of the Melbourne book and in the German Hours. They are not unattended by a certain unevenness and carelessness of style which may indicate the hands of assistants. The style of Bodleian MS. Douce 118, on the other hand, in particular in the more elaborately decorated pages, is more measured and contained (figs. 163 and 169). In this respect it relates more closely to the breviary of Marguerite de Bar (figs. 170 and 174). All these manuscripts share the same strong, restricted palette, in which deep plum-blue, red and heavy burnished gold are offset by subtle modelling in softer shades of blue, grey, white and touches of black.

Many of the marginal themes are common to Picardy, England and Flanders. The clue to the scene in the lower margin of f.123r (fig. 171) is provided by Villard de Honnecourt, who records in his sketchbook, both verbally and with illustration, how one tames a chained lion by beating a dog in front of it. The same subject occurs in the fourteenth-century Queen Mary's psalter.

On f.142r of MS. Douce 118 (fig. 172) a man poised in the beak of a terminal grotesque holds out a scroll with the words *Nicolaus me fecit qui illuminat librum*: a modest call for attention on the part of the chief illuminator by contrast to the ever-present coats-of-arms of the commissioning family and the local references to the knights of Bar, Châtillon, Dampierre etc. engaged in either imaginary or memorable jousts and battles. A black-robed nun joins the family cavalcade on some folios.

Indeed, the illustrative programme of the historiated initials themselves is distinguished by an unusually large number of scenes featuring the patrons at prayer in the company of Christ and his saints. It seems that the illuminator had no strict pattern to follow here as in the psalter section. Comparison with initials in Marguerite de Bar's breviary, however (figs. 173 and 174) reveals a common source of inspiration.

It seems sound therefore to conclude that a manuscript atelier in Verdun, working for clerical, religious and noble clients often closely connected by marriage or political and ecclesiastical concerns, produced the Aspremont psalter-offices. Such a workshop was clearly accustomed to executing psalters and breviaries for both monastic and

diocesan use, a fact which, together with the religious and episcopal links of the family concerned, no doubt accounts for the particular contents of this work. The calendar which prefaces Bodleian MS. Douce 118, with its emphasis on feasts special to Verdun and Metz, is in keeping with this provenance.

The offices were already separated from the psalter section by the sixteenth century, when they came into the hands of Walter Cromer, physician to Henry VIII. A Paris calendar and hours of Sarum use were then affixed. Millar suggests that the original Aspremont and Kievraing arms may have been painted over at this time; they are untouched in MS. Douce 118. On the fly-leaves etc. of the sixteenth-century additions notes were made relating to the families of Cromer and the successive owners, Pennant and Tuke. Those concerning the Tuke family were continued on f.139v of the Melbourne manuscript and are referred to under 'ownership' above.

During the course of the manuscript's long sojourn in England the coats-of-arms became erroneously associated with those of Lord Cobham, who had sided with Edward II against rebellious barons and died in 1339. Thus, for some time the work was believed to be an East Anglian production.

Frank Rinder, adviser to the Felton Bequest Committee, purchased the offices, now detached from their sixteenth-century supplements, at Christie's in March 1922 for the National Gallery of Victoria.

Bibliography: Sinclair (1969), pp.315–316; Millar (1925), pp.20–32, pls. I–III; (Felton, 1938), pp.4–6; Lindsay (1963), p.72; Randall (1966), p.35; Stones (1970), p.112; Manion (1977), pp.3–19; Oliver (1976), p.48; de Winter (1980), pp.27–62.

Notes
1. As well as the article cited in the bibliography, Millar wrote a detailed description of the manuscript, typescript copies of which are deposited in the British Library and the National Gallery of Victoria. For MS. Douce 118 see Pächt and Alexander (1966), no. 554. p.43.
2. See J. Bretel, *Le Tournoi de Chauvency* (ed. M. Delbouille), Liège, 1932, for a description of the arms of Aspremont and the presence of Joffroy and Isabelle de Kievraing at Chauvency.
3. Dr K. Carlvant, actively engaged in research in this area, has expressed reservations about such an early date. She has kindly given access to an extract from a forthcoming work on a group of northern French and Flemish manuscripts in which she mentions the Aspremont psalter-offices.
4. Miss K. Davenport is concluding a doctoral thesis on the de Bar manuscripts at the Courtauld Institute, University of London, and has very thoroughly investigated the heraldic decoration of these interrelated books. She has generously provided information on the relationships between the Aspremont and de Bar families. For P. de Winter's research see Bibliography, p.232.

Plate 37, figs. 175–182
No. 71. *Antiphonal* (with excerpt of *De Musica* by Jerome of Moravia O.P.). Latin
Paris, *c.*1335–1345
State Library of Victoria, *096 1/R66A

Vellum, 285 x 200. A modern vellum + 428 + B modern vellum. I–XXIV⁸, XXV⁴, XXVI–XLVI⁸, XLVII⁴, XLVIII–L⁸, LI⁵, LII–LIV⁸, LV³, LVI⁴. Catchwords agree, modern pencil foliation by tens; 16c. pagination in arabic numerals 1–10 on ff.4v–9r. Folio 424v is blank. Script: 14c. French gothic liturgical hand in black ink with red rubrics. *Explicit* on f.196v, *Antiphonarium de tempore*. A similar but later scribe has written on ff.424r and 425r–428v. Ruling: light brown ink, one column of 27 lines or nine groups of four-line red staves with black square notation and words written beneath. Sometimes as many as four lines of text are interspersed between the lines of music. Binding: 17c. old calf over early but not contemporary boards with four brass bosses (fifth is lost), with brass corner pieces.

Ownership: Inside back cover in contemporary black ink is *Correct pour la saison d'(h)iver*. On Av is the impression of a shield with *fleur-de-lys* but no precise details of the arms remain. Inside front cover is a stencilled lion rampant with the words 'Sir T. P./Middle Hill/233'. On the spine is printed 'no. 223'. Av has in a 19c. hand '423' and '48'. Bv has 'W. H. Robinson 5.2.1947'. Inside back cover is evidence of a chain having been attached to the book.

Text: Latin. Contents: ff.1r–4r prologue and tract of Jerome of Moravia O.P. *De Musica*, beginning in the middle of cap. XXI, *Omnis cantus ecclesiasticus ...*, and ending at the conclusion of cap. XXII, *Benedicamus domino alleluya R. Deo gratias alleluya*; f.4r instructions to scribe re ruling and musical notation in the antiphonal and provisions for checking new book against exemplum; ff.4v–196v temporal for Advent to twenty-fifth Sunday after Pentecost; ff.196v–398r sanctoral; ff.373v–397v common of the saints; ff.398r–424r hymnal; f.424r antiphons for SS. Sebastian and Ivo; ff.425r–428v office for the translation of St Thomas Aquinas. Special Dominican feasts include SS. Louis of France, Dominic, Lawrence, Peter Martyr and Thomas Aquinas.

Decoration: Initials in black, burnished gold, red or blue, finely flourished in blue or red occupy the height of one line of text and a musical stave. They introduce various antiphons, verses and responses throughout the text. Smaller initials in the same colours and flourished in like manner introduce subsidiary verses and prayers. There are also black cadel initials flourished in black and sometimes with heads or floral motifs.

Thirteen decorated initials with ivy-leaf infills, and twenty-three historiated initials, all about two staves and one line of text in height (approximately 45 x 45), introduce antiphons and responses for particular offices etc. as

detailed below. These initials are blue or pink and are set against rectangular grounds of pink, blue or burnished gold patterned with white tracery (fig. 175). Grotesques occasionally occur within the ivy-leaf tendrils of the decorated initials. The backgrounds of the scenes in the historiated initials have tessellated patterns in deep blue, red or pink.

A narrow bar border in blue, red and gold extends from the decorated and historiated initials along the vertical margin. In pages with historiated initials the bar extends along three sides of the page terminating in fine ivy-leaf fronds or grotesques at the top of the page. Small ivy sprigs sprout from the bar itself (Plate 37). The decorated initials have a single vertical bar with fronds along the upper and lower margins.

Colours are homogeneous for all the decoration: deep blues and rich vermilion are contrasted with paler hues of pink and bluish-grey and there is restrained but effective use of black, white and gold. Flesh tones and features are rendered in white and black in the draughtsmanlike technique characteristic of much early French gothic illumination. In the historiated initials almost no attempt is made to render a specific architectural setting; diapered and tessellated backgrounds predominate.

Programme of Decoration and Illustration: The decorated and historiated initials are related to the text as follows:

f.1r O decorated initial. *Omnis cantus*: excerpt from *De Musica*

f.4v A Annunciation. *Aspiciens a longe*: antiphon for 1st nocturn for matins for 1st Sunday in Advent

f.35r H Nativity. *Hodie*: antiphon for 1st nocturn for matins for Christmas

f.46v H Adoration of the Magi. *Hodie in iordane baptizato Domine*: matins for Epiphany

f.54v D decorated initial. *Domine ne in ira tua*: matins for 6th Sunday after Epiphany

f.80v E decorated initial. *Ecce nunc tempus*: matins for 1st Sunday in Lent

f.125v A decorated initial. *Alleluia* for invitatory for Easter Sunday

f.126r A Resurrection. *Angelus Domini descendit*: matins for Easter Sunday

f.143r P Ascension. *Post passionem*: matins for Ascension

f.147v C Pentecost. *Cum complerentur*: matins for Pentecost

f.154r B decorated initial. *Benedicat nos Deus*: matins for Trinity Sunday

f.197v C Martyrdom of St Andrew. *Cum perambularet*: matins for St Andrew

f.207v S decorated initial. *Stephanus autem plenus gratia*: matins for St Stephen

f.211v V decorated initial. *Valde honorandus*: matins for St John, apostle

f.234r A Presentation in the Temple. *Adorna thalamum tuam, Sion*: matins for Purification of the Virgin

f.249r M Annunciation. *Missus est Gabriel*: matins for Annunciation

f.253r V decorated initial. *Virtute magna reddebant Apostole*: matins for St Mark

f.257v O St Peter Martyr. *O petre fidus*: matins for St Peter Martyr (fig. 181)

f.261r decorated initial. *Dulce lignum*: matins for finding of the Holy Cross

f.266v Translation of St Dominic. *Fulget decus ecclesie*: matins for translation of St Dominic (fig. 176)

f.269r F Birth of St John the Baptist. *Fuit homo missus*: matins for Nativity of St John the Baptist

f.276r S Crucifixion of St Peter. *Simon Petre antequam*: matins for feast of SS. Peter and Paul

f.281v Q Martyrdom of St Paul. *Qui operatus est petro*: matins for feast of commemoration of St Paul (fig. 179)

f.287r L Christ and Mary Magdalen (*Noli me Tangere*). *Laetentur omnes*: matins for St Mary Magdalen (Plate 37)

f.294v M St Dominic and the Ladder. *Mundum vocans*: matins for St Dominic (fig. 177)

f.299v L Martyrdom of St Lawrence. *Levita Laurentius*: matins for St Lawrence

f.305v V Dormition of the Virgin. *Vidi speciosam*: matins for the Assumption

f.311v R St Louis. *Rex regnum*: matins for St Louis (fig. 182)

f.316v I decorated initial. *Invenit se Augustinus*: matins for St Augustine

f.324v H Nativity of the Virgin. *Hodie nata est beata Virgo Marie*: matins for Nativity of the Virgin

f.334r F St Michael. *Factum est silentium*: matins for St Michael

f.345r S All Saints. *Summae Trinitate*: matins for All Saints

f.350v C Funeral service. *Credo quod Redemptor*: matins for commemoration of faithful departed

f.369v E decorated initial. *Ecce ego mitto vos*: common of apostles and evangelists

f.398r C decorated initial. *Conditor alme siderum*: hymn for 1st vespers of Advent

f.404r A decorated initial. *Ad coenam Agni*: hymn for 1st vespers of Easter

Commentary: This antiphonal was clearly designed for use in a French Dominican convent. The offices in honour of St Louis, king of France, the translation of St Dominic, of St Peter Martyr and St Lawrence, together with the slightly later addition of that for the translation of St Thomas Aquinas are all indications of its Dominican character. The programme of illustration also reveals the book's French Dominican emphasis. Indeed, despite the absence of a calendar, litany, or scribal colophon, we may with reasonable probability conclude that this antiphonal was executed in Paris *c.*1335–1345 for the royal Dominican convent dedicated to St Louis at Poissy or Poissy-Saint-Louis as it is

often called. King Philip IV initiated the foundation of this convent during the Dominican chapter of 1298 to commemorate the recent canonization of his grandfather St Louis. By 1304 Dominican nuns were established at Poissy. Both chapel and convent were richly endowed and royal gifts were not infrequent. Approval to enter the community had to be gained from the King, and it is recorded that in 1350 four of the one hundred and fifty nuns were princesses.[1]

Most relevant here is the fact that when Philip founded the convent he provided also for the establishment of a library, a library which clearly included liturgical books. Four Dominican friars were commissioned to copy or arrange for the copying of books for the nuns, and a small priory was set up near by for thirteen friars charged to care for the spiritual and intellectual needs of their religious sisters.

The library at Poissy, including the holdings of both the convent proper and the adjacent friary, was substantial and contained illuminated manuscripts of the highest quality. It was dispersed at the French revolution and to date no systematic attempt has been made to reconstruct its holdings although some thirty books bearing marks of Poissy provenance are scattered in libraries throughout the world. Still others may be traced through references in ancient inventories and documents.[2]

Most of these manuscripts date from the fourteenth and fifteenth centuries. While some were actually written for the convent itself, others such as the famous 'Belleville Breviary' executed by Jean Pucelle *c.*1327 seem to have found their way there by royal or noble gift to one of the nuns.

The Melbourne antiphonal, in style, format and illustrative programme is closely related to a series of breviaries, psalters and processionals which bear explicit marks of Poissy provenance. Notable among these are two breviaries in the Bibliothèque de l'Arsenal, MSS. 602–603 and MS. 107, a breviary sold at Sotheby's, 4 June 1974, lot 2919 (figs. 178 and 180), and a psalter also sold at Sotheby's, 9 December 1974, lot 60. All these manuscripts date probably to the second quarter of the fourteenth century. They bear the stamp of the best Parisian atelier of the period, namely that of Jean Pucelle, although Pucelle is known to have died in 1332 and none of the books is by the hand of the master himself. Nor is the hand of one master illuminator discernible throughout the works. In the Melbourne book the bar borders are unembellished by the wealth of drolleries so popular in many works of the period and there is a clear sense of ceremonial functionalism and simplicity maintained throughout. Colours nevertheless are rich, and figures sway with courtly grace (Plate 37). The mantle of St Louis in the Melbourne antiphonal is generously patterned with the royal *fleur-de-lys* and mitred bishops carry a rich golden casket of the relics of St Dominic for the feast of his translation (figs. 182 and 176).

The depiction of the catafalque draped in red, lit with candles attended by a cowled mourner in the funeral service scene on f.350v is not far removed in spirit from illustrations of the Vigils of the Dead in the Books of Hours by this time popular with the lay nobility. St Dominic is represented on f.294r according to the legend of his mounting to heaven by a ladder attended by angels. Comparison of this scene in the Melbourne antiphonal with that in the breviary formerly from Sotheby, lot 2919 (figs. 177 and 178), demonstrates the adaptation and variation of common patterns by illuminators probably not too far removed from each other by time or place. Similar shared patterns are discernible in the scene of the martyrdom of St Paul on f.281v of the Melbourne antiphonal and the execution of St Peter Martyr on f.357v of the Sotheby breviary, lot 2919 (figs. 179 and 180).

In the Melbourne manuscript St Peter Martyr appears simply – with the attribute of his martyrdom (fig. 181). Characteristic of Parisian illumination at this period and particularly of the Pucelle workshop was the highly developed and elegant treatment of the flourished initial. This too is a feature of the Melbourne antiphonal (fig. 175) while the foliate initials follow standard Parisian designs, only very occasionally being enlivened by grotesque extensions or embellishments.

This manuscript exemplifies the careful control which the Dominican friars exercised to ensure the production of accurate texts. The passage which precedes the antiphonal on f.4r gives precise instructions to the copyist and lays down that the text must be checked or 'proof-read' before use. In this regard the words inside the back cover are significant: *Correct pour la saison d'(h)iver* – although the manuscript in its present state covers more than this period.

The book at one time belonged to Sir Thomas Phillipps. It was sold at Sotheby's, London, in 1946 and subsequently in 1947 by W. H. Robinson to the State Library of Victoria.

Bibliography: Sinclair (1969), pp.369–370; Sinclair (1962a), pp.332–333; Sotheby (1946), p.11.

Notes

1. M. Avril first indicated the probable Poissy provenance of this manuscript. The history of the Convent of Poissy is reasonably well documented. For more recent studies, which include references to earlier studies and to archival material, see W. A. Hinnebusch O.P., *The History of the Dominican Order*, Vol. I, New York, 1966, pp.257, 385 and p.408, n. 82; and A. Waltz, *Compendium Historia Ordinis Praedicatorum*, 2nd edition, Rome, 1948, p.165. Reverend Philip Kennedy O.P. kindly assisted with this information. See also references in Delaissé, Marrow and de Witt (1977), pp.37–58. Christine de Pisan, whose daughter was a member of the congregation, describes the convent in her poem *Le Dit de Poissy*. Leopold Delisle made several references in his writings to the importance of the library of Poissy and referred to books donated by royal patronage. See, for example, L. de Delisle, *Cabinet des Manuscrits*, Vol. I, Paris, 1868, pp.11, 99, 101,

and *Notice de douze livres royaux*, Paris, 1902, pp.115–122. Lyn Nossal assisted with this information.

2. M. Manion is currently engaged in establishing the number and present location of books associated with either the convent or the priory of Poissy.

Plate 38, figs. 183–194

No. 72. Livy, *History of Rome: Three Decades* (translated by Pierre Bersuire O.S.B.). French

Paris, *c.*1400

National Gallery of Victoria, MS. Felton 411/4

Vellum, 440 x 325. A contemporary vellum + 510 + B contemporary vellum. I–XXII⁸, XXIII⁴, XXIV–XXV⁷, XXVI⁸, XXVII⁴, XXVIII⁹, XXIX–XXX⁸, XXXI⁶, XXXII–XXXV⁸, XXXVI⁶, XXXVII–XLVIII⁸, XLIX², L⁹, LI–LVI⁸, LVII⁶, LVIII–LIX⁸, LX⁶, LXI–LXVI⁸, LXVII⁴. Catchwords agree, quire signatures in modern pencil, incorrect towards the end. Modern foliation in pencil. Folios 207rᵇ, 207v, 211v, 376vᵇ, and 510vᵇ are blank. Script: French gothic in black ink with red rubrics. Folio 510vᵃ has *explicit: Cy fenist le IXᵉ live et derrenier de la [tie] rce decade de Titus Livius.* The name of the scribe and rubricator Gillequin Gressier is written in lower right-hand corner. Ruling: pale mauve ink: 36.[98].28.[98].65 x 16.7.14.[325].78. Lines of text: 60. Ruling unit: 5. Binding: modern brown morocco. Two metal studs, leather straps and gilt plaques.

Ownership: Inside front cover in a 15c. hand is, *C'est le livre de Titus Livius contenant trois lives.* Ar has in a 15c. hand, *lib. titi livii et incipit in 2° fo. in processu libri tour laquelle.* Folio 510vᵃ, by another 15c. hand, has the motto *Nul ne si frote ob de Bourg^{ne}*.

Text: French. Contents: f.1rᵃ prologue of translator; ff.1rᵇ–3rᵃ glossary of certain words; ff.3rᵇ–7v tables of Book I; ff.8r–510rᵃ translation of history divided into three decades, each prefaced by chapter tables, with seventy-two *incidents* or commentaries inserted in Decade I. Books XI–XX and XXXIII of the original work are omitted since they were not available in the fourteenth century. The third decade therefore has only nine books. The translation ends abruptly in the middle of Book XL.

Decoration: One-line dentelle initials occur throughout, and some introductory letters are touched with yellow. Three-line foliate initials mark the beginnings of chapters. Eight- or nine-line foliate initials introduce the prologue and each book of the history. There are numerous line-fillers of the same design as the dentelle initials, and the *incidents* or commentaries are marked by matching vertical bars.

On the pages which announce each decade, ff.8r, 212r and 377r (Plate 38, figs. 183 and 184), elaborate three-sided baguette borders of varying leaf and floral design support

branching ivy-leaf decoration which also extends across the top of the page. A vertical projection of the baguette border divides the two columns of text. Simpler three-sided ivy-leaf bar borders, also with a dividing bar between the text-columns, introduce the prologue and other books. Dragons and fabulous birds feature in some borders. Colours of the initials and border decoration are burnished gold, blue, red and mauve, with white tracery and black hairline sprays and outlines. Three large miniatures (205 x 217; 218 x 256 and 208 x 212) extending the width of the text introduce the three decades. Set within a rectangular frame of blue and gold lines against a patterned gold ground, they are subdivided into four scenes, each contained within tri-coloured quadrilobed compartments (Plate 38, figs. 183 and 184).

Twenty-seven miniatures (95 x 95), extending the width of one column of text, introduce the prologue and individual books.

The distinct styles of the two artists responsible for the miniatures are reflected in their use of colour. The more skilful and modern artist uses rich blues, reds and greens, with fine greys, mauves and pinks, offset by white, black and firmly modelled flesh tones built up from green underpaint (Plate 38). In the more insipid palette of the second miniaturist pale orange, washed out pinks, blues and flat yellow predominate. In some places his paint has deteriorated and peeled off (fig. 183).

Programme of Illustration: The miniatures illustrate the text as follows:

f.1rᵃ Bersuire, translating: prologue

f.8r Dedication scene, upper left; discovery of Romulus and Remus, upper right; Romulus promulgates the laws of Rome, lower left; the Battle of the Horatii and Curiatii, lower right: Decade I, Book I (Plate 38)

f.30rᵇ Romans worship their gods: Book II (fig. 191)

f.54rᵃ Quintus Fabius delivers a stern message to the rebellious?: Book III

f.80rᵇ Cornelius Cossus slays Tolumnius: Book IV

f.102rᵃ Debate before the Consul: Book V (fig. 189)

f.121vᵇ Marcus Manlius pleads before Camillus: Book VI

f.137vᵇ Message is sent and received from Caerites: Book VII (fig. 188)

f.154rᵃ The Romans defeat the Privernates: Book VIII

f.169vᵇ Herennius Pontus gives advice to young Samnites: Book IX

f.188rᵃ A lictor scourges a Frusinate conspirator: Book IX (fig. 187)

f.212r Bersuire translating, upper left; assassination of Hannibal, upper right; Hanno receives Roman ambassadors, lower left; battle between Hannibal's and Roman cavalry, lower right: Decade II, Book XXI (fig. 183)

f.229rᵇ Hannibal dispatches messenger: Book XXII

f.244vᵇ Hannibal leaves conquered Acians and makes for Composa: Book XXIII

f.261r^a The Locrians surrender to Hanno: Book XXIV (fig. 190)

f.274r^b The Romans create new pontiffs: Book XXV (fig. 192)

f.288r^b The siege of Capua: Book XXVI

f.307r^b Hannibal slays the proconsul Gn. Fulvius: Book XXVII

f.326r^a Hanno and the Celtiberians defeated by the Romans: Book XXVIII

f.344r^a Scipio directs repairs of ships for expedition to Sicily: Book XXIX

f.357v^b Senate scene: Report of loss of provinces?: Book XXX

f.377r Bersuire translating, upper left; meeting of Roman senators, upper right; siege of City, lower left; battle scene, lower right: Decade III, Book XXXI (fig. 184)

f.393r^a Romans worship their gods: Book XXXII

f.405v^a Discussion on Oppian law: Book XXXIV

f.423r^a Scipio conquers the Lusitani: Book XXXV

f.436v^a Senate scene: Installation of new consul?: Book XXXVI

f.449v^a Aetolian legates seek peace: Book XXXVII

f.463v^b King Amynander sends messenger to chiefs of Argithea: Book XXXVIII

f.482v^b Romans subdue the Ligurians: Book XXXIX

f.499v^a Messenger from Ligurians seeking peace: Book XL

Commentary: This sumptuous volume was produced in Paris. Its high-quality vellum, regular script, meticulously executed initial and border decoration and elaborate illustrative programme rank it among the de-luxe copies of Bersuire's translation, which enjoyed great popularity with French royal and noble patrons throughout the late fourteenth and early fifteenth centuries. Although it has sometimes been stated that the Melbourne Livy belonged originally to Jean sans Peur and was handed down to Antoine, Grand Bastard of Burgundy, through his father Philippe le Bon, Sinclair's scholarly study of the text cautions that existing evidence, namely the *ex-libris* on f.510v^a, allows us to trace ownership back only as far as Antoine.

The Melbourne Livy can, however, be precisely located within the context of Parisian illumination. The organization and contents of its illustrative programme relate it to a group of extant copies of Bersuire's translation executed in Paris between 1380 and 1410. Comparison, for example, between the opening page for the second decade in Paris B.N. MS. fr.271, f.1r (c.1390–1400), with that of the Melbourne manuscript (figs. 185 and 183) and between the illustration to the first decade in the Melbourne work with its counterpart in Geneva MS. 77, f.9r (c.1410) (Plate 38 and fig. 186), demonstrates the continuity of a common model over some ten to fifteen years, although quite distinct artistic personalities are involved. It must also be noted that no two manuscripts of even the most closely related sub-

groups have completely identical programmes.[1]

Millard Meiss has attributed all of the miniatures in the first decade of the Melbourne Livy, except for those prefacing Books VIII and IX, together with the large miniature introducing the third decade on f.377r, to the workshop of the *Cité des Dames* Master. An illuminator trained in a more old-fashioned school, whose work appears in some less distinguished books of the 1390s, illustrated most if not all of the remaining miniatures.

Forty-one books executed between 1400 and 1425 have been identified by Meiss as illuminated in whole or in part by the workshop of the *Cité des Dames* Master. Secular texts predominate in this list and the artist and his associates are so named because of their illustration of several copies of the *Cité des Dames* shortly after its completion by Christine de Pisan in 1405. The frontispiece of the *Cité des Dames*, Paris B.N. fr.1179 (c.1405) (fig. 193), together with the miniatures of the Melbourne Livy, shows this style at an early stage. It is already marked by a firm command of modelling form and a sensitive rendering of light and colour. These characteristics develop the Italianate tradition introduced by Jacquemart de Hesdin, a tradition which reached its peak in the work of the Boucicaut Master and the Brothers Limbourg. Italianate, too, as Meiss has observed, is the use of green underpaint to build up flesh tones. Equally distinctive of this workshop are the figure-types with their pointed chins and three-quarter profiles, their deft movements and finely modelled, form-enhancing draperies. Such elements are in marked contrast to the work of the more old-fashioned miniaturist who also contributed to the Melbourne Livy. Compare, for example, figs. 189 and 190, and 191 and 192.

The style of the *Cité des Dames* Master appears in two later versions of Bersuire's Livy: Paris B.N. MS. fr.260–262 (c.1405–1408) and B.N. MS. fr.264 (c.1410). These illustrations also demonstrate quite marked modifications and innovations in the programmatic models and overall decorative treatment of Livy manuscripts. The scene on f.12r of B.N. MS. fr.260 (fig. 194) bears little resemblance to its counterpart in the Melbourne book (Plate 38). It moves in the direction of the more detailed and interpretative renderings of the Boucicaut Master and his associates.

Indeed, by contrast to the earliest extant illustrations of this text, such as Sainte-Geneviève MS. 777 (c.1370), which contains numerous anecdotal scenes, or to renditions later in the fifteenth century, there is rarely any attempt in the Melbourne Livy and its more closely associated manuscripts to exploit the action and variety inherent in this famous history of Rome. Rather, the illustration is confined to variations on a few readily recognizable themes. Bersuire, the translator – not Livy himself – accompanies the reader and viewer throughout, present in the textual commentaries or *incidents*, in the dedication scene, and the author portraits which recur at stated intervals throughout the book (Plate 38, figs. 183 and 184).

Stately, dignified discussions, debates and parleyings between consuls, kings, senators and legates are also rhythmically repeated (Plate 38, figs. 183, 185, and 189). It is sometimes difficult to recognize the precise event taking place; explicit rather is the notion of debate and measured communication. Battles, naturally enough, are also a consistent motif, inherited from the grand tradition of the chronicle. Here chivalric elements predominate with no attempt to classicize (Plate 38, figs. 183 and 185). The theme of war extends to tactical manœuvres such as sieges, and more detailed textual allusions are sometimes incorporated, like the surrender of the Locrians on f.261r (fig. 190).

Depictions of the Romans worshipping their gods (fig. 191) contain one of the rare classical allusions, with Mars and Venus on pedestals – shown very much, however, through the medieval mists of time. Elsewhere, the Roman religion is completely transposed into a Christian idiom. Bersuire used the word *évêque* in his translation for Roman *pontifex*, and the illuminator is quick to seize on a familiar concept for the illustration of the rubric: 'The Romans created priests and bishops and nobody sacrificed to strange gods', showing a group of mitred bishops (fig. 192). Specific allusions to unique events in the history are indeed rare. The finding of Romulus and Remus on f.8r (Plate 38) is one example, couched none the less in terms of a contemporary pastoral idyll and having affinities with compositions of the Annunciation to the Shepherds or calendar activities. Again, Scipio on f.344r is shown supervising the repairs of the fleet for the Sicilian expedition. More unusual is the selection for illustration of a fleeting reference in the text to the punishment of the Frusinate conspirators on f.188r (fig. 187). This is presented with all the gusto of a contemporary martyrdom scene, and the prisoner tied to the stake has a parallel in an allegorical figure in the later, and far more particularized, renderings of Boccaccio's *Decameron* by the same workshop.[3]

Standard messenger scenes (fig. 188) meanwhile carry along a semblance of narrative, and indeed this is how the cycle, if cycle it should be called, concludes, breaking off as abruptly as the text with a messenger scene on f.463v.

In one sense the decoration and design of this particular group of Livy manuscripts captures the spirit of Bersuire's preface, where the scholar explains that he has undertaken his translation for King Jean who wished France to emulate Rome, which had risen from being a small nation to conqueror of the world by the virtue of constancy, by the wisdom of its rulers and by the power of its armies – a fitting backdrop to France's current involvement in the Hundred Years War.

As noted above, the scribe and rubricator Gillequin Gressier signed his work. We know of no other manuscripts by his hand. P. de Winter has commented on the number of scribes who signed their works or whose names are known to us from contemporary documents. He provides a list of thirty-nine scribes for the period 1375–1405, whereas rarely is the name of an illuminator preserved. De Winter argues that this is so because it was normally the scribes who undertook the commission, planned the work and employed the illuminators. Pressed for time, they may have farmed out leaves to craftsmen working in discrete ateliers, a practice which would account for such very different styles often appearing within a single work which is nevertheless distinguished by an overall systematically designed programme.[4]

Apart from the reference to Antoine of Burgundy nothing is known of the provenance of the Melbourne Livy until the second decade of this century, when it was in private ownership in Austria. It was subsequently purchased by the art dealers Gilhofer and Rauschburg and offered for sale by them at Sotheby's London in 1931, but was bought in. Subsequently Dudley M. Colman of Hove purchased the book, and later W. H. Robinson. It was acquired through the Felton Bequest for the National Gallery of Victoria in 1937.

Bibliography: Sinclair (1969), pp.317–318; Sinclair (1959), pp.7–13; Sinclair (1961); Felton (1938), p.6; Lyna (1962), pp.359–361; Lindsay (1963), p.42; Hoff and Plant (1968), p.24; Meiss (1969), pp.350–356; Meiss (1974), p.380; Zacher (1971), pp.44–47 *et passim*; de Winter (1978), p.186; Sotheby (1931).

Notes
1. Zacher, *op. cit.*, groups the Melbourne Livy in 'Family III' of four main groups. Her listing of manuscripts is not, however, complete. Paris B.N. MSS. fr. 260–262, and 264, for example, are omitted.
2. For Meiss on this Master and his workshop, see *The Limbourgs and their Contemporaries*, especially pp.377–382. Meiss actually ascribes very few works to the Master himself. It is best at this stage to speak in general terms of a distinctive style and workshop.
3. See Paris B.N. fr. 16994, f.76v (*c*.1415).
4. See de Winter (1978).

Figs. 195–198
No. 73. *Book of Hours* (fragments). Latin
Paris, 1408
Baillieu Library, University of Melbourne, Victoria

Four vellum bi-folios, 176 x 132, much damaged by water and restored in the 19c. Foliation in modern arabic numerals. Script: 15c. French gothic liturgical hand in dark brown ink with red rubrics. Ruling: brown ink: 23[60].49 x 28[92].12.1.43.

Text: The folios comprise a section of the sequences of the four Gospels regularly contained in a Book of Hours, and part of matins for the Hours of the Virgin.

Decoration: One-line decorated initials in blue and pink with ivy-leaf and floral motifs on gold grounds occur in the text. Line-fillers on gold grounds with varying patterns of

abstract and object motifs are also present. Larger decorated initials three or four lines high introduce the lines of text beneath the pages containing miniatures. These are in pink or blue on gold grounds with ivy-leaf infills. All pages have a full ivy-leaf border. On those containing miniatures the border springs from a three-sided baguette which encloses the miniature and lines of text. These baguettes have burnished gold grounds decorated with leaf and tendril patterns. The four miniatures are contained within simple square or rectangular frames (58 x 58 and 60 x 65).

Colours have been much overpainted by the 19c. restorer and the borders darkened by moisture. Ultra-violet light clearly reveals, however, the style of the early fifteenth-century master beneath, and comparison with less damaged leaves from the same book in other collections shows that the restorer has tried to copy closely the medieval palette of rich red, blue, yellow, green and white.

The subjects of the miniatures are St Mark, Gospel of St Mark (fig. 195); St Luke, Gospel of St Luke; St John on Patmos, Gospel of St John; the Annunciation, matins for Hours of the Virgin (fig. 196).

Commentary: Despite the much damaged state of these leaves, they are of considerable art-historical interest, since they belong to one of the few books from an early fifteenth-century Parisian atelier which bears a secure date. Before the book's dispersal, f.158v is known to have carried the inscription *Factum est anno m° cccc° viii° quo ceciderunt pontes parisiis.* Dr de Hamel has pointed out that an almost identical note occurs in Bodleian MS. Douce 144. This refers to the floods of 29–31 January 1408, when the three bridges of Paris were swept away. Better preserved leaves (figs. 197 and 198) indicate that, like MS. Douce 144, this manuscript was a product of the famous Boucicaut Master workshop which flourished in Paris in the early fifteenth century.

The subsequent history of the book is also not without interest. This has been supplied by Dr de Hamel in his entry for lot 21 of Sotheby's Catalogue of 14 July 1981, where he relates that in the nineteenth century the manuscript belonged to John Boykett Jarman, goldsmith, jeweller and collector. After its damage by a flood in his house in 1846 Jarman had the manuscript restored by Wing.[1]

At a sale of Jarman's goods on 13 June 1864 at Sotheby's, lot 47, it was bought by Edward Arnold. The latter subsequently sold it again through Sotheby's on 6 May 1929 as lot 240. The following September, Sir Alfred Chester Beatty purchased the manuscript from Chaundry in Oxford. He then proceeded to dismember it, doubtless affected to some extent by the damaged nature of the work. Three miniatures were given away in June 1931 and are now in Princeton. Six were sold at Sotheby's on 22 March 1932, lots 322–327 and the residue of the manuscript was dispersed at the Chester Beatty Sale on 24 June 1969. The Melbourne folios were purchased from Alan Thomas in

October 1974. Other miniatures are in the Barber Institute, Birmingham, and the University of North Carolina. Those reproduced here for comparative purposes (figs. 197 and 198) come from a private European collection.

Bibliography: Sotheby (1864), lot 47; Sotheby (1929), lot 240; Sotheby (1932), lots 322–327; Sotheby (1969); Sotheby (1981); Thomas (1969), nos. 6b–e.

Note

1. See also J. Backhouse, 'A Victorian Connoisseur and his Manuscripts' in *British Museum Quarterly*, Vol. 32, 1967–1968, pp.76–87, and M. Meiss, *The Boucicaut Master*, Princeton, 1968, pp.34–40. Dr Elizabeth Beatson is also interested in the reconstruction of this manuscript and has generously discussed her research with us.

Plate 39, figs. 199–202

No. 74. *Vigils of the Dead.* Latin and French
Besançon, *c.*1440–1450
State Library of Victoria, *096/R66Hm

Vellum, 195 x 140. A–C modern paper + D–F contemporary vellum + 96 (excludes one interleaved blank sheet of modern paper between ff. 12 and 13) + G–H contemporary vellum + I–L modern paper. I–II⁶, III⁸, IV²⁻¹⁺⁸, V⁸, VI⁶, VII–XII⁸, XIII⁵. The conjugate leaf of VI² is folded forward and cut with the stub appearing before quire III. Two catchwords, agreeing. Modern pencil foliation in arabic numerals. Script: 15c. French gothic liturgical hand in black ink fading to brown with rubrics in red or blue; calendar in gold, blue and red. Ruling: pale red ink: 26.[63].51 x 31[97].67. Lines of text: 14. Ruling unit: 7. Calendar: 20.[12.6.8.3.5.41].45 x 30.96.69. Lines of text: 17. Ruling unit: 5.5. Binding: 19c. dark brown velvet, spine lost.

Ownership: Gr and f.96v have notes about prayers in two different 16c. hands. On Dv in a 16c. hand is: *Ces presentes appertiennent a Maistre Nicole Fonssard chanoine de Saincte Chapelle du Roy a Dijon.* Also on Dv in a 17c. hand is *Depuis elles sont venues en la possession de Pierre Mareschal, S' de Frontenay, Conseiller du Roy et President en sa Chambre des Comptes en bourgogne en Octobre 1600.* Also on Dv are notes on taxes in a 17c. hand; a reference to the demolition and sale of the Sainte Chapelle in 1807 in a 19c. hand; and the note 'Purchased by me April 28, 1826 Abraham Lincolne, Highbury Place Islington'. Ev–Fr have notes on the Montholon family, resident in Dijon at the turn of the 17c. Ar has notes in a 19c. hand with additions indicating that the book was given by Lincolne to his goddaughter Jane Hopkins, Tichmarsh, in 1852, who at her death (30 Dec. 1892) bequeathed it to her baby L.S.D. Inside front cover is the book-plate of the Felton Bequest. On Cr, Dr, and f.1v is the stamp 'Public Library of Victoria'.

Text: Latin, calendar and rubrics in French. Contents: ff.1r–12v full calendar with entries in gold, blue and red;

Parisian and northern saints are listed with no specific regional emphasis; ff.13r–19r gospel sequences; ff.19r–21v the seven last words of Christ; ff.22r–36r penitential psalms; ff.36v–43r litany, including SS. Ferreolus, Ferrutius, Antidius, Benigne and Mammes; ff.44r–96r Vigils of the Dead.

Decoration: One- and two-line dentelle initials appear throughout. Four-line foliate initials introduce the main divisions of the text beneath three miniatures. Line-endings of the same design as the dentelle initials occur after the third quire. In three places their tracery forms letters: f.55v *S(al)ve gra Maria plena*; f.56v *dicit deus*; and f.89r *Iacque u* (fig. 200).

Panel borders of floral-acanthus design, traced through from recto to verso, accompany each page of text. Full borders of the same type decorate the pages with miniatures. These miniatures (85 x 60, 85 x 60, 90 x 60) are framed in gold and arched at the top. Decorated bars surround the miniatures and four lines of text on three sides. Borders and miniatures are executed in shades of blue, green, red, pink and white with added burnished gold.

Programme of Illustration: The miniatures illustrate the text as follows: f.13r St John the Evangelist and the poisoned cup: gospel sequences (Plate 39); f.22r David at prayer: penitential psalms (fig. 199); f.44r burial service in a churchyard: Vigils of the Dead.

Commentary: This manuscript is a fragment of a Book of Hours. There are indications that the original prayer-book may have been compiled from more than one artistic source, which, as Delaissé and Marrow have demonstrated, was sometimes a workshop practice. It has been noted above, for example, that the first leaf of the fourth quire, f.21, was separately inserted, while the border decoration for the rest of this gathering, and on the pages containing the three miniatures, reveals a different hand at work from that in the rest of the book. The fine vellum of the miniature pages and their conjoint leaves is a further distinguishing feature. The style of the miniatures themselves is uneven. In the depiction of St John on f.13r (Plate 39), tonal modelling conveys some sense of bodily form and facial expression which is absent from the other two compositions (fig. 199). The burial service on f.44r is a particularly summary adaptation of an early Parisian design. In this context it may also be significant that the calendar, which follows a Parisian visual tradition in its alternating gold, red and blue entries, does not mention the Besançon saints included in the litany. It would seem that a variety of models was drawn on for the book, and that the activities of individual craftsmen were relatively loosely co-ordinated.[1]

The most plausible hypothesis is that this manuscript is the product of a regional atelier probably located in Besançon. Its combination of a mid-fifteenth-century French style of border decoration with miniature compositions based on patterns made popular in Paris by the Boucicaut Master and associates some three decades earlier is paralleled in four Books of Hours, all for the use of Besançon: Pierpont Morgan m 293 (*c.*1440); Hague MS. 76 (*c.*1450); Vienna Nat.bibl. cod. 1889 (*c.*1460); and a volume sold at Sotheby's, 11 December 1979, lot 54 (*c.*1425–1450).

Shared archaisms are backgrounds of diapered patterns identical with those in Boucicaut workshop products which coexist with naturalistic depictions of blue sky, as in the David at prayer and the burial service on ff.22r and 44r (fig. 199). Faces are characteristically slightly flattened in three-quarter profile and hands are enlarged. Comparison of the Melbourne miniatures with their counterparts in the Vienna codex reveals that the former are closer to their Parisian prototypes (Plate 39 and fig. 201; figs. 199 and 202) and hence possibly earlier in date.

It is also noteworthy that, in addition to common stylistic features, both the New York and Melbourne manuscripts have similar inscribed line-endings (on ff.51v and 54v of P.M. m. 293). Such inscriptions are rare and may indicate a specific workshop practice. The name 'Iacque' on f.89r (fig. 200) of the Melbourne book is more likely to refer to the workshop assistant responsible for this part of the decoration than to the chief miniaturist.[2]

As the notes under 'ownership' above indicate, in the sixteenth and seventeenth centuries the manuscript belonged successively to two families of Dijon. By 1826 it was in England, passing from Abraham Lincolne to his goddaughter Jane Hopkins in 1852, thence to her daughter in 1892. In 1933 it was acquired for the State Library of Victoria through the Felton Bequest from the bookseller W. H. Robinson.

Bibliography: Sinclair (1969), pp.355–356; Sinclair (1926c), pp.170–178.

Notes

1. See discussion in Delaissé, Marrow and de Wit (1977), pp.181–214, for another case of a 'loosely coordinated' manuscript.
2. See R. Schilling, 'The Master of Egerton 1670. Hours of René of Anjou' in *Scriptorium*, 1954, pp.272–282, concerning the rarity of inscribed 'line-endings'.

Fig. 203

No. 75. *Book of Hours*. Latin
Arras, 15c.
State Library of New South Wales, Mitchell 1/7f

Vellum, 160 x 114. 220 folios. I², II³, III–XIII⁸, XIV⁶, XV–XVII⁸, XVIII⁶, XIX–XXIII⁸, XXIV¹⁰, XXV⁸, XXVI⁴, XXVII–XXVIII⁸, XXIX⁵, XXX⁸. Script: two forms of gothic liturgical hand: first hand ff.6r–199v, second hand ff.3r–4r, 200r–209r; in brown ink, with rubrics in red. Calendar in red and brown. Ruling: brown ink: 14.[59].34

x 25.[83].52. Lines of text: 16. Ruling unit: 5. Calendar: 16.[9.1.5.10.3.33.5].32 x 25.[83]. 52. Binding: carved ivory covers. The front cover, carved in relief, is a portrait of the Virgin, with full border of ivy and thistle-leaf sprays; three coats-of-arms (unidentified); in the lower margin *Ave Maria*. The back cover, not in relief, shows Gabriel playing a harp and scrolls with *Regina Coeli Alleluya*, spine parchment. Prickings in outer borders, leaves apparently untrimmed. Folios 1r–2v, 211r–211v, 213r–220v blank.

Ownership: Folio 1r bears the inscriptions *Ex libris Antonii Vignon Atrebatis, 1575*, and *Ex libris Lucien Anatolii Foucher Mdccclxxxxi*. On ff.3r, 213r there are imprints of the seal of the Mitchell Library. Additional devotions in a 15–16c. hand are on ff.5r, 5v, 209v, 210r, 212r and 212v.

Text: Latin. Contents: ff.3r–5v prayers; ff.6r–17v calendar including St Vaast on 6, 14 February, 15 July, 1 October (with St Remigius), SS. Winnoc and Bertin; ff.18r–22r gospel sequences; ff.22v–29v additional prayers; ff.30r–94v Hours of the Virgin; ff.94v–128r variations; ff.128v–129v prayers to the Virgin; ff.130r–139v penitential psalms; ff.140r–150v litany, including SS. Aubert, Amand, Audomarus, Vaast; ff.151r–158v commendation of souls; ff.159r–189v Vigils of the Dead; ff.190r–201v additional prayers; ff.203r–209r commemorations in honour of saints, including, on f.204v, *Oratio de sancto manna*.

Decoration: There are eight blue and red initials five lines high with red, blue and green pen-work. They occur on ff.58r, 72v, 77r, 79v, 82v, 85r, 90v and 151r and introduce lauds, prime, tierce, sext, none, vespers, compline and the commendation of souls. On ff.30r, 130r and 159r there are decorated initials, four lines high, and full bar borders with corner clusters of acanthus in red, green, blue, mauve and white. The spaces between the acanthus scrolls are filled with hairline sprays terminated in gold dots (fig. 203). These decorated pages introduce matins for the Hours of the Virgin, the penitential psalms and the Vigils of the Dead.

Commentary: This Book of Hours is an example of modest provincial French fifteenth-century decoration. Its main interest lies in its provenance. The stress on St Vaast and the prayer on f.204v in honour of the 'holy manna', a relic held in Arras, indicate that the book was designed for use in that city. In 1575 it was in the possession of a local citizen, Antoine Vignon.

A letter dated 1912 from Mr Paul Christian to the prospective buyer alludes to a notarial inventory of *c.*1820 establishing ownership of the manuscript by the French regicide Joseph Fouché (1759–1820).

In 1891 the book passed to Lucien Anatole Foucher and later to M. Métaire of Champlemy. On his death it was sold to Mr J. T. Hackett by Messrs Rosenwald and Rein, 64 rue des Archives, Paris. A letter in 1918, in Hackett's handwriting, comments on the extreme rarity of the ivory binding. There is, however, no established provenance for these covers. The book was sold in 1918 to the Mitchell Library.

Bibliography: Sinclair (1969), pp.118–121; (Hackett, 1918), pp.48–49; (Sydney, 1967), p.25.

Figs. 204–206
No. 76. *Book of Hours*. Latin and French
North-eastern France, second half of 15c.
National Library of Australia, Canberra, Clifford
 Collection. MS. 1097/5

Vellum, 176 x 125. A–B contemporary vellum + 150 + C contemporary vellum. I–II⁶, III⁸, IV⁴, V⁷⁽¹⁺⁶⁾, VI⁸, VII⁷, VIII–IX⁸, X⁷ (wants 4), XI–XII⁸, XIII¹¹, XIV–XVII⁸, XVIII⁶, XIX², XX⁶, XXI⁸. Some catchwords agreeing. Folios 25r and 43r are damaged. They have been cut and used as mounts for miniatures, pasted in. Script: 15c. gothic liturgical hand in brown ink with red rubrics. Calendar in red and brown ink. Ruling: pale red ink: 23.[66].36 x 23[106].47. Lines of text: 17. Ruling unit: 6. Calendar 27.[14.5.2.44].33 x 23.[108].45. Binding: 17c. calf with remains of silk ties.

Ownership: Inside front cover in an 18c. hand is '1 Fontaine Pʳᵉ'. Written in 19c. pencil on Ar is 'From F. G. Dowty, Bridgewater. For sale'. His book-plate appears inside front cover together with the signature 'Charles H. Clifford 1854'.

Text: Latin, calendar and one prayer in French. Contents: ff.1r–12v calendar; the text of January to March on ff.1r–3v has been washed off; special feast days in red include St Mammes (5 August); entries in brown include SS. Mammes, Eloy (twice), Bertin, Thiery, Remy, Ferreolus, Hubert and Thomas of Canterbury; ff.13r–18r gospel sequences; ff.18v–21r *Obsecro te*; ff.21v–24v *O intemerata*; ff.25r–69v Hours of the Virgin (compline opens abruptly on f.66r); ff.70r–80v penitential psalms; ff.81r–85v litany including SS. Dominic, Francis, Remigius, Vaast, Amand, Eligius, Egidius, Fiacre and Anastasia; ff.86r–92v Hours of the Cross; ff.93r–136v Vigils of the Dead; ff.137r–148v additional prayers, including *Glorieuse vierge pucelle* on ff.138v–140r.

Decoration: One-line dentelle initials and line-endings of similar design occur throughout the text. Two- and three-line dentelle initials have marginal extensions of ivy-leaf sprays. Twelve four-line blue or wine-red initials, with infills of gold tracery or naturalistic floral sprays in green, red, mauve and blue painted on blue, wine-red or washed gold rectangular grounds, introduce four lines of text beneath twelve large miniatures. There are nine borders of homogeneous design. They feature acanthus scrolls in blue, green and bronze with blue, green and red floral sprays, and occasional birds and grotesques (fig. 205). One other

border, on f.141r, though similar in colouring, is more densely inhabited by birds, grotesques and floral motifs (fig. 206). The two remaining margins on ff.25r and 43r are not part of the original decoration (see commentary).

Eleven large miniatures (90 x 66) introduce the main divisions of the text. They are painted in various blond tones of blue, pink, green, straw-yellow, grey and white. Brushed gold is used sparingly for highlighting. A second hand has executed the twelfth miniature in similar colours.

Programme of Illustration: The subjects of the miniatures are as follows: f.25r Annunciation: matins for the Hours of the Virgin (fig. 204); f.34r Visitation: lauds (fig. 205); f.43r Annunciation to the shepherds: prime; f.47r Nativity: tierce; f.51r Adoration of the Magi: sext; f.55r Flight into Egypt: none; f.59r Presentation: vespers; f.70r David and Bathsheba: penitential psalms; f.86r Crucifixion: Hours of the Cross; f.93r Pentecost: Hours of the Holy Ghost; f.97r Job on a dunghill: Vigils of the Dead; f.141r Pietà: prayer, *Ave domina sancta maria mater dei regina celi . . .* (fig. 206).

Commentary: The main artist, probably responsible for all of the miniatures except the Pietà, comes from northern France. His manner of modelling forms and painting rocky landscapes with airy vistas is distantly related to the circle of Simon Marmion. The less accomplished artist who executed the Pietà (fig. 206) shows little concern for modelling. He outlined his forms in black ink, following a conventional atelier pattern. The northern origins of the main illuminator's style are consistent with the regional indications of the calendar and litany, which list several saints of northern France and the Netherlands.

Two of the early miniature-pages are not in their original state. Folio 25r has been tipped in at the beginning of quire IV. Its miniature of the Annunciation still retains traces of a geometric decorative surround, over which a second border of ivy-leaf design has been pasted (fig. 204). Both patterns are unrelated to the other borders of the manuscript and the page is clearly a clumsy pastiche. Likewise f.43r is suspect. Its miniature of the Annunciation to the shepherds has been excised and remounted without a surrounding border. Moreover, its position as an introduction to the hour of prime, with the Nativity following on f.47r at tierce, disturbs the illustrative sequence. Despite such anomalies, both these miniatures are in the style of the main illuminator. The missing introductory leaf of compline no doubt also contained a miniature in keeping with the traditional pattern of illustration for this section, such as the death of the Virgin or her coronation.

This manuscript was apparently purchased by Charles H. Clifford in 1854, and was acquired as part of the Clifford library by the National Library of Australia in 1964.

Bibliography: Sinclair (1969), pp.25–27.

Plate 40, figs. 207–213
No. 77. *Book of Hours.* Use of Paris. Latin and French
Paris, *c.*1460–1465
Fisher Library, University of Sydney, New South Wales

Vellum, 170 x 119. A–B modern paper + 255 + C–D modern paper. I¹², II¹², III–VIII⁸, IX⁷, X–XVII⁸, XVIII⁷, XIX–XXI⁸, XXII⁴, XXIII–XXV⁸, XXVI–XXVII⁴, XXVIII–XXX⁸, XXXI–XXXII⁴, XXXIII⁶, XXXIV⁷. Modern foliation in pencil in arabic numerals. Script: 15c. French *lettre-bâtarde* in brown ink, with red rubrics, calendar in red, blue and gold. Additional prayers and devotions have been added by three 16c. hands. The hand on ff.210r–247v imitates the original script. Folios 13r–14v are in a large roman hand. Folios 15r–23r and 248r–254v are in a smaller roman hand. Folios 23v, 248v and 255r are blank. Ruling: light red ink: ff.13r–23v: 21.[64].34 x 13.[108].49. Lines of text: 18. Ruling unit: 5. Folios 24r–255v: 22.[61].36 x 18.[100].52. Lines of text: 17. Ruling unit: 6. Calendar: 27.[11.6.6.6.1.30].32 x 15.[100].55. Lines of text: 17. Ruling unit: 6. Binding: black morocco, with silver catch and clasp.

Ownership: On f.227r in the 16c. hand which imitates the original *lettre-bâtarde* is the inscription *ce present livre appartient à sœur Anne la Routye religieuse de lostel dieu de paris. Quil le trouvera sil le luy rende. Et fut amenée à lostel dieu en la age de quatorze ans au mois de mars en lan mil cinq cens et cinq. Et quil laura après son deces priez dieu pour les trespassez.* Folio 254v has in a 16c. hand *Les presentes heures furent achevées lan de grace mil cent e quartorze.*' On f.254v is a blue shield with the monogram AR in gold entwined by gold cord. The shield is surmounted by two scrolls and a rectangular panel with a bowl of flame in the centre flanked by leafy fronds in red and blue. Inscribed in black on the scrolls is: *Sit nomen Domini benedictum, Non me derelinquas Deus,* and *Domine Deus Me[us] V[eru]s.* The decoration is crudely painted and no earlier than the 16c. On Br is written in a 19c. hand 'W. Stuart from my mother 31st Oct. 1842'. Inside front cover is a white library label with the words 'Tempsford Hall Library Case – Shelf – . Please return this book to its place when done with.' Underneath is a small black and gold label with a coat-of-arms, now effaced. Pasted inside front cover is an extract from an English bookseller's catalogue referring to 'lot 897, the property of Mrs M. H. O. Stuart (Decd.)'.

Text: Latin, with calendar and some prayers in French. Contents: ff.1–12r full calendar with entries alternating in red and blue and special feasts in gold. Parisian and northern saints are listed with no specific regional emphasis; ff.13r–15r nine Advent antiphons in two 16c. hands; ff.15v–23r, in a 16c. hand, extracts from the beginning of the gospels of St Matthew and St Luke, interrupted by the loss of f.18, and additional prayers and devotions in Latin with rubric in French on f.22r; ff.24r–29r gospel sequences;

f.29r–32v *Obsecro te*; ff.32v–35v *O intemerata*; ff.36r–94v Hours of the Virgin, with nine lessons for matins; ff.95r–106r penitential psalms; ff.106r–110r litany; ff.110v–113v Hours of the Cross; ff.114r–116v Hours of the Holy Ghost; ff.117r–157v Vigils of the Dead; ff.158r–162v Fifteen Joys of Our Lady: *Doulce dame de misericorde . . .*; ff.163r–166v seven requests: *Doulx dieux doulx père sainte trinité*; ff.167r–176v *Dulcissime domine ihesu christi verus deus*; ff.176v–187v commemorations of SS. Claude, Sebastian, Denis, Lawrence, Vincent, Anthony, Fiacre, Maur, Germain, Catherine, Geneviève, Margaret, Apollonia, Barbara, Michael, Nicholas and Anne; ff.187v–191v five feasts of the Virgin; ff.192r–195v Stabat Mater; ff.196r–209v special devotions, some in French, in honour of SS. Barbara, Catherine, John the Baptist, the Franciscan group – SS. Francis, Clare, Louis and Anthony – SS. Augustine, Nicholas of Tolentino, and Sebastian; ff.210v–253v additional devotions in two 16c. hands, including on ff.250v–251r commemoration of St Mathurin.

Decoration: In the original section of the manuscript, ff.1r–209v, one-line blue and burnished gold initials flourished in red and black, and two-line initials of foliate design or with infills of floral motifs occur throughout. More elaborate two-line initials in grisaille on burnished gold introduce the calendar pages. The four-line initial 'I' which introduces the gospel sequences is of the same design. Three-line initials with foliate or floral motifs introduce the text beneath the miniatures (Plate 40). Line-endings in red and blue with some gold, matching the flourished initials, are present throughout. Panel borders decorate many pages of the text. Full borders surround f.1r, the first page of the calendar, and all pages containing miniatures.

The borders are of floral-acanthus design in which sinuous, thin tendrils and sprays of fruits and flowers are interspersed with short, curving acanthus leaves on a white ground. Birds, insects and grotesques are delicately rendered and sometimes occupy a narrow ground plane of green sward at the base of the page. On some pages motifs of vases and flower pots or larger grotesques are a feature of the side or lower margins.

The miniatures and small sections of text on the fully decorated pages are surrounded by a gold bar on three sides. This is decorated with fruit and floral motifs in harmony with the border. The miniatures themselves are arched at the top and their gold frames outlined in black are slightly serrated around the curve of the arch.

In both border, miniature, and initial decoration, blue, green and gold predominate varied with red and brown and offset by the white of the vellum or that used for flesh tones. In the miniatures this palette is enriched by the use of yellow, orange, and varying shades of pink and grey, gold being used to highlight certain sections of drapery, outlines etc. (Plate 40).

In the decoration of the additional sections of the manuscript, an attempt has been made to harmonize with the earlier work, especially on ff.210r–247v, where decorated initials follow similar flourished foliate and floral designs. The initial decoration and line-endings used by the second main sixteenth-century hand reflect later trends. Set on square grounds, they no longer have foliate projections and are usually thin shapes in gold or blue.

There are only two borders in the later sections of the manuscript. They frame the miniatures and text on ff.227v and 250v. The border on f.227v keeps closer to the original decoration in colour and design. That on f.250v has a heavy washed gold ground and simplified repetitive motifs.

Programme of Illustration: Seventeen miniatures (60 x 90) and one historiated initial illustrate the original text as follows: f.29r Virgin and Child: historiated initial 'O' (3 lines high): *Obsecro te*; f.36r Annunciation: matins for Hours of the Virgin; border medallions: the meeting of Joachim and Anna, upper right; birth of the Virgin, centre right; presentation of the Virgin, lower right; marriage of Joseph and Mary, lower left; f.56v Visitation: lauds (Plate 40); f.67r Nativity: prime; f.72v Annunciation to the shepherds: tierce (fig. 213); f.76v Adoration of the Magi: sext; f.80v Presentation in the Temple: none; f.84r Flight into Egypt: vespers; f.90r Coronation of the Virgin: compline; f.95r David at prayer: penitential psalms; border scene: David and Bathsheba; f.110v Crucifixion: Hours of the Cross (fig. 211); f.114r Pentecost: Hours of the Holy Ghost; f.117r preparation of corpse for burial: Vigils of the Dead (fig. 207); f.156r the three Marys: the Fifteen Joys of the Virgin (fig. 209); f.163r the Trinity: the Seven Requests; f.192r Pietà: Stabat Mater; f.196r St Barbara: prayers in honour of St Barbara. Two miniatures illustrate the later additions: f.227v kneeling nun before St Anne teaching the Virgin: prayer to St Anne; f.250v St Mathurin between kneeling crowned lady and nun.

Commentary: Both border and miniature decoration indicate that this manuscript was illuminated early in the second half of the fifteenth century, probably around 1460. It is the product of a French atelier which Eleanor Spencer first named the Master of Jean Rolin II, and subsequently the Master of the *Horloge de Sapience* after a manuscript now in Brussels (Bibl. Royale, IV.III). The miniatures of the Fisher Hours are not by the master himself. The modelling of the faces and forms is less skilful, and colour harmonies less subtle than the best work of this atelier, but this hand appears in several manuscripts attributed to the workshop and the dependence on common patterns is obvious.[1]

This atelier, based on Parisian traditions, seems to have developed from that of the Bedford Master, active in the earlier decades of the century. A comparison of the illustrations for the Vigils of the Dead on f.117r of the Fisher Hours (fig. 207) with f.155r of Vienna Nat.bibl. cod. 1840 (fig. 208) shows our miniaturist developing as his main theme the subject of one of the small medallions in the

manuscript in Vienna. The latter work was begun in the Bedford Master's atelier and finished later in the century by the Master of the *Horloge de Sapience* and associates. The medallion system is an echo of earlier Parisian patterns and f.36r, which introduces matins in the Fisher Hours, also uses this device.

The work of this mid-century group of miniaturists is clearly associated also with the style of the '*egregius pictor Franciscus*' or Maître François, active in Paris from the late 1460s to the 1490s. There is also a manuscript by this master in the Australian collection, No. 78. The style of the Fisher Hours is closest to that of Maître François in the miniature of the Annunciation to the shepherds (figs. 213 and 214), where the figure types are sturdy and space is clearly stratified. Mature compositions of the Master of the *Horloge de Sapience*, however, do not develop in this direction, and it seems more prudent at this stage of research to distinguish different though interrelated artistic strains rather than to hypothesize that the *Horloge de Sapience* atelier is a youthful phase of the Maître François School.

The representation of the three Marys is a relatively uncommon theme. Comparison of the composition in the Fisher Hours on f.156r with that in another work ascribed to the Master of the *Horloge de Sapience*–Maître François group (Vienna Nat.bibl.cod. S.N. 13237, figs. 209 and 210) demonstrates again the use of shared models. An interesting feature of the Fisher Hours is that it shows this workshop drawing also on patterns used by a Flemish artist, the so-called Coëtivy Master, who Nicole Reynaud has argued is the Flemish panel painter and miniaturist Henri de Vulcop. The compositions of David on f.95r and the Crucifixion on f.110v in the Fisher Hours relate closely to those of the Coëtivy Master in Vienna Nat.bibl. codex 1929 (figs. 211 and 212). Particularly striking is the dependence of the Crucifixion in the Fisher Hours on the same model as that used for the Coëtivy Hours, if we contrast with it Maître François' rendering of the scene in Plate 41.[2]

While the Master of the *Horloge de Sapience* and his associates built on earlier Parisian tradition, their style seems to reflect also a new injection of Netherlandish influence into French illumination.

This workshop produced several manuscripts for clients in Autun as well as Paris, but the Fisher Hours was certainly in Paris by the early sixteenth century as the passage on f.227v documents. It seems likely that Sœur Anne and fellow members of her community were responsible for the later textual and decorative additions.

In the nineteenth century the book was in the possession of W. Stuart. In 1972, after the death of Mrs M. H. O. Stuart, it was sold through Quaritch to the Fisher Library, University of Sydney. The Friends of the Library assisted the purchase.

Bibliography: Quaritch (1972), lot 897.

Notes

1. See Spencer (1931), and the following by the same authority: 'L'Horloge de Sapience' in *Scriptorium*, 1969, pp.277–299; 'Dom Louis de Busco's Psalter' in *Gatherings in honor of Dorothy E. Miner*, 1974, pp.227–240; 'Le Lectionnaire du Cardinal Charles II de Bourbon' in *Les Dossiers de l'Archéologie*, Vol. 16, Mai–Juin, 1976, pp.124–129.
2. Nordenfalk associates the origin of the composition of the three Marys with Chartres. See C. Nordenfalk, 'Bokmålningar från medeltid och renässans' in *Nationalmusei samlingar*, Stockholm, 1979, p.108 and plate xiii. For the Coëtivy Master see Pächt and Thoss (1974), pp.29–32, figs. 32–41; N. Reynaud, 'La Résurrection de Lazare et le maître de Coëtivy' in *La Revue du Louvre et des Musées de France*, Vol. 15, 1965, pp.171–182. Spencer also refers to the collaboration between the Coëtivy Master and the atelier of the Master of the *Horloge de Sapience*.

Plate 41, figs. 214–218
No. 78. *Book of Hours*. Use of Rome. Latin and French
Paris or Angers, c.1475
National Gallery of Victoria, MS. Felton 1072/3

Vellum, 178 x 125. A–B modern vellum + 116 + C–D modern vellum. I⁶, II–VII⁸, VIII⁶, IX–XV⁸. Folios 59v–60v and 106v are blank. Modern foliation in pencil in arabic numerals. Script: 15c. French *lettre-bâtarde* in black ink with blue and red rubrics, calendar entries in black and blue. Ruling: pale red ink: 24.[58].43 x 19.[108].51. Lines of text: 25. Ruling unit: 5. Calendar: 25.[9.3.1.44].43 x 19.[108].51. Lines of text: 34. Binding: 19c. red velvet with one gilt clasp.

Ownership: Inside front cover is the book-plate of Edward Montagu Stuart Granville, first Earl of Wharncliffe, and the motto *A vito vir et honore*.

Text: Latin, with one rubric in French. Contents: ff.1r–6v calendar; entries in blue for special feasts include SS. Maurilius (13 September) and Maurice (22 September); entries in black include SS. Aubin (1 March) and René (12 November); ff.7r–10v gospel sequences; ff.10v–13r *Obsecro te*; ff.13r–14v *O intemerata*; ff.15r–59v Hours of the Virgin; ff.61r–68v penitential psalms; ff.68v–72v litany of the saints; ff.73r–75r Hours of the Cross; ff.75v–77v Hours of the Holy Ghost; ff.78r–106r Vigils of the Dead; ff.107r–113r additional prayers; ff.113r–114r commemorations of SS. Christopher and Sebastian.

Decoration: One-line gold initials on blue or red grounds with infills and surrounds of gold tracery, and two-line initials in blue on gold grounds with ivy-leaf infills occur throughout the text. Line-endings are bars of blue, red or gold patterned with gold dots, lines and scrolls or blue and white ivy-leaf designs. Some capital letters, otherwise undecorated, are touched with yellow or gold. Twelve double foliate initials 'K L', two lines high, head the calendar pages.

One three-line initial on f.7r and twelve four-line initials introduce the text on the pages containing large miniatures. These are of varying designs. Some are foliate – blue on gold grounds with ivy-leaf infills – others are parti-coloured red, yellow, green and gold and are shaped like a series of curving horns or cornucopias with grounds of blue or pink patterned with acanthus leaves outlined in white or gold (fig. 214). Other initials are simpler in shape. Coloured red, blue or gold, the outline of the letter itself is softened by a curling leaf pattern of the same colour with infills of acanthus on blue or grey grounds. One of the most finely rendered initials is on f.73r, where the seven lines of text are set within the context of the full-page miniature of the Crucifixion (Plate 41). The grisaille and gold palette is used both for the large initial with its elegant floral infill and for the smaller initials and line-endings, so that the section of script itself forms an integral part of the whole decorative page and suggests that initial-decorator and miniaturist may here be the one person.

One historiated initial six lines high on f.10v, outlined in curving grisaille fronds, is set against a gold ground. The background for the composition within the initial is dark brown.

Many pages of text, including those with small miniatures, have bracket-left or bracket-right borders. Full borders frame the calendar pages with small rectangular miniatures set into the side and bottom panels. Full borders also decorate ten pages containing miniatures (approximately 88 x 58). With the exception of that on f.78r (fig. 217), these are all based on the French floral-acanthus-type design with curving acanthus fronds, interspersed with foliate and floral motifs, fine stems and small circlets in red, blue, green and gold. Fine ivy-leaf vines occur in the borders of the calendar pages, and this series is traced through from recto to verso. All borders form panels contained by ruled gold lines. On the pages containing the larger miniatures, however, considerable variation is achieved in this element of the decoration. The ground is sometimes divided into contrasting sections of gold and white ruled geometric shapes, and marginal scenes set on small green swards are let into the side panels. At the bottom of the page the border merges into a full-scale composition, also set on a green ground, which extends the width of the ruled frame. The range and colour of floral motifs on these pages are also more extensive, with lighter shades of violet-grey and pinks mingled with the predominant blue, green, red and gold. Colours for the scenes in both the side and lower margins are the same as for the decorative motifs. Surfaces are liberally treated with gold.

The border which surrounds the illustration to the Vigils of the Dead on f.78r (fig. 217) is unique. It consists of entwined leafless gold branches against a blue ground. These branches rise from either side of the cemetery scene in the lower margin.

The twenty-four small calendar miniatures (32 x 22 and 34 x 29) and five other small miniatures (40 x 30) have simple gold rectangular frames ruled in black. The ten miniatures (88 x 58) which introduce particular hours or sections of the book are arched at the top. They too are framed by a narrow gold band ruled in black and slightly serrated around the curved top.

The manuscript also contains three full-page miniatures on ff.15r, 61r and 73r. They are framed by a simple black line and contain gold framed text-inserts of seven or eight lines which float before the scene like a bill-board advertising the action (Plate 41).

Colours for all the miniatures are distinguished from those of the border decoration and its subsidiary scenes. Figures dressed in mauve, grey and off-white offset by the use of gold, black and brown are set against starred blue backgrounds and landscapes in varying shades of green, or buildings and interiors in dark pink and brown. Dashes of bright orange-red are used for accessories, and occasionally rich blue, pink or yellow strike a powerful contrast to the predominant grisaille tones. Gold and black are also used for contrast (Plate 41).

Programme of Illustration: The twelve calendar pages show the appropriate zodiacal sign against a landscape setting in the side border and the labours of the months in the lower margin as follows: f.1r January, man feasting; f.1v February, man warming himself; f.2r March, man pruning; f.2v April, maiden seated in walled garden; f.3r May, man and woman on horse, hunting; f.3v June, man scything; f.4r July, man and woman reaping; f.4v August, two men threshing; f.5r September, man treading grapes, another bearing load of grapes; f.5v October, man sowing; f.6r November, man feeding hogs with acorns; f.6v December, man killing hog.

The ten arched miniatures and three full-page compositions are related to the text as follows: f.7r St John and the legend of the poisoned cup: Gospel of St John; f.15r the Annunciation and *Procès de Paradis* (full page): matins for the Hours of the Virgin (fig. 215); f.27r the Visitation: lauds; side scene: woman gathering fruit; knave behind her; lower border: warrior fights mounted wild man; f.34v the Nativity: prime; side scene: hunter and dog; lower border: hunting scene; f.37r Annunciation to the shepherds: tierce; side scene: shepherd chases wolf with lamb in its mouth; lower border: two maidens in circular sheep fold, at left man embraces lady in a wood (fig. 214); f.40v Adoration of the Magi: sext; side scene: cortège of camels with attendants and gifts; lower border: the meeting of the three magi; f.43v Presentation in the Temple: none; side scene: lamp-lighter; lower border: God speaks with Adam and Eve in Paradise; f.46v Flight into Egypt: vespers; side scene: jester and piper; lower border: shooting scene on river; f.51v Death of the Virgin: compline; side scene: kneeling angels; lower border: seated hermit on wooded embankment with two ships in sea below; f.61r David and Abigail (full page):

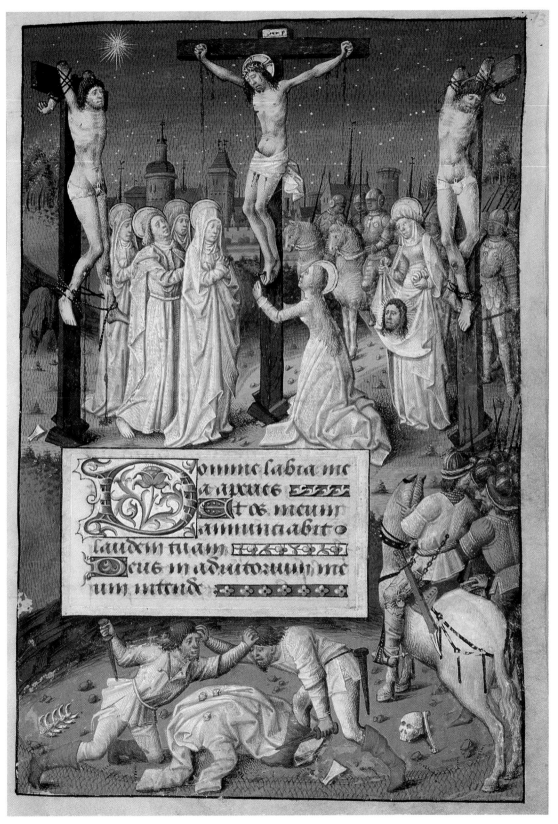

Plate 41. Crucifixion. No. 78, f. 73r. 178 x 125

in illo tēpore.
missus est
gabriel an
gelus a deo in ciuitatem

Plate 42. St Luke. No. 79, f.15v. 163 x 115

Plate 43. St Lawrence and St Barbara. No. 80, ff. 110v–111r. 170 x 180

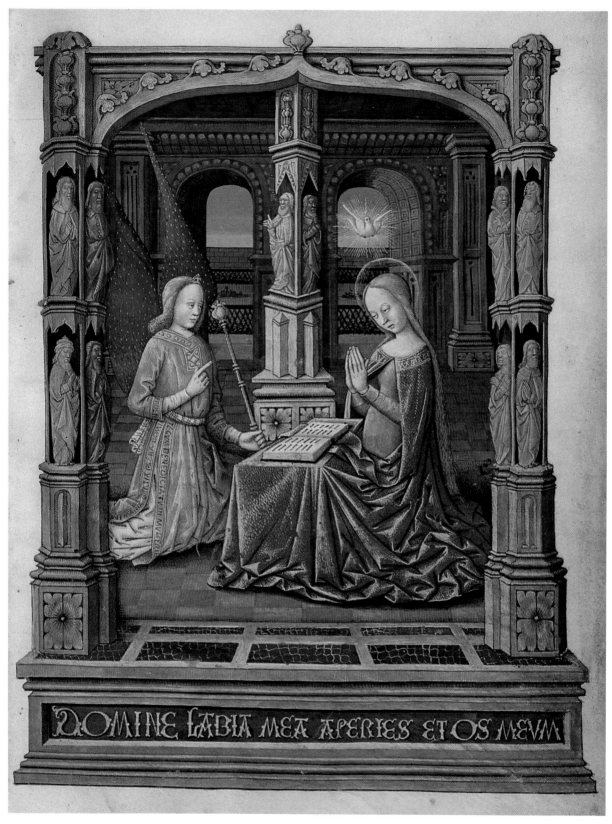

Plate 44. Annunciation. No. 81, f. 13r. 213 x 152

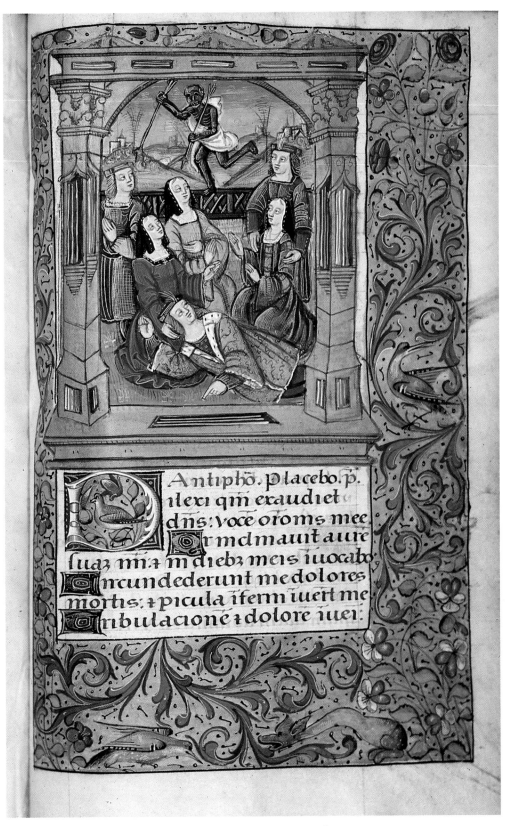

Plate 45. Death stabs young lovers. No. 84, f. 70r. 212 x 150

Plate 46. Bishop anoints children, bishop blesses children. No. 85, f.4r. 480 x 325

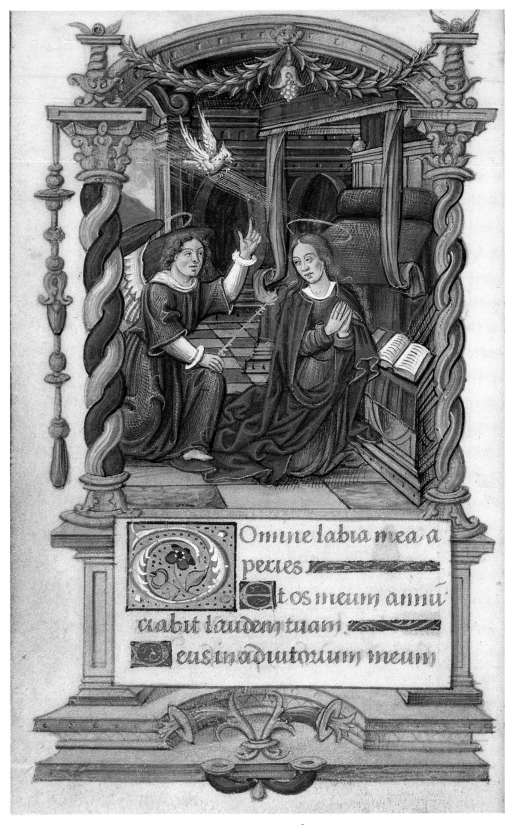

Plate 47. Annunciation. No. 87, f.23v. 145 x 90

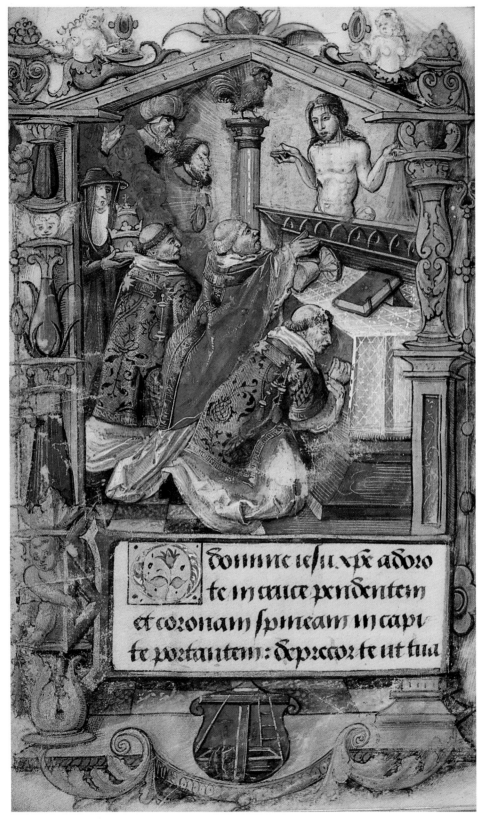

Plate 48. The Mass of St Gregory. No. 88, f.171v. 173 x 107

penitential psalms; f.73r Crucifixion (full page): Hours of the Cross (Plate 41); f.75v Pentecost: Hours of the Holy Ghost; side scene: hunter knifes pig; lower border: expulsion of Adam and Eve from Paradise, and their labours; f.78r the legend of the three living and three dead: Vigils of the Dead; side scene: seated cowled mourners; lower border: cemetery scene (fig. 217).

The one historiated initial, 'O' on f.10v showing the Virgin and Child, introduces the *Obsecro te*.

The five small miniatures illustrate gospel sequences and commemorations of appropriate saints. Gospel sequences: f.8r St Luke; f.9r St Matthew; f.10r St Mark. Commemorations: f.114r St Christopher, bearing the Christ Child; f.115v martyrdom of St Sebastian.

Commentary: The Wharncliffe Hours is a fine example of the work of the so-called Maître François. A letter written from Paris in 1473 by Robert Gaguin, general of the order of Trinitarians, to Charles de Gaucourt, governor of Amiens, states, 'We gave to the excellent painter Francis (*egregius pictor Franciscus*) the outlines of the pictures and the schemes of the images which you ordered to be painted for the books of the *Cité de Dieu*, and he has finished the work as he began it with the most perfect craftsmanship. Indeed, he is such an accomplished artist that Apelles would rightly have taken second place to him.' The *Cité de Dieu* referred to in this passage has been identified, from the de Gaucourt coat-of-arms therein, as Paris B.N. MSS. fr.18–19.[1]

The name *egregius pictor Franciscus* was subsequently associated by André de Laborde with the 'Maître François, *enlumineur*' who appears, together with his companion, in the inventory of the household of Charles II, Comte du Maine, for the year 1473. While it is not possible to establish this identity with certainty it is clear that the illuminator of de Gaucourt's *Cité de Dieu* worked for several patrons in the region of Le Mans and Angers, and that his style, as well as drawing on Parisian traditions, especially those of the Bedford Master atelier, was also markedly influenced by Jean Fouquet and the school of Tours. The title 'Maître François' therefore has been commonly given to the illuminator responsible for B.N. MSS. fr.18–19, and this work has become the touchstone for identification of his style in other manuscripts of the late fifteenth century.[2]

As mentioned on p.187 in connection with No. 77, relationships exist between the work of the Master of the *Horloge de Sapience* and that of Maître François (figs. 213 and 214); indeed, these artists seem to have collaborated in certain commissions during the 1460s. The miniatures of the Wharncliffe Hours, however, bear the authentic stamp of the hand of the illuminator of de Gaucourt's *Cité de Dieu*, and may be dated *c*.1475–1480, that is to say at the height of this master's career.

Characteristics of his developed style include readily recognizable figure types with firmly modelled heads built up by a kind of stippling process, and a stratified treatment of space in which the middle distance is more clearly defined than in the work of either the Bedford or the *Horloge de Sapience* masters. Varying shades of green and hazy blue emphasize systematic recession in landscape scenes, and figures and buildings are clearly located within the space of the composition. At the same time, Maître François persists in using a series of conventions inherited from earlier Parisian workshop traditions for the rendering of buildings and settings. Combined with those conventions are features which derive from the theatre. No account is taken, for instance, of the relative size of the figures in proportion to the buildings with which they are associated. It is the protagonists of the drama who are always the main focus of attention. Indeed, Maître François' work is marked by explicit dramatic narrative qualities. His figures communicate effectively by gesture and sprightly movement, and even in the now traditional medium of the Book of Hours he enlivens compositions by marked references to contemporary drama. Thus, the full-page miniature introducing matins for the Hours of the Virgin shows the virtues Mercy and Truth, Justice and Peace reconciled in heaven through the event of the Incarnation (fig. 215). The scene is based on the Mystery play by Maître François' contemporary Arnoul Gréban, who had close associations with the same patrons as those of the illuminator. Maître François seems to have been responsible for developing this particular composition and relating it to the Hour of matins for the Little Office of the Virgin. It appears in several manuscripts executed by him from the early 1470s on. The tiny Book of Hours in the British Library, Egerton MS. 2045, provides one such example (fig. 216).[3]

The miniature accompanying the penitential psalms in the Wharncliffe Hours, which shows the unusual subject of the meeting of David and Abigail, also demonstrates the master's ability to vary the conventional programme of the prayer-book with scenes which reflect the versatility and ingenuity required for illustrating the larger quasi-historical and allegorical treatises which his atelier produced in substantial numbers.

In particular, Maître François often uses dramatic themes to illustrate the Vigils of the Dead. In the Wharncliffe Hours, despite its macabre subject, the page which introduces the Vigils is one of the most beautifully and richly illuminated of the whole book (fig. 217). In the legend of the three living and three dead depicted in the main miniature, the horsemen and their mounts are rendered in subtle mauve and off-white tones highlighted by trimmings and accessories in blue, black and red, while the skeletons advance with dance-like precision. This page also provides an excellent example of the finely co-ordinated activity of the workshop. The marginal scenes which feature in the borders throughout the manuscript are not by the hand of Maître François himself, a fact which is evident

even in the treatment of the colour and gold highlights which are not so subtly handled by the assistant. Nevertheless the integration of a variety of decorative elements on f.78r provides a strikingly homogeneous effect. Even the illuminated initial which introduces the text picks up the dominant colours of the page and the curve of its horn-like terminal is in keeping with the movement in the scene above. Movement and fearful reaction in the main miniature are effectively contrasted with prayerful meditation by the cowled figures in the side margin and the preparation for burial in the cemetery below; and dry wintry branches of the border glint gold against a deep blue sky. Comparison with a miniature from another manuscript from the atelier of Maître François, Paris B.N. MS. Smith-Lesœuf 9, p.349 (fig. 218), indicates how the assistant has drawn on a workshop pattern for his cemetery scene, adapting it to the needs of this particular commission.

The full-page miniature of the Crucifixion (Plate 41) shows Maître François modelling his figures in a manner strongly reminiscent of Fouquet. The drapery of the group around the crosses is weightily yet softly rendered by means of subtle grisaille and white tones set against a brightly coloured landscape. This same composition, however, reveals quite distinct influences which are more readily associated with Netherlandish painters than with the great illuminator and panel painter of Tours. The theme of the soldiers, for instance, who are actively engaged in fighting over Christ's clothing, is Germanic or east Netherlandish in origin. Northern too, is the emphasis on the suffering of the thieves who have had both legs and arms broken, and the presence of the standing Veronica holding the sacred sudarium derives ultimately from Flemish painting.

Even Maître François' figure style, in which stocky, often almost ugly-featured individuals, characterized by a certain harsh realism, intermingle with more courtly, elegant representatives decked in high headdresses and pointed shoes or in glistening armour with sheathed swords, indicates a mixture of both French and Netherlandish elements. Eleanor Spencer has suggested that this artist, who headed one of the most successful ateliers in Paris in the last forty years of the fifteenth century, may have originally come from the Netherlands, perhaps from the environs which produced Dirc Bouts, with whose spatial conventions he was clearly familiar.[3]

In this respect it may be also significant that in the Egerton Hours, MS. 2045, many of whose compositions so closely relate to those of the Wharncliffe Hours, scenes such as the Pentecost on f.178v use a particularly detailed sculptural enclosure around the figures which, it has been claimed, is Netherlandish in origin. Certain miniatures in the Egerton Hours were in fact finished later by a Flemish artist.[4]

The calendar of the Wharncliffe Hours seems to indicate that it was made for a patron in the diocese of Angers. It

could have been executed in Paris or possibly by Maître François when he was resident for some time in the court of the Comte du Maine. The assistant responsible for both the decorative border and marginal scenes seems to have been allowed considerable scope in the choice of subject matter, although the illuminated pages always present a visual harmony.

In the nineteenth century the book was in the possession of the family of the Earl of Wharncliffe, where it remained until 1920, when it was purchased through the Felton Bequest for the National Gallery of Victoria.

Bibliography: Sinclair (1969), pp.313–315; Christie (1920), lot 87; Lindsay (1963), p.72; Manion (1972 and 1981); (Felton, 1938), pp.2 and 4; Spencer (1931), pp.14b, 73 *n*1, 88–90, 212–213.

Notes

1. See *Epistolae et Orationes Roberti Gaguini*, ed. L. Thuasne, Paris, 1904, Vol. I, p.225; L. Thuasne, 'François Fouquet et les miniatures de la Cité de Dieu de Saint Augustin' in *Revue des Bibliothèques*, Paris, 1898, pp.33–57. See also P. Durrieu, *Un grand enlumineur parisien au XV*ᵉ *siècle. Jacques de Besançon et son œuvre*, Paris, 1892. Durrieu first grouped this school under the name 'Jacques de Besançon'.
2. A. de Laborde, *Les manuscrits à peintures de la Cité de Dieu*, Paris, 1909, Vol. II, p.401.
3. For E. P. Spencer's contribution to this field see No. 77, *n*1, p.187. See also Pächt and Thoss (1974), pp.80–85. J. A. Herbert also deposited a typescript, *The Wharncliffe Horae Descriptive Notes*, London, 1920, at the British Library and the National Gallery of Victoria.
4. Concerning the case for the Netherlandish contribution to such sculptured settings, see de Winter (1981), pp.365ff.

Plate 42, figs. 219–222

No. 79. *Book of Hours*. Use of Paris. Latin and French
Paris, c.1490–1500
Adelaide Church of England Diocesan Library, South
 Australia, on loan to State Library of South Australia

Vellum, 163 x 115. A–E modern paper + F modern vellum + 208 + G–J modern paper. I–II⁶, III⁸, IV⁷ (wants 2), V–VIII⁸, IX⁷ (wants 4), X–XII⁸, XIII⁷ (wants 6), XIV–XXVI⁸, XXVII⁷ (wants 8). Pagination in 16c. arabic numerals, 1 to 394 from ff.13r–205v. Script: French gothic liturgical, hand in black ink, with rubrics in blue and gold; calendar in red, blue and gold. Ruling: red ink: 25.[53].37 x 23.[85].55. Lines of text: 16. Ruling unit: 5.5. Calendar: 7.11.[15.5.40].25.12 x 8.10[90].38.17. Lines of text: 17. Ruling unit: 5.5. Binding: 19c. red morocco.

Ownership: Folio 206v has an illegible signature.

Text: Latin; calendar and rubrics in French. Contents: ff.1r–12v full calendar; ff.13r–21v gospel sequences, with last section of text missing; f.22r *Obsecro te*, with opening section of text missing; ff.26r–113r Hours of the Virgin,

with short Hours of the Cross and of the Holy Ghost inserted at each appropriate hour (see programme of illustration below); a section of the text is missing between ff.62v and 63r (the end of lauds for the Hours of the Virgin and the beginning of matins for the Hours of the Cross) and between ff.95v and 96r (the end of none for the Hours of the Holy Ghost and the beginning of vespers for the Hours of the Virgin); ff.114r–127r penitential psalms; ff.127v–134v litany, including SS. Denis, Geneviève, Marcellus and Quentin; ff.135r–185r Vigils of the Dead; ff.185v–190r *O intemerata*; ff.190v–206v commemorations.

Decoration: One- and two-line dentelle initials appear throughout, together with two- and three-line foliate and semi-grisaille initials with infills of flowers on washed gold or natural grounds. Line-fillers of the same pattern as the dentelle initials are a consistent part of the textual decoration.

Along the side margin of every page of text is a wide border panel (85 x 25) outlined in red ink, with twining stems sprouting fruits and flowers, and thick curving acanthus leaves, interspersed with insects, buds, animals and grotesques. The border ground is often divided into geometric patterns with sections in thinly washed gold contrasting with the natural vellum. The calendar pages are framed by four-sided borders of the same design.

In the lower margins of the calendar pages appear small rectangular miniatures in gold frames: the zodiacal signs on the verso and the labours of the months on the recto pages. Nineteen small square miniatures, six or seven lines high and similarly framed, introduce certain prayers and commemorations. On these pages the decorative border extends from the side margin along the upper or lower section of the page. Fifteen large miniatures (*c.*38 x 48), arched at the top and framed in gold, introduce each hour and major divisions of the text. These pages are decorated by full borders, and their opening lines of text, as well as commencing with the elaborate three-line decorated initial type, are written in alternate lines of blue and gold.

Predominant colours for all decorative elements are rich blue, green, red, yellow, white and gold, with softer shades of pink, mauve, grey, brown and blue being used in the miniatures.

Programme of Illustration: The twelve verso pages of the calendar show the appropriate zodiacal sign, against a landscape setting. On the recto pages the labours of the months are: f.1r January, man feasting; f.2r February, man warming himself; f.3r March, man and woman pruning; f.4r April, two maidens seated in walled garden; f.5r May, man and woman on horseback, hunting; f.6r June, man scything; f.7r July, three men reaping; f.8r August, four men threshing (fig. 219); f.9r September, man treading grapes; f.10r October, man sowing; f.11r November, man and woman baking; f.12r December, man gathering acorns.

The programme for the fifteen large miniatures is as follows: f.13r St John on Patmos: Gospel of St John; f.15v St Luke: Gospel of St Luke (Plate 42); f.18r St Matthew: Gospel of St Matthew; f.20v St Mark: Gospel of St Mark; f.26r Annunciation: matins for Hours of the Virgin; marginal scenes of Anna and Joachim at the golden gate at top right, birth of the Virgin at bottom right, Virgin spinning at bottom left; f.51v Visitation: lauds; f.64v Pentecost: matins for Hours of the Holy Ghost; f.66r Nativity: prime for Hours of the Virgin; f.75r Annunciation to the shepherds: tierce; f.82v Adoration of the Magi: sext; f.89v Presentation in the Temple (fig. 221): none; f.105v Coronation of the Virgin: compline; f.114r Anointing of David: penitential psalms; marginal scenes of David and Goliath at upper right, David and Bathsheba at lower right, David at prayer at lower left (fig. 222); f.135r Job and his comforters: Vigils of the Dead; f.190v The Trinity: commemoration.

Nineteen small square miniatures (35 x 38) introduce prayers and commemorations in honour of the saints as follows: f.185v Virgin and Child: *O intemerata*; f.191v St Michael; f.192r St John the Baptist; f.193r St John the Evangelist with the poisoned cup; f.193v SS. Peter and Paul; f.194v St James; f.195r St Christopher; f.196r St Lawrence; f.196v St Sebastian; f.198r St Denis; f.199r St Nicholas; f.199v St Claudius; f.201v St Anthony; f.202r St Anne; f.202v St Catherine; f.203v St Margaret; f.204r St Barbara; f.205r St Geneviève; f.206r St Agnes.

Commentary: This manuscript is a fine example of a late fifteenth-century Parisian Book of Hours. In contrast to much routine work of the period, precise and fine detailing of individual elements such as flowers, birds, insects, grotesques etc. distinguishes the border decoration, with its richly embellished gold grounds and highlights.

One artist was responsible for all the miniatures. His work shows an experienced command of modelling form by tonal variation, combined with the current use of washed gold, thinly hatched. In a rich palette, white is used for contrast to good effect, as for example in the rendering of the hair of older men (fig. 222) or the expanse of altar cloth in the Presentation (fig. 221). Conventional interior settings are competently handled, with modelled figures casting shadows and furniture set at an angle or windows opening on to the outside world, giving a sense of spatial recession and depth (Plate 42 and fig. 221).

A notable feature of this illumination is the depiction of landscape, which is of high quality throughout the manuscript, details being as finely painted in the small calendar vignettes (fig. 220) as in the larger narrative scenes (fig. 222). The miniaturist, using conventions familiar since Fouquet, paints distant views of towns or castles silhouetted on horizons of finely tempered hues of azure blue. Foregrounds are in graduated greens and yellows, and the trees are pointed with minute daubs of white or gold, in

line with contemporary practice.

The programme of illustration follows one of the sequences common to a group of French Books of Hours of this period. Marginal scenes which accompany the Annunciation and the anointing of David (fig. 222) echo the tradition established in Paris in the early years of the Bedford Master. As illustration to the penitential psalms, the less popular theme of the anointing has been chosen for the main focus, with the standard subjects of David and Goliath, David at prayer and with Bathsheba rendered as subsidiary.

At least two miniatures have been excised. The missing introduction to vespers after f.95v probably contained an illustration of the Flight into Egypt. The Hours of the Holy Ghost and of the Cross, which are inserted after the corresponding Hours of the Virgin, were probably both introduced at matins by a miniature, as they are for example in Nos. 86, 87 and 88 of this catalogue. Only the miniature for Pentecost accompanying the Hours of the Holy Ghost is still in place; the excised leaf which introduced the text of the Hours of the Cross no doubt contained an illustration of the Crucifixion. It is also likely that a third missing leaf which introduced the *Obsecro te* contained a miniature or historiated initial, and since, in other manuscripts which integrate short Hours of the Cross and of the Holy Ghost with the Hours of the Virgin, an extract from the Passion of St John accompanied by an illustration of a scene such as the Betrayal or Agony in the Garden appears before the *Obsecro te*, it is also possible that a whole gathering is missing at this point which would have contained the Passion extract and an accompanying miniature.

The rich appearance of the manuscript suggests that it was a private commission, since such copious ornamentation was unusual for stock-in-trade articles. A document with the volume indicates that it was owned in the late nineteenth century by a Mrs Shaw of 8 Cambridge Square, London. In 1890 it passed to her niece Lucy Ellen Anderson, who brought it to 39 Craven Hill, Gawler, South Australia. At her death it passed to her cousin Dr F. W. Pennefather, Bishop of Adelaide. He presented it to the diocese of Adelaide in 1904. It is currently on loan to the State Library of South Australia.

Bibliography: Sinclair (1969), pp.243–245.

Plate 43, figs. 223–228
No. 80. *Book of Hours*. Use of Rome. Latin and French
Bourges, c.1480
State Library of New South Wales, Mitchell 1/7c

Vellum, 170 x 90. A–B modern paper – watermark has the date 1810 – + C modern vellum + 115 + D modern vellum + E–F modern paper. I², II⁶, III¹, IV⁸, V², VI–VIII⁸, IX⁷ (wants 7), X⁷ (wants 4), XI–XII⁴, XIII³ (wants 1–3), XIV–

XVII⁸, XVIII⁶, XIX⁴ (wants 3 and 4), XX², XXI³. Two catchwords, ff.92v and 100v, agreeing. Quire I consists of 2 blank leaves, except for ruling, stuck down along spine. Quire III, f.9r, is a blank leaf of thicker vellum than the rest of the manuscript. Folios 61v and 113r, except for ruling, are blank. Script: late 15c. French *lettre-bâtarde* in black ink with red rubrics, calendar in black and red. Ruling, in pale red ink: 13.[47].2.16.5.7 x 12.4.[122].28.4. Lines of text: 29. Ruling unit: 4.2. Calendar: 10.[8.3.5.3.5.37.1].18 x 15.[124].28.3. Lines of text: 33. Ruling unit: 3.7. Binding: 19c. calf with floral centre design and border in blind and gilt.

Ownership: A coat-of-arms, motto and monogram are included in the original decoration as detailed below. Folio 1r has a 16c. engraving of St Jerome in the desert and the words *Officium Beate Marie Virginis* in a 16c. cursive hand; ff.113v–115r contain additional prayers, also in a 16c. cursive hand. Pasted on to f.155v is the note *Fait vers/en 1433* [changed to 1533] *donne a Mr. L.'Abbe Desmazures en 1821 par Mr. le docteur Alibert premier medecin ordinaire du roi.* On Bv in modern pencil is 'From the Hackett Collection p.47 said to be French work of the Fouquet School the last quarter of the 15th century'.

Text: Latin, with calendar in French. Contents: ff.3r–8v full calendar with entries for all days with Parisian and northern saints emphasized; entries in red include invention of St Stephen, SS. Urbanus, Mauritius, Denis and Ursinus; ff.10r–17v gospel sequences; ff.18r–19v *O intemerata*; ff.20r–61r Hours of the Virgin (none breaks off incompletely at f.49v, vespers opens imperfectly on f.50r, compline begins imperfectly on f.54r); ff.56r–61r seasonal variations; ff.62r–65v Hours of the Cross, lacking none to compline; ff.66r–68v Hours of the Holy Ghost; ff.69r–75v penitential psalms; ff.76r–78v litany; ff.79r–106v Vigils of the Dead; ff.107r–111v commemorations of SS. Sebastian, John the Baptist, John the Evangelist, George, Mary Magdalen, Catherine, Lawrence and Barbara; ff.111v–112v Stabat Mater. The commemoration of St George on f.108v has the rubric only; that for Mary Magdalen on f.109r begins imperfectly.

Decoration: One-line versal initials in gold on rectangular grounds of red or blue with fine gold tracery appear throughout the text. Two-line initials of the same design mark divisions within the offices and prayers. In the calendar three-line gold initials alternating against red and blue grounds preface each page. On pages containing large miniatures the text is introduced by four-line initials. These are usually blue or red or vice versa with gold filigree patterning around shafts. On f.20r beneath the miniature of the Annunciation (fig. 228) the initial is historiated with a head of God the Father. On ff.31v, 41v, 44v, 47v and 62r the four-line initials have infills of floral design on a gold ground similar to that of the accompanying decorative

border. On ff.38v, 69r and 79r they contain the monogram 'A' in gold.

Line-fillers in red and blue with gold filigree designs similar to the initials are prevalent throughout the text.

Every page has a decorative border, usually traced through from recto to verso. The calendar and regular pages of text have panel borders. Full borders frame the pages containing miniatures. The border design is the floral and acanthus leaf type prevalent in middle and late fifteenth-century French illumination. Its basic elements consist of hairline sprays of green and gold leaves interspersed with red berries and blue, red and white flowers. Curving acanthus leaves in blue and gold, edged sometimes with red, occur usually at the corners and in the middle of the panels. Shields with the coat-of-arms *or shield parly per pale, sinister coat azure, 3 six-pointed stars and dexter coat azure, a chief indented or, one bend sinister sable* appear in the borders on ff.20r, 62r, 69r, 79r and 111v. The motto *Je quiers mon mieulx* is inscribed in gold lettering on a red scroll in the borders of ff.10r and 62r, and on a blue scroll in that of f.62v, traced through from 62r. The monogram 'A', as well as appearing in certain initials (see above), is depicted on a shield in the lower border of f.111r and in the right border of f.10r near the inscribed scrolls.

The calendar has twelve small double miniatures. On the left is the labour of the month and on the right the sign of the zodiac. The latter scenes are modelled in gold against a deep blue ground and are now much rubbed and blurred. In the labours, washes of grey-blue, soft greens and brown predominate. Gold highlights on clothes, grain etc., and expanses of white and off-white skin tones offset the subdued palette, as does the occasional use of a rich blue or orange for clothing.

Twenty-six large miniatures arched at the top (80 x 75) introduce the major sections of the book. They are placed at the top of the page to the left or right in line with the inner margin and are accompanied by thirteen lines of text (Plate 43, figs. 223, 225, 227 and 228). Both small and large miniatures are simply framed by red and gold lines. The palette of the large miniatures is the same as that used for the labours of the months.

Programme of Illustration: The subjects of the labours in the double miniatures of the calendar pages are: f.3r January, man feasting; f.3v February, man digging; f.4r March, man pruning vines; f.4v April, man going on pilgrimage; f.5r May, lovers courting; f.5v June, man scything; f.6r July, man reaping; f.6v August, man sowing; f.7r September, man gathering acorns; f.7v October, man treading grapes; f.8r November, man stoking fire; f.8v December, man killing a pig.

The twenty-six large miniatures are related to the text as follows: f.10r St John on Patmos: Gospel of St John (fig. 227); f.11r St Luke: Gospel of St Luke; f.12v St Matthew: Gospel of St Matthew; f.14r St Mark: Gospel of

St Mark (fig. 223); f.15r Virgin and Child with attendant angels: *Obsecro te*; f.18r Virgin and Child with attendant angels: *O intemerata*; f.20r Annunciation: matins for Hours of the Virgin (fig. 228); f.31v Visitation: lauds; f.38v Nativity: prime; f.41v Annunciation to the shepherds: tierce; f.44v Adoration of the Magi: sext; f.47v Presentation in the Temple: none; f.62r Betrayal of Christ: matins for Hours of the Cross (fig. 225); f.63r Christ before Caiaphas: lauds; f.64r Crowning with thorns: prime; f.65r Carrying of the Cross: tierce; f.66r Pentecost: Hours of the Holy Ghost; f.69r David and Goliath: penitential psalms; f.79r the three living and three dead: Vigils of the Dead. Illustrations of the appropriate saints accompany their commemorations as follows: f.107r St Sebastian; f.108r St John the Baptist; f.108v St John the Evangelist; f.109v St Catherine; f.110v St Lawrence (Plate 43); f.111r St Barbara (Plate 43); f.111v Pietà: Stabat Mater.

Commentary: Claude Schaefer has shown that this Book of Hours, a product of the atelier of Jean Colombe, probably dates from the period after 1480 when commissions seem to have been numerous and the workshop had developed systematic patterns and methods of production to cater for a wide variety of clients. Types of commissions ranged from detailed and elaborate programmes for historical and philosophical treatises and unique prayer-books, such as the Hours of Louis de Laval (Paris B.N. lat. 920) to simpler works in which certain distinctive compositions were repeated or adapted with slight variations for a large clientele. It is to this latter group that the Sydney Hours belongs.[1]

The manuscript has been well used. Many of the miniatures are rubbed and the pages are soiled. Its elongated format is relatively unusual; but it can be compared with another Book of Hours from the Colombe workshop now at Chantilly (Musée Condé MS. 78); and examples of this format continue into the Bourdichon school.[2]

Although probably not by Jean Colombe himself, characteristic of the master's school are the sketchy impressionistic landscapes, and the interiors in which Renaissance pilasters and barrel vaults alternate with simple grey walls hatched in dark brown, often containing simulated sculptural scenes. Readily recognizable as proper to Colombe's atelier is the colour scheme mentioned above, and the figure style, although forms here are less firmly modelled than those which can be attributed with certainty to Jean Colombe himself. A greater liveliness of action and stronger colour contrasts are present in the miniatures illustrating the Vigils of the Dead and the commemorations of the saints (Plate 43). There is a link here with the programmes of the more elaborate manuscripts produced by the workshop. Comparisons are closest with small subsidiary scenes in the borders of such works as the Story of Troy, Vienna Nat.bibl. cod. 2577 (fig. 226). In the illustrations of the Passion, in the Sydney Hours, heavy

dark brown and blue hues predominate with gold from drapery or massed caps and helmets flickering through the sombre palette (fig. 225).

The miniatures accompanying the gospel sequences of SS. Matthew, Mark and Luke incorporate relevant scenes from these gospels as sculptured decoration on the walls which surround the evangelist and his symbol. This device is a distinctive feature of the Colombe workshop, and the Sydney compositions invite comparison with a manuscript now in Besançon (Bibl. Municipale MS. 148) (figs. 223 and 224). Forms are more strongly modelled in the Besançon manuscript.

Another version of the distinctive evangelist composition with subsidiary sculptural scenes occurs in a manuscript from the Colombe atelier now in Oxford (Bodl. MS. Gough Liturg. 14).

Schaefer has very tentatively suggested that the motto and coat-of-arms in the Sydney manuscript may refer to a well-known family from Bourges, Jean Fils de femme (or de fame). The notes on f.115v indicate that the book was owned in the nineteenth century by J. L. Alibert, physician to Louis XVIII and Charles X, who presented it to the Abbé Desmazaures in 1821. It was purchased by J. T. Hackett some time before 1918, when it was acquired by the State Library of New South Wales.

Bibliography: Sinclair (1969), pp.116–118; Hackett (1918), pp.47–48; Finn (1926), pp.21–26; (Sydney, 1967), pl. xi, pp.25–26; Backhouse (1970); Schaefer (1977), pp.137–150.

Notes
1. Janet Backhouse attributed this manuscript to the Colombe atelier in her review of Sinclair (see bibliography above).
2. The example from the atelier of Bourdichon is referred to by C. Schaefer (1977) n31. See *La collection Jules Marsan, Vente Hotel Drouout, MSS. du XII^e au XVI^e siècle*, le 19 mars 1976, Lot 39 (colour reproduction).

Plate 44, figs. 229–234
No. 81. *Book of Hours*. Use of Rome. Latin and French
Tours, late 15c.
Private collection, on loan to Fisher Library, University of Sydney, New South Wales

Vellum, 213 x 152. A–D modern paper + 96 + E–H modern paper. I–II⁶, III⁶ (wants 5 and 6), IV–V⁸, VI⁶ (wants 5 and 6), VII⁶ (wants 5 and 6), VIII–XIII⁸, XIV². Some catchwords, all agreeing. Remnants of quire signatures. Folios 11r–12v are blank; ff.85r–86v are blank except for ruled lines. Script: 15c. French *lettre-bâtarde* in brown ink with red rubrics. Ruling: light red ink: 27.[80].45 x 29.[120].64. Lines of text: 22. Ruling unit: 5. Calendar: 23.[10.1.5.1.8.1.55].48 x 27.[122].64. Lines of text: 33. Ruling unit: 4. Binding: 19c. morocco with gold tooling.

Ownership: Written on Bv in pencil in a nineteenth-century hand is 'An illuminated Roman Missal with 9 large and 22 small miniatures executed in the reign of Henry the Seventh the year 1485 about 339 years old' and the figures

'1867
1485

382 years old'.

Accompanying the manuscript is a sheet of paper with contents listed in black ink in a 19c. hand and a smaller paper with the note 'Given to Ruth M. Manning from E. U. Manning, June 30, 1937'.

Text: Latin, calendar in Latin and French. Contents: ff.1r–6v calendar, with headings and vigils in red and major feasts in blue; ff.7r–10r gospel sequences; ff.13r–43v Hours of the Virgin, including variations; ff.43r–44r Hours of the Cross (imperfect); ff.44v–46v Hours of the Holy Ghost; ff.47r–53r penitential psalms; ff.54r–56v litany; ff.57r–81v Vigils of the Dead; f.82r–82v *Deus qui voluisti*; ff.82v–84v *Obsecro te*; ff.87r–95v commemorations of saints.

Decoration: One- and two-line gold initials occur throughout the text. They are set on alternating blue and red rectangular grounds with infills and sometimes also surrounds, patterned with gold feathery foliage or floral motifs. Folios 38r and 40v have three-line initials in red and blue respectively. Brushed with gold and set on alternate blue and red grounds, they are patterned in similar manner to the one-line initials. Four-line initials in gold or in red, heavily embellished with gold scroll-work, introduce the lines of text beneath the nine large miniatures. They are set on blue grounds with infills and surrounds patterned in the same manner as the smaller initials. The ten-line historiated initial on f.82r is of the red and gold raised scroll type. Line-endings in red and blue are also patterned with simple leaf and line designs.

Each of the pages which contain the historiated initial and the small miniatures has a decorated border. These are of the bracket-left or bracket-right type. Full borders decorate the pages with large miniatures. All these borders are of basically the same floral-acanthus type, with grounds divided into sections of white vellum and contrasting gold, or else completely washed in gold. Considerable variety is achieved in the border patterns by diverse treatment and divisions of the grounds. Grotesques, birds and insects inhabit the borders (figs. 229 and 231).

The small miniatures (average size 4.5 x 5) and the large miniatures, except for the Annunciation, are curved at the top (average size 11.5 x 8.1) and have gold and red ruled frames. A ruled black line separates the large miniature and introductory text beneath it from the decorative border on three sides. The Annunciation which introduces the Hours of the Virgin is enclosed in a sculptured gold architectural frame with niches containing figures of the prophets on either side. It is firmly supported by a solid projecting platform with the opening words of the office written

thereon like an inscription on a memorial shrine (Plate 44). Inscriptions are also liberally used on the garments of the figures throughout. Decorated initials, borders and miniatures have a common palette in which blue, red, green and expansive sections of gold predominate, with white and black used as strong contrasts. In the miniatures, hues are varied more subtly, especially in the landscape backgrounds where skies lighten towards the horizon; a light orange-pink and yellow combine with the grey and brown architectural features; and solidly modelled brownish-yellow flesh tones counterbalance the thick gold and white highlights applied to many of the surfaces. In the most elaborate full-page miniature of the Annunciation a distinctive feature is the violet and green combination of the architectural background (Plate 44).

Programme of Illustration: The large miniatures are related to the text as follows: f.13r Annunciation: matins for Hours of the Virgin (Plate 44); f.23v Nativity: prime; f.26r Annunciation to the shepherds: tierce; f.29r Adoration of the Magi: sext (fig. 231); f.31v Circumcision: none; f.34r Death of the Virgin: vespers; f.44v Pentecost: Hours of the Holy Ghost (fig. 229); f.47r David and Bathsheba: penitential psalms; f.57r Job and his comforters: Vigils of the Dead.

One historiated initial and twenty small miniatures introduce the four gospel sequences, appropriate prayers and commemorations as follows: f.7r St John: Gospel of St John; f.8r St Luke: Gospel of St Luke; f.8v St Matthew: Gospel of St Matthew; f.9v St Mark: Gospel of St Mark; f.82r historiated initial 'D', Christ in Majesty; prayer, *Deus qui voluisti*; f.82v Pietà: *Obsecro te*; f.87r St Michael; f.87v St Stephen; f.87v St Sebastian; f.88v St Christopher; f.89v St Andrew; f.89v St Claude; f.90v St Martin; f.91r St Nicholas; f.91v St Benedict; f.93r St Catherine; f.93v St Barbara; f.94r St Margaret; f.94v St Geneviève; f.95r St Apollonia; f.95v St Mary Magdalen.

Commentary: M. Avril has identified some twenty manuscripts containing work by this illuminator, who develops the tradition of Fouquet and Colombe and also collaborates with Bourdichon. The Annunciation on f.13r clearly shows the influence of earlier Fouquet and Colombe compositions (compare Plate 44 and fig. 228). In other miniatures, the sculptural quality of the figures, with their arrested gestures and solemn, fixed expressions, is more closely related to the style of Bourdichon (figs. 229 and 231).

Two manuscripts from the Morgan Library, MS. 96 and MS. 366, belong to this group. Comparison of those works with the Sydney Hours (figs. 229 and 230, 231–233) suggests that the latter is probably the more advanced in date. The more secure modelling of the figures, the greater assurance of spatial organization, together with the later style of border decoration are evidence for this.

A more unusual member of the group is a work dedicated to the Sermons of St Bernard (Paris B.N. fr.916)

which was copied in 1474 for Jacques d'Armagnac, Comte de Nemours. The miniature of Christ preaching to the apostles on f.69r (fig. 234) clearly reveals our artist's hand. The group of listeners in the foreground with folded or joined hands and upturned faces focused on the preaching Christ, and the two low-seated coulisse figures, are adaptations of compositional schemata which recur constantly in the many Books of Hours issuing from this milieu. Avril has also identified the artist's hand in a Roman pontifical of Guillaume Durand, *c*.1480, now in Vienna (Nat.bibl. cod. 1819), where he collaborates with another Touraine artist. In Poitiers, Bibl. Municipale MS. 55, his work is found side by side with that of Bourdichon himself.

The developed borders of the Sydney manuscript, together with its hardened figure style and clearer definition of spatial relationships, indicate a date for its execution fairly late in the artist's career, probably in the later 1480s or early 1490s.

Nothing is known of the manuscript until it came into the hands of the family of the present owner, who deposited it on loan to the Fisher Library in 1981.

Note

1. For M. Avril on this artist see review 'Manuscrits à peintures d'origine française à la Bibliothèque de Vienne' in *Bulletin Monumental*, Tome 1934, IV, 1976, pp.334–335. Professor J. Plummer kindly directed us to the work of Gregory Clark, *A Group of Late 15th-Century Illuminated Manuscripts from Tours and the Shop of Jean Bourdichon*, Princeton, 1979 (unpublished thesis), which also deals with this artist. Other manuscripts identified by Avril and Clark include: British Library MS. Harley 2683, and MS. Harley 2877, two Books of Hours for the Use of Tours, one sold at Sotheby's, 10 December 1969, lot 60, and the other B.N. MS. lat. 1202, a Book of Hours, formerly part of the collection of Dyson Perrins, sold at Sotheby's 1 December 1959, lot 85, and another at Chicago, Newberry Library MS. 47; Musée Marmouth, Angers Bibl. Municipale MS. 109; New York Public Library, MS. 150, and the Hague Konink. Bibl. MS. 74 G. 28.

Fig. 235

No. 82. *Book of Hours*. Use of Rome. Latin and French Northern France, late 15c.
State Library of New South Wales, Mitchell 1/7d

Vellum, 209 x 138. A – B modern paper + C contemporary vellum + 158 + D contemporary vellum + E–F modern paper. I–II⁶, III–VI⁸, VII⁶, VIII–XX⁸, XXI³⁻¹. Catchwords agreeing after II, IV, VI, XV, XVI, XVII, XVIII and XX. Script: French gothic liturgical hand in black ink, with rubrics in red and calendar in red and black. Ruling: red ink: 20.[69].49 x 25.[103.5].76. Lines of text: 16. Ruling unit: 6.5. Calendar: 15.15.[69].34.5 x 75.5[104].25. Lines of text: 17. Ruling unit: 6. Binding: 19c. red morocco.

Ownership: Folio 1r has a 17c. inscription 'Loyse de Lange', and 'de Vilars'. Folio 158v has the inscription

written in a later hand: *Anno Domini miiii°ii.*Notes by an 18c. hand occur on Cr and the number '224'.

Text: Latin, calendar in French. Contents: ff.1–12v calendar, almost full, with special feast days in red including SS. Medard, Germain, Mammes and Martin; entries in black include SS. Frodobert, Amand, Gengulph, Vaast, Bertin, Mammes, Omer, Fremin, Legier, Eloy (twice), and Ferreolus; ff.13r–19r gospel sequences; f.20v prayers in 16c. hand; ff.21r–74v Hours of the Virgin; ff.75r–78r Hours of the Cross; ff.78v–82v Hours of the Holy Ghost; ff.83r–95r penitential psalms; ff.95v–100v litany, including St Mammes; ff.101r–148v Vigils of the Dead; ff.150r–152r *Obsecro te*; ff.154r–156r *O intemerata.*

Decoration: There are numerous initials, one and two lines high, executed in red or blue on burnished gold rectangular grounds. Four-line blue floriate initials introduce the text beneath the miniatures. Line-endings in blue or red on burnished gold occur throughout the text but not in the calendar.

Panel borders decorate the recto folios of the calendar and many text pages. Full borders decorate the pages containing miniatures (fig. 235). These borders are of conventional late fifteenth-century French design with blue and gold acanthus leaves and red, blue and green foliate and floral forms. Their grounds are sometimes divided into geometric and curvilinear areas by patches of brushed gold, with black outlines. They contain birds, insects and grotesques. Burnished gold bars which support coloured motifs enclose the miniatures and text within these borders. Fourteen large miniatures (95 x 70), arched at the top, are framed by pink marble columns or brown bands. Executed in shades of blue, brown, mauve, plum, white and green, with brushed gold used for highlighting and modelling, they introduce the main divisions of the text.

Programme of Illustration: The subjects of the miniatures are as follows: f.13r St John on Patmos: gospel sequences; f.21r Annunciation: matins for Hours of the Virgin; f.33r Visitation: lauds; f.46r Nativity: prime; f.49r Annunciation to the shepherds: tierce; f.53v Adoration of the Magi: sext; f.57v Presentation: none; f.61v Flight into Egypt: vespers; f.69v Coronation of the Virgin: compline; f.75r Crucifixion: Hours of the Cross; f.79r Pentecost: Hours of the Holy Ghost; f.83r David and Goliath: penitential psalms; f.101r Job on a dunghill: Vigils of the Dead; f.149r Pietà: *Obsecro te* (fig. 235).

Commentary: This Book of Hours is a standard product of a late fifteenth-century French regional atelier. The calendar and litany include saints venerated throughout the Burgundian area of north-eastern and central France. Sinclair has suggested a Dijon provenance for the manuscript, but it should be noted that St Benigne, patron saint of that city, is not mentioned.

The inclusion of a kneeling woman in contemporary dress in the composition of the Pietà on f.149r (fig. 235) is not unusual at this time. Another example occurs in No. 77 of this catalogue. The book may have been executed as a stock-in-trade product for a female customer. It was bequeathed by David Scott Mitchell to the State of New South Wales in 1907.

Bibliography: Sinclair (1969), pp.109–110.

Fig. 236
No. 83. *Book of Hours.* Latin
Paris?, early 16c.
State Library of New South Wales. No shelf mark

Vellum, 88 x 64. 37 + A–B paper. I³, II–IX⁴, X². Modern foliation beginning on f.3r. Script: late gothic with roman rounded forms in black ink, with rubrics in red. Ruling: light brown ink: 8.[40].15 x 7.[63].15. Lines of text: 18. Ruling unit: 3.3. Folios 1r–3r and 36r–37v are blank. Binding: old morocco.

Ownership: Inside front cover is armorial book-plate of Edward Arnold together with 'Andrew W. Arnold, The Grove, Dorking Surrey'.

Text: Latin. Contents: ff.4r–8v gospel sequences; ff.9r–19r Passion according to St John; ff.19v–23r Hours of the Cross; ff.23v–27r Hours of the Holy Ghost; ff.27v–30r commemorations of the Trinity; ff.30v–31r *Salue sancta facies*; ff.31v–35v *Obsecro te.*

Decoration: Throughout the text there are gold initials, one, two and three lines high, with infills of gold pen-work, on red, blue and green rectangular grounds, together with red and green line-endings. Every page of text is framed by a red and gold cordelière. Six miniatures (71 x 48 or 72 x 46) have plain indented red and gold frames (fig. 236). They are painted in shades of vermilion, yellow, gold, green, blue, mauve and white.

Programme of Illustration: The miniatures illustrate the text as follows: f.3v St John on Patmos: gospel sequences; f.9v the Agony in the Garden: Passion according to St John; f.20r Crucifixion: Hours of the Cross; f.24r Pentecost: Hours of the Holy Ghost; f.28r Trinity: prayers to the Godhead (fig. 236); f.32r Virgin and Child: *Obsecro te.*

Commentary: This dainty manuscript, the smallest volume in the Australian collection, is probably a fragment of a Parisian Book of Hours. No sections of the text which might indicate provenance or specific destination remain, but the decorated initials, the figurative style of the miniature compositions and the balance of colours are all consistent with Parisian workshop practices, and may be compared, for example, with those of No. 87 of this catalogue.

From the Arnold family of Dorking in Surrey, the manuscript passed to a relative of P. Strong in Mosman, New South Wales. The trustees of the Public Library of New South Wales purchased the volume from Mr Strong in 1965.

Bibliography: Sinclair (1969), pp.140–141; (Sydney, 1967), p.25.

Plate 45, fig. 237
No. 84. *Book of Hours.* Use of Rome. Latin and French
Rouen, *c.*1500–1510
State Library of New South Wales, Mitchell 1/7e

Vellum, 212 x 150. A–B contemporary vellum + 102 + C–D contemporary vellum. I–II⁶, III–IX⁸, X⁶, XI–XIII⁸, XIV⁴. Modern foliation in arabic numerals beginning on f.13r. Script in two hands: ff.1r–100v rounded roman hand, ff.101r–102v French *lettre-bâtarde*, in brown ink, with rubrics in red. Calendar in red, blue and gold ink. Ruling: red ink: 20.[80].50 x 28.[132].52. Lines of text: 26. Ruling unit: 5. Calendar: 20.[80].50 x 27.[128].57. Lines of text: 17. Ruling unit: 7.5. Binding: old red velvet, with spine repaired, and two silver clasps.

Ownership: Inside front cover is the armorial book-plate of David Scott Mitchell. Imprint of the Mitchell Library's seal is on f.102v.

Text: Latin, calendar in French. Contents: ff.1r–12v full calendar; ff.13r–15v gospel sequences; ff.16r–52v Hours of the Virgin; ff.53r–55v Hours of the Cross; ff.56r–58v Hours of the Holy Ghost; ff.59r–64v penitential psalms; ff.65r–69v litany; ff.70r–87v Vigils of the Dead; ff.88r–90r *Obsecro te*; ff.90v–91v *O intemerata*; ff.92r–93r Stabat Mater; ff.93v–100v commemorations; ff.101r–102v additional prayers.

Decoration: One- and two-line dentelle initials and two-line semi-grisaille initials with floral infills on gold grounds occur throughout the text. Similar four-line semi-grisaille initials, beneath the large miniatures, mark the main divisions of the text. Red and blue endings which match the dentelle initials are used sparingly.

The shape and distribution of borders help to order the contents of the book. Panel borders, unaccompanied by miniatures, introduce certain sub-sections, such as the three gospel extracts on ff.13r, 14v and 15r. Full-length panels also decorate some of the pages with small miniatures. Others have L-shaped sections at the upper or lower corners or bracket-left borders. Full borders frame the pages with large miniatures.

A distinctive feature of the border decoration is the variation and elaboration of shapes and designs which are based, nevertheless, on a limited range of motifs. Expanses of brushed gold contrasted with deep blue predominate. The long-established floral-acanthus pattern inhabited by birds and grotesques is sometimes enriched by a thick branch motif which on f.16r is entwined by a ribboned banderole. On other pages branch motifs become the dominant form. Elsewhere, the borders are elaborated by the division of the ground into contrasting colours of blue, gold and red by a wide range of black-outlined shapes: diagonal bars, diamonds, squares, *fleur-de-lys* etc., patterned with the contrasting floral motifs and colours found also in the initials (fig. 237).

The small miniatures (40 x 40) have plain gold frames. The large miniatures (110 x 80 or 100 x 85), arched at the top, are set in architectural frames, with horizontal arcades, broad columns and projecting plinths painted in brushed gold with some touches of blue, green and mauve (Plate 45).

The palette, which is consistent for borders and miniatures alike, is dominated by brushed gold and a strongly contrasting deep blue. Green, pink, red, white and shades of grisaille are subdued by comparison.

Programme of Illustration: The subjects of the thirteen large miniatures and their accompanying text are as follows: f.13r the four evangelists: gospel sequences (fig. 237); f.16r Annunciation: matins for Hours of the Virgin; f.26v Visitation: lauds; f.33r Nativity: prime; f.36r Annunciation to the shepherds: tierce; f.38r Adoration of the Magi: sext; f.40r Presentation: none; f.43r Massacre of the Innocents: vespers; f.48r Coronation of the Virgin: compline; f.53r Crucifixion: short Hours of the Cross; f.56r Pentecost: short Hours of the Holy Ghost; f.59r King David with his harp: penitential psalms; f.70r Death stabs young lovers: Vigils of the Dead (Plate 45).

Eighteen small miniatures introduce prayers and commemorations of the saints as follows: f.88v Virgin and Child: *Obsecro te*; f.93v Trinity; f.94r God the Father; f.94v God the Son; f.95r God the Holy Ghost at Pentecost; f.95v St Michael; f.95v St John the Baptist; f.96r St John the Evangelist; f.96v SS. Peter and Paul; f.97r St Stephen; f.97r St Lawrence; f.97v St Sebastian; f.98v St Nicholas; f.98v St Anthony; f.99r St Catherine; f.99v St Margaret; f.100r St Barbara; f.100v St Mary Magdalen.

Commentary: This manuscript is a good example of the so-called Rouen School which flourished in north-west France from the end of the fifteenth century throughout the last phase of book illumination.

The organization of the pages as one homogeneous decorative unit, achieved in large measure by colour emphases and the predominance of the border decoration, is characteristic of this region. So too are the border elaborations; manuscripts in Vienna Nat.bibl. cod. 2625, *c.*1507–1509, and cod. 1883, *c.*1530, provide close comparisons.[1]

The stress on linearity at the expense of volumetric modelling is likewise typical of certain workshops in this region. The flattened gilt frames of the miniatures are less

illusionistic than their tonally modelled counterparts from Paris or north-east France. The figures, too, with their squarish proportions and smooth, inanimate faces, often with owl-like grey shadows beneath the eyes, are rendered largely as surface patterns.

The illustrative programme has some distinguishing features. The miniature on f.13r of the four evangelists in separate compartments of the one composition (fig. 237) is based on a pattern which seems to have originated in Rouen. The model for Death Stabbing Young Lovers on f.70r (Plate 45) may come from a contemporary woodcut. The Massacre of the Innocents on f.43r as illustration to vespers of the Hours of the Virgin more frequently occurs in northern manuscripts than in French Books of Hours, where the Flight into Egypt is usually the dominating theme.

The manuscript was part of David Scott Mitchell's personal library, which was bequeathed to the State of New South Wales in 1907.

Bibliography: Sinclair (1969), pp.110–112; (Sydney, 1967), p.26.

Note
1. For reproductions from these manuscripts see Pächt and Thoss (1974), Vol. 2, figs. 140, 171–173, 175–177.

Plate 46, fig. 238
No. 85. *Pontifical.* Latin
France, *c.*1500
State Library of Victoria, *fo96.1/R66P

Vellum, 480 x 325. 149ff. I³, II–XVII⁸, XVIII⁶, XIX⁸, XX⁴. Catchwords agree, contemporary foliation by roman numerals i–cxliiii on ff.4–147. Folios 1v and 3v blank. Script: French 16c. gothic liturgical hand, in black ink with rubrics and underlining in red. Ruling: purple ink: 46.[210].69 x 38.[340].102. Lines of text: 32. Ruling unit: 10.5. Some groups of 4-line red staves (black square notation). Binding: 19c. leather over oak boards with bevelled edges.

Ownership: In the text, on f.6r, the seven grades of ordination open with *Nos Philippus dei gratia episcopus mirapiscensis*. Inside the front cover are the following inscriptions: in a 16c. hand, *Philippus de Levi, Episcopus Mirapiscensis Dei Gratia 1537*; in a 17c. hand, *Ce livre a este relie par moy en 1673 Du Puy du fou de Champagne*; 'This binding was in red velvet with silver clasps both of which had been taken off before I had it.' (in the hand of Sir Thomas Phillipps); *nouvellement relie en 1849 par ordre du possesseur Sir Thos. Phillipps de Middle Hill*. On spine is no. '4418'. Inside front cover is 'Ph 4418 a.1.449' in modern pencil. Inside back cover is 'W. H. Robinson 5.2.1947.'

Text: Latin. Contents: ff.2r–3v introductory tables distinguishing three parts in the pontifical; ff.4r–55r *de*

personarum benedictionibus ordinationibus et consecrationibus; f.55r–104r *de consecrationibus et benedictionibus aliarum tam sacrarum quam prophanarum rerum*; ff.104r–144r *pars in quia quidam ecclesiastica officia inseruntur.*

Decoration: Throughout the text there are illuminated initials one to four lines high, and one-line punctuation marks, executed in burnished gold on blue or deep maroon grounds alternately, with fine gold filigree pen-work. Line-fillers of the same design occur on many pages. The larger initials are always executed on blue or maroon grounds with gold tracery. Musical responses are frequently introduced by similar initials, two staves in height. On f.23r the initial 'R', six lines high, has a gold central ground with naturalistic floral sprays.

Full borders occur on ff.4r and 6r. They conform to the late fifteenth-century French style of geometric patterning with diagonal bands or diamond- and heart-shaped areas and floral-acanthus motifs, painted in shades of blue, red, maroon, mauve, pink, green, bronze and brushed gold (Plate 46). Other pages have vertical panel borders of traditional floral-acanthus design, inhabited by birds, insects, human figures or grotesques (fig. 238). The episcopal arms of Philippe de Lévis feature in several borders: a shield *or three chevrons sable*. On ff.7r and 8r the shield is *or two chevrons sable*.

Five miniatures are painted in tones of brown to beige, mauve-grey, blue, wine-red, scarlet and white with touches of green. Gold hatched lines are used for modelling and highlighting.

Programme of Illustration: The five miniatures are related to the text as follows: f.4r bishop anoints children (64 x 58): sacrament of confirmation; f.4r bishop blesses children (64 x 58): sacrament of confirmation; f.6r bishop ordains priests (95 x 86): (*Nos Philippus dei gratia episcopus mirapiscensis . . .*): seven grades of ordination; f.56r bishop dedicates church (85 x 85): dedication of church; f.142r bishop pronounces benediction (95 x 95): episcopal blessings.

Commentary: This pontifical is a luxurious example of French manuscript production during its final phase. Every page gleams with gold generously applied and the predominating maroon grounds of the larger illuminated initials add an opulent tone to the appearance of the script. At the same time the lighter palette of the decorative borders offsets the stronger and more brilliant tonalities in the text.

The miniatures are typical of that style of late French illustration which is to a large degree past its prime. The figures are competently rendered, yet they are static with wooden gestures and their faces are smooth and expressionless. The gold hatching used for modelling and highlighting stresses surface decorative values. Spatial constructions are unconvincing since the compositional forms are not well articulated.

In a paper devoted to the pontifical, Sinclair has described its distinguished history. The manuscript was commissioned by Philippe de Lévis (1466–1537), bishop of Mirepoix from 1497, whose name appears in the text on f.6r. Sinclair has established that the manuscript is in all likelihood the pontifical referred to in an inventory of 1536, and he deduces that the name and date (1537) inside the front cover may well be an *ex-libris* added at the time of the bishop's death.

The style of decoration is consistent with a date of *c.*1500, and the book may have been commissioned, together with the other manuscripts listed by Sinclair and Pellegrin, after Philippe de Lévis' consecration.

While it was yet in France the pontifical was rebound by Du Puy of Champagne in 1673. In 1824 it was acquired in Paris by Sir Thomas Phillipps, in whose collection it became no. 4418. W. H. Robinson purchased it at Sotheby's in 1946 and sold the volume to the State Library of Victoria in 1947.

Bibliography: Sinclair (1969), pp.373–374; Sinclair (1962c), pp.401–404; Sotheby (1946), item 29, p.23, pl. xli; Pellegrin (1973), pp.291–297; Sinclair (1962a), p.336.

Notes
1. Sinclair (1962c).
2. Pellegrin, *op. cit.*

Figs. 239–240
No. 86. *Book of Hours.* Use of Rome. Latin
Paris(?), *c.*1510–1515
Ballarat Fine Art Gallery, MS. Crouch 8

Vellum, 110 x 67. A–B modern vellum + 129 + C–D modern vellum. I⁹, II–XVI⁸. Modern foliation beginning on f.10. Script: fine small roman hand in dark brown ink, with rubrics in red and blue; calendar in blue and brown. Ruling: red ink: 10.[39].18. x 12.[79].19. Lines of text: 24. Ruling unit: 3.5. Calendar: 14.[2.1.3.1.27].19 x 10.[76].14. Water stains on ff.123–129, affecting text. Binding: old crimson velvet, with two silver clasps.

Ownership: Inside front cover is 'Ex libris R. A. Crouch'.

Text: Latin. Contents: ff.1r–9r calendar with special feast days in blue, including St Martin of Tours; entries in brown include SS. Gatianus of Tours, Claudius and Alban; f.9v *Almanack pour douze ans* (years mdxvi–mdxxvii); ff.10r–13v gospel sequences; ff.14r–20r Passion according to St John; ff.20v–22v *Obsecro te*; ff.23r–24r *O intemerata*; ff.24v–25v Stabat Mater; ff.26r–71v Hours of the Virgin with the short Hours of the Cross and of the Holy Ghost inserted in the appropriate places; ff.71v–81v variations; ff.82r–89r penitential psalms; ff.89v–95r litany, including SS. Maurus, Leobinus of Chartres, Mauritius and Eligius; ff.95v–121v commemorations of the saints; ff.128v–129r prayer of the Trinity, prayers of St Gregory.

Decoration: Throughout the text there are numerous one- and two-line gold initials on alternating red and blue rectangular grounds. Beneath the large miniatures there are three- and four-lined initials in semi-grisaille with naturalistic floral infills. Line-endings in red and blue with gold tracery occur throughout. Twenty small miniatures (25 x 25) have plain gold indented frames. Fourteen large miniatures (100 x 55) surmount cartouches or tablets containing several lines of text. They are surrounded by ornate semi-architectural frames which usually feature knotted and tasselled 'rope-pulls' on one side (figs. 239 and 240). Both large and small miniatures are executed in shades of scarlet, dull mauve, blue, green, white and gold, with brushed gold liberally applied for highlighting and modelling.

Programme of Illustration: The main divisions of text and some prayers are introduced by fourteen large miniatures with subjects as follows: f.10r St John the Evangelist on Patmos with a vision of the Virgin and Child: Gospel of St John; f.14r Agony in the Garden: Passion according to St John; f.26r Annunciation: matins for Hours of the Virgin; f.32v Visitation: lauds; f.41v Crucifixion: matins for Hours of the Cross; f.43r Pentecost: matins for Hours of the Holy Ghost; f.44r Nativity: prime for Hours of the Virgin (fig. 239); f.48v Annunciation to the shepherds: tierce; f.53r Adoration of the Magi: sext (fig. 240); f.57r Presentation: none; f.61r Flight into Egypt: vespers; f.67r Coronation of the Virgin: compline; f.82r David and Bathsheba: penitential psalms; f.95v Job and his comforters: Vigils of the Dead.

Twenty small miniatures introduce three gospel sequences, devotions and commemorations, as follows: f.11v St Luke writing: Gospel of St Luke; f.12r St Matthew writing: Gospel of St Matthew; f.13r St Mark writing: Gospel of St Mark; f.20v Virgin and Child: *Obsecro te*; f.23r Virgin and Child: *O intemerata*; f.24r Pietà: Stabat Mater. The commemorations are illustrated by the appropriate saints with their attributes: f.122v St John the Baptist; f.122v SS. Peter and Paul; f.123r St Stephen; f.123v St Lawrence; f.124r St Claudius; f.124v St Anthony; f.125r St Anianus; f.125v St Martin; f.126r St Francis; f.126r St Clare; f.126v St Agnes; f.127r St Mary Magdalen; f.127v St Geneviève; f.128r St Paula.

Commentary: This Book of Hours was probably executed in Paris in the second decade of the sixteenth century. The ornate architectural frames of its miniatures reflect Italian Renaissance models which had been popular for some time in French manuscript illumination, partly through the influence of contemporary woodcuts.

Stylistically the miniatures are uninspired products, in which traditional compositions are rendered in strong colours harshly highlighted in gold (figs. 239–240). Wooden figures with expressionless faces and stereotyped gestures dominate the foregrounds, and landscape settings lack the subtlety of their counterparts, for instance, in the

earlier Parisian Hours in Adelaide, No. 79, Plate 42, figs. 219–222.

The inclusion of the Passion according to St John after the regular gospel sequences and the integration of the short Hours of the Cross and of the Holy Spirit with the Hours of the Virgin occur in other French manuscripts executed in Paris or Touraine in the late fifteenth and early sixteenth centuries, often with appropriate introductory illustrations as here. There are three other examples of this format in the Australian collection: Nos. 79, 87 and 88.

Earlier in this century, the manuscript belonged to Colonel the Honourable R. A. Crouch, who presented it to the Ballarat Fine Art Gallery in 1944.

Bibliography: Sinclair (1969), pp.283–284. Sinclair (1968), p.30, pl. ix.

Plate 47, figs. 241–242
No. 87. *Book of Hours.* Use of Paris. Latin
Paris(?), *c.*1510–1520
State Library of Victoria, *096/R66 Ho

Vellum, 145 x 90. A–C modern vellum + 125 + D–F modern vellum. I⁶, II–IX⁸, X⁴, XI¹⁰, XII⁶, XIII¹⁰, XIV⁶, XV¹⁰, XVI⁹. Modern foliation beginning on f.7r. Script: late gothic with roman rounded forms, in dark brown ink with rubrics in red and calendar in red and brown. Ruling: pale red ink: 12.[54].24 x 12.[101].32. Lines of text: 20. Ruling unit: 5. Calendar: 12.[8.4.2.42].22 x 11.[106].28. Lines of text: 33. Ruling unit: 3.5. Binding: 19c. light brown calf by J. W. Zaehnsdorf. The miniature on f.7r has been slightly retouched.

Ownership: Inside front cover is the armorial book-plate with legend *Ex Bibliotheca Nicolai Joseph Foucault comitas consistoriani*; Ar has *ex-libris* of C. W. Loscombe; on Av is the book-plate of Alfred Trapnell; on Br is *ex-libris* of the Public Library of Victoria; Bv and f.125v carry stamp 'Public Library of Victoria'.

Text: Latin. Contents: ff. 1r–6v calendar with special feasts in red, including SS. Geneviève, Anne, Egidius, Marcellus and Martin of Tours. Entries in brown include translation of St Martin, SS. Alban, Eligius (twice), Egidius, Boniface and Remigius; ff.7r–10v gospel sequences; ff.11r–18r Passion according to St John; ff.18v–21r *Obsecro te*; ff.21v–23r *O intemerata*; ff.23r–75v Hours of the Virgin *secundum usum parisiensum* with the short Hours of the Cross and of the Holy Ghost inserted in the appropriate places; ff.76r–84r penitential psalms; ff.84r–87v litany, including SS. Marcellus, Carolus, Remigius, Eligius, Egidius, Maurus, Leobinus; ff.87v–117v Vigils of the Dead; ff.118r–125r commemorations of the Trinity and of saints.

Decoration: Throughout the text there are numerous one- and two-line gold initials with golden tracery infills, on alternate red and blue rectangular grounds, except in the litany, where red, blue, and green grounds are employed. Three-line semi-grisaille initials, with naturalistic floral infills painted over brushed gold rectangular grounds, introduce the text below the large miniatures. Red, blue and green line-endings with gold tracery appear throughout the text. Seventeen small miniatures have plain gold indented frames. Fourteen large miniatures surmount cartouches containing five lines of text. They are framed by semi-architectural borders (80 x 55 or 75 x 55) composed of ornate coloured pillars, golden arcades and plinths. Knotted cord tassel motifs hang from some of the outer capitals (Plate 47). The final large miniature on f.88r has an unadorned architectural frame (86 x 60), gold pilasters and a moulded cornice (fig. 242). All of the miniatures are painted in shades of scarlet, dull mauve, blue, green, grey, fawn, white and gold, with brushed gold used sparingly for highlighting and diluted greys or white for modelling.

Programme of Illustration: The main divisions of the text and one prayer are introduced by fifteen large miniatures. Their subjects are: f.7r St John on Patmos with a vision of the Virgin and Child: Gospel of St John; f.11v Agony in the Garden: Passion according to St John; f.23v Annunciation: matins for Hours of the Virgin (Plate 47); f.39v Visitation: lauds for Hours of the Virgin; f.46v Crucifixion: matins for Hours of the Cross; f.47v Pentecost: matins for Hours of the Holy Ghost; f.48v Nativity: prime for Hours of the Virgin (fig. 241); f.53v Annunciation to the shepherds: tierce for Hours of the Virgin; f.57v Adoration of the Magi: sext for Hours of the Virgin; f.61v Presentation: none for Hours of the Virgin; f.65v Flight into Egypt: vespers for Hours of the Virgin; f.71r Coronation of the Virgin: compline for Hours of the Virgin; f.76r King David with his harp: penitential psalms; f.88r Job and his comforters: Vigils of the Dead (fig. 242); f.118r Trinity: commemoration of the Trinity.

Seventeen small miniatures (35 x 35) introduce three gospel sequences, devotions and commemorations as follows: f.8r St Luke writing: Gospel of St Luke; f.9r St Matthew writing: Gospel of St Matthew; f.9v St Mark writing: Gospel of St Mark; f.18v Virgin and Child: *Obsecro te*; f.21v Pietà: *O intemerata*; f.118v St Michael; f.119v St John the Baptist; f.120r St John the Evangelist with the poisoned cup; f.120v SS. Peter and Paul; f.121r St James; f.121v St Sebastian; f.122v St Nicholas; f.123r St Anne; f.123v St Mary Magdalen; f.124r St Catherine; f.124v St Margaret; f.125r St Geneviève.

Commentary: This Book of Hours was probably produced in Paris or in a Parisian-influenced atelier in the early sixteenth century. Its decorated elements, initials, borders and compositions, together with textual contents and programme of illustration, follow the same workshop models as those used for No. 86 (see figs. 239, 240).

Fig. 191. Romans worshipping gods. No. 72, f. 30r. (detail)

Fig. 192. Romans appointing pontiffs. No. 72, f. 274r. (detail)

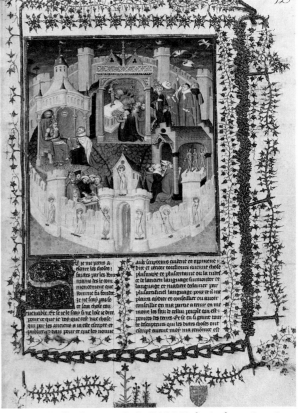

Fig. 193. Frontispiece, Cité des Dames. Paris, B.N. MS. fr. 1178, f. 3r

Fig. 194. Dedication scene. Paris, B.N. MS. fr. 260, f. 12r. 385 x 280

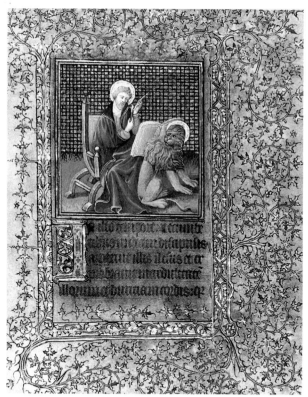

Fig. 195. St Mark. No. 73. 176 × 132

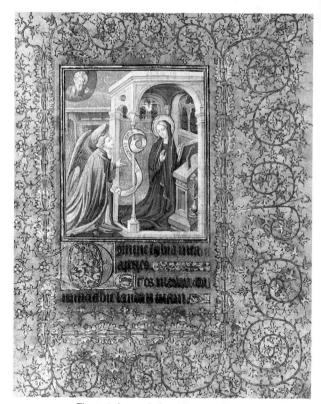

Fig. 196. Annunciation. No. 73, 176 × 132

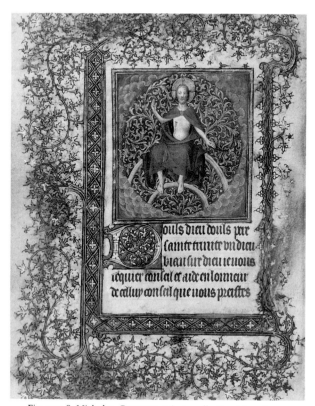

Fig. 197. St Nicholas. Germany, private collection (2). 176 × 132

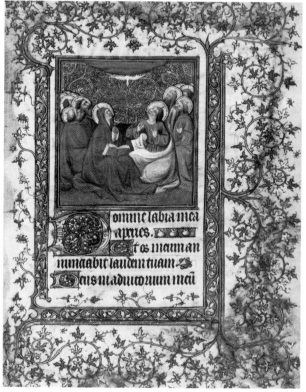

Fig. 198. Pentecost. Germany, private collection (2). 176 × 132

Fig. 199. David at prayer. No. 74, f. 22r. 195 x 140

Fig. 200. Text page with inscribed line-ending. No. 74, f. 89r.
(detail)

Fig. 201. St John the Evangelist. Vienna, Nat. bibl. cod. 1889, f. 13r.
200 x 150

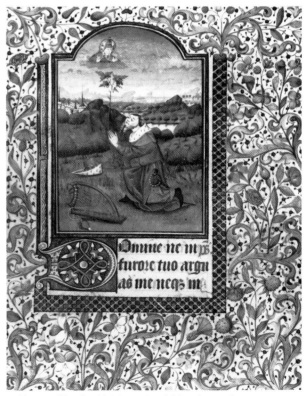

Fig. 202. King David. Vienna, Nat. bibl. cod. 1889, f. 97r. 200 x 150

Fig. 203. Initial 'D'. No. 75, f.159r. 160 x 114

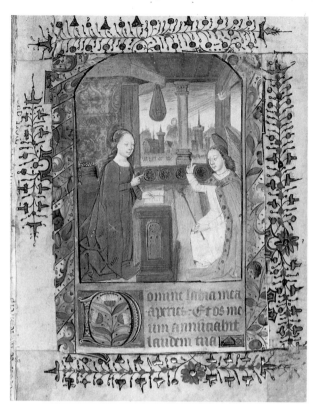

Fig. 204. Annunciation. No. 76, f.25r. 176 x 125

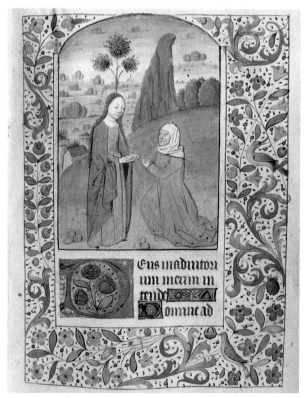

Fig. 205. Visitation. No. 76, f.34r. 176 x 125

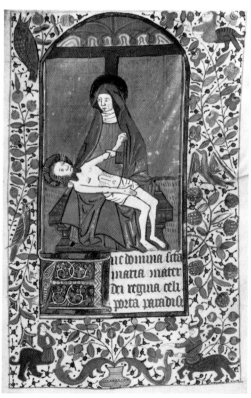

Fig. 206. Pietà. No. 76, f.141r. 176 x 125

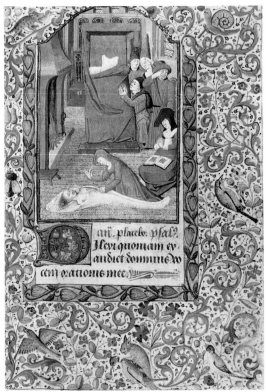

Fig. 207. Preparation of corpse for burial. No. 77, f. 117r.
170 x 119

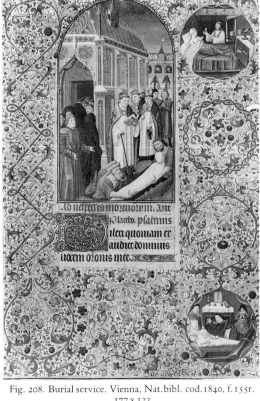

Fig. 208. Burial service. Vienna, Nat. bibl. cod. 1840, f. 155r.
177 x 123

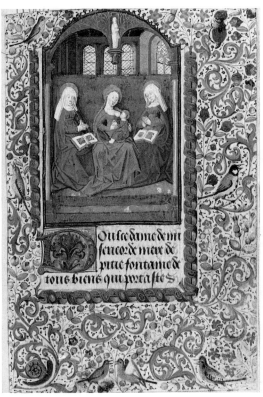

Fig. 209. The Three Marys. No. 77, f. 156r. 170 x 119

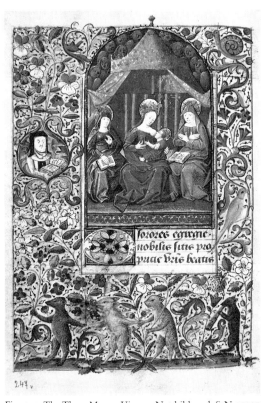

Fig. 210. The Three Marys. Vienna, Nat. bibl. cod. S.N. 13237,
f. 247v

Fig. 211. Crucifixion. No. 77, f. 110v. 170 x 119

Fig. 212. Crucifixion. Vienna, Nat. bibl. cod. 1929, f. 31r. 177 x 123

Fig. 213. Annunciation to the shepherds. No. 77, f. 72v. 170 x 119

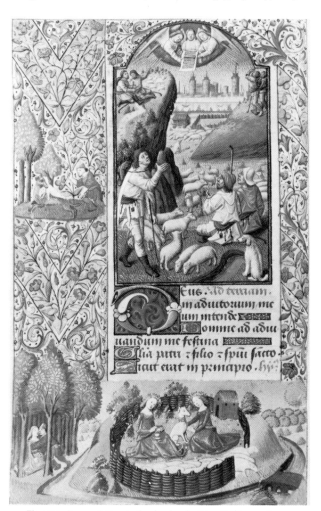

Fig. 214. Annunciation to the shepherds. No. 78, f. 37r. 178 x 125

Fig. 215. *Procès de Paradis* and Annunciation.
No. 78, f.15r. 178 x 125

Fig. 216. *Procès de Paradis* and Annunciation. London,
B.L. Egerton MS. 2045, f.25r. 89 x 65

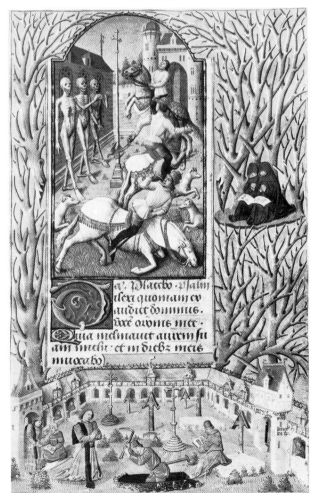

Fig. 217. The three living and the three dead. No. 78, f.78r. 178 x 125

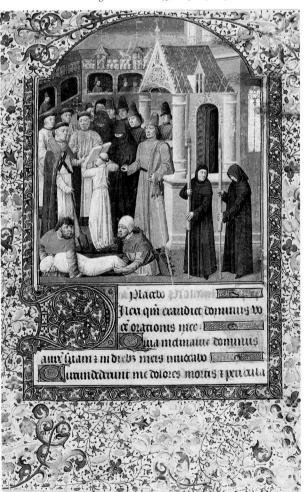

Fig. 218. The three living and the three dead. Paris, B.N. Smith-
Lesœuf MS. 9, p.349

Fig. 219. August: men threshing corn. No. 79, f.8r. (detail)

Fig. 220. October: Scorpio. No. 79, f.9v. (detail)

Fig. 221. Presentation in the Temple. No. 79, f.89v. 163 x 115

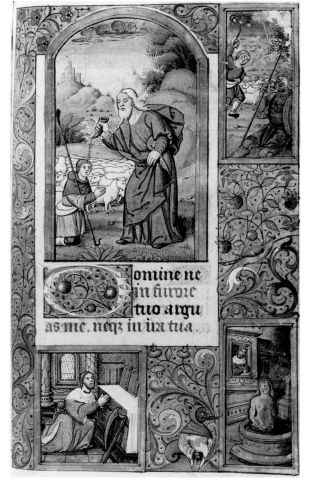

Fig. 222. David being anointed. No. 79, f.114v. 163 x 115

Fig. 223. St Mark. No. 80, f.14r. (detail)

Fig. 224. St Mark. Besançon, Bibl. Municipale MS.
148, f.18r. 160 x 115

Fig. 225. Betrayal. No. 80, f.62r. (detail)

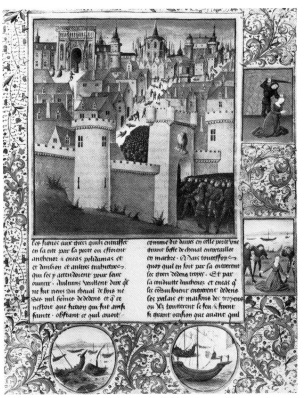

Fig. 226. Siege of Troy. Vienna, Nat. bibl. cod. 2577, f.145r. 328 x 245

M prīapio
erat uerbum
et uerbū erat
apud deum et deus erat
uerbum. hoc erat ī prīm

Fig. 227. St John on Patmos. No. 80, f.10r. (detail)

Omne labia
mea aperies.
Et os meū
annunciabit laudem tuā
deus ī adiutorium
meum intende

Fig. 228. Annunciation. No. 80, f.20r. (detail)

Omne labia mea ape
ries. Et os meum an
nūtiabit laudem tuā
eus ī adiutoriui

Fig. 229. Pentecost. No. 81, f.44v. 213 x 152

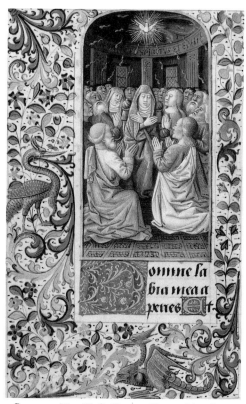

Omne la
bia mea a
pries. Et

Fig. 230. Pentecost. New York, Pierpont Morgan M96, f.64v. 156 x 95

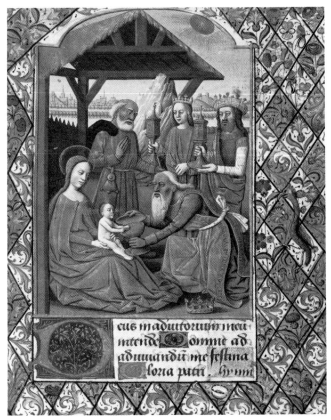

Fig. 231. Adoration of the Magi. No. 81, f.29r. 213 x 152

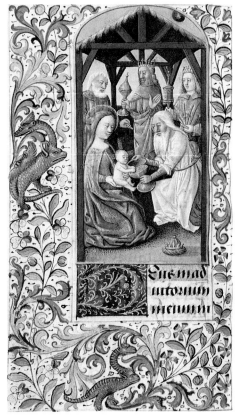

Fig. 232. Adoration of the Magi. New York, Pierpont Morgan
M96, f.83v. 156 x 95

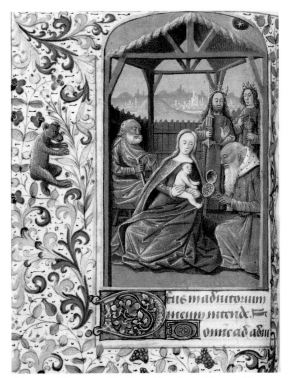

Fig. 233. Adoration of the Magi. New York, Pierpont Morgan
M366, f.59v. 146 x 95

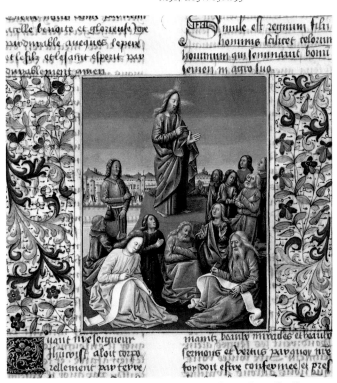

Fig. 234. Christ preaching. Paris, B.N. MS. fr.916, f.69r. (detail)

Fig. 235. Pietà. No. 82, f.149r. 209 x 138

Fig. 236. Trinity. No. 83, ff.27v–28r. 88 x 128

Fig. 237. Four evangelists. No. 84, f.13r. 212 x 150

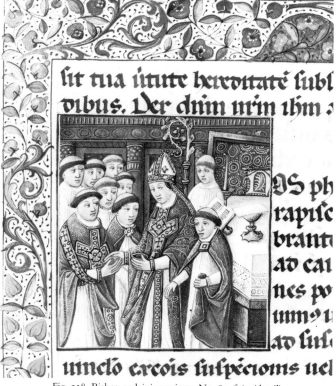

Fig. 238. Bishop ordaining priests. No. 85, f.6r. (detail)

Fig. 239. Nativity. No. 86, f.44r. 110 × 67

Fig. 240. Adoration of the Magi. No. 86, f.53r. 110 × 67

Fig. 241. Nativity. No. 87, f.48v. 145 × 90

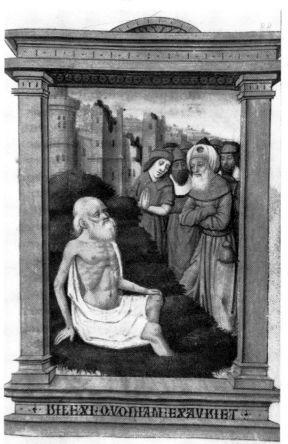

Fig. 242. Job and his comforters. No. 87, f.88r. 145 × 90

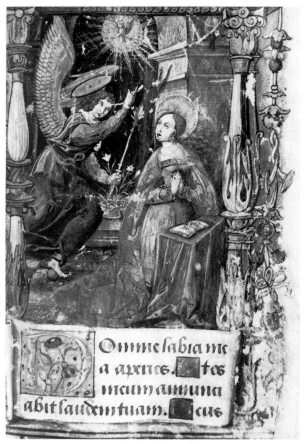

Fig. 243. Annunciation. No. 88, f.37r. 173 x 107

Fig. 244. St James. No. 88, f.160r. (detail)

Fig. 245. Annunciation. Geoffroy Tory,
Hours, Paris, 1531

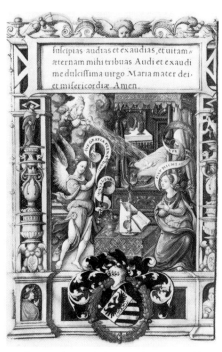

Fig. 246. Annunciation. London, B.L. Add.
MSS. 21235, f.23v. 218 x 153

Fig. 247. Initial 'P'. No. 89, f.1r. (detail)

Fig. 248. Kneeling prophet. No. 90, f.2r. (detail)

Fig. 249. Hours of the Cross. No. 91, f.7r. 182 x 130

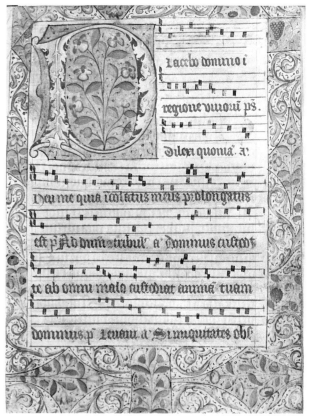

Fig. 250. Vigils of the Dead. No. 92, f.1r. 155 x 115

Fig. 251. Initial 'O'. No. 93, f.95v. (detail)

Fig. 252. Nativity of St John the Baptist. No. 94. 124 x 133

Fig. 253. Crucifixion. No. 95, f.Av. 252 x 175

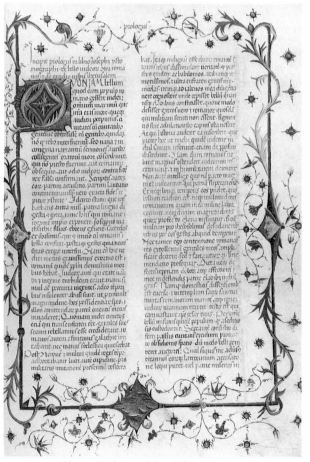

Fig. 254. Title page. No. 96, f.1r. 325 x 225

The work of the miniaturist responsible for all the compositions, with the exception of Job on f.88r (fig. 242), reveals certain northern stylistic and iconographic characteristics. His stocky figures, despite their stereotyped postures and gestures, and his conventional landscapes are rendered in relatively soft and sketchy brush strokes, with a regard for detailed modelling in light and shade that shows some acquaintance with northern realism. Surface highlighting in gold, though present, is applied sparingly.

He uses, too, stratified landscape settings which ultimately derive from Netherlandish models, although by this time they were widely disseminated and readily available in Paris. In both the Nativity on f.48v (fig. 241) and the Crucifixion on f.46v the middle distance is clearly defined by a horizontal wall, a device often used in the Maître François atelier, which incorporated strong Netherlandish influences. Originally Flemish, but also by this time well known to Parisian illuminators, is the setting for the Annunciation with the red bed behind the Virgin, a motif which goes back to Rogier van der Weyden (Plate 47). Less common, it would seem, outside the Netherlands is the depiction of St Joseph as a younger husband rather than an aged greybeard. This image was developed by a group of fifteenth-century Netherlandish artists, probably in response to a theological shift of emphasis on the saint's role in the Holy Family. It never supplanted in popularity, however, the rendering of Joseph as the venerable foster-father of Christ. One other example occurs in the Australian collection, in No. 88 (see p.226).

The miniature of Job on f.88r (fig. 242), which is executed by another hand, reflects the influence of Bourdichon. The figures, large in proportion to their setting, are modelled in broader planes of light and shade and with more assurance and control. The weighty, dignified inscribed frame is a Colombe–Bourdichon motif.

The book belonged at one stage to Nicolai Joseph Foucault who, as Sinclair has noted, was a distinguished French administrator of the late seventeenth and early eighteenth centuries. The next recorded owner is C. W. Loscombe, who died at Clifton in England in December 1853. His library was sold by Sotheby and Wilkinson on 19 June 1854, and this manuscript may have been Lot no. 1156. Alfred Trapnell, whose book-plate appears on Av, has not been identified with certainty although he may have been the noted late nineteenth-century English porcelain collector of that name. The book was purchased in 1929 by the State Library of Victoria from E. A. Pair, an antiquarian bookseller with the Melbourne firm of Robertson and Mullens.[1]

Bibliography: Sinclair (1969), pp.351–353.

Note

1. This information was supplied by Mr Trevor Mills of the State Library of Victoria.

Plate 48, figs. 243–246
No. 88. *Book of Hours.* Use of Rome. Latin and French
Touraine, 1526
State Library of New South Wales, Dixson 5/1

Vellum, 173 x 107. A modern paper + 172 + B–D contemporary vellum + E–F modern paper. I–II⁶, III–XXII⁸. Modern foliation. Script: early 16c. *lettre bâtarde*, in black ink, with rubrics in red and calendar in blue and red. Ruling: red ink: 14.[65].28 x 14.[123].36. Lines of text: 19. Ruling unit: 6.3. Calendar: 15.5.[14.6.45].27.5 x 11.[123].39. Edges severely cropped and gilded. Binding: 19c. morocco with gilt patterning.

Ownership: Cv has prayers by a 16c. hand: *O domine Iesu qui factus In agonia guttas sanguinis . . .*; *Domine Ihesu clementissime qui discipulos tuos ad preliandum contra mundum . . .* On Dr are the prayers: *Oraison de sainct Joseph. Salue Ioseph saluatoris sancte pater nomine locum tenens . . .* and *Deus qui beatum Ioseph puero Iesu nutritia ad custodem . . .* Inside front cover is the book-plate of the Rev. John Francis M.A. (1749–1828). Sir William Dixson's book-plate is on Ar.

Text: Latin, calendar and rubrics in French. Contents: ff.11r–12v calendar, with special feast days in blue, including St Gatianus of Tours, 2 May, 18 December (Gatianus has also been entered, by a later hand, on 23 October); entries in red include St Sulpicius of Bourges (26 August) and SS. Eloy, Medard, Eustace and eleven thousand virgins; ff.13r–17v gospel sequences; ff.18r–26v Passion according to St John and prayers for use at Mass; ff.27v–30r *Obsecro te*; ff.30v–32r *O intemerata*; ff.32v–36r Stabat Mater and other devotions; ff.36v–100v Hours of the Virgin, with the Short Hours of the Cross and of the Holy Ghost inserted in the appropriate places; ff.101r–109v penitential psalms; ff.110r–118r litany, including St Gatianus; ff.118v–153r Vigils of the Dead; ff.153v–170v commemorations of the saints.

Decoration: Throughout the text there are numerous one-line capitals touched with gold. Two types of two-line initials are present on pages with small miniatures: gold on square blue grounds with white tracery, or grisaille on square brushed gold grounds with infills of naturalistic flowers. Line-endings of blue or red with gold tracery are used sparingly. Three-line decorated initials introduce the main divisions. Twenty-nine small miniatures have plain gold indented frames. Seventeen large miniatures are framed by semi-architectural borders composed of ornate pediments, pillars and plinths decorated with Italianate *putti*, ribbons, garlands, scrolls and shields. Cartouches beneath the miniatures contain three or four lines of text. The date '1526' is inscribed on an entablature at the apex of the miniature on f.69r. Three borders contain shields: on f.63r, now indecipherable but which may have been armorial; on f.78v, now rubbed; and on f.171v, displaying instruments of the Passion (Plate 48). A laurel wreath with

profile of a helmeted soldier appears in the lower border of f.154r. All the miniatures are painted in shades of red, blue, grey, green and acid-yellow, with gold used for modelling and highlighting.

Programme of Illustration: The main divisions of the text and some prayers are introduced by seventeen large miniatures (*c*.95 x 75). Their subjects are: f.13r St John in a cauldron of boiling oil: gospel sequences; f.18v Betrayal of Christ, a night scene: Passion according to St John and prayers; f.27v the Virgin in Glory: *Obsecro te*; f.37r the Annunciation: matins for Hours of the Virgin (fig. 243); f.52r The Visitation: lauds for Hours of the Virgin; f.61v the Crucifixion: matins for Hours of the Cross; f.63r Pentecost: matins for Hours of the Holy Ghost; f.64r Nativity: prime for Hours of the Virgin; f.69r Annunciation to the shepherds: tierce for Hours of the Virgin; f.74v Adoration of the Magi: sext for Hours of the Virgin; f.78v Presentation in the Temple: none for Hours of the Virgin; f.83v Flight into Egypt (a cistern, with rectangular grid, in the foreground): vespers for Hours of the Virgin; f.90v coronation of the Virgin: compline for Hours of the Virgin; f.101r David and Bathsheba: penitential psalms; f.119r Job on a dunghill; scroll in the upper border holds inscription *miseremini mei miseremini mei saltam vos amici mei quia*(?) (Job XIX, 21): Vigils of the Dead; f.154 the Trinity: commemoration of the Trinity; f.171v the Mass of St Gregory: prayers to St Gregory (Plate 48).

Twenty-nine small miniatures (*c*.50 x 40) introduce three gospel sequences, devotions and commemorations, as follows: f.14r St Luke painting portrait of the Virgin: Gospel of St Luke; f.16r St Matthew writing on scroll: Gospel of St Matthew; f.17r St Mark writing at lectern: Gospel of St Mark; f.30v The Virgin and St John beside the Cross: *O intemerata*; f.33r Pietà: Stabat Mater. Special commemorations are illustrated by the appropriate figures with their attributes as follows: f.154v God the Father; f.155v God the Son; f.156r God the Holy Ghost – Pentecost; f.156v St Veronica; f.158r St Michael; f.158v St John the Baptist; f.159r St John the Evangelist; f.159v SS. Peter and Paul; f.160r St James (fig. 244); f.160v St Stephen; f.161r St Lawrence; f.161v St Christopher; f.163r St Sebastian. f.164r St Martin; f.164v St Nicholas; f.165r St Gatianus; f.165v St Anthony; f.166r St Claudius; f.167v St Anne; f.168r St Mary Magdalen; f.168v St Catherine; f.169r St Margaret; f.169v St Barbara; f.170v St Apollonia.

Commentary: This book comes from the last period of manuscript illumination in France, when printing was already well established. The wealth of ornamentation and the fine script pointed in gold identify the Hours as a luxurious item, probably intended for a special commission. The emphasis placed on St Gatianus in the calendar, litany and commemorations points to a patron from Touraine.

Myra Orth has shown that a group of manuscripts executed in Touraine during the second and third decades of the sixteenth century reveal a combination of Italianate and Antwerp mannerist features together with the influence of the printed medium. She argues that these eclectic compositions can be assigned to two distinct centres on the basis of quality.[1]

The Sydney manuscript would seem to fit into an early phase of the less discriminating of these centres. The illuminator of its large miniatures clearly had access to models used also for contemporary prints. Woodcuts related to the Virgin in Glory, on f.27v for example, were widely disseminated by 1500 (see also No. 61, fig. 141), and a parallel to the turbulent figure of Gabriel in the Annunciation on f.37r (fig. 243) appears in Geoffroy Tory's printed Hours of 1531, which incorporated woodcuts from his first edition of 1525 (fig. 245). The manuscript version lacks, however, the robustness and spatial conviction of Tory's design.

Parallels to the miniatures in the Sydney book also appear in two manuscripts from the British Library assigned by Orth to Touraine, namely Add. MS. 21235, the so-called Granvelle Hours (1531–1532) and MS. Facs. 654 (formerly Loan MS. 58) (1539–1540). Similar compositions are executed much more elaborately and skilfully in these later examples (fig. 246). Nevertheless, the same elaborate semi-architectural framing devices with dates of execution inscribed on prominent entablatures and the same combination of sharp acidic colours are clearly recognizable.[2]

The crude, assertive style of the main miniaturist of the Sydney manuscript owes much to Antwerp mannerism. His figures in the depiction of Pentecost on f.63r, for example, may be compared with those in Jan Provost's triptych in Stourhead House or his Execution of St Catherine in Antwerp.[3]

Other miniatures, such as the Mass of St Gregory on f.171v (Plate 48) are based on northern compositions dating from as early as the mid-fifteenth century. Individual iconographical motifs originating in the north are also incorporated in the later French work. A rectangular grid in the Flight into Egypt on f.83v is an echo of the same motif in the Bladelin Nativity of Rogier van der Weyden, and it has already been observed in an earlier commentary that the portrayal of St Joseph as a man in the prime of life, rather than as an aged greybeard, was initially a northern feature, restricted in its circulation.[4] Here, in scenes such as the Nativity on f.64r, it may reflect the specific wishes of the patron. A particular interest in the saint is attested by the additional prayers written in a sixteenth-century hand on Dr.

A second illuminator was responsible for the twenty-nine small miniatures. He interpreted conventional patterns with vigour and an emphasis on movement, as is exemplified in the striding St James on f.160r (fig. 244).

When the book left France is unknown. The first recorded English owner is the nineteenth-century Canter-

bury schoolmaster and rector, John Francis. His daughter, who married William Grant Broughton, the pioneering colonial bishop, may have brought the manuscript to Australia. It was later acquired by the Sydney booksellers Messrs Angus and Robertson, who sold it in 1902 to Sir William Dixson.[5] The volume was bequeathed to the State Library of New South Wales in 1952.

Bibliography: Sinclair (1969), pp.102–104; Sinclair (1967), p.26.

Notes

1. M. Orth, *Progressive Tendencies in French Manuscript Illumination 1515–1531. Godefroy le Batave and the 1520's Hours Workshop.*

Doctoral Dissertation, Institute of Fine Arts, New York University, 1976, ch. 5, and *idem,* 'Geoffroy Tory et l'enluminure. Deux livres d'Heures de la collection Doheny' in *Revue de l'Art,* Vol. 50, 1980, pp.40–47.
2. Janet Backhouse first noted the similarity with these two manuscripts. See also her article 'Two Books of Hours of Francis I' in *British Museum Quarterly,* Vol. 31, 1967, pp.90–96.
3. Reproduced in M. Friedländer, *Early Netherlandish Painting,* Leiden, 1967, Vol. IXb, Plates 124, 135.
4. See S. Blum, *Early Netherlandish Triptychs. A Study in Patronage,* Berkeley, 1969, p.20, for discussion of grid motif in the Flight into Egypt.
5. Since Angus and Robertson have kept no records of their early transactions it has not been possible to trace the late 19c. ownership.

French Short Entries

Fig. 247
No. 89. St Augustine, *De Retractationum* (excerpts), *Contra Faustum Manichaeum, De Genesi ad Litteram*
Northern France, second half of 12c.
Fisher Library, University of Sydney, New South Wales, Nicholson 5

Vellum, 356 x 246. A modern paper + 175 + B modern paper.

Flourished initials, alternately blue with red pen-work and red with blue pen-work mark the major divisions of the text. Some of these are more elaborate, with green being used as well as red and blue, and fine, leafy flourishes embellish the tail of the letters which are also sometimes decorated with interlace (fig. 247).

The style of these initials relates very closely to that in manuscripts produced in the Abbey of Corbie in the twelfth century.[1]

Bibliography: Sinclair (1969), pp.182–183; Sinclair (1964d), pp.456–457; (Sydney, 1967), p.10.

Note

1. See Christian de Merindol, *La Production des Livres peints à l'Abbaye de Corbie au XIIème siècle,* Tome III, Lille, 1976.

Fig. 248
No. 90. Isaiah, Vulgate; with *Glossa ordinaria.* Latin
France, late 13c.
Fisher Library, University of Sydney, New South Wales, Nicholson 28.

Vellum, 360 x 250. A–B modern paper + 100 + C–D modern paper.

One- and two-line initials in blue or red with flourishes extending into the margin. One decorated initial on f.1r and one historiated initial on f.2r. These are in blue, red and yellow on burnished gold. The scene on f.2r shows the kneeling prophet with two figures holding a jagged saw at his head (fig. 248).

Bibliography: Sinclair (1969), pp.219–220. Pettigrew (1827), pp.xcix–c, item 22; (Sydney, 1967), p.22.

Fig. 249
No. 91. *Book of Hours.* Use of Rome (fragmentary). Latin
France, or French Flanders, second half of 15c.
State Library of New South Wales, Dixson 4/1

Vellum, 182 x 130. A–B modern paper + 74 + C–D modern paper. One-line gold initials flourished with black

or blue initials flourished with red. Two-line dentelle initials throughout, and large decorated initials, seven lines high, in pink with white tracery on gold rectangular grounds with foliate infills in blue, pink and white on ff.7r, 10r, 13r, 25r, 50r and 63r. These initials preface the major divisions of the book and are accompanied by full borders of fifteenth-century floral-acanthus motif design. The litany and calendar have a northern French and Flemish emphasis (fig. 249).

Bibliography: Sinclair (1969), pp.100–102.

Fig. 250

No. 92. *Vigils of the Dead and Processional.* Latin
Rouen?, second half of 15c.
State Library of New South Wales, Rare Books and Special
 Collections, Richardson 223

Vellum, 155 x 115. A modern paper + 63 + B modern paper. The text is imperfect. One-line initials in blue or gold and two-line dentelle initials. On f.11 a large decorated initial (50 x 40) in blue and red on a gold ground with an infill of foliate sprays introduces the musical notation and text for the Vigils of the Dead. This page is also decorated by a full border of floral and acanthus leaf design, its ground being divided into white and gold sections in keeping with late fifteenth-century French conventions (fig. 250). The feasts of the processional and references to *sorores* indicate that the book was executed for nuns of the Dominican order. Saints in the litany suggest a possible Rouen provenance.

Bibliography: Sinclair (1969), pp.134–135.

Fig. 251

No. 93. *Benedictional.* Latin
France, first half of 16c.
State Library of New South Wales, Dixson 5/2

Vellum, 163 x 112. A modern paper + B modern vellum + 138 + C modern vellum + D modern paper. One-line gold initials on blue or red grounds. Line-fillers in blue or red with gold linear patterns. Decorated initials two or three lines high introduce the blessings. They are executed in fine shades of blue, or pink modelled in white and semi-grisaille, and are set on gold rectangular grounds. Delicately rendered motifs of flowers, leaves, buds and fruits decorate the gold grounds (fig. 251).

Vellum, script and decoration give the impression of elegant restraint.

Bibliography: Sinclair (1969), p. 98; (Sydney, 1967), p.29.

Fig. 252

No. 94. *Gradual* (fragment). Latin
France, early 16c.
Art Gallery of New South Wales

Fragment of vellum leaf, 124 x 133. Historiated initial 'D' in blue with white tracery designs on a burnished gold ground containing scene of Nativity of St John the Baptist. Strong blues, reds and greens contrasted with white predominate. The firmly modelled figures and convincing rendering of space indicate a competent early sixteenth-century French atelier.

Bequest of Miss Gwendolen Griffiths, 1968.

Spanish Manuscripts

Fig. 253
No. 95. *The Rule and Holy Custom for the Knights of St Michael Archangel and St Bartholomew of Burgos*. Latin and Spanish
Burgos, 15c.
Ballarat Fine Art Gallery, Victoria, MS. Crouch 14

Vellum, 252 x 175. A contemporary vellum + 19. I^8, II3, III–IV4. Script: ff. 1v–5v, 15c. gothic book hand in black ink. Ruling: one column, varying from 22 to 33 lines. Folios 6r–19v different hands extending to 1716, each signed by notaries and dated at Burgos. Binding: contemporary calf over oak boards.

Ownership: Three names difficult to decipher in a 16c. hand appear on Ar.

Text: Latin and Spanish. Contents: f. 1r–1v sequences from Gospels of St John, I, 1 and St Matthew XX, 17 (Latin); ff. 1v–5v Rule of the Knights of SS. Michael and Bartholomew of Burgos; f. 5r additions to the Rule.

Decoration: The contemporary vellum folio Av which precedes the text has a full-page miniature of the Crucifixion set against a landscape background with a city view in the distance (fig. 253). The composition is executed in pen and ink tinted with blue, brown and red, gold being used for the halo of Christ.

A blue and gold frame bears the inscription: *O Bone Ihesu illumine oculos meos ne unquam obdormiam in morte ne quando dicat inimicus meus prevalvi adversus eum in manus tuas Domine comendo spiritum* (O good Jesus enlighten my eyes so that I may not sleep in death and my enemy may not say that he has prevailed against me. Into your hands, Lord, I commend my spirit).

Commentary: This simple, but sensitively rendered miniature, in which a fine impressionistic drawing technique is effectively contrasted with the more firmly modelled head of Christ and the solid enclosing frame, appears to be contemporary with the fifteenth-century section of the manuscript.

Colonel the Honourable R. A. Crouch purchased the manuscript from Leo Baer of Paris in 1947 and later presented it to the Ballarat Fine Art Gallery.

Bibliography: Sinclair (1969), pp. 293–294; Sinclair (1968), p. 24, pl. vi.

Fig. 254
No. 96. Flavius Josephus, *The Wars of the Jews* (translated by Rufinus). Latin

Catalonia, 15c.
State Library of Victoria, *f091/J77

Vellum, 325 x 225. A modern vellum + 147 + B modern vellum. I^8, II–XIV10, XV9. Catchwords agree, some quire signatures. Script: 15c. gothic in black ink with red rubrics and running titles. Ruling: brown ink: two columns of 43 lines. Binding: 19c. blue morocco with gilt crest.

Ownership: On the covers are a crest, the initials 'T.W.' and the motto 'Deus alit me'. On the spine is the number '3505'. On Bv is 'W H Robinson 5.9.49'. Av has a sticker with the words: 'Bound by C. Lewis, Duke St. St. James's'.

Decoration: Initials, two and three lines high, in blue and red finely flourished in the alternate colour occur throughout. Decorated initials six or seven lines high introduce the prologue and seven books of the history on ff. 1ra, 2va, 35ra, 62ra, 77vb, 88ra, 98vb and 118vb. They are coloured blue or pink and are set against gold grounds which are sometimes indented at the corners and curved towards the outer margin. The foliate and tracery designs which fill the interstices are elongated and tapering in shape. These initials are in varying shades of blue, green, pink, brown and red. Spiky fronds extend into the borders, which are also decorated by gold circlets. Folio 1r has a full border, in the same colours, composed of a three-sided bar entwined by slender, curving, leafy fronds and fine tendrils with spiked flowers. At the top of the page the border terminates in tapering branches of the same pattern. Heads in profile or three-quarter view, framed by leaves in a rough diamond shape, appear in the centre of each of the side panels. A diamond-shaped lozenge also appears in the centre of the lower margin (fig. 254).

Commentary: This manuscript has been previously described as Italian. Both script and decoration, however, are characteristic of fifteenth-century Catalonian illumination.[1] The initials T.W. on the cover, as Sinclair has indicated, are the monogram of the Reverend Theodore Williams (1785–1875). The book was purchased by Sir Thomas Phillipps in 1827, and it is his library number which appears on the spine. It was bought by the State Library of Victoria from W. H. Robinson in 1949.

Bibliography: Sinclair (1969), pp. 375–376; Sinclair (1964a), p. 335; (Victoria, 1956), p. 107.

Note
1. M. Avril first indicated the probable Catalonian origins of this manuscript.

Acknowledgments

From its beginnings this book has been a collaborative project. Generously funded by the Australian Research Grants Scheme, Vera Vines and I have worked as a team, sharing in all the processes of early detailed photography, recording of information and research in overseas collections for comparative material. In the course of the study we have continued to develop our own areas of specialization. Vera Vines has concentrated on English, Netherlandish and late French examples, while I have focused on French and Franco–Flemish manuscripts from the thirteenth to the late fifteenth century, and on Italian illumination, encompassing the few German and Spanish manuscripts that Australia possesses. Our entries, nevertheless, are the result of shared endeavour and are therefore not individually signed. In addition, a distinctive contribution has been made by other colleagues. As the specific signatures indicate, Margaret Riddle, Department of Fine Arts, University of Melbourne, has written the entry on the Byzantine Gospels No. 1; John Stinson, Department of Music, La Trobe University, is responsible for the most recent work on the fifteenth-century English choirbook, No. 51; and certain Italian entries are based on the postgraduate research of Cecilia O'Brien, Department of Fine Arts, University of Melbourne, Nos. 25, 31, 32, 33, 34 and 41. Ms O'Brien was also very actively involved in the critical last months of the project as a research assistant. She has made a significant and valued contribution to the final shape of many of the entries, especially in the field of Italian Renaissance illumination, and to the organizational details of photographic presentation etc. Her vital part in the production of this book is here gratefully acknowledged. Mrs Veronica Condon's assistance with the recording of the liturgical aspects of Nos. 4, 9 and 11 is also much appreciated.

We have experienced enthusiastic co-operation from the administrative and professional staff of all the Australian institutions whose works are represented here. Assistance went far beyond simply making the manuscripts accessible. Private collectors were also both welcoming and helpful. It is not possible to acknowledge individually all those who have so assisted us, particularly since the staff of these institutions has changed over the years, and we have dealt with many different people throughout the various stages of our research. Specific acknowledgments of individuals is confined here to scholarly contributions, but we thank most heartily the Directors, Chief Librarians, Curators and Librarians of Rare Books together with the members of their staff who have welcomed and supported us on repeated visits to the collections for which they are responsible. All the relevant Australian institutions and libraries are set out below, together with a list of the works which they have kindly permitted us to reproduce.

As is further elaborated in the Introduction, this project builds on the earlier work of Professor K. V. Sinclair, who produced the first comprehensive catalogue of western medieval and Renaissance manuscripts in this country; to this work we regularly refer. Research on the manuscripts was also aided by many scholars. In particular we thank the following specialists with whom, in most cases, we have discussed the works personally, and who gave unstintingly of their time and expertise: Jonathan Alexander (Manchester), François Avril (Paris), Janet Backhouse (London), Hugo Buchthal (London), Joanna Cannon (London), Giordano Maria Canova (Padua), Kerstin Carlvant (New York), Maria Grazia Ciardi-Dupré Dal Poggetto (Florence), Kay Davenport (London), Albert Derolez (Ghent), Michael Fitzpatrick O.F.M. (Melbourne), Dillian Gordon (London), Pamela Green (Sydney), Christopher de Hamel (London), Ulrike Jenni (Vienna), Philip Kennedy O.P. (Melbourne), A. Korteweg (The Hague), Marie-Claude Leonelli (Avignon), Albinia de la Mare (Oxford), Michael Michael (London), Trevor Mills (Melbourne), Nigel Morgan (London), Judith Oliver (Baltimore), Otto Pächt (Vienna), Malcolm Parkes (Oxford), John Plummer (New York), Lilian Randall (Baltimore), Nicholas Rogers (Cambridge), Barbara Ross (Canberra), Jose Ruysschaert (Vatican City), Claude Schaefer (New York), Kathleen Scott (Berkeley), Eleanor Spencer (Paris), Alison Stones (London), Dagmar Thoss (Vienna), J. A. J. M. Verspaendonk (Utrecht) and Patrick de Winter (Cleveland).

In addition to the libraries and museums from which works reproduced are listed below, we thank the Directors and Librarians of the following institutions for access to study of their collections: Avignon: Museum Calvet, Musée du Petit Palais; Baltimore: Walters Gallery; Bologna: Biblioteca Universitaria, Convento di S. Domenico; Brussels: Bibliothèque Royale; Cambridge: Fitzwilliam Museum, Corpus Christi College Library; Cortona: Biblioteca Comunale e dell'Accademia Etrusca; Florence: Biblioteca Nazionale Centrale, Biblioteca Laurenziana; Modena: Biblioteca Estense; Munich: Bayerische Staatsbibliothek; Oxford: Keble College; Padua: Biblioteca Capitolare, Biblioteca Antonina; Paris: Bibliothèque de l'Arsenal; Perugia: Nobile Collegio del Cambio, Nobile Collegio della Mercanzia; Princeton: University Library; Venice: Biblioteca Nazionale Marciana, Fondazione Giorgio Cini.

Publication has been subsidized by donations from the charitable foundations and trusts listed on p. 2 and by Dame

Elisabeth Murdoch, to whom we owe a special debt of gratitude both for her personal encouragement and for her generous financial assistance. The research has also been supported by both the Australian Research Grants Committee and the University of Melbourne. Photography for publication was carried out largely by arrangement through individual institutions or owners; but the photographers Sue McNab, National Gallery of Victoria, and Adrian Featherston, Department of Visual Arts, Monash University, contributed special expertise.

Finally, warmest thanks are due to Anna Denton who typed the bulk of the manuscript, and to Susan Johnston and Liz Carey and Norma Bergoe who assisted in the demanding final stages. This team, together with the patient and expert staff of Thames and Hudson, especially our painstaking editor, Stephen England, knows much of the inner story of the making of this book!

Margaret M. Manion

Works have been reproduced with the permission of the following institutions and owners.

Australia

AUSTRALIAN CAPITAL TERRITORY

Australian National Gallery, Plate 24.
Australian National University, Classics Department, fig. 63.
National Library of Australia, Plates 20, 29, 30 and figs. 104, 108, 109, 111–115, 148, 153, 154, 204–206.

NEW SOUTH WALES

Art Gallery of New South Wales, fig. 252.
Fisher Library, University of Sydney, Plates 14, 17, 18, 19, 40 and figs. 58, 60–62, 83, 85, 86, 110, 144–146, 207, 209, 211, 213, 247, 248. *Private Collection on Loan to Fisher Library*, Plate 44 and figs. 229, 231.
L. F. Fitzhardinge, Plate 13.
St Patrick's College, Manly, figs. 84, 116–119.
State Library of New South Wales: Dixson Library, Plates 3, 48 and figs. 10, 11, 64, 243, 244, 249, 251. *Mitchell Library*, Plates 21, 32, 43, 45 and figs. 65, 128, 134, 147, 203, 223, 225, 227, 228, 235–237. *Rare Books and Special Collections*, Plates 6, 8 and figs. 28–32, 34, 36–39, 149, 250.
University Library, University of New South Wales, fig. 75.

SOUTH AUSTRALIA

Adelaide Church of England Diocese, Plate 42 and figs. 219–222.
State Library of South Australia, Plates 5, 12 and figs. 24–27, 48–55, 107.

VICTORIA

Baillieu Library, University of Melbourne, Plate 26 and figs. 66, 67, 88, 90–92, 195, 196.
Ballarat Fine Art Gallery, Plates 10, 16, 27, 34 and figs. 40–46, 94, 95, 105, 139, 141, 142, 150, 239, 240, 253.
Geelong Church of England Grammar School, Corio, Plate 25.

National Gallery of Victoria, Plates 1, 23, 36, 38, 41 and figs. 1–7, 76–79, 164, 165, 167, 171, 173, 183, 184, 187–192, 214, 215, 217.
St Paschal's College, Box Hill, Plate 4 and figs. 16, 18, 20–22.
State Library of Victoria, Plates 2, 7, 9, 15, 22, 28, 31, 33, 35, 37, 39, 46, 47 and figs. 8, 9, 56, 57, 59, 68–74, 81, 82, 96–98, 100–103, 106, 120–127, 131–133, 135–138, 151, 152, 156–161, 175–177, 179, 181, 182, 199, 200, 238, 241, 242, 254.
Private Collections: Armadale, Plate 11. Melbourne, fig. 87. North Melbourne, fig. 47.

Comparative material from European and American collections

Assisi: Archivio Capitolare, fig. 15.
Besançon: Bibliothèque Municipale, fig. 224.
Bologna: Museo Civico, figs. 33 and 35.
Geneva: Bibliothèque Publique et Universitaire, fig. 186.
Germany: Private Collection (1), figs. 166 and 168; Private Collection (2), figs. 197 and 198.
London: British Library, figs. 216 and 246; Courtauld Institute of Art (by courtesy of Dillian Gordon), fig. 12; Sotheby & Co., figs. 130, 178 and 180.
New York: Pierpont Morgan Library, figs. 230, 232 and 233.
Ohio: The Cleveland Museum of Art, fig. 129.
Oxford: Bodleian Library, figs. 89, 93, 163, 169 and 172.
Paris: Bibliothèque Nationale, figs. 17, 155, 162, 170, 174, 185, 193, 194, 218 and 234.
Perugia: Biblioteca Capitolare, fig. 19; Biblioteca Comunale Augusta, fig. 23.
Salerno: Museo del Duomo, fig. 13.
Utrecht: Archiepiscopal Museum, fig. 140.
Vienna: Nationalbibliothek, figs. 201, 202, 208, 210, 212, 226.
Vatican City: Biblioteca Apostolica Vaticana, figs. 14 and 80.

Bibliography

Åkerström-Hougen, G.: *The Calendar and Hunting Mosaics of the Villa of the Falconer in Argos*, Stockholm, 1974.

Anderson, G.A., and L.A. Dittmer: *Canberra, National Library of Australia MS. 4052/2, 1–16* (The Musico-Liturgical Fragments from the Nan-Kivell Collection), Henryville, Ottawa and Binningen, Institute of Mediaeval Music, 1961.

Backhouse, J.: Review of Sinclair 1969 in *The Library*, 5th series, Vol. XXV, 1970, pp. 355–357.

——: *The Madresfield Hours. A Fourteenth-Century Manuscript in the Library of Earl Beauchamp*, Oxford, the Roxburghe Club, 1975.

Bent, M.: 'A Lost English Choirbook of the Fifteenth Century' in *International Musicological Society Twelfth Congress, Copenhagen, 1972*, Copenhagen, Hagen, 1974, pp. 257–262.

Buchthal, H.: *An Illuminated Gospel Book of about 1100 A.D.*, Special Bulletin of the National Gallery of Victoria, 1961.

Buchthal, H., and H. Belting: *Patronage in Thirteenth-century Constantinople* (Dumbarton Oaks Studies, 16), Washington, 1978.

Bukofzev, M.F.: 'Changing Aspects of Mediaeval and Renaissance Music' in *The Musical Quarterly*, Vol. XLIV, 1958, pp. 1–18.

Buttrose, I.: *The Friends of the Public Library of South Australia*, Adelaide, 1950.

Canova, G.M.: *Miniature dell'Italia settentrionale nella fondazione Giorgio Cini*, Venice, 1978.

Christie, Manson and Woods Ltd.: *Catalogue of Books and Manuscripts . . . Day of auction 26 Feb., 1920*, London 1920, lot 87.

——: *Catalogue . . . Day of Auction 8 Dec., 1958*, London, 1958, lot 190.

Ciardi-Dupré Dal Poggetto, M.G.: 'Il primo papa Francescano, Niccolo IV (1288–1293), e il suo influsso sulla miniatura umbra' in *Francesco d'Assisi . . .* 1982. See under 'Francesco d'Assisi' below.

D'Ancona, P.: *La Miniature italienne du X^e au XVI^e siècle*, Paris, 1925.

Delaissé, L.M.J., James Marrow and John de Wit: *The James A. de Rothschild Collection at Waddesdon Manor: Illuminated Manuscripts*, London, 1977.

de Ricci, S.: *A Handlist of a Collection of Books and Manuscripts belonging to the Right Hon. Lord Amherst of Hackney at Didlington Hall, Norfolk*, Cambridge, 1906.

de Winter, P.M.: 'Copistes, éditeurs et enlumineurs de la fin du XIV^e siècle. La production à Paris de manuscrits à miniatures' in *Actes du 100^e Congrès National des Sociétés Savantes (1975)*, Paris, 1977, pp. 27–62, 186.

——: 'Une réalisation exceptionelle d'enlumineurs français et anglais vers 1300: le Bréviaire de Renaud de Bar, évêque de Metz' in *Actes du 103^e Congrès National des Sociétés Savantes (1978)*, Paris, 1980, pp. 27–62.

Dunston, A.J.: 'Two Gentlemen of Florence – Amerigus and Philippus Corsinus' in *Scriptorium*, Vol. XXII, 1968, pp. 47–50.

Durrieu, P.: *Bibliothèque de l'École des Chartres*, Vol. L, Paris, 1889.

Eastman, E.: *An Enquiry into Links between Antique and Mediaeval Calendar Iconography*, M.A. thesis, University of Melbourne, 1983 (unpublished).

Edwards, F.: *Catalogue of Francis Edwards Ltd.*, London, 1951.

(Felton): *Public Library, Museum and National Gallery of Victoria, Manuscripts and Books of Art Acquired under the terms of the Felton Bequest*, Melbourne, 1938.

Finn, D.J.: 'A Horae of XV Century and Mystery Plays' in *Our Alma Mater*, Riverview, 1926, pp. 21–26.

Francesco d'Assisi Documenti Archivi Codici e Biblioteche Miniature, ed. Francesco Porzio (Comitato Regionale Umbro per le Celebrazioni dell'VIII Centenario della nascita di San Francesco di Assisi), Milan, 1982.

Gilbert, C.: *Psautier-livre d'heures à l'usage de Liège XIII^e siècle*, typescript, 1930–4, p. 9, no. 4.

Green, J.R.: *Antiquities. A Description of the Classics Department Museum in the Australian National University, Canberra*, Faculty of Arts, the Australian National University, Canberra, 1981.

(Hackett): *Catalogue of J.T. Hackett's Art Collection. Sold by auction by J.R. Lawson, Sydney, 1918*, lots 492–4, 497.

Hoff, U., and M. Plant: *National Gallery of Victoria: Painting, Drawing and Sculpture*, Melbourne, 1968.

Jayne, S., and F. Johnson: *The Lumley Library*, London, 1956.

Kelly, C.: 'Franciscan Scholarship in the Middle Ages – II' in *Catholic Review*, Vol. V, 1949, pp. 213–214.

——: 'The Codex Sancti Paschalis' in *Provincial Chronicle of Holy Ghost Province*, Australia–New Zealand, Vol. III, no. 2, 1949, pp. 74–94.

——: 'The Codex Sancti Paschalis – Further Observations' in *Provincial Chronicle . . .*, Vol. III, no. 3, December 1949, pp. 21–25.

Kraus, M.P.: *The Eightieth Catalogue*, New York, 1956.

Lindsay, D.: *The Felton Bequest*, Melbourne, 1963.

Little, A.G., M.R. James and A.M. Bannister: 'Description of a Franciscan Manuscript formerly in the Phillipps Library now in the possession of A.G. Little' in *Collectanea Franciscana*, Vol. V, Aberdeen, 1914, pp. 9–114.

Lyna, F.: 'A propos du Tite-Live de Melbourne' in *Scriptorium*, Vol. XIV, 1962, pp. 359–361.

Maddocks, H.: *The 'Pilgrimage of the Life of Man' in the State Library of Victoria*, B.A. Honours thesis in Fine Arts, University of Melbourne, 1980 (unpublished).

Maggs Bros.: *Bulletin*, No. 8, London, 1974, Lot 10.

Manion, M.: *The Wharncliffe Hours*, Sydney, 1972.

——: 'The 13th Century Psalter-Offices of Joffroy d'Aspremont' in *Art Bulletin of Victoria*, No. 18, 1977, pp. 3–19.

——: 'An Italian Book of Hours circa 1375' in *Fine Books and Book Collecting*, eds. C. de Hamel and R.A. Linenthal, Leamington Spa, 1981.

——: *The Wharncliffe Hours*, facsimile of 32 pages with introduction and commentaries, London, 1981.

——: No. 79 'Libro d'Ore', no. 112 'Messale Francescano', no. 146 'Antifonario del commune dei Santi' in *Francesco d'Assisi* ... 1982, *op. cit.*, pp. 328, 363–365, 389.

Marrow, J.H.: *Passion iconography in Northern European Art of the Late European Middle Ages and Early Renaissance*, Kortrijk, 1979.

Meiss, M.: *French Painting in the Time of Jean de Berry. Late XIV Century and the Patronage of the Duke*, London, 1969, 2nd ed.

——: *The Limbourgs and their Contemporaries*, London, 1974.

Meyer, P.: 'Rapport sur d'anciennes poésies religieuses en dialecte liégeois' in *Revue des Sociétés Savantes*, 5ᵉ sér., Vol. VI, 1873, p. 238.

——: 'Le Psautier de Lambert le Bègue' in *Romania*, Vol. XXIX, 1900, pp. 528–529.

Millar, B.G.: 'Bibliothèque de la National Gallery of Victoria à Melbourne. Livre d'heures exécuté pour Joffroy d'Aspremont et pour sa femme Isabelle de Kievraing' in *Bulletin de la Société Française*, Vol. IX, 1925, pp. 20–32.

Munby, A.N.L.: *The Formation of the Phillipps Library*, Cambridge, 1954–56: *Phillipps Studies*, No. IV.

O'Brien, C.M.: *The Illumination of Italian Renaissance Manuscripts of the Scriptores Historiae Augustae*, M.A. thesis, University of Melbourne, 1982 (unpublished).

——: 'A Florentine Book of Hours in the National Gallery of Victoria' in *Art Bulletin of Victoria*, No. 22, 1982, pp. 52–62.

Oliver, J.H.: *The Lambert-le-Bègue Psalter: A Study in 13th-Century Mosan Illumination*, Ph.D. thesis, Columbia University, 1976.

Olschki, L.S.: *Catalogue LXIV, Manuscrits sur velin avec miniatures du Xᵉ au XIVᵉ siècle*, Florence, 1910.

Pächt, O., and J. Alexander: *Illuminated Manuscripts in the Bodleian Library, Oxford. 1, German, Dutch, Flemish, French and Spanish Schools*. Oxford, 1966.

——: *Illuminated Manuscripts in the Bodleian Library, Oxford. 3, British, Irish and Icelandic Schools*. Oxford, 1973.

Pächt, O., and U. Jenni: *Die illuminierten Handschriften und Inkunabeln der Österreichischen Nationalbibliothek, Holländische Schule*. 2 vols., Vienna, 1974.

Pächt, O., and D. Thoss: *Die illuminierten Handschriften und Inkunabeln der Österreichischen Nationalbibliothek, Französische Schule 1*. 2 vols., Vienna, 1974.

Pellegrin, E.: 'Possesseurs français et italiens de manuscrits latins du fonds de la reine à la Bibliothèque Vaticane. I, Possesseurs français' in *Revue d'Histoire des Textes*, Vol. 3, 1973, pp. 291–297.

Pettigrew, T.J.: *Bibliotheca Sussexiana*, Part I, London, 1827, p. xcix, item 22.

Randall, L.M.C.: *Images in the Margins of Gothic Manuscripts*, Berkeley, 1966.

Riddett-Smalley, R.: *A Sarum Breviary in Melbourne. An English Manuscript of the Fourteenth Century in the Library of the University of Melbourne*, B.A. Honours thesis, University of Melbourne, 1976 (unpublished).

Robbins, R.H., and J.L. Cutler: *Supplement to the Index of Middle English Verse*, Lexington, 1965, pp. xix, 6, 28, 29, 30, 60, 121, 145, 146, 154, 181, 204, 263, 277, 280, 281, 289.

Robinson, H., Booksellers: *Catalogue No. 50*, London, 1934, pp. 14–15.

Roper, B.: 'The College Library', *Manly*, Vol. I, 1916, p. 125.

(St. John's College): *A Handbook to St. John's College within the University of Sydney*, Sydney, 1881.

Schaefer, C.: 'Les Débuts de l'Atelier de Jean Colombe' in *Gazette des Beaux-Arts*, November 1977, pp. 137–150.

Sinclair, K.V.: 'The Miniaturists of the Livy Manuscript in the National Gallery Collection' in *Annual Bulletin of the National Gallery of Victoria*, Vol. I, 1959, pp. 7–13.

——: *The Melbourne Livy. A Study of Bersuire's Translation based on the Manuscript in the Collection of the National Gallery of Victoria*, Melbourne, 1961.

——: 'Phillipps Manuscripts in Australia' in *The Book Collector* Vol. XI, no. 3, 1962, pp. 332–337.

——: 'Some late manuscripts of the works of classical authors' in *Phoenix*, Vol. XVI, 1962, p. 280.

——: 'Un manuscrit enluminé ayant appartenu à deux Bourguignons: Nicole Fonssard et Pierre Maréchal' in *Annales de Bourgogne*, Vol. XXXIV, 1962, pp. 170–178.

——: 'Un pontifical retrouvé de Philippe de Lévis' in *Annales du Midi*, Vol. LXXIX, no. 60, 1962, pp. 401–404.

—: 'An unnoticed astronomical and astrological manuscript' in *Isis*, Vol. LIV, 1963, pp. 396–399.

—: 'Manuscrits médiévaux d'origine franciscaine en Australie' in *Archivium Franciscanum Historicum*, Vol. LVII, 1964, pp. 367–377.

—: 'Quelques manuscrits cisterciens inconnus en Australie' in *Analecta Sacri Ordinis Cisterciensis*, Vol. XX, 1964, pp. 233–234.

—: 'Un Psautier de Lambert le Bègue à Melbourne' in *Australian Journal of French Studies*, Vol. I, 1964, pp. 5–10.

—: 'De nouveaux manuscrits Augustiniens' in *Augustiniana*, Vol. XIV, 1964, pp. 456–457.

—: 'A new fragment of Petrarch's Epistolae Seniles' in *Speculum*, Vol. XL, no. 2, 1965, pp. 323–326.

—: 'Les manuscrits du psautier de Lambert le Bègue' in *Romania*, Vol. XXXVI, 1965, pp. 24–25.

—: 'Anglo-Norman Studies: the last twenty years' in *Australian Journal of French Studies*, Vol. II, 1965, pp. 250–251.

—: *Medieval and Renaissance Treasures of the Ballarat Art Gallery. The Crouch Manuscripts*, Sydney, 1968.

—: *Descriptive Catalogue of Medieval and Renaissance Western Manuscripts in Australia*, Sydney, 1969.

Sotheby, Wilkinson and Hodge: *Catalogue of ... books and manuscripts ... Sale 13 June 1864*, London, 1864, lot 47.

Sotheby & Co.: *Catalogue of ... books and a few manuscripts ... Sale 1 Aug. 1923. The property of J.T. Hackett Esq.*, London, 1923, lot 848.

—: *Catalogue of the Magnificent Series of Illuminations on Vellum. From the Holford Library. Sale 12 July 1927*, London, 1927, lot 15.

—: *Catalogue of the Valuable Library ... formed by the late Edward Arnold Esq. Sale 6–8 May 1929*, London, 1929, lot 240.

—: *Catalogue of the Livy of the Bâtard of Bourgogne ... Sale 23 June 1931*, London, 1931.

—: *Catalogue of Rare Printed Books, Illuminated Manuscripts and Miniatures ... Sale 21, 22 March 1932*, London, 1932, lots 322–327.

—: *Catalogue of Illuminated Manuscripts ... Sale 3 July 1933*, London, 1933, lot 252.

—: *Catalogue of Valuable Printed Books and Manuscripts ... Sale 13 Nov. 1933*, London, 1933, lot 14.

—: *Bibliotheca Phillippica. Catalogue of a Further Portion of ... the late Sir Thomas Phillipps ... Sale 1 July 1946*, London, 1946, lots 12, 28, 29.

—: *The Dyson Perrins Collection Part I ..., Illuminated Manuscripts ... Sale 9 Dec. 1958*, London, 1958, lot 2.

—: *The Dyson Perrins Collection Part III – Fifty-nine Illuminated Manuscripts ... Sale 29 Nov. 1960*, London, 1960.

—: *Chester Beatty Sale. 24 June 1969*, London, 1969, lot 58, pp. 105–107, pl. 51–52.

—: *Bibliotheca Phillippica. Medieval Manuscripts New Series. Part XI ... Sale Tuesday 30 Nov. 1976*, London, 1976, lot 893.

—: *Catalogue of Illuminated Manuscripts ... Sale 13 July 1977*, London, 1977, lots 39, 51.

—: *Catalogue of Single Leaves and Miniatures from Western Illuminated Manuscripts ... Sale 14 July 1981*, London, 1981, lot 28.

—: *Catalogue of Western Manuscripts and Miniatures ... Sale 22 June 1982*, London, 1982, lot 5.

—: *Catalogue of Single Leaves and Miniatures from Western Illuminated Manuscripts ... Sale 25 April 1983*, London, 1983, lots 117, 133.

Spatharakis, J.: *The Portrait in Byzantine Illuminated Manuscripts*, Leiden, 1976.

Spencer, E.P.: *The Maître François and his Atelier*, Harvard dissertation (1931) (unpublished).

Stinson, J.A.: 'An English Choirbook Fragment in the National Library of Australia' in *Musik im Kirchlichen, Höfischen und Städtischen Leben vom 13. bis 15. Jahrhundert* in Klosterneustift bei Brixen, 16–21 August, 1982 (publication forthcoming).

Stones, M.A.: *The Illustration of the French Prose Lancelot in Flanders, Belgium and Paris, 1250–1340*, Ph.D. thesis, University of London, 1970.

(Sydney University Library): *Medieval Manuscripts, Catalogue of the Exhibition* (with introduction by K.V. Sinclair), Sydney, 1967.

Techener, J.J.: *Description raisonné d'une collection choisie d'anciens manuscrits, de documents historiques et de chartes*, Paris, 1862, Part I, no. 152, pp. 227–232.

Techener, L.: *Catalogue de livres précieux provenant de la bibliothèque particulière de M. Leon Techener*, Paris, 1887, Part II, no. 12, p. 4.

Thomas, A.G.: *Fine Books. Catalogue 23*, London, 1969, lot 6b–e.

—: *Fine Books. Catalogue 31*, London, 1973, lot 66a, b.

—: *Fine Books. Catalogue 37*, London, 1978, p. 93.

Triggs, A.B.: *Auction 'Linton', Yass. Mr. James R. Lawson Collections and household effects of A.B. Triggs*, Sydney, 1945, lot 1111.

Tyrrell, J.R.: *Old Books, Old Friends, Old Sydney*, Sydney, 1952.

Ullman, B.L.: *The Origin and Development of Humanistic Script*, Rome, 1960.

(Victoria State Library): *The Public Library of Victoria*, by C.A. McCallum, Melbourne, 1956.

Warner, G.F.: *Descriptive Catalogue of the Illuminated Manuscripts in the Library of C.W. Dyson Perrins*, Oxford, item 91, 1920; item 129, 1929.

Zacher, I.: *Die Livius-Illustration in der Pariser Buchmalerei (1370–1420)*. Inaugural dissertation, Berlin, 1971.

Index

Page numbers in italic refer to illustrations; the letters 'a' and 'b' indicate left- and right-hand columns respectively

Acciaiuoli, the 92–3
Adam and Eve 188b, *197a*
Adoration of the Magi 70b, 134a, *160*, 171a, 174a, 177a, 185a, 186b, 188b, 199b, 201b, 203a, 204a, 205b, 207b, 208b, *219*, *221*, 226a
Advent 177b
Aemilianus 90a
Agony in the Garden 93a, 94, *116–17*, 132b, 150, 204b, 207b, 208b
Alan of Lille 96a, *118*
Alberti, Leone Battisti 96b
Albizzi, the 92–3
Alexander 115
Almagest (Ptolemy) 95b, *117*
Andrea, Giovanni d' 72b
Angers 187b
Annunciation, the 93, 99b, *116*, *126*, 137b, *160*, *162*, 171, 174a, 177a, 182a, 185a, 186b, 188b, *192*, *195*, 199b, 202–3, 204, 205b, 207b, 208b, *210*, *212*, *215*, *218*, 226; to the shepherds 134a, *163*, 174a, 181a, 185a, 186b, 187a, 188b, 199b, 201b, 203a, 204a, 205b, 207b, 208b, *214*, *222*, 226a
antiphonals 18, 39, 40b, 57, 73b, 98, *101*, 145, *165–6*, 176–8
Antoine, Grand Bastard of Burgundy 180
Antoninus Pius 90a
Aristotle 75a, 76a, *77*
Arma Christi 93b, 94a, 150a
Arras 183–4
Ascension, the 28a, *67*, 74a, 177a
Aspremont, Joffroy d' 173–6
Aspremont psalter-offices 10, 12, 172a
Assisi 59b, 71a; Archivio Capitolare *44*
Assumption, the 28a, 37b, 70b, 71b, 99b, 174a
Attavante 90b, 91a
Australia, National Library of, *see* Canberra
Australian National Gallery, *see* Canberra
Australian National University, *see* Canberra

Baillieu Library, *see* Melbourne
Ballarat Fine Art Gallery *51–2*, 58b, 60, *62*, *68*, 69a, 74b, *103*, 109, *120*, *123*, 129a, *142*, 149, 152b, *156–8*, 207a, *221*, 224, 229a
Bar, de (family) 175
Barbaro, Francesco 75b
Basil the Great 75b
Bede, 10a
Bedford Master, the 200a
Beguines 171b
benedictionals 18

Benett 110a, 111
Bening, Alexander 137b
Bernard of Parma 96a, *117*
Bersuire's *Livy* 10, *146*, *167–8*, *179–81*, *209*
Besançon 182–3, 202a
bibles *159*, 169–70
Boethius 95a, *117*
Bologna 40, 57a, 58a, 71a, 72b; Museo Civico *49*
Bonfratelli, Apollonio de' 95
Boniface VIII, Pope 15, *66*, 72b
Bonosus 90a
Books of Hours 19, 70–1, 74–5, 80, 83, 86b, 92–4, *105–8*, 112b, *116–17*, *123*, *125–8*, *132–9*, 148, *153–4*, 172, *173a*, 181–2, *189–93*, *195–6*, *197–206*, 207–8, *210*, *212–20*, 222, 225–6, *227–8*
Bosch, Brother Georgius 96b
Bosom of Abraham, the *161*, 171b
Boucicaut Master, the 182a, 183b
Bourdichon, Jean 203, 225a
Bourges 200a, 202a
Bouts, Dirc 198a
breviaries 18, 96–7, 98–100, *102*, *118*, *119–20*, 152, *158*, 174b
Breviarium ab Urbe Condita (Eutropius) 89a
Bruges 12, 135a
Bruni, Leonardo 76a, *78*, *79*, 86a
Burgos 229a

calendars *103*, 109, 112b, *120*, *127–8*, 134a, 135a, 137a, 138a, 149b, 170–1, 184, 187b, 188b, 198b, 200b, 204a, 205a
Canberra, Australian National Gallery 17, *84*, 95a; Australian National University 56, 85; National Library of Australia *80*, 86b, *105–6*, 112b, *123–5*, 130a, 131a, 132a, *152a*, *158–9*, 169b, 184b
Canon Tables 23, *24*, *41–2*
Carinus 90a
Carrying of the Cross 70b, 93, *125*, 132b, 171b, 201b
Carta Caritas Posterior 139b
Carthusian order 140b, 149
Carus 90a
Cases of Conscience (Pisano) 96b, *118*
Casus Longi super Decretales (Bernard of Parma) 96a, *117*
Censorius 115
Chierico, Francesco d'Antonio del 76b, 90b, 94a
choirbooks 69–70, 88b, *113*, *124*, 130
Christ 36, 45, 49, 50, 52, 57b, 58a, 69b, 74a, 132, 137b, 145, *161*, *164*, 171a, 177b, *219*; betrayal of 132b, 171b, 201b, 217, 226a; death of, *see* Crucifixion; deposition of *53*, 70b, 71a, 132b, 171b; entombment of 132b; flagellation of 132b; in Majesty *54*, 70b, 71b,

174, 203a; scourging of *64*, 70b, 171b; seven last
 words of 132b, 183a; suffering of 74b, 93a, 138b, *154*,
 172b; temptation of 171a; wounds of 112b, *123*, 129a,
 132, 133a, 138–9, *161*, 171b
Christ before Pilate 171b
Christmas 37b, 39b, 40b, 98a, 174
Cicero 85
Cimabue 38a
Cini Foundation, *see* Venice
Circumcision 39b, 174a, 203a
Cistercian order 111a, 139b
Cité des Dames Master, the 180b, *209*
Cliffords of Chudleigh 110a, 112a, 129b, 133b, 169–70,
 185a
Codex Escurialensis 94a
Coëtivy Master, the 187a
Cologne 152b
Colombe, Jean 201–2, 203a
Commentaries on Isaiah (Jerome) 140a, *141*, 149, *155*
Corpus Christi 28a, 87a, 100b
Corpus Christi College, Cambridge 98, 100a
Corsinus, Amerigus 76b
Cortese, Cristoforo 73b
Corvinus, Matthias 94b
Crivelli, Taddeo 97a
Crouch, Col. the Hon. Richard Armstrong 16–17, 59,
 60, 69a, 74b, 109b, 149b, 150b, 208, 229a
Crown of Thorns 28a, 93a, 129a, 201b
Crucifixion *32*, 38, *44*, *53*, 70b, 71a, 93, *125*, 132b,
 134a, 138b, 150a, *160*, 171b, 173a, 185a, 186–7, *189*,
 197a, 198a, 204a, 205b, 207b, 208b, *214*, *224*, 225a,
 226a

David 24, 74b, 94, 99b, 100a, *119*, 149b, 171a, 199b,
 205b, 208b, *211*; and Abigail 188b; and Bathsheba
 185a, 186b, 199b, 203a, 207b, 226a; and Goliath 199b,
 201b, 204a; anointing of 199b, 200a, 216; at prayer 81,
 83, 88, 93a, 137b, 150a, 171a, 183, 186–7, 199b
decretals 15, *66*, 72b
Deguilleville, Guillaume de *104*, 110a, 111, 121–2
De Legendis Gentilibus (Basil) 75b
De Liberis Educandis (Plutarch) 75b
De Liberorum Educatione (Piccolomini) 76b
De Musica (Boethius) 95a, *117*
De Musica (Jerome of Moravia) 176b
De Re Uxoria (Barbaro) 75b
Deruta (Pinacoteca Comunale) 38a, *44*
Diademeneus *114*
di Giovanni del Fora brothers 91a, 93b
Division of Apostles 149b
Dixson, Sir William 15–16, 28, 87b, 225b
Dixson Library *see* New South Wales
Dominican order 59, 70a, 177–8
Dyson Perrins, C.W. 23a, 25b, 92, 94b

Eadmer, *Life of St Wilfrid* 9, *123*, 129a
Easter 37b, 38a, 177

Ecclesiastical History (Eusebius) 152a, *158*
eleven thousand virgins 28a, 225b
Epiphany 37b, 39b, 177a
Epistolae Seniles (Petrarch) 71–2
Epistulae ad Familiares (Cicero) 85
Ethics (Aristotle) 75a, 76a, *77*
Eusebius 152a, *158*
Eustathius 24–5
Eutropius 89a
Ezekiel 24

Felton Bequest, the 26, 27b, 94b, 110a, 112a, 135a,
 136b, 172b, 176a, 181b, 182b, 183b, *189*, 198b
Ferrara 86b, 87b, 96–7
Fet Asaver 129b
Fifteen Joys of Our Lady 186
Fifteen O's 112b, 132, 133a
Firmus 90a
Fisher Library *see* Sydney
Fitzhardinge, L.F. *65*, 71b
Flight into Egypt, the 70b, 134, 171a, 185a, 186b, 188b,
 200a, 204a, 206a, 207b, 208b, 226a
Florence 74b, 75b, 89a, 92a, 94a
Forlì, Giustino del fu Gherardino da 69b
Foucault, Nicolas 208, 225
Fouché, Joseph 16, 184a
Fouquet, Jean 197a, 198a, 199b, 203a
Four Sleepers, the 149b
Franciscan order 28b, 38–9, 58b, 71a, 87

Gabriel 226b
Geelong Grammar School 98, *101*
Ghent 12
Ghirlandaio 94
Giovanni da Stia 75–6
Good Friday 37b
graduals 18, 27b, 58b
Greban, Arnoul 197b
Gressier, Guillequin 181a

Hackett, James Thompson 15, 16, 88b, 138a, 139a,
 184a, 202a
Hadrian 89b, *114*
Heavenly Ladder of John Climacus, The 25b
Hesdin, Jacquemart de 180b
Historia Augusta 10, 14; see also *Scriptores*
Historia Romana (Paul) 89a
History of the Florentine People (Bruni) 76a, *78*
Holy Innocents 39b, 59a, 177a
Holy Week 37b, 38a
Horloge de Sapience, Master of the 186–7
Hours of Queen Isabel la Catolica 137b
Hours of the Annunciation 170b, 172a
Hours of the Assumption 170b, 172a
Hours of the Cross 70a, 71a, 74b, 86b, 92b, 93b, 132a,
 134a, 135b, 173a, 184b, 185a, 186, 187b, 199a, 200,
 201b, 204, 205, 208, *223*, 225b, 226a

Hours of the Holy Ghost 92b, 93b, 134a, 137, 138b, 173a, 185a, 186, 187b, 197a, 199, 200, 201b, 203a, 204, 205, 207, 208, 225b, 226a
Hours of the Passion 70a, 71a, 74b, 92b, 93a
Hours of the Purification 170b, 172a
Hours of the Virgin 70a, 74b, 86b, 92b, 93a, 112b, *127*, 129a, 131, 132a, 134, 135a, 137, 138b, 170b, 171b, 182a, 184, 185a, 186, 187b, 188b, 198–9, 200b, 201b, 203a, 204a, 205, 207, 208, 225b, 226a

Immaculate Conception, the 99b
Interpretation of Hebrew Names, The 169a
Isaiah 24, 174a, 227b

Jacopo, Mariano del Buono di 91a
Jeremiah 24
Jerome of Moravia 176b
Joachim and Anna 99b, 186b, 199b
Job 185a, 199b, 203a, 207b, 208b, 221, 225a, 226a
Jonah 99b, *161*, 171a
Joseph and Mary 98, *144*, 174a, 186b; *see also* Flight into Egypt
Josephus, Flavius *224*, 229
Judas 93a
Julius Capitolinus 90, *114*

Kievraing, Isabelle de 173–6

labours 23b, 24–5, *107*, *127–8*, 135b, 171a, 188b, 199a, 201a, *216*
Lambert-le-Bègue, psalters of 171–2
Lamentation, the *53*, 70b, 71a
La Prima Guerra Punica (Bruni) *79*, 86a
La Routye, Soeur Anne 185b
La Sainte-Baume 139a
Last Judgment 134b
Last Supper *117*
Lazarus 94a, *116*
Lévis, Philippe de 206–7
Libellus Antiquarum Diffinitionum 139b
Liège 170a
Limbourg brothers, the 180b
Lincolnshire 110a
litanies *127*, 130a, 131a, 132a, 134a, 135, 138b, 149b, 170b, 184b, 186a, 187b, 200b, 207a, 225b
Livy 10, *146*, *167–8*, 179–81, *209*
Lombardy 74a
Lorraine 173a
Lumley family, the 135a, 136
Lyra, Nicolas de 130b

Maiestas see Christ in Majesty
Maître François 187a, 197–8, 225a
Manderscheid Hours, the 137b
Marcatellis, Raphael de 135–6
Marmion, Simon 185a
Massacre of the Innocents *35*, 57, *119*, 134, *161*, 171a, 174a, 205–6

Master of Mary of Burgundy, the 137b
Medici family, the 89–91, 94b
Meditations on the Life of Christ (Pseudo-Bonaventura) 71a
Melbourne, University of (Baillieu Library) 88b, 98b, *102*, *113*, *119*, *120*, 181b, 210
Memento mori 70b, 94a
Metz 175–6
Milan 85a
missals 18, 28b, *84*, 91–2, 95
Mitchell, David Scott 15, 139b, 140a, 204b, 205a, 206a
Mitchell Library *see* New South Wales
Moran, Cardinal 134
Musica Enchiriadis (Pseudo-Hucbald) 95a

Name of Jesus, monogram of *156*
Nanni, Ser Ricciardo di 91a
Naples 76b
Nativity, the *33*, 39b, 40b, *46*, *54*, 70b, 98a, *101*, *160*, *164*, 171a, 174a, 177a, 186b, 188b, 199b, 201b, 203a, 204a, 205b, 207b, 208b, *221*, 225a, 226a; of St John the Baptist 37b, *224*; of the Virgin 37b, 99b, *102*, 174b, 177b, 186b, 199b
Neri da Rimini 58
New South Wales, Art Gallery of *224*; Public Library of 15, 16; State Library of 204b; (Dixson Library) 27b, 87a, 225b, 227b;(Mitchell Library) 87b, 136b, 152a, 183b, 200a, 205a; (Rare Books and Special Collections) 57a, 152b; University of 91b, *115*
Niccolo da Bologna 72, 73
Nicholas IV, Pope 38b
Nicholson, Sir Charles, Bart, 14–15, 73a, 75, 76, 85a, 86a
Numerian 90a

Office for the Dead 58a

Padua 71b, 72a
Page-Turner, Sir George 69a
Palm Sunday 37b
Paolini, Domenico 75b
Paris 176b, 179a, 181b, 185b, 187b, 198b; use of *148*, 185b, 198b, 208a
Passion, the 70b; according to St John 173a, 200a, 204b, 207, 208, 225b, 226a
Paul the Deacon 89a
Pentecost 28a, 37b, 93b, *116*, *120*, 134a, 137b, 177a, 185a, 186b, 197a, 199b, 200a, 201b, 203a, 204a, 205b, 207b, 208b, *210*, *218*, 226
Perugia *46*, 70
Petrarch 71–2
Philip IV, King 178a
Phillipps, Sir Thomas 28b, 39a, 69a, 85a, 89a, 90b, 178b, 206a, 207a, 229b
Piccolomini, Aeneas Silvius 76b
Pietà *84*, 93b, 95a, *126*, 134a, 137b, 185a, 186b, 201b, 203a, 204b, 207b, 208b, *212*, *220*, 226a

Pilgrimage of the Life of Man 104, 110–12, *121–2*
Pilgrimage of the Soul 110–12, *122*
Pisano, Bartholomeo 96b, *118*
Plutarch 75b
Poissy 177–8
pontificals 18, 60, *194*, 206, *220*
Postillae Litterales (de Lyra) 130b
prayer-books 19, *124*, 131, *142*, 149, *156–8*, 172, 174b
Presentation in the Temple, the 70b, *160*, 171, 174a,
 177a, 185a, 186b, 188b, 199b, 201b, 204b, 205b,
 207b, 208b, *216*, 226
Privileges of the Cistercian Order 139b
Probus 90a
Procès de Paradis 188b, *215*
Proculus 90a
Provost, Jan 226b
psalter-hours 18, *143*, 170
psalter-offices 18, 173–6
psalters 18, 74a, *81*, 87, *113*, *124*, 130a, 137a, 152b, *158*
Pseudo-Bonaventura 71a
Pseudo-Hucbald 95a
Ptolemy 95b, *117*
Pucelle, Jean 178
punctus flexus 149a
Purification, *see* Virgin

Queen Mary psalter 98, 100

Registrum Parvum (Britton) 129b
Regulae Monacharum (St Jerome) 96b, *118*
Richardson, Nelson M. (Don) 40, 57b, 58b
Rinuccini, Neri 90a
Roermond 140a
Roman emperors, portraits of 89–90, *114–15*
Rome 95a; history of 179–81; use of 86b, 133b, 136b,
 138a, 187b, 200a, 202a, 203b, 205a, 207a, 225b
Rouen 205–6
Rule and Holy Custom for the Knights of St Michael 229a
Rules for finding the new moon 60
rulings 11

St Afra 112b, 170b
St Agnes 199b, 207b
St Aidan 109a
St Alban 109a, 135a, 169a, 207a, 208a
St Aldegundis 134a
St Alphege 132a
St Amand 134a, 135a, 137a, 138a, 170b, 184, 204a
St Amalberga 149b
St Anastasia 184b
St Andrew 37b, 38b, 59a, 99b, 100a, *120*, 132a, 134b,
 177a, 203a
St Anianus 207b
St Anne 132, 150a, 186, 199b, 208, 226a
St Anselm 92b, 149b
St Anthony 28b, 86b, 88a, 92b, 135a, 186a, 199b,
 200b, 207b, 226a
St Antidius 183a
St Apollonia 132a, 186a, 203a, 226a
St Arnulf 170b
St Athanasius 137a
St Aubert 184a
St Aubin 187b
St Audomarus 134a, 184a
St Augustine 132a, 135a, 177b, 186a, 227a
St Austreberta 135a
St Barbara *106*, 132, 133a, 134b, 186, *191*, 199b, 200b,
 201b, 203a, 205b, 226a
St Bartholomew 171a
St Bartholomew of Burgos 229a
St Basil 135a
St Bavo (or Bavon) 132a, 134a, 149b;
 abbot of, *see* Marcatellis
St Benedict 92b, 96b, 109a, *118*, 135a, 137a, 203a
St Benigne 183a
St Bernard 139–40, *154*
St Bernardine 86b, 87a, 88b, 137a
St Bertin 132a, 134a, 137a, 138a, 184, 204a
St Bibiana 74b
St Birinus 112b
St Blaise 137a, 149b
St Boisilus 109a
St Boniface 92b, 137a, 149b, 208a
St Botulph 109a
St Carolus 208a
St Catherine 99b, 112b, 132, 170b, 186a, 199b, 200b,
 203a, 205b, 208b, 226
St Cecilia 174a
St Chad 109a
St Christopher 132, 134b, 187b, 197a, 199b, 203a, 226a
St Clare 28b, 86b, 87a, 92b, 186a, 207b
St Claude (or Claudius) 186a, 199b, 203a, 207, 226a
St Clement 137a
St Constantine 149b
St Cornelius 134b
St Cuthbert 109a, 132a, 135a
St Cyprian 134b
St David 109a
St Denis 134a, 169a, 186a, 199, 200b
St Dominic 59a, 92b, *165*, 176b, 177b, 178, 184b
St Dunstan 109a, 135a
St Edith 112b
St Edmund 112b, 135a
St Edmund Rich of Canterbury 169a
St Edward the Confessor 132a, 135a
St Egidius 135a, 137a, 149b, 184b, 208a
St Eligius (or Eloy) 132a, 134a, 137a, 138a, 184b, 204a,
 207a, 208a, 225b
St Elizabeth of Hungary 28b, 86b, 87a, 92b
St Elzearius 137a
St Ethelreda 135a
St Eustace 225b
St Everildis 135a

St Ferreolus 183a, 184b, 204a
St Ferrutius 183a
St Fiacre 184b, 186a
St Firmin 132a
St Foillan 170b
St Francis 28b, 38a, 87a, 88a, 92b, 137a, 184b, 186a, 207b
St Fremin 204a
St Frodobert 204a
St Gatien (or Gatianus) of Tours 92b, 207a, 225b, 226a
St Geneviève 134a, 186a, 199, 203a, 207b, 208
St Gengulph 204a
St George 132, 200b
St Gereon 134a
St Germain 135a, 137a, 186a, 204a
St Gertrude of Nivelles 132a, 134a, 149b, 170b
St Gilbert of Sempringham 112b
St Godehard 149b
St Godfroet 149b
St Gregory 134b, 150a, *196*, 207a, 226
St Guthlac 132a
St Helena 149b
St Herculanus of Perugia 70a, 71a
St Hilda 109a, 135a
St Hubert 149b, 170b, 184b
St Hugo 132a
St Hugo of Lincoln 112b
St Iacobinia 169a
St Iulita 169a
St Ivo 176b
St James *46*, 134b, 199b, 208b, *222*, 226
St James the Less 171a
St Jerome 94b, 96b, *118*, 132a, 135a, 137a, 140b, 149, *155*, 170a, 200b
St John of Beverley 109a, 132a, 135a
St John Orsini 92b
St John the Baptist 86b, 99b, 112b, *125*, 132, 134b, 177b, 186a, 199b, 200b, 201b, 205b, 207b, 208b, 226a
St John the Evangelist 23, 24, 37b, 38b, 39b, *51*, 59a, 93a, 112b, 133a, 134, *147*, 150a, 171a, 182a, 183a, 188b, 199b, 200b, 201, 203a, 204a, 205b, 207b, 208b, *211*, *218*, 226a
St Joseph 98, 225a, 226b
St Joseph of Arimathea 93a
St Julian 92b
St Lambert 149b, 170b, 171b
St Lawrence 59, 88b, 99b, 112b, *113*, 132a, 134b, 137a, 176b, 177b, 186a, *191*, 199b, 200b, 201b, 205b, 207b, 226a
St Lebuin 149b
St Legier 204a
St Leobinus of Chartres 207a, 208a
St Leonard 135a
St Livinus 149b
St Louis, King of France 37a, 38a, *166*, 176b, 177b, 178a, 186a
St Louis of Toulouse 28b, 92b, 138a

St Luke 23, 24, *41*, 134a, 182a, *190*, 197a, 199b, 201a, 203a, 207b, 226a
St Mammes 183a, 184b, 204a
St Marcellus 199a, 208a
St Margaret 112b, 132a, 138a, 149b, 150, 186a, 199b, 203a, 205b, 208b, 226a
St Mark 23, 24, *41*, 130b, 134a, 177b, 182a, 197a, 199b, 201a, 203a, 207b, 208, *210*, *217*, 226a
St Martin 134b, 135a, 137a, 203a, 204a, 207, 208a, 226a
St Mary Magdalen 88b, 132, 138b, *145*, *154*, 177b, 200b, 203a, 205b, 207b, 208b, 226a
St Mathurin 186
St Matthew 23, 24, 38a, 134a, 197a, 199b, 201a, 203a, 207b, 208b, 226a
St Matthias 37b, 59b
St Maur (or Maurus) 186a, 207a, 208a
St Maurice (or Mauritius) 187b, 200b, 207a
St Maurilius 97b, 187b
St Maximus 59b
St Medard 138b, 204a, 225b
St Michael 38a, 99b, 111a, 112b, 132a, 169a, 177b, 186a, 199b, 203a, 205b, 208b, 226a
St Mustiola of Chiusi 70a, 71a
St Nicaise 137a
St Nicholas 112b, 129a, 132a, 134b, 137a, 150a, 170b, 186a, 199b, 203a, 205b, 208b, *210*, 226a
St Nicholas of Tolentino 186a
St Omer (or Audomarus) 134a, 138a, 184a, 204a
St Oswald 109a, 132a, 135a
St Oswin 109a
St Paschal's College, Box Hill, Victoria 28b, *32*, 45–6
St Patrick's College, Manly, N.S.W. 96a, *118*, *126*, 133b
St Paul *30*, 99b, 132a, 134b, *166*, 171a, 177b, 178b, 199b, 205b, 207b, 208b, 226a; Epistles of 27, 151, *157*
St Paula 207b
St Peter 59, 99b, 112b, 132a, 134b, *166*, 171a, 174a, 176b, 177b, 199b, 205b, 207b, 208b, 226a
St Philip 45
St Pontianus 149b
St Prisca 112b
St Pudentiana 74b
St Quentin 134a, 170b, 199a
St Remacle 170b
St Remigius (or Remy) 132a, 134a, 149b, 170b, 184, 208a
St René 187b
St Reparata 74b
St Roch 149b
St Rombaud 149b
St Samson 135a
St Scholastica 132a
St Sebastian 176b, 186a, 187b, 197a, 200b, 201b, 203a, 205b, 208b, 226a
St Servatius 149b, 170b
St Stephen 28a, 39b, 40b, *51*, 59a, 132a, 134b, 177a, 200b, 203a, 205b, 207b, 226a

St Sulpicius of Bourges 225b
St Swithin 132a, 135a
St Thiery 184b
St Thomas Apostle 37b, *161*, 171b, 172a
St Thomas Aquinas 59a, 60, 176–7
St Thomas of Canterbury 40b, 112b, *125*, 132, 133b, 184b
St Thomas of Hereford 169
St Tiburtius 59b
St Urbanus 200b
St Ursinus 200b
St Ursula 132a, 134a
St Vaast 134a, 135a, 138a, 184, 204a
St Valerianus 59b
St Vedast 170b
St Veronica 138b, 139a, *154*, 198a, 226a
St Victor 134b
St Vincent 134b, 186a
St Vincent Ferrer O.P. 59a
St Wilfrand 135a
St Wilfrid 9, 109a, 135a
St Willibrord 135a, 138a, 149b
St Willerine (misspelling) 135
St William of Maleval *142*, 149b, 150
St William of York 109a, 135a
St Winnoc 134a, 138a, 184a
St Zenobius 74b
St Zerbonius of Elba 70a
Salerno (Museo del Duomo) 38a, *44*
Salvator Mundi 108, 137a, *153*
Sarum, use of 98, 112b, 129b, 131b, 132a, 135
Saturninus 90a, *115*
Scriptores Historiae Augustae 14, *82*, 89, *114–15*
Seven Requests, the 186b
Sinibaldi 90a
South Australia, State Library of *33*, 39a, 40a, *47*, *53–4*, *64*, 70, 71, *123*, *190*, *216*
Statutes of England 129b
Stigmata, the 87a
Strozzi, the 92–3, 94b
Summa Parva (de Hengham) 129b
Summa Theologica 60
Sydney, University of (Fisher Library) 55–6, *66*, 72b, 75, 76, *77–9*, 86a, 96, *117*, *118*, *124*, 130b, *148*, 151, *157*, 185b, *192*, 202a, *213*, *218–19*, 223, 227

Theological Rules (Alan of Lille) 96a, *118*
Theological Treatise 130b
Theophanes 24
Theophilus 171b, 172a
three Marys, the 171b, 186b, 187a, *213*
Titus *115*
Touraine 225b, 226b
Trate on Oratory 96b
Transfiguration, the 28a, 87a, 99a

Trinity, the 99b, 132, 138b, *163*, 171b, 186b, 199b, 204b, 205b, 207a, 208, *220*, 226a
Trinity Sunday 28a
Trivia Senatoria (Alberti) 96b
Troy, siege of *217*
Tuscany 59b

Umbria 28b, 59b, 71a

Varnucci, Bartolomeo 91a
Vatican Library 38a, *44*, *117*
Vein Man and Zodiac Man *103*, 109b
Veneto 86a
Venice 69–70, 96b; Cini Foundation 69b, 73b, 74a
Verdun 175–6
Verrazano, Alessandro 90a
Verus *114*
Victoria (Roman empress) 90b
Victoria, State Library of 16, 27, 30, *35*, *43*, 55, 57a, 59b, *61*, *67*, 72a, 73b, 74a, *82*, 89a, 95, *104*, *107*, 110a, *114–15*, *117*, *121–2*, *127–8*, 129b, 130a, 135a, 138a, 140a, *141*, *143*, *147*, *154–5*, *159–61*, *165–6*, 169a, 170a, 176b, 182b, *194–5*, 206a, 208a, *211*, *220–1*, *224*, 225a, 229b; National Gallery of 14, 23, 26, *29*, *41–2*, *83*, 92a, 94b, *116*, *144*, *146*, *162–3*, *167–8*, 173a, 187b, *189*, *209*, *214–15*
Victorinus 90b, *115*
Vigils of the Dead 19, 70, 74b, 86b, 92b, 112b, 130a, 131a, 132a, 134, 135a, 137a, 138b, *147*, 170b, 171b, 182–3, 184, 185a, 186, 188a, 197, 199, 200b, 201b, 203a, 204a, 205, 207b, 208, *211*, *213*, *223*, 225b, 226a
Vignon, Antoine 184a
Virgin, the 93a, 94a, 139–40, 150a, 172, 226a; and Child 24b, *68*, 74b, *80*, 86–7, 93a, 98, *126*, 132–3, 134a, 137, 150a, 153, 156–7, 171b, 172b, 174, 186b, 197a, 199b, 201b, 204b, 205b, 207b, 208b; Coronation of 134b, 171b, 174b, 186b, 199b, 204a, 205b, 208b, 226a; death of 174a, 188b, 203a; Dormition of *54*, 70b, 71b, 177b; Fifteen Joys of 186; Hodegetria 24; Hours of, *see* Hours; Little Office of 172a, 197b; Mass of 70a, 92b, 134a, 137; Nativity of 37b, 99b, *102*, 174b, 177b, 186b, 199b; Offices of *144*, *163–4*, 172b, *173–6*; Presentation of 132b, 134b, *162*, 174a, 186b; Purification of 59b, 177a; *see also* Assumption, Joseph and Mary
Virgin of Humility 71b
virtues 23b, 24–5, *42*, 197b
Visitation, the 70b, 99a, *126*, 185a, 186b, 199b, 201b, 204a, 207b, 208b, *212*
Vrelant style 133a, 134b

Wars of the Jews (Josephus) *224*, 229
Weyden, Rogier van der 225a, 226b
Wharncliffe Hours, the 187–8, *189*, 197–8

York, use of 135